932 Ros
Rossi, Corinna
The pyramids and the Sphinx

$35.00
ocm64664029

W9-COI-769

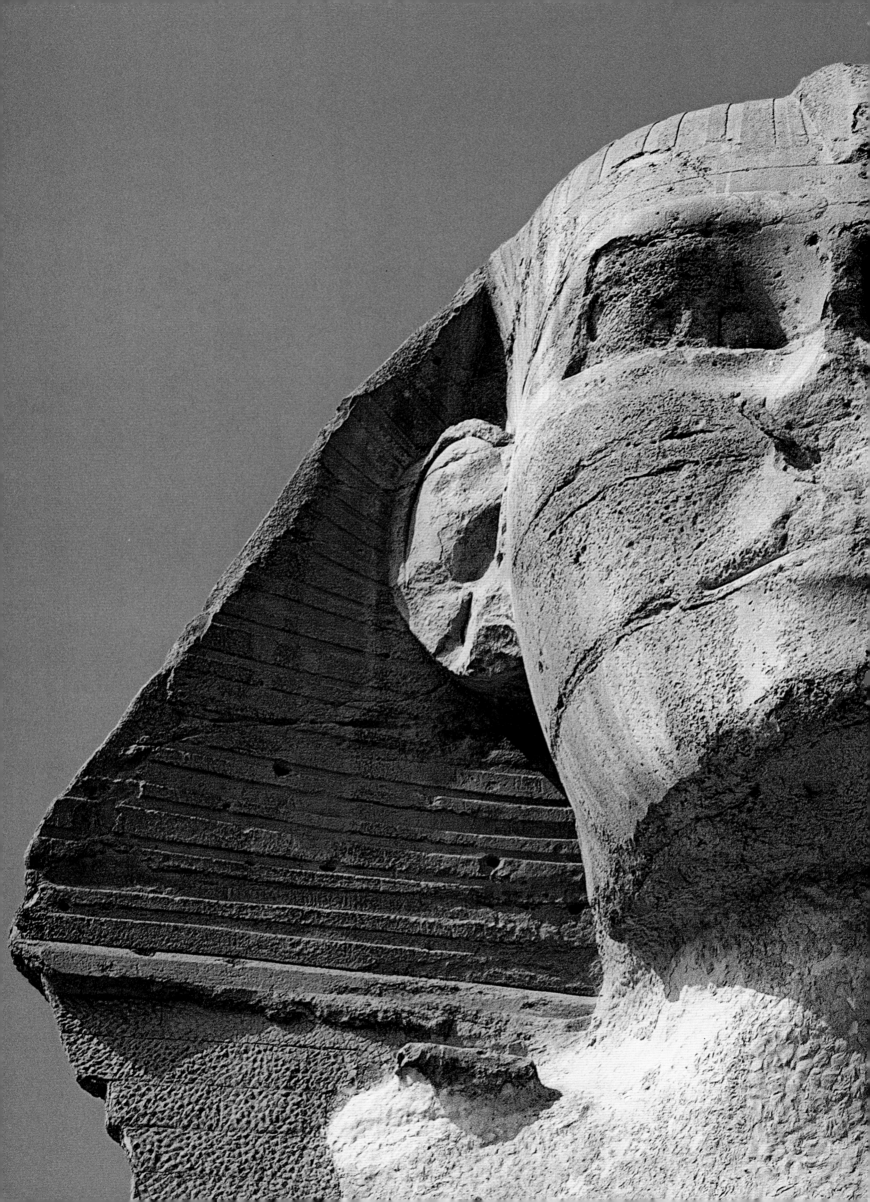

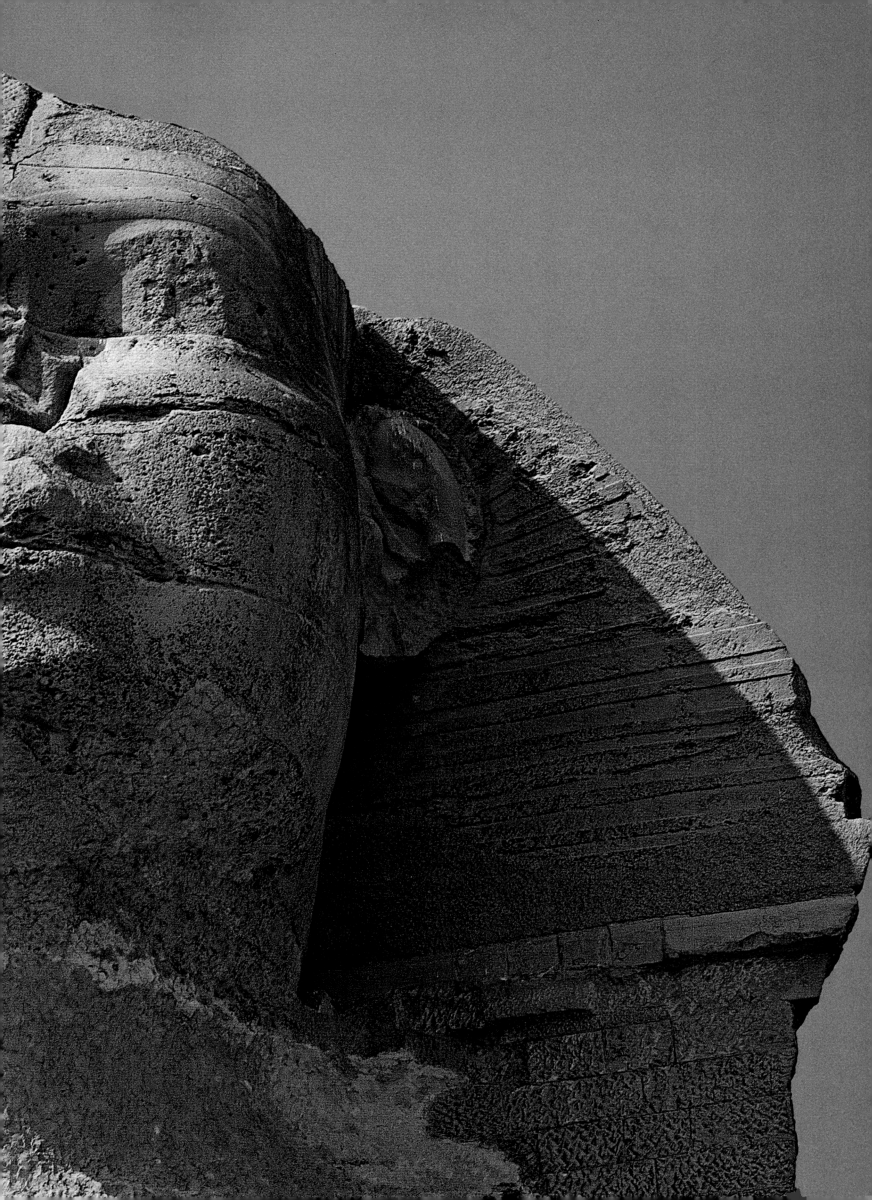

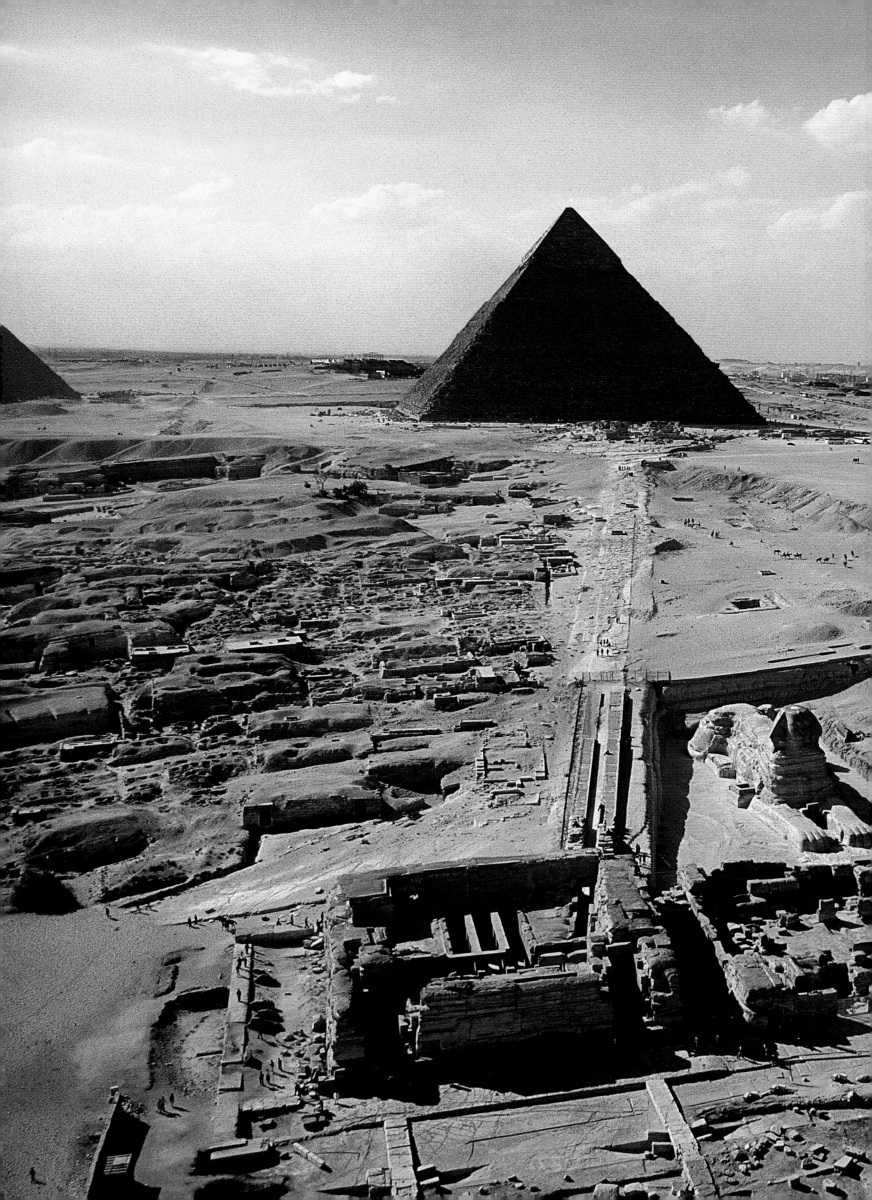

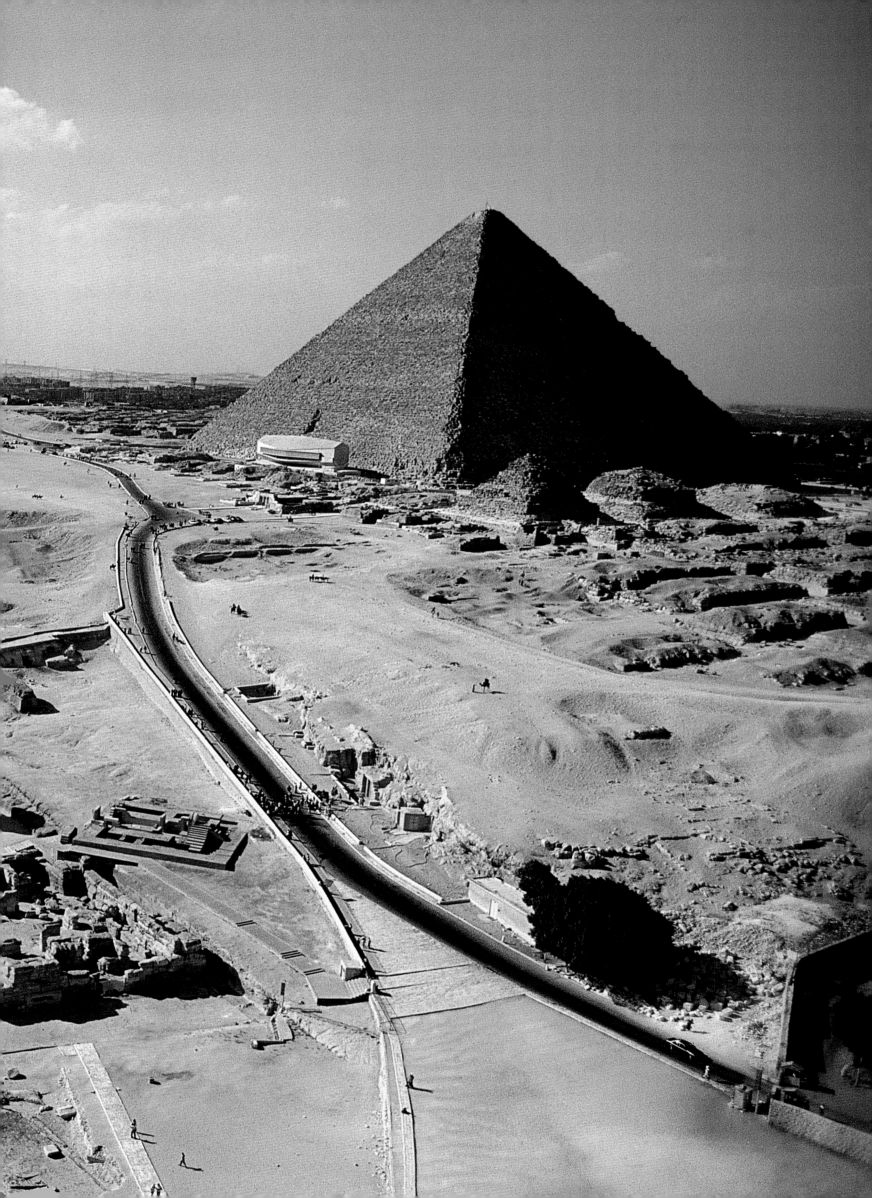

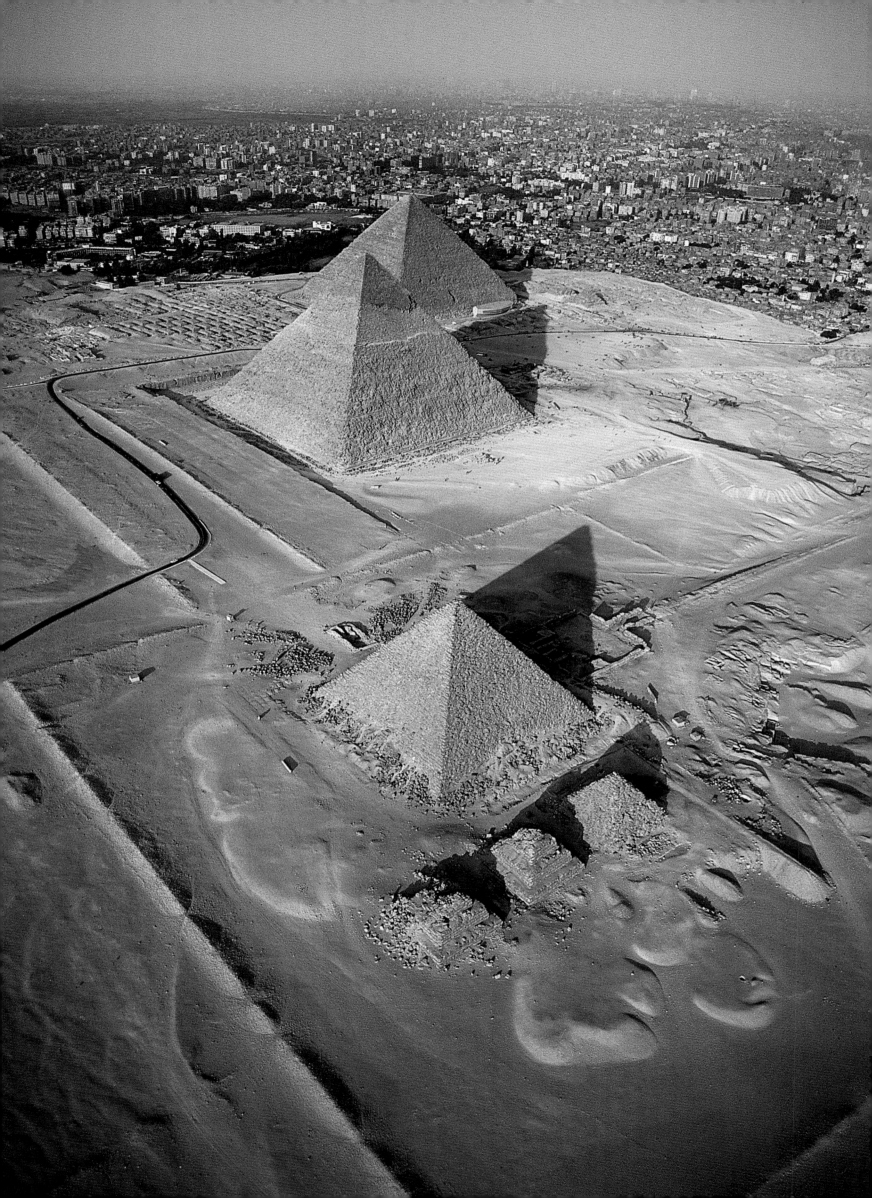

CONTENTS

TEXT
Corinna Rossi

EDITORIAL COORDINATION
Laura Accomazzo

GRAPHIC DESIGN
Maria Cucchi

1 *The pyramids on Giza plateau are one of the most famous monument groups in the world.*

2-3 *The Sphinx has the face of the Pharaoh Khafre, the builder of the second pyramid.*

4-5 *The aerial view shows, from left to right, the pyramids of Menkaure, Khafre, and Khufu.*

6 *A straggling arm of the metropolis of Cairo has reached and almost encircled the plateau of Giza.*

7 *Kai is seen on a wall of his tomb recently discovered in the western necropolis in Giza. He is depicted in the middle of his decorated boat accompanied by a team of rowers.*

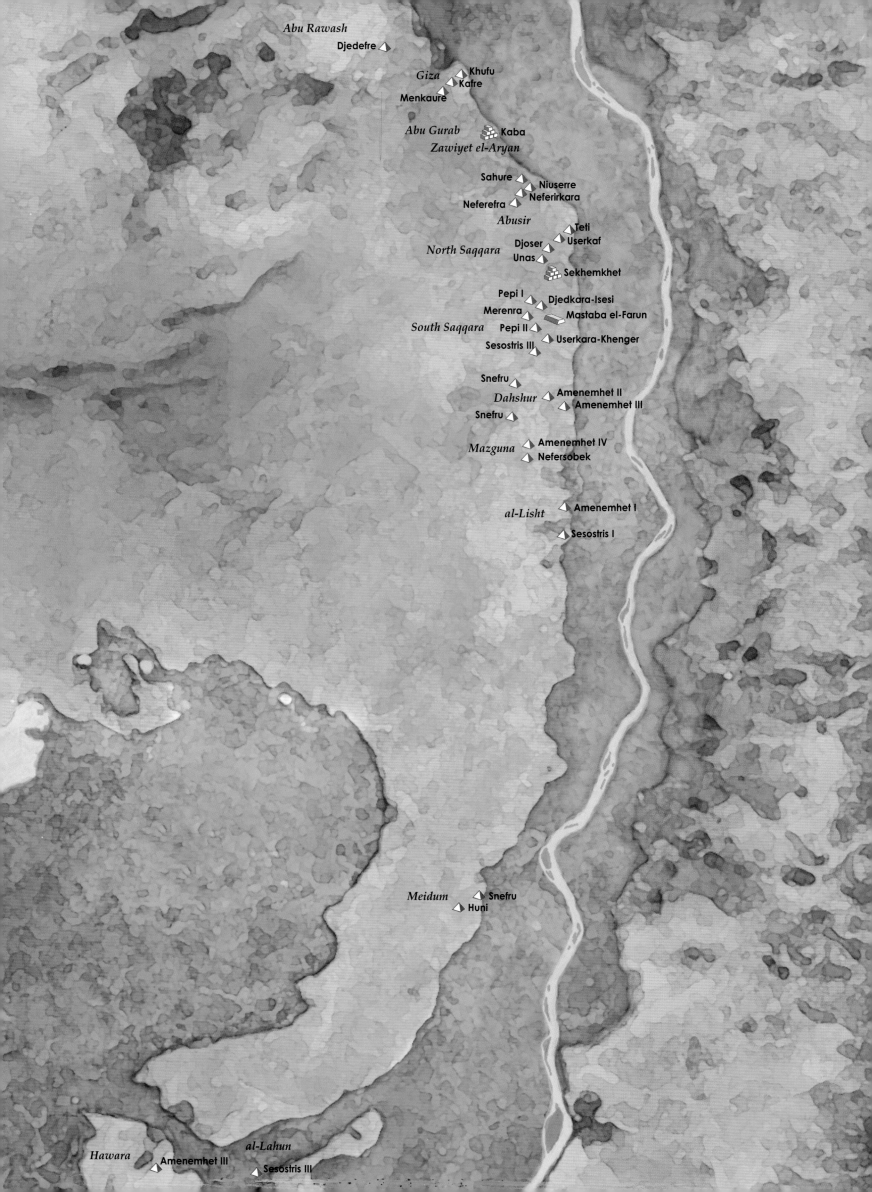

Abu Rawash

Djedefre

Giza

Khufu
Kafre
Menkaure

Abu Gurab Kaba
Zawiyet el-Aryan

Sahure
Niuserre
Neferirkara
Neferefra
Abusir

Teti
Djoser Userkaf
North Saqqara
Unas
Sekhemkhet

Pepi I Djedkara-Isesi
Merenra Mastaba el-Farun
South Saqqara Pepi II
Userkara-Khenger
Sesostris III

Snefru
Dahshur Amenemhet II
Amenemhet III
Snefru

Mazguna Amenemhet IV
Nefersobek

al-Lisht Amenemhet I
Sesostris I

Meidum Snefru
Huni

Hawara al-Lahun
Amenemhet III Sesostris III

CHRONOLOGY

PREHISTORIC PERIOD - TO 3000 BC

BEFORE 10,000 - Paleolithic period

CIRCA 4500-3000 - Neolithic period

EARLY DYNASTIC PERIOD - CIRCA 3000-2650 BC

FIRST AND SECOND DYNASTIES - CIRCA 3000-2650 BC
Narmer - Aha - Hetepsekhemwy - Raneb - Ninetjer - Peribsen - Khasekhemwy

OLD KINGDOM - CIRCA 2650-2150 BC

THIRD DYNASTY - CIRCA 2650-2575 BC
Djoser - Huni

FOURTH DYNASTY - CIRCA 2575-2465 BC
Sneferu - Khufu - Khafre - Menkaure - Shepseskaf - Queen Khentkaus

FIFTH DYNASTY - CIRCA 2465-2325 BC
Userkaf - Sahure - Neferirkare - Unas

SIXTH DYNASTY - CIRCA 2325-2150 BC
Teti - Pepy I - Pepy II - Queen Nitokerty

FIRST INTERMEDIATE PERIOD - CIRCA 2150-2040 BC

SEVENTH THROUGH TENTH DYNASTIES - CIRCA 2150-2040 BC
Collapse of central government; country divided among local rulers; famine and poverty.

MIDDLE KINGDOM - CIRCA 2040-1640 BC

ELEVENTH DYNASTY - CIRCA 2040-1991 BC
Mentuhotep II
Reunification of Egypt by Theban rulers.

TWELFTH DYNASTY - CIRCA 1991-1783 BC
Amenemhet I - Senusret I - Amenemhet II - Senusret III - Amenemhet III - Amenemhet IV - Queen Sobekneferu
Powerful central government; expansion into Nubia (Sudan). Capital at Lisht, near Memphis.

THIRTEENTH DYNASTY - CIRCA 1783-1640 BC
Rapid succession of rulers; country in decline.

SECOND INTERMEDIATE PERIOD - CIRCA 1640-1550 BC

FOURTEENTH DYNASTY - CIRCA 1640-1580 BC

FIFTEENTH AND SIXTEENTH DYNASTIES - CIRCA 1585-1530 BC

SEVENTEENTH DYNASTY - CIRCA 1640-1550 BC
Country divided with Asiatics ruling in the Delta. Theban dynasty begins reunification process.
Seqenenre Tao I - Seqenenre Tao II - Kamose

NEW KINGDOM: CIRCA 1550-1070 BC

EIGHTEENTH DYNASTY - CIRCA 1550-1307 BC
Ahmose - Amenhotep I - Thutmose I - Thutmose II - Thutmose III - Queen Hatshepsut - Amenhotep II - Amenhotep III - Akhenaten - Tutankhamun - Ay - Horemheb
Reunification and expulsion of Asiatics in north, annexation of Nubia in south.
Period of greatest expansion and prosperity. Thebes (Luxor) became main residence.

NINETEENTH DYNASTY - CIRCA 1307-1196 BC
Ramesses I - Seti I - Ramesses II - Merenptah - Siptah - Queen Twosret
After glorious reign of Ramesses II, prosperity threatened by incursions of "Sea Peoples" in north. Residence in Delta.

TWENTIETH DYNASTY - CIRCA 1196-1070 BC
Setnakht - Ramesses III - Ramesses IV - Ramesses V - Ramesses VI - Ramesses VII - Ramesses VIII - Ramesses XI
Economic decline and weak kings ruling from the Delta. Civil disturbances and workers' strikes. Royal tombs robbed.

THIRD INTERMEDIATE PERIOD - CIRCA 1070-712 BC

TWENTY-FIRST DYNASTY - CIRCA 1070-945 BC
Smendes - Siamun
Egypt in decline. Siamun may be the pharaoh who gave his daughter in marriage to Solomon.

TWENTY-SECOND DYNASTY - CIRCA 945-828 BC
Shoshenq I - Osorkon I - Shoshenq II - Osorkon IV
"Shishak" of the Bible. Egypt fragmented and politically divided.

TWENTY-THIRD AND TWENTY-FOURTH DYNASTIES - CIRCA 828-712 BC
Egypt divided among local rulers.

LATE PERIOD - CIRCA 712-332 BC

TWENTY-FIFTH DYNASTY - CIRCA 712-657 BC
Kashta - Piankhy (Py) - Shabaka - Shebitku - Taharqa - Tantamani
Rulers from Kush (Sudan) united Egypt and started cultural revival. Threatened by Assyrians who invaded in 671, 667, and 663 BC. Last king fled south.

TWENTY-SIXTH DYNASTY (SAITE) - 664-525 BC
Psamtek I - Necho II - Psamtek II
Dynasty from Sais in Delta. Defeated Kushite kings and continued rebuilding program after Assyrians left.

TWENTY-SEVENTH DYNASTY - 525-404 BC
Cambyses
Egypt annexed into Persian Empire.

TWENTY-EIGHTH THROUGH THIRTIETH DYNASTIES - 404-343 BC
Amyrtaios - Nectanebo I - Nectanebo II
Last native rulers of Egypt. Cultural renaissance and nationalism but political decline.

THIRTY-FIRST DYNASTY - 343-332 BC
Artaxerxes III
Persian reconquest.

GRECO-ROMAN PERIOD - 332 BC - AD 313

MACEDONIAN DYNASTY - 332-304 BC
Alexander the Great
Macedonian rulers after death of Alexander in Babylon (323 BC).

PTOLEMAIC DYNASTY - 304-30 BC
Ptolemy I–XV
Last ruler, Cleopatra VII, allied with Mark Anthony against Rome. Defeated by Octavian at the Battle of Actium.

ROMAN PROVINCE - 30 BC-AD 313
Egypt becomes a Roman province. Heavy taxation drains wealth from country. Christianity spreads and eliminates ancient religion.

10-11 THE WALLS OF THE TOMBS IN SAQQARA ARE LINED WITH VERY FINELY-PAINTED HIGH RELIEFS THAT OFTEN SHOW THE DECEASED IN HIS BEST CLOTHES, LIKE IN THIS LOVELY PORTRAIT OF THE VIZIER PTAHHOTEP.

12-13 THE BODY OF THE SPHINX WAS CARVED OUT OF A PROJECTION OF THE ROCK IN THE LOWER PART OF GIZA PLATEAU BUT THE HEAD WAS MADE BY SCULPTING BLOCKS OF BETTER QUALITY LIMESTONE.

14-15 AT THE TOP OF KHAFRE'S PYRAMID THERE IS STILL A SECTION OF THE LINING MADE FROM FINE LIMESTONE THAT WAS QUARRIED IN TURA. THE PYRAMID WAS ONCE COMPLETELY LINED IN THIS MANNER.

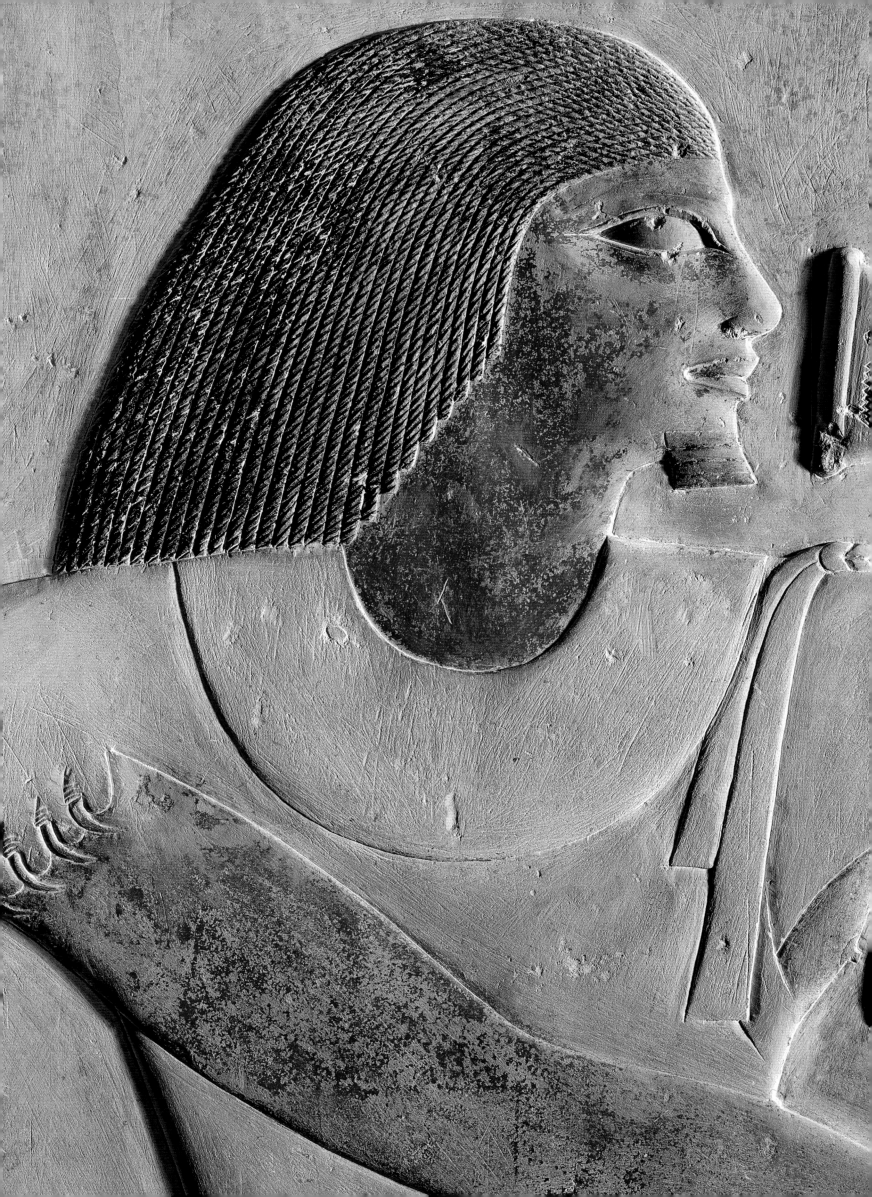

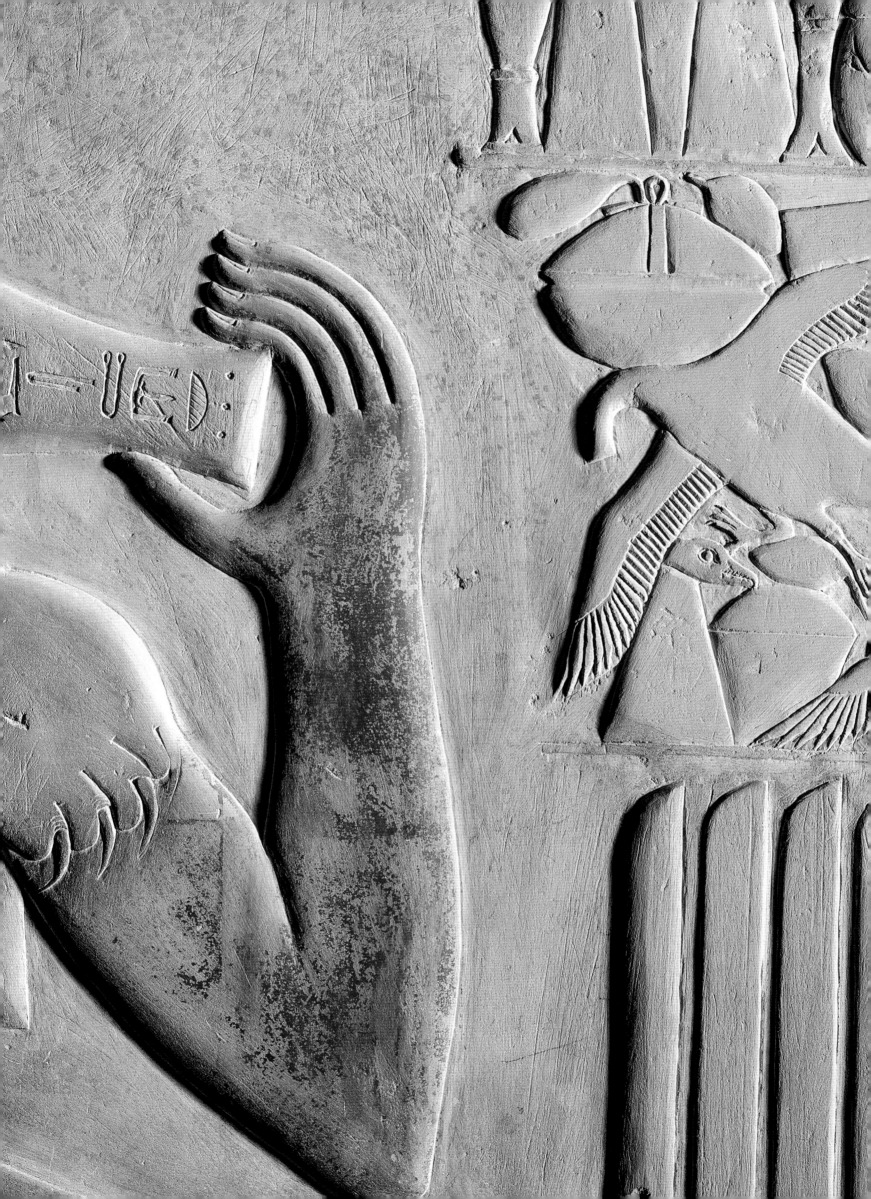

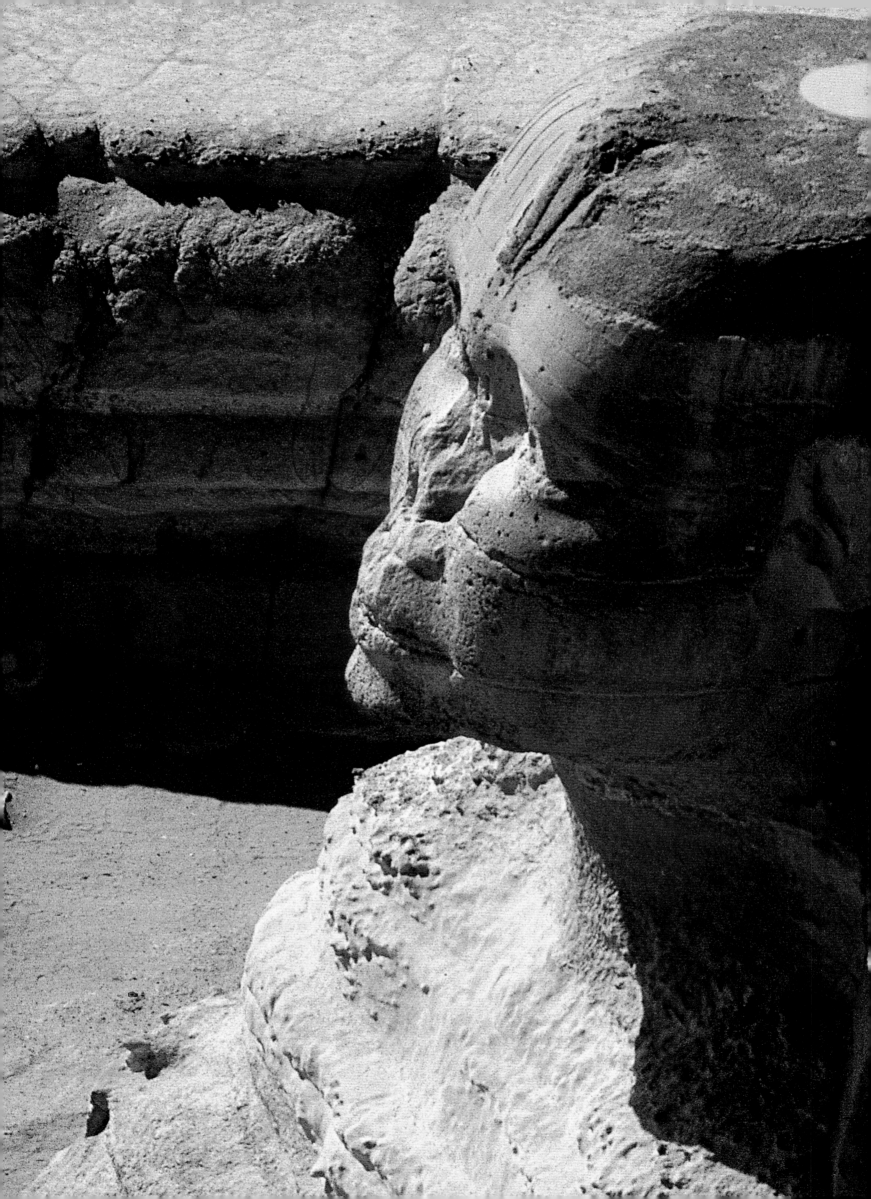

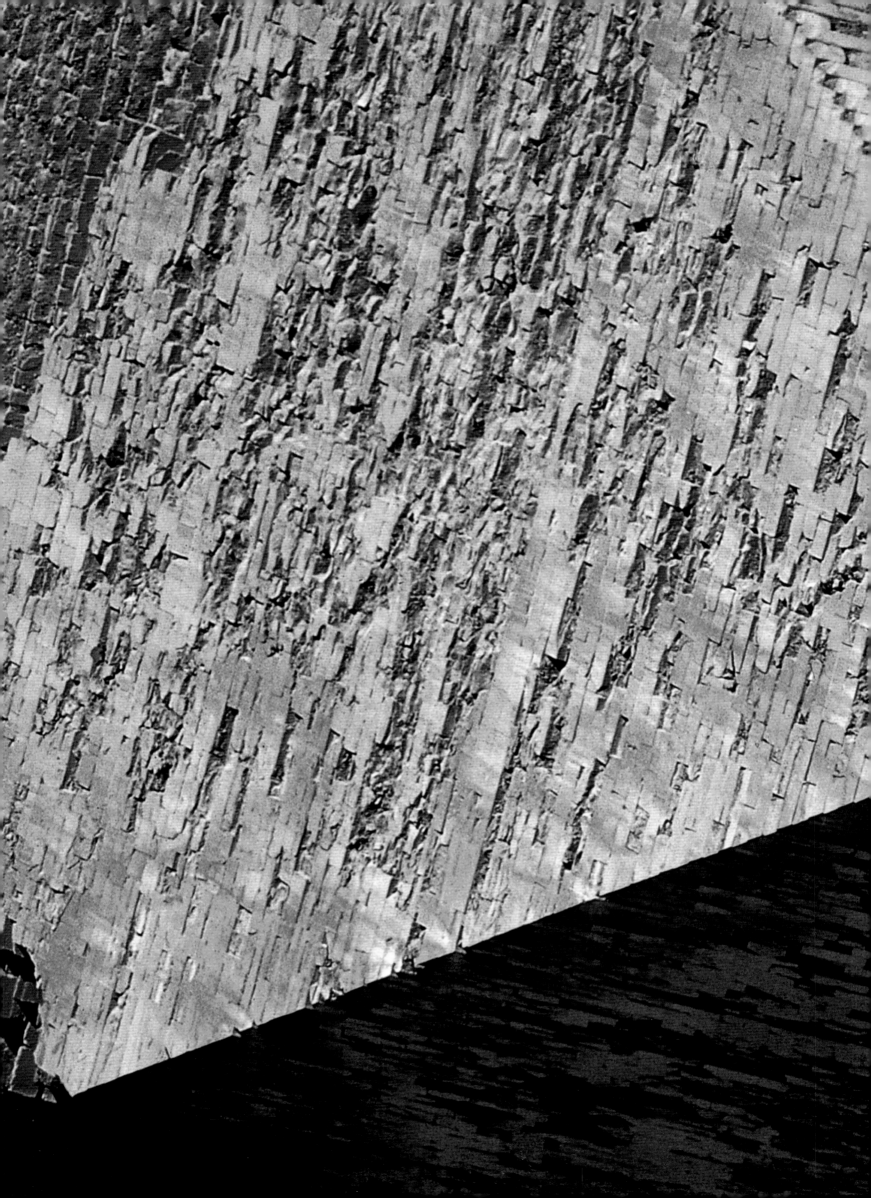

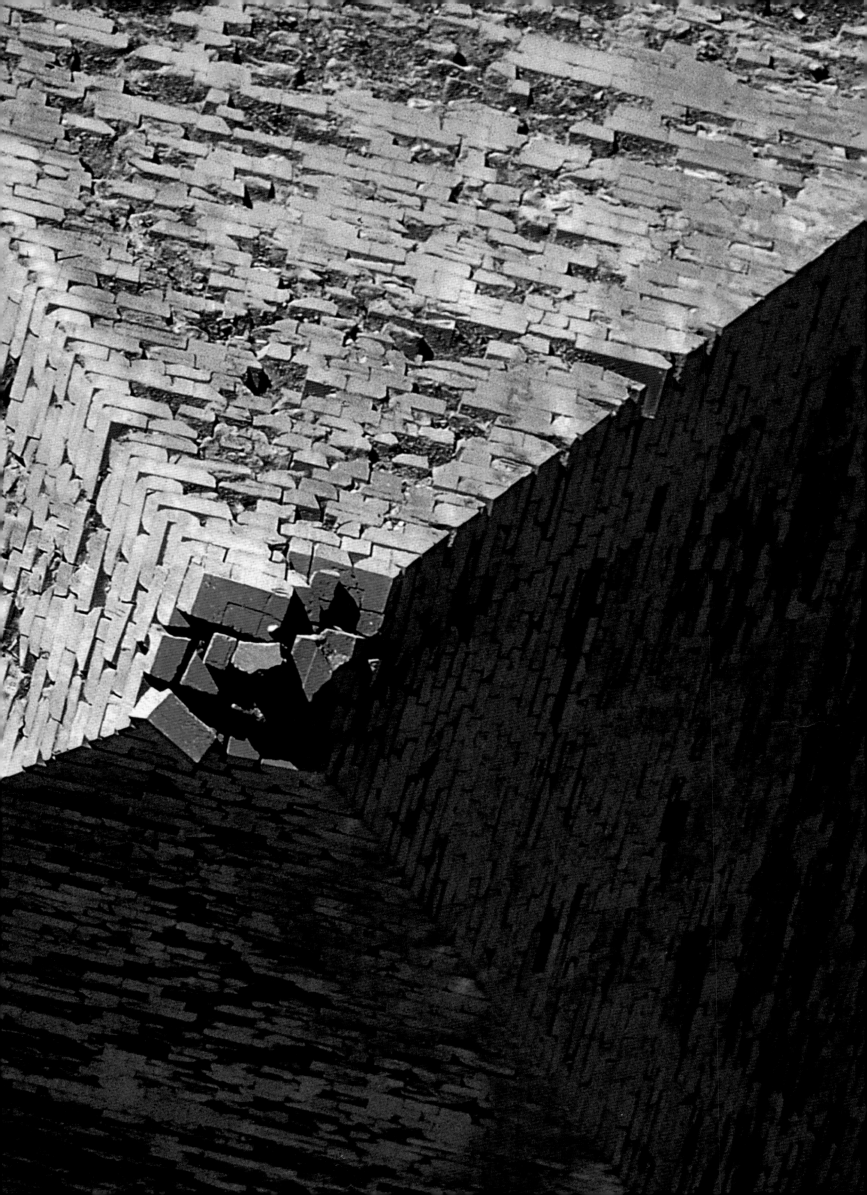

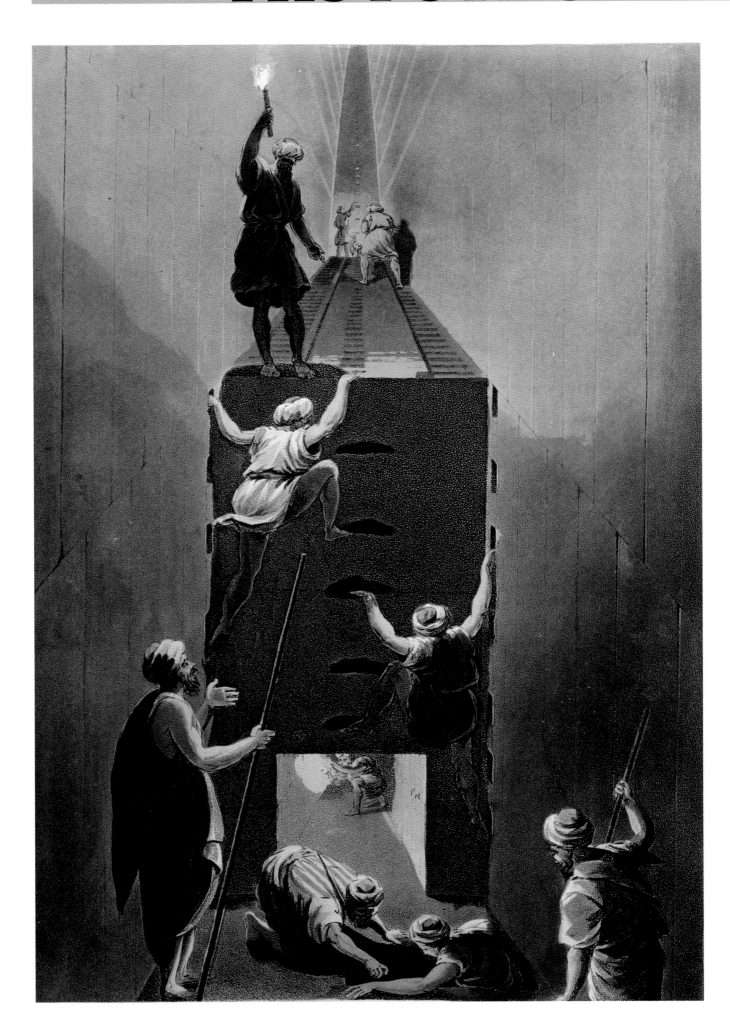

INTRODUCTION

The pyramids are the most widely recognized symbol of ancient and modern Egypt. Immense monuments built forty centuries ago, they are one of the most impressive remains of the civilization that once populated the banks of the Nile. Throughout history, travelers, tomb robbers, masonry thieves, and explorers have admired them, climbed them, attacked them, and on occasion harmed them, but their fascination and fame have never dimmed. Today, every year millions of tourists from all over the world visit the most famous pyramids, those on the plateau of Giza at the edge of Cairo, and admire the ambition and the ingenuity of the ancient pharaohs.

Egypt as a whole has more than eighty pyramids, though not all are as famous or spectacular as those in Giza. Archaeologists and experts now systematically study these monuments, and in most cases can reconstruct their history and evolution.

The habitable space in ancient Egypt was governed simply by the course of the Nile, running from south to north, and by the path of the sun, crossing the sky from east to west. The association of the pharaoh to the sun was a very ancient practice, and the west, where the sun set each day, was the natural setting for the royal burial places. The large pyramids were built in the millennium between 2650 and 1650 BC, during the historical periods conventionally referred to as the Old and Middle Kingdoms. These huge monuments are spread along the desert plateau that lines the west side of the Nile Valley between Cairo and Fayum oasis. On days in which the haze lifts, the suggestive series of triangles can be seen on the horizon, works of human engineering that because of their size and appearance vie and blur with the natural landscape.

16 AND 17 TOP KHUFU'S PYRAMID WAS OPENED AND ENTERED IN ANTIQUITY BUT EXPLORATION OF ITS PASSAGES, AS SEEN IN THESE PLATES BY LUIGI MAYER, HAS NEVER CEASED TO FASCINATE SCHOLARS AND TRAVELERS.

17 BOTTOM THE SAND AND RUBBLE THAT COVERED THE PLATEAU FOR CENTURIES HID THE COMPLEXITY AND SIZE OF THE FUNERARY BUILDINGS AND TOMBS IN THE VAST NECROPOLISES THAT SURROUNDED THE GIZA PYRAMIDS.

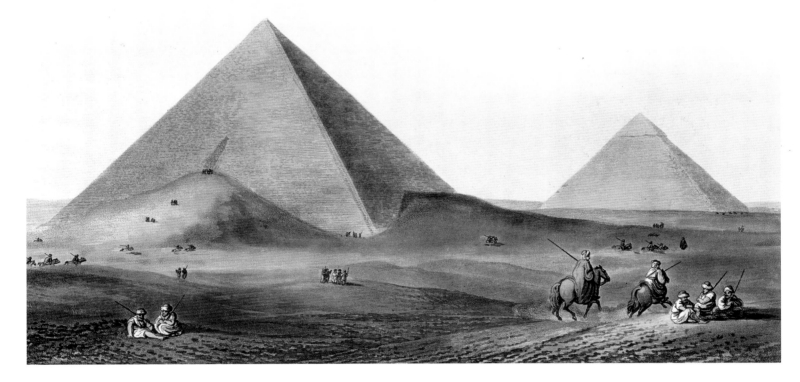

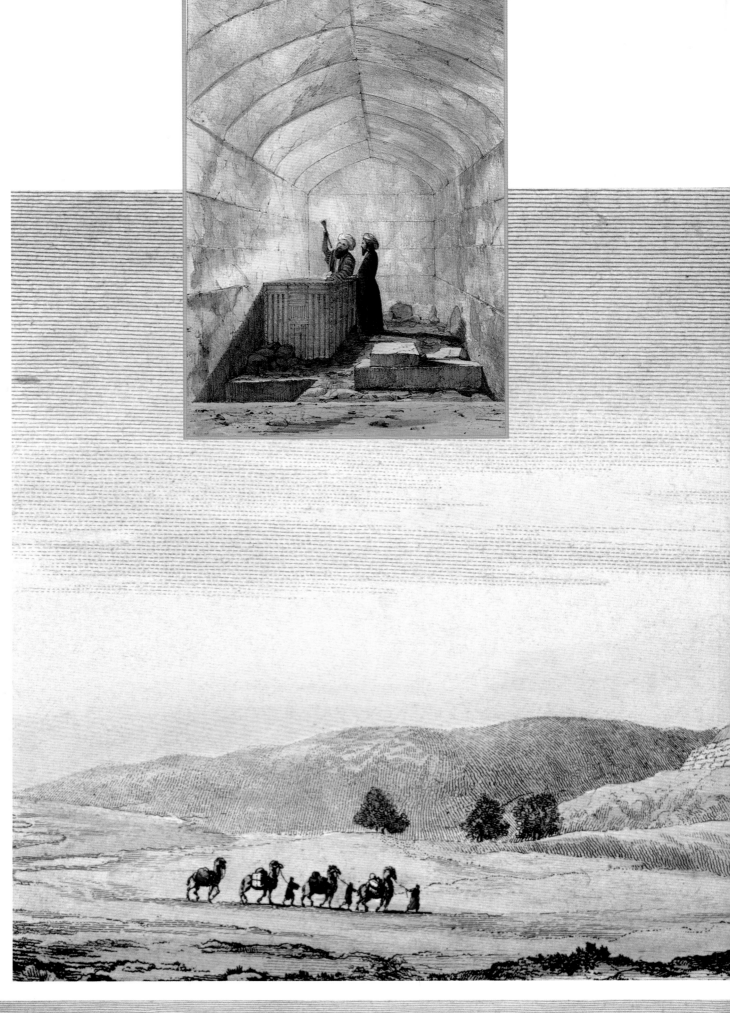
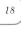

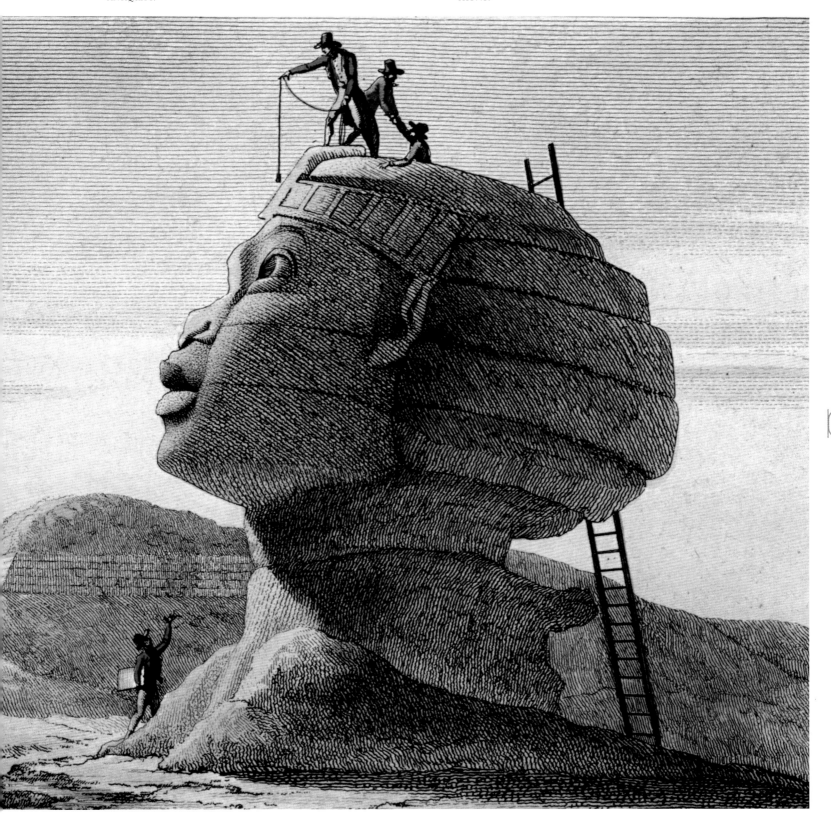

18 TOP THE GRAVE GOODS PLACED IN THE BURIAL APARTMENTS IN THE PYRAMIDS AND ALL THOSE OBJECTS THAT COULD BE REMOVED DISAPPEARED WITHOUT TRACE BACK IN ANTIQUITY.

18-19 TOP THE SPHINX HAS REGULARLY BEEN COVERED BY SAND LEAVING ONLY THE HEAD IN VIEW, AS REVEALED IN THIS DRAWING BY DOMINIQUE VIVANT DENON IN 1798.

18-19 BOTTOM THE WEST BANK OF THE NILE BETWEEN GIZA AND DAHSHUR HAS MANY PYRAMIDS BUILT IN THE OLD AND MIDDLE KINGDOMS, AS THIS TABLE FROM THE DÉSCRIPTION DE L'EGYPTE SHOWS.

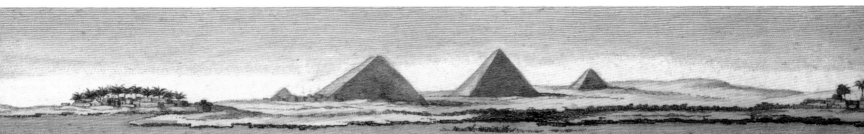

HIEROGLYPHICS FOUND IN G.T PYRAMID.
DRAWN $\frac{1}{12}$ REAL SIZE.

Fig.1.

A

B

C

FORMER HEIGHT 227

ROOF

APART

D

SUPPOSED

BASE OF PYRAMID

SECTION THROUGH CENTRE (LOO

BASALT BASALT

Fig. 4.

PAVEMENT

MASONRY

SECTION OF S.RN

PROBABLE EXTENT OF APART

CENTRE OF PYRAM

Fig

Scale of 10 20 30 40 50

J.S. Perry

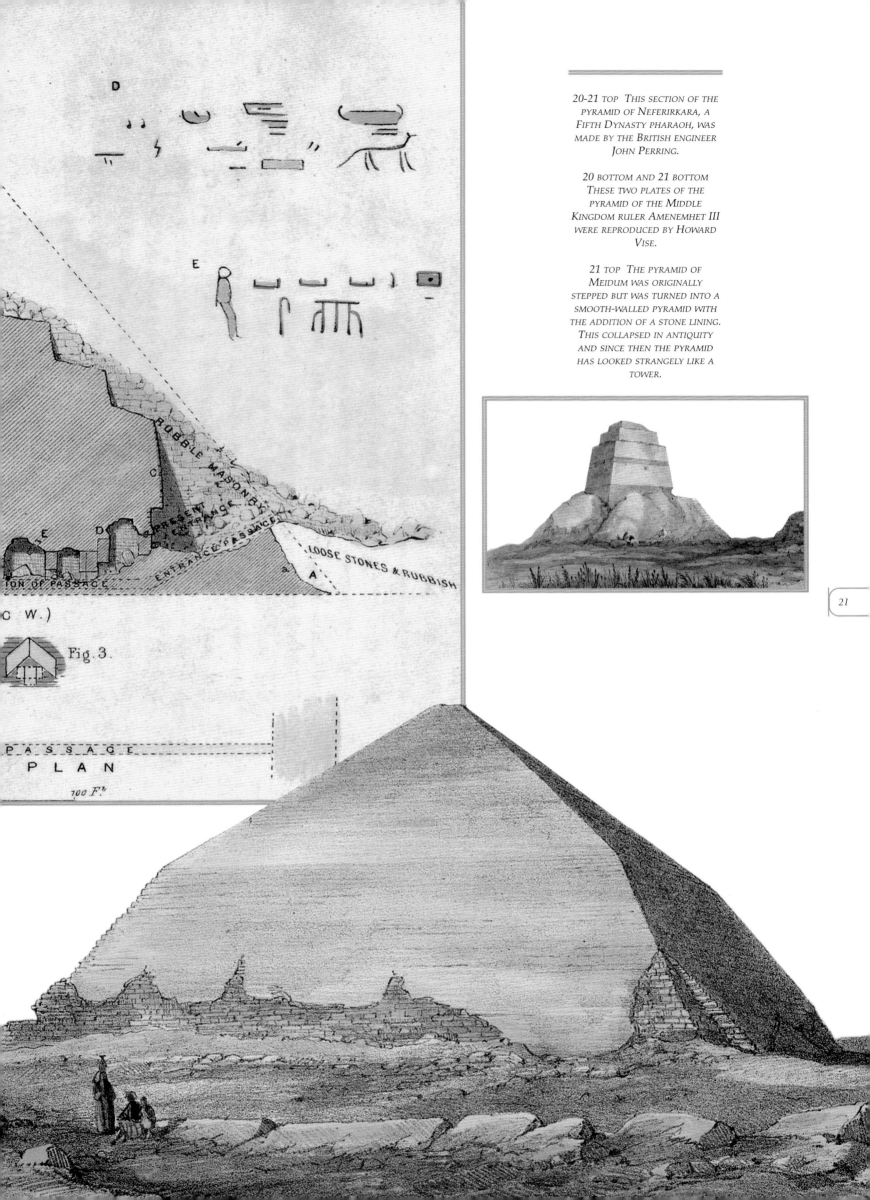

20-21 TOP THIS SECTION OF THE PYRAMID OF NEFERIRKARA, A FIFTH DYNASTY PHARAOH, WAS MADE BY THE BRITISH ENGINEER JOHN PERRING.

20 BOTTOM AND 21 BOTTOM THESE TWO PLATES OF THE PYRAMID OF THE MIDDLE KINGDOM RULER AMENEMHET III WERE REPRODUCED BY HOWARD VISE.

21 TOP THE PYRAMID OF MEIDUM WAS ORIGINALLY STEPPED BUT WAS TURNED INTO A SMOOTH-WALLED PYRAMID WITH THE ADDITION OF A STONE LINING. THIS COLLAPSED IN ANTIQUITY AND SINCE THEN THE PYRAMID HAS LOOKED STRANGELY LIKE A TOWER.

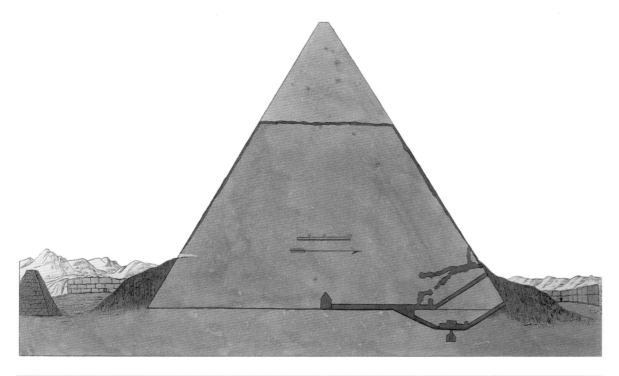

22-23 In 1818 the Italian explorer Giovanni Battista Belzoni worked for four months to clear the entrance to Khafre's pyramid from sand. He eventually managed to enter the monument and reach the burial chamber.

23 top During clearance of the entrance to Khafre's pyramid, a series of tunnels dug by tomb robbers in antiquity were also discovered.

23 center Giovanni Battista Belzoni decided not to use the dangerous tunnels used by the tomb robbers and succeeded in entering the original entrance covered by enormous horizontal slabs of stone.

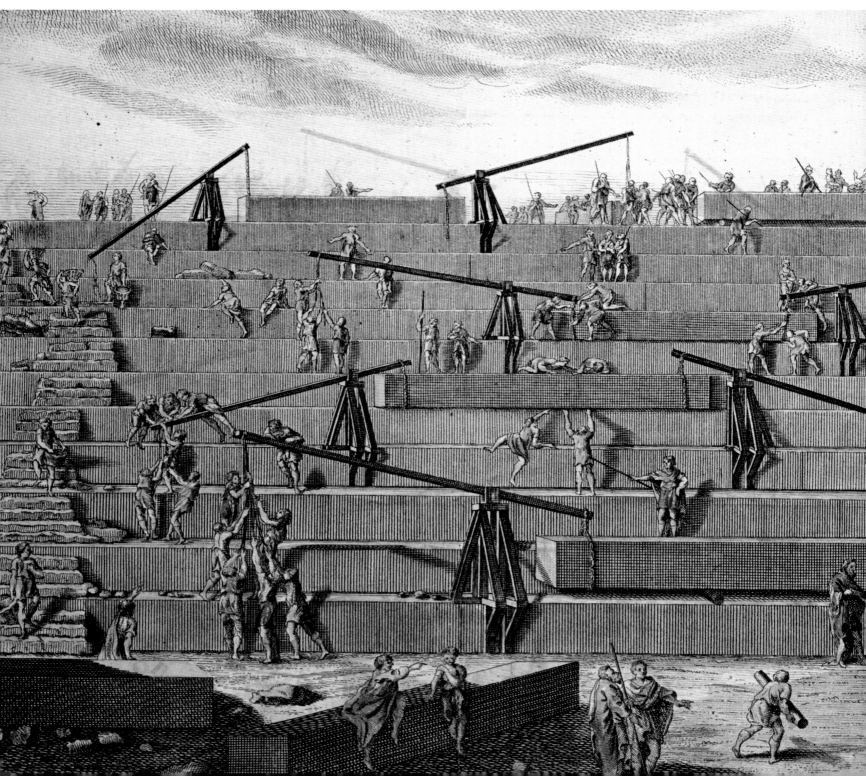

24 TOP THIS IMAGINATIVE VIEW OF THE PYRAMIDS WAS BY THE ENGLISH TRAVELER AND ANTIQUARIAN WILLIAM _[DELETE UNDERSCORE]]JOHN BANKES.

24-25 VARIOUS THEORIES, LIKE THE ONE ILLUSTRATED IN THIS NINETEENTH-CENTURY LITHOGRAPH, WERE PUT FORWARD TO EXPLAIN HOW THE BLOCKS OF THE PYRAMIDS WERE RAISED TO THE TOP OF THE MONUMENTS.

25 TOP THIS EQUALLY IMAGINATIVE IMAGE WAS PRINTED AT THE START OF THE CHAPTER DEDICATED TO PYRAMIDS IN THE BOOK BY FREDERIK LUDWIG NORDEN.

HISTORICAL
INTRODUCTION

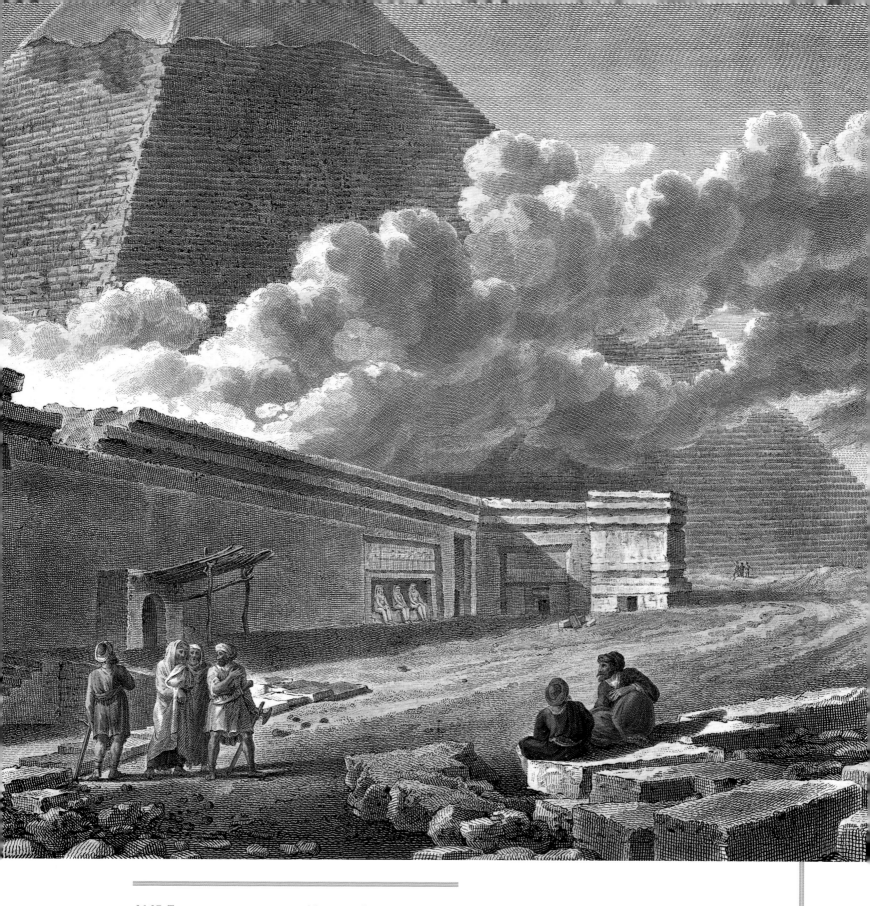

26-27 THIS PLATE WAS THE WORK OF THE FRENCH ARTIST LOUIS-FRANÇOIS CASSAS, WHO TRAVELED IN EGYPT AT THE END OF THE NINETEENTH CENTURY. KHAFRE'S PYRAMID HAS BEEN REPRESENTED FAITHFULLY WITH THE LIMESTONE LINING AT THE TOP, BUT THE TEMPLE AT ITS FOOT WAS THE RESULT OF PURE FANTASY.

26 BOTTOM IN THIS ILLUSTRATION CASSAS LET HIS IMAGINATION TAKE THE UPPER HAND. THE PYRAMID HAS THE STRUCTURE OF A FOURTH DYNASTY MONUMENT (PERHAPS THE PYRAMID OF KHUFU OR KHAFRE), THE FUNERARY TEMPLE IS IN PTOLEMAIC STYLE AND THE AVENUE OF SPHINXES IS TYPICAL OF THE NEW KINGDOM.

*28 TOP THE SCOTTISH ARTIST
DAVID ROBERTS VISITED LOWER
EGYPT ON MORE THAN ONE
OCCASION. THIS PLATE OF GIZA
PLATEAU WAS MADE IN JANUARY
1839.*

*28-29 THIS SPECTACULAR
LITHOGRAPH BY DAVID ROBERTS
SHOWS KHAFRE'S PYRAMID (LEFT),
THE SPHINX HALF-COVERED BY
SAND AND KHUFU'S PYRAMID
(RIGHT).*

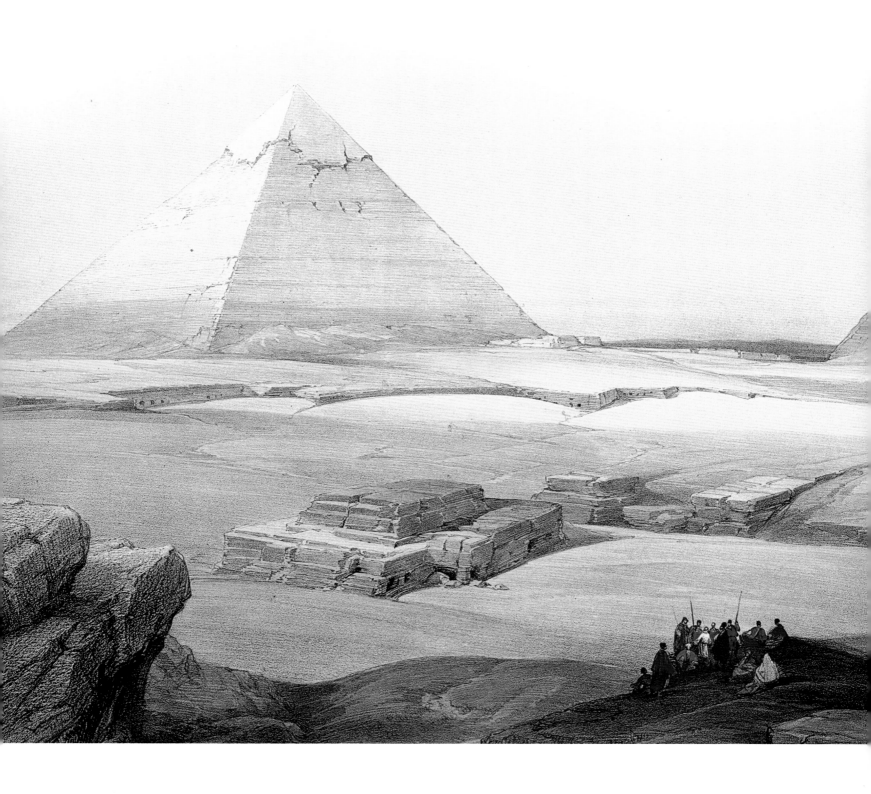

30-31 AND 32-33 THE SPHINX HAS BEEN COVERED ALMOST ENTIRELY BY DESERT SAND SEVERAL TIMES IN ITS HISTORY AND SEVERAL TIMES CLEARED. IN THESE TABLES ROBERTS HAS IMMORTALIZED THE FAMOUS, ENIGMATIC MONUMENT HALF-BURIED, [CHANGE COMMA TO PERIOD. START SENTENCE WITH "HOWEVER"] HOWEVER, AT THE TIME OF THE ARTIST'S VISIT GIOVANNI BATTISTA CAVLIGIA FROM GENOA HAD ALREADY DUG IT FREE.

34-35 MEN AND CAMELS SEARCH FOR REFUGE AROUND THE SPHINX, HERE COVERED WITH SAND UP TO ITS NECK, FROM THE TERRIBLE HOT WIND CALLED THE SIMÙN, IN THIS WATERCOLOR BY SCOTTISH ARTIST DAVID ROBERTS.

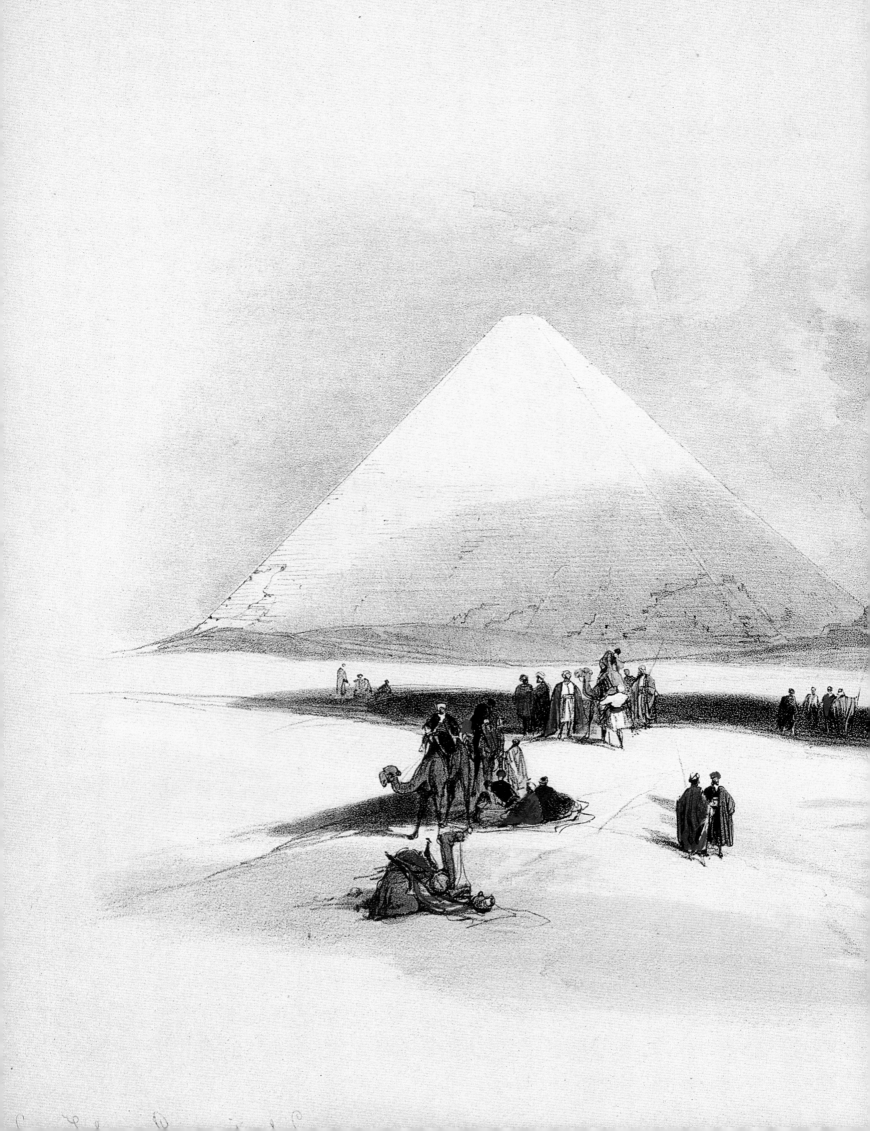

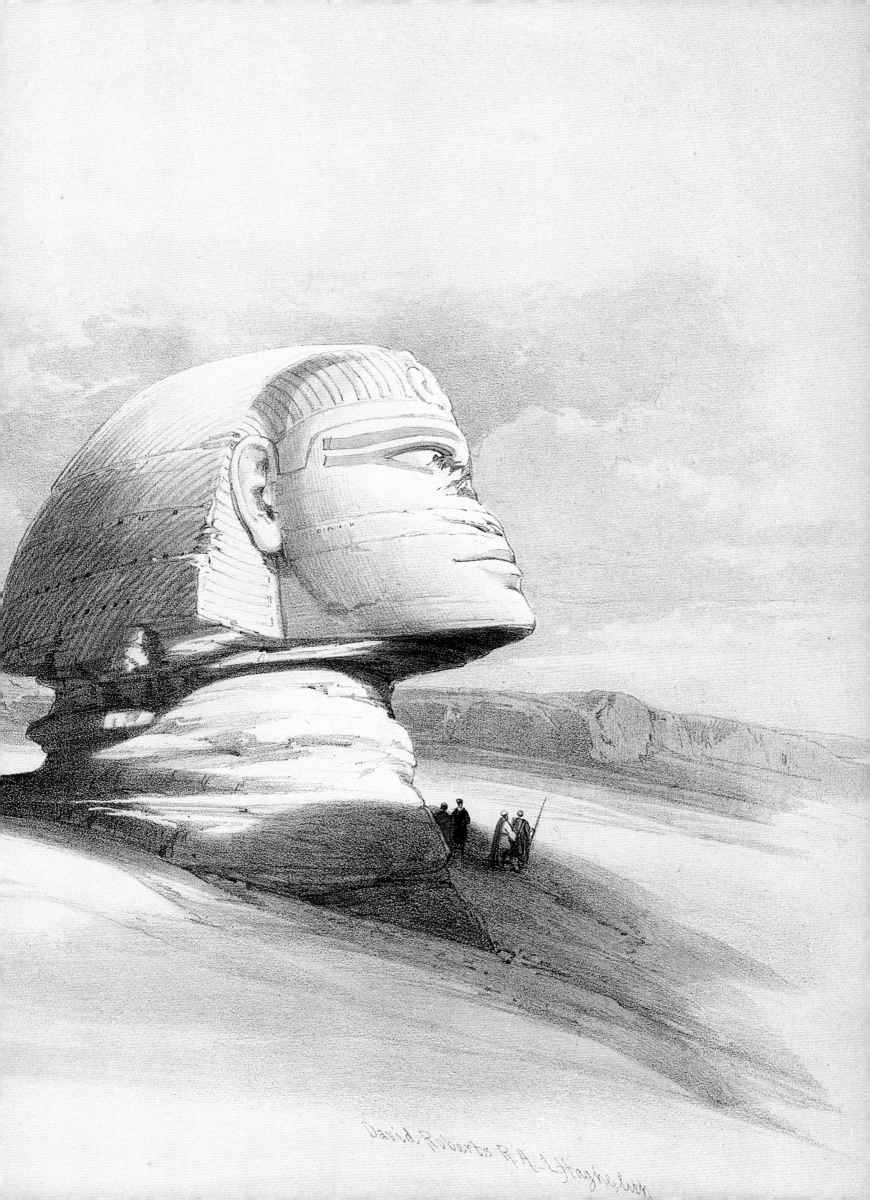

David Roberts R.A. Lithograph

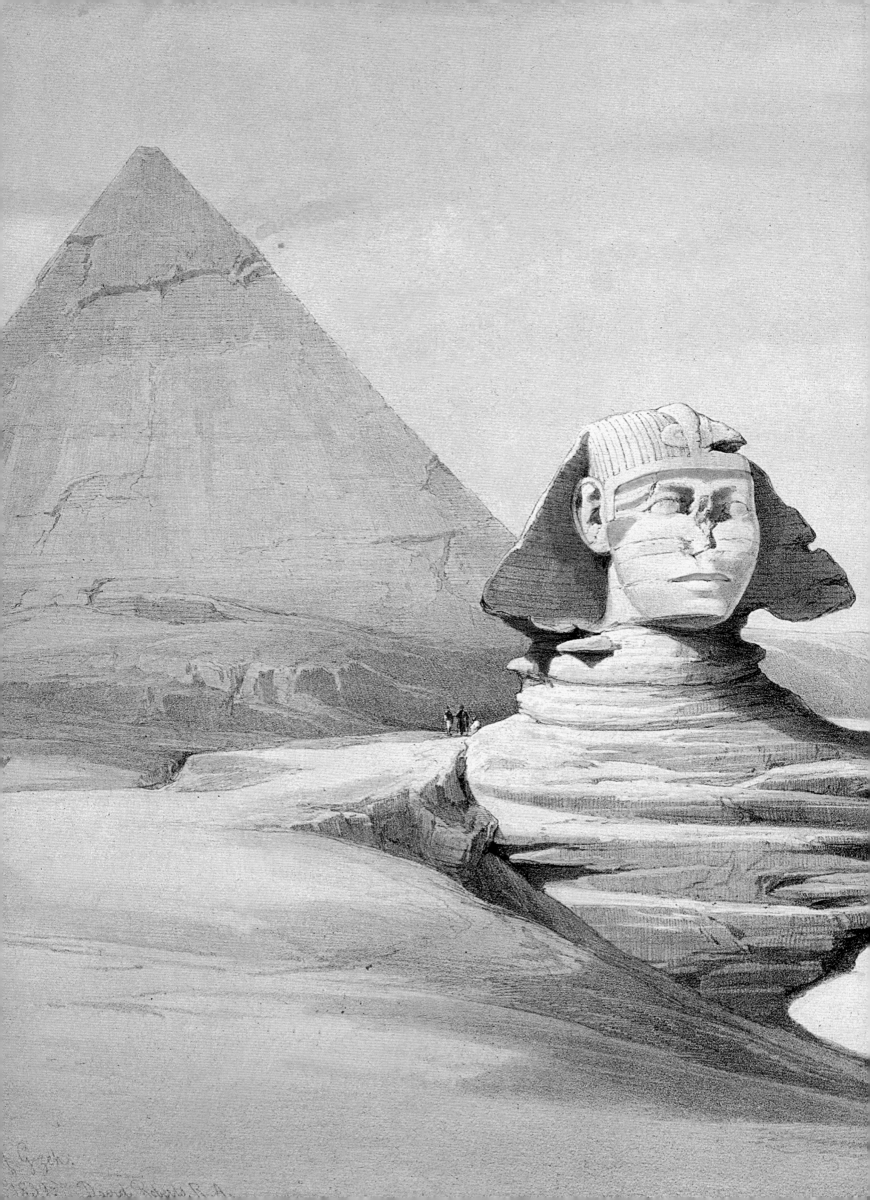

Gyzeh.

David Roberts R.A.

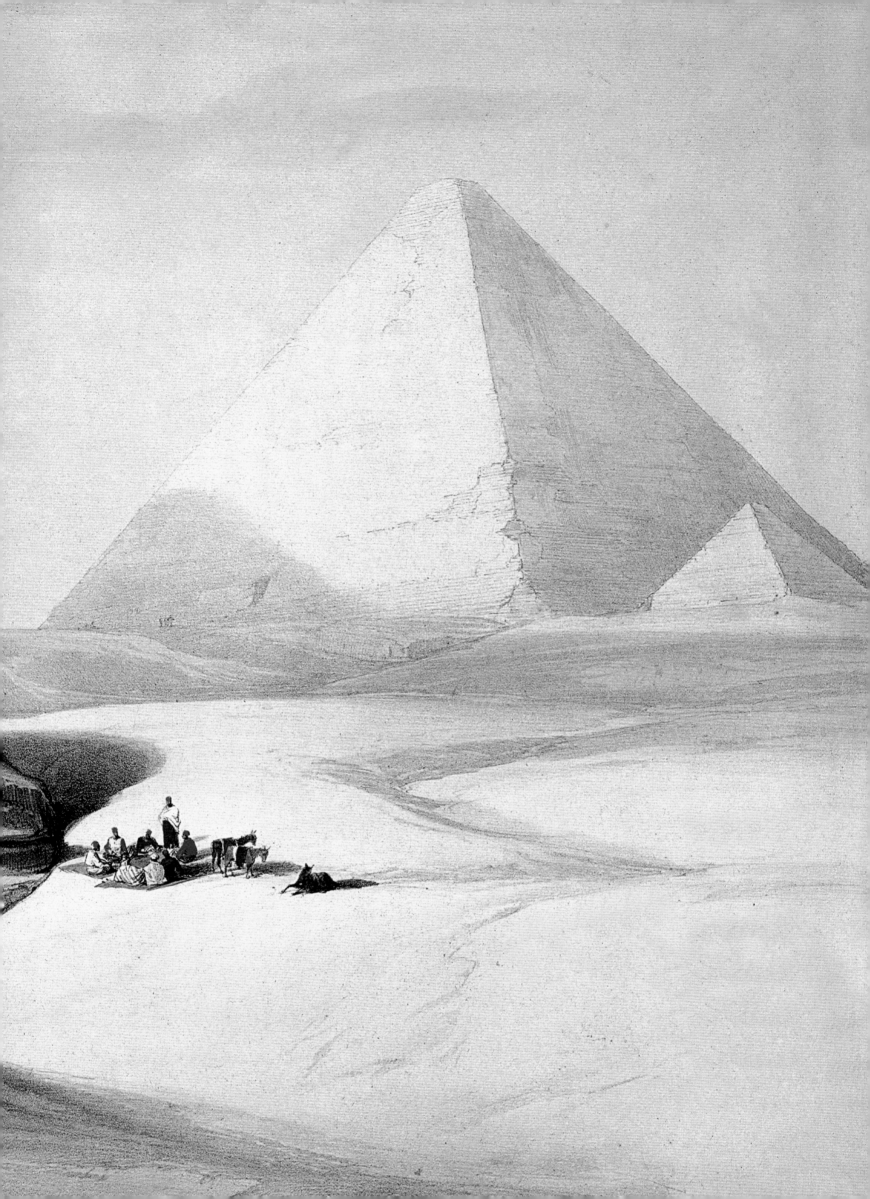

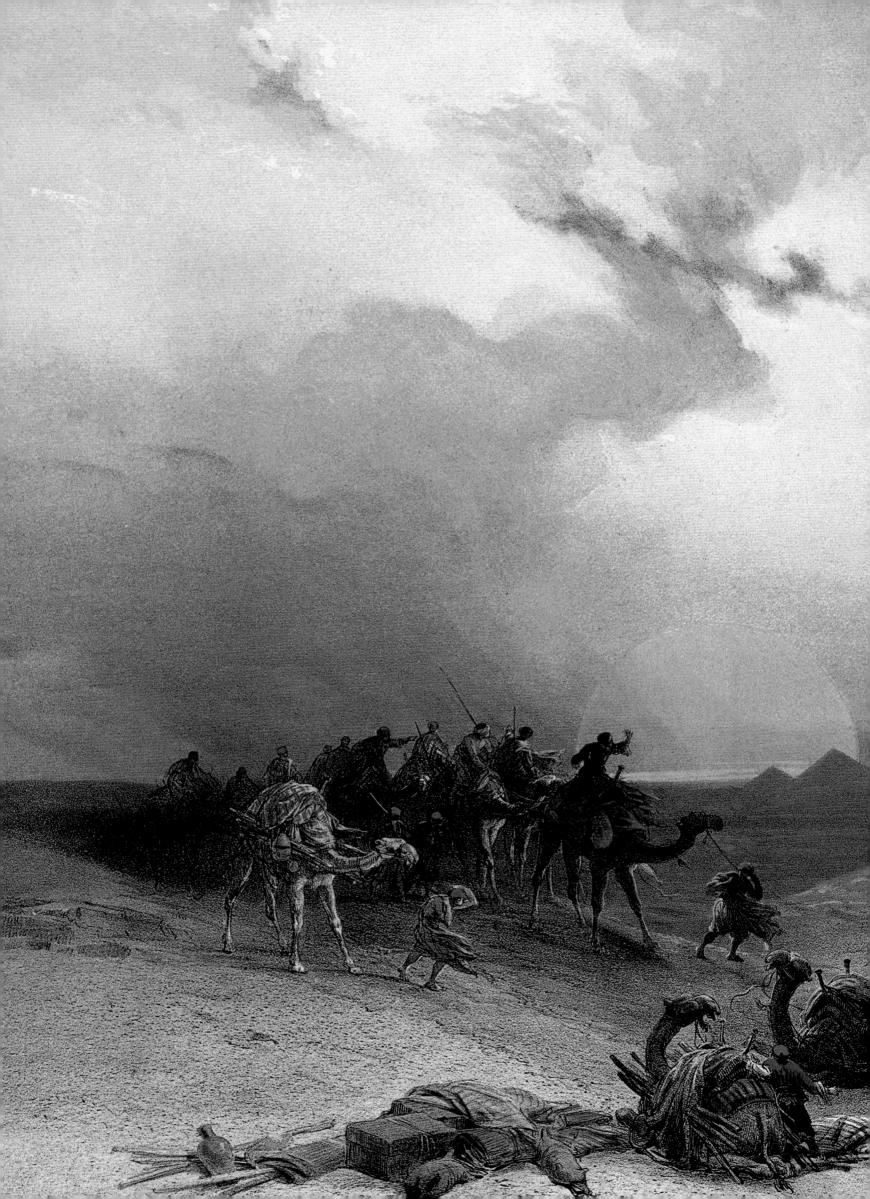

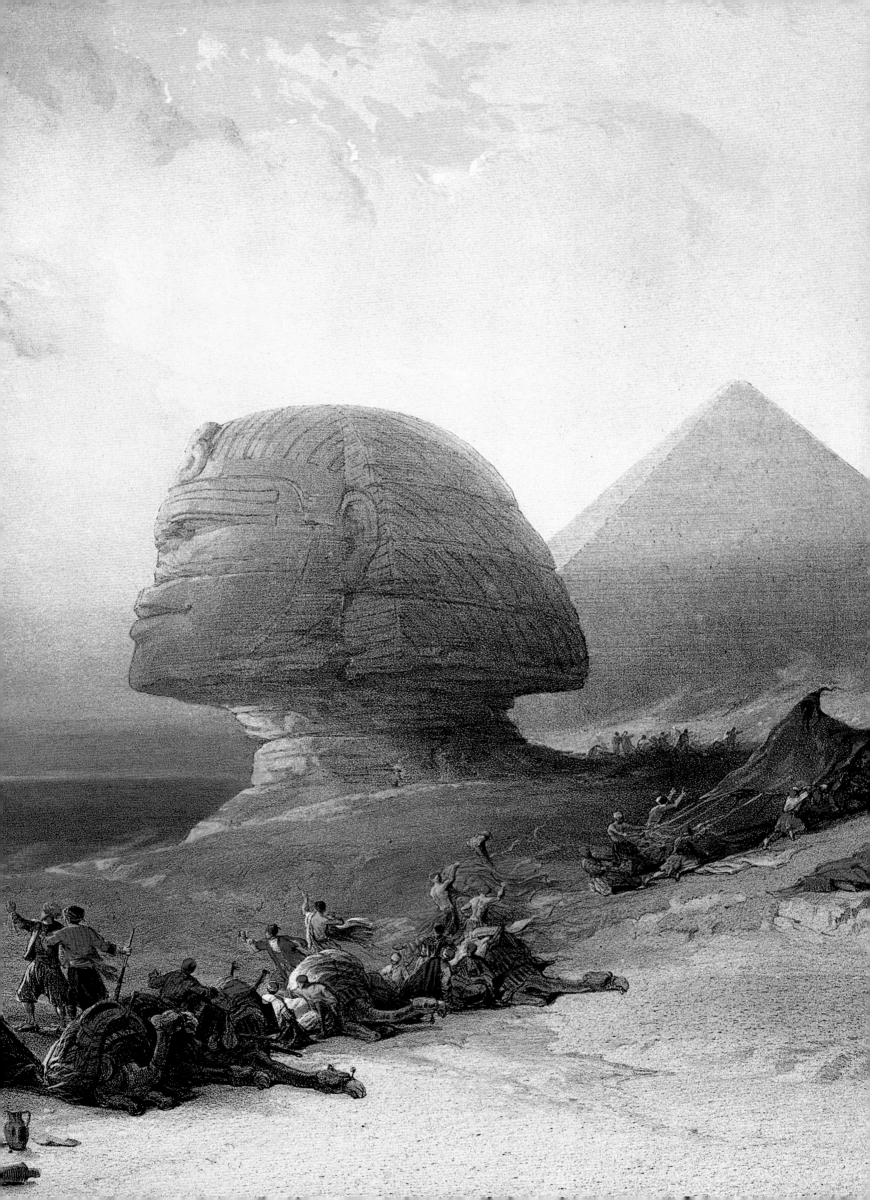

THE STEP PYRAMID

36 LEFT THE ARCHITECT IMHOTEP WAS RESPONSIBLE FOR BUILDING THE LARGE FUNERARY COMPLEX THAT INCLUDED THE FIRST STEPPED PYRAMID.

36-37 THIS VIEW SHOWS THE LARGE ENCLOSURE OF DJOSER'S STEPPED PYRAMID AND ITS SET OF SECONDARY BUILDINGS.

The history Egypt's pyramids began around 2650 BC on the sandy plateau of Saqqara. A dense palm grove covers the valley floor and stretches to the foot of the hills where it suddenly gives way to the desert. At the top of the hill, rising from the sand are the remains of one of the most important necropolises in ancient Egypt, used from the time of the First Dynasty. This was the site that Djoser, a Third Dynasty pharaoh, chose for construction of his funerary monument. The architect responsible for the design and construction of the pyramid was Imhotep; from the collaboration of the two the first Egyptian pyramid came into being.

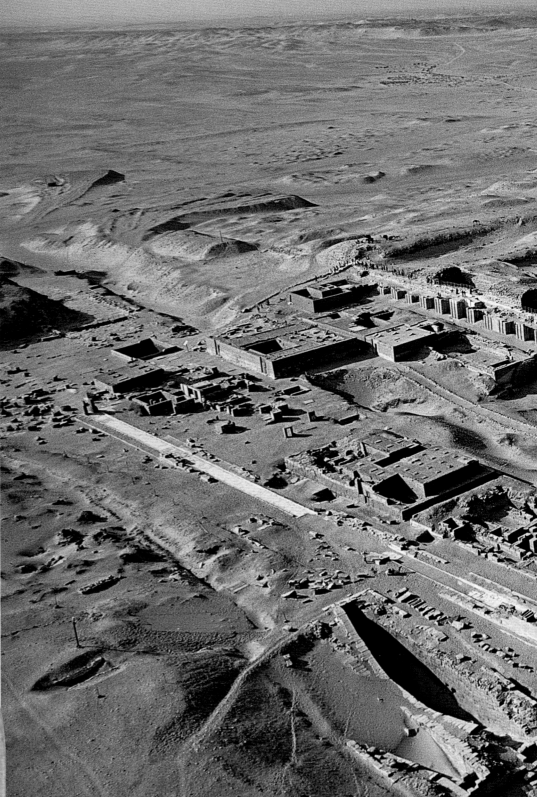

OF SAQQARA

Construction of the pyramid was fairly eventful, including a series of innovations that were to have a fundamental influence on the history of architecture and the funerary cult of the pharaohs.

Before Djoser, the kings and dignitaries had been buried in large tombs covered with a rectangular building. Due to the shape of these ancient buildings, the Arabic word *mastaba* ('bench') is used today as a descriptive name for these burial structures. They were built principally from mud brick with the use of stone to block the entrance and line the burial chamber.

Imhotep changed this practice; he used stone for the construction of the entire building. This decision marked an important historical turning point: in a very short time the ancient Egyptians understood this new material's potential and began to exploit it to the maximum. In just a few generations, the techniques used to quarry and work stone improved. Stone cutting increased, the precision of the joints was improved and, with it, the stability of the entire construction. This development can be seen in the pyramids at Giza, which were built just two hundred years after the Stepped Pyramid.

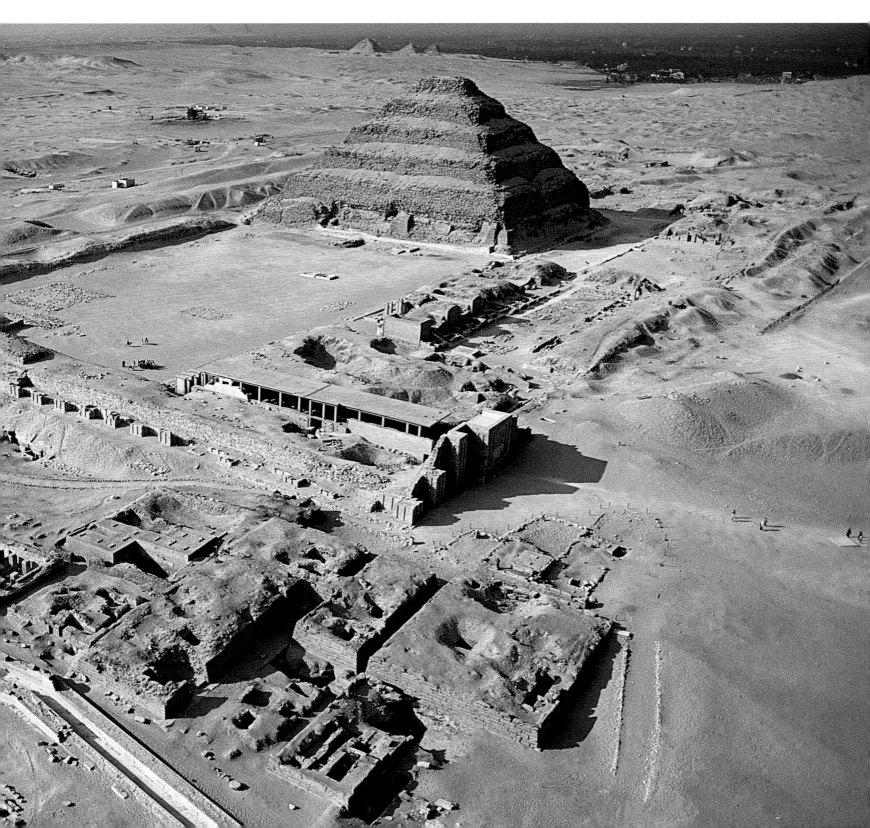

38-39 A WALL DECORATED WITH COBRAS IN THE BURIAL CHAPEL IN THE SOUTH TOMB.

39 TOP DJOSER'S PYRAMID IN SAQQARA IS RECTANGULAR IN PLAN AND HAS SIX LARGE STEPS.

39 BOTTOM THE COBRA, OR URAEUS SERPENT, IN STRIKE POSE WAS USED AS A DECORATIVE MOTIF. IT SYMBOLIZED THE HOPE INHERENT IN A NEW LIFE.

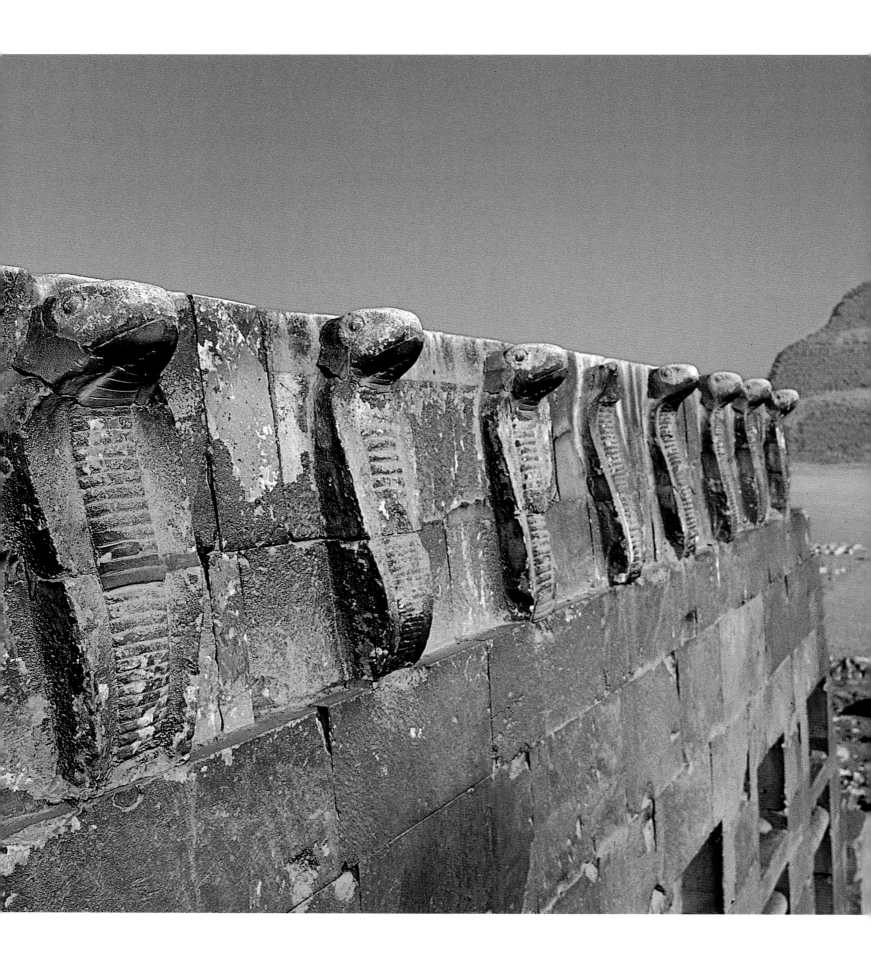

40-41 *The desert plateau to the west of the Nile valley [capital V] is home to a series of groups of pyramids, including those of Saqqara (foreground) and Dahshur (further south).*

42-43 *This vertical view of Saqqara and its surroundings shows the entire funerary site. Built originally by the pharaoh Djoser, it was enlarged over various epochs.*

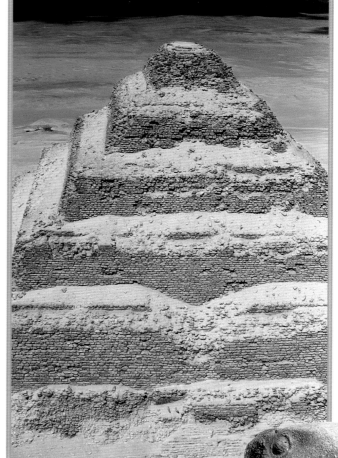

The other major innovation was related to the shape of the funerary monument. Following tradition, Djoser initially had a *mastaba* tomb built for himself. This was a low square block with outer walls slightly inclined inward. After a short time, however, it was decided to expand the structure and then to cover it with a series of *mastabas* that decreased in size as they rose. In its final form, the monument was a series of six steps that contained and completely hid the previous stages of the construction. Archaeologists only discovered the history of the monument's construction because of the partial collapse of the first step on the east side, below which the side of the original *mastaba* is visible.

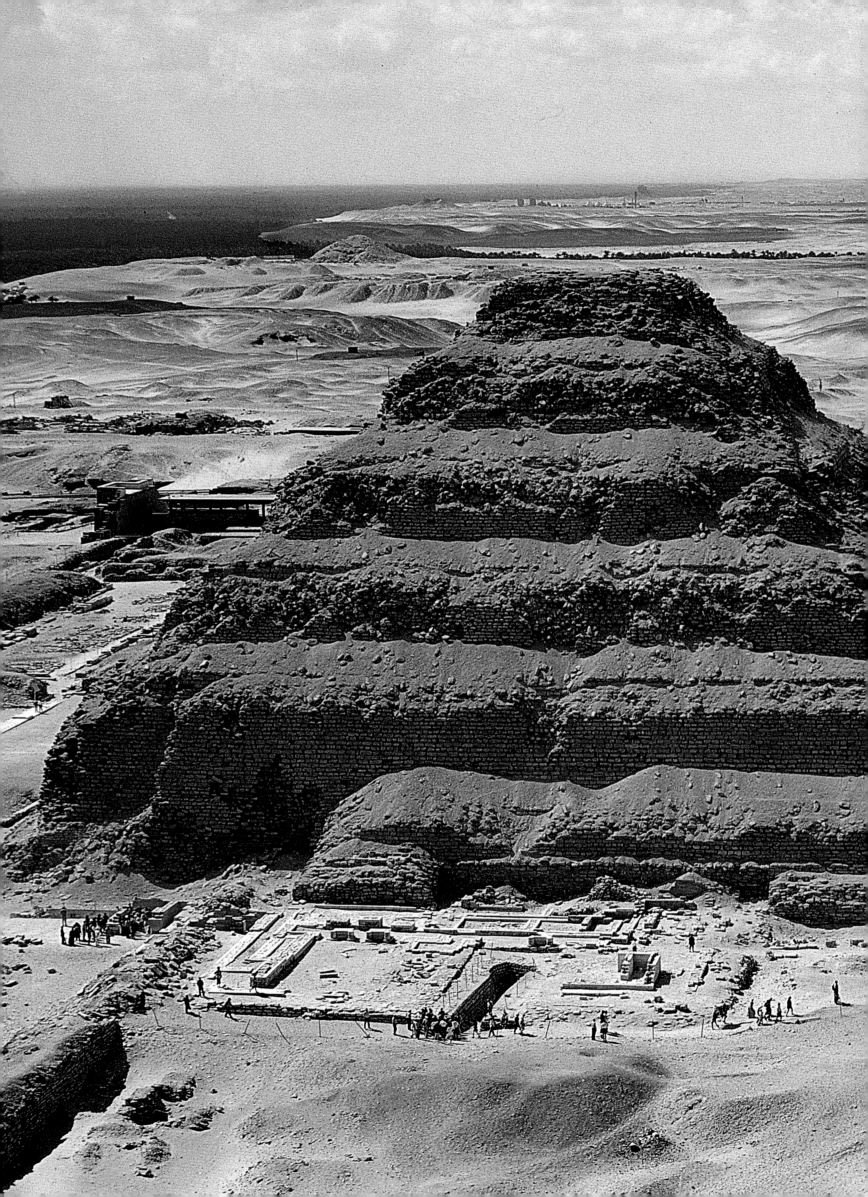

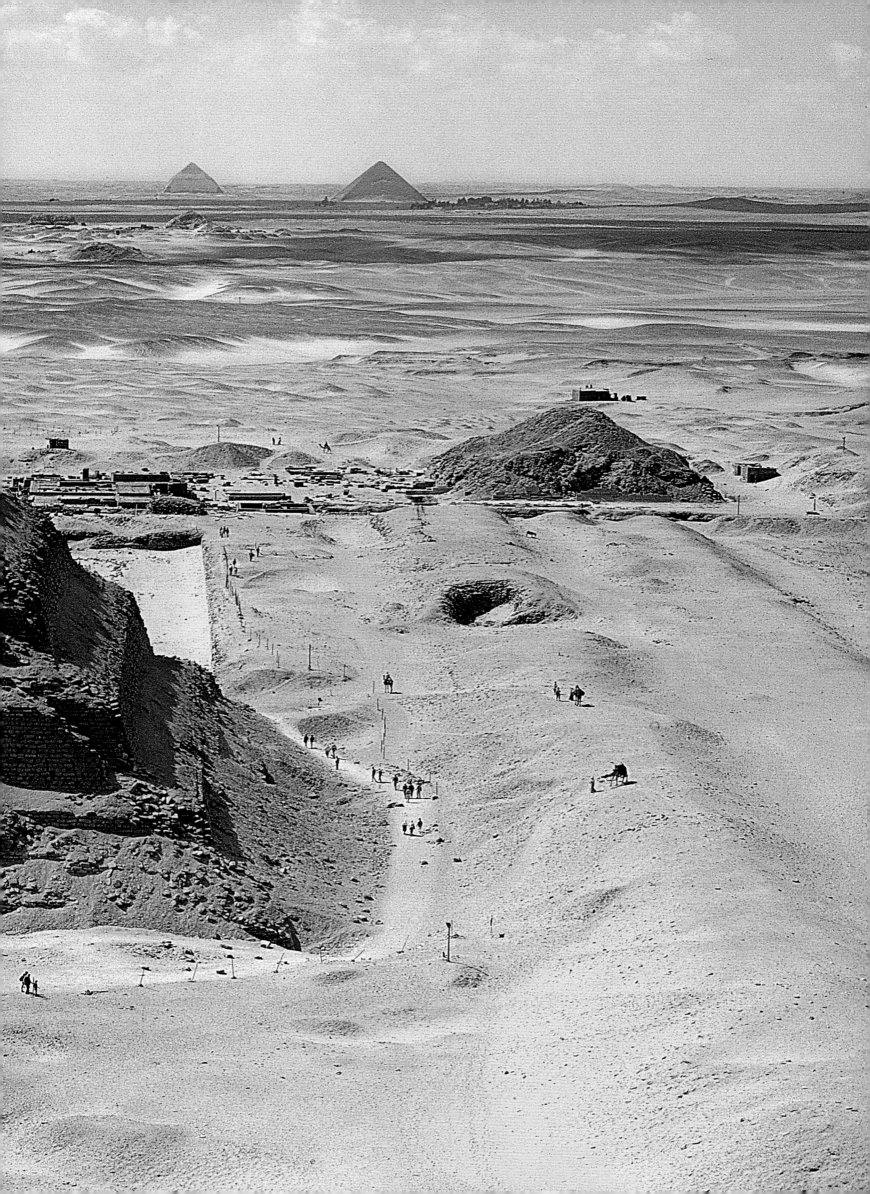

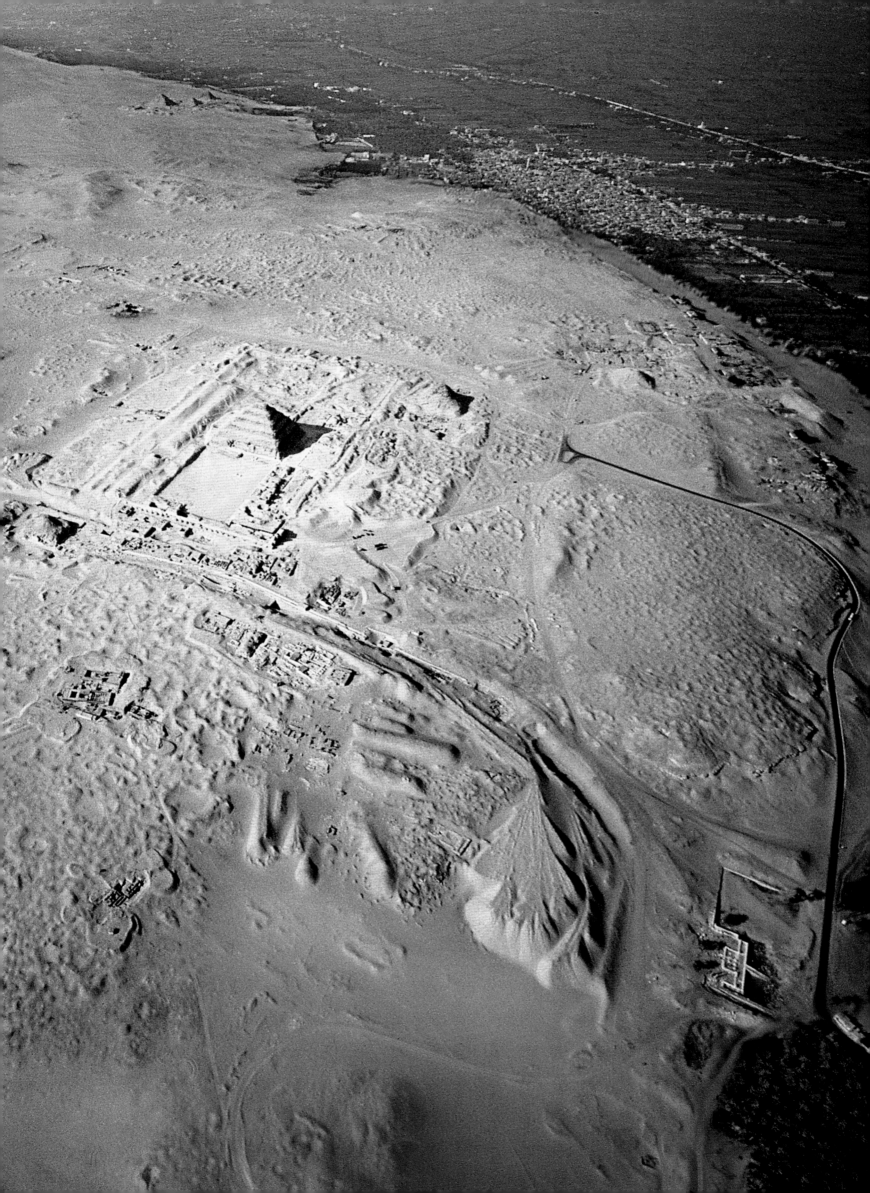

THE STEP PYRAMID
OF SAQQARA

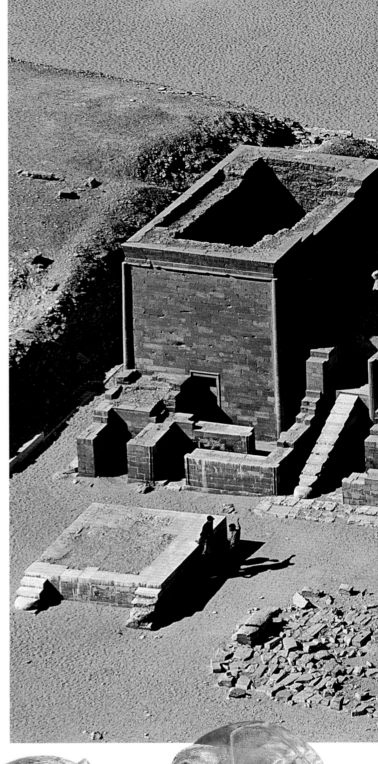

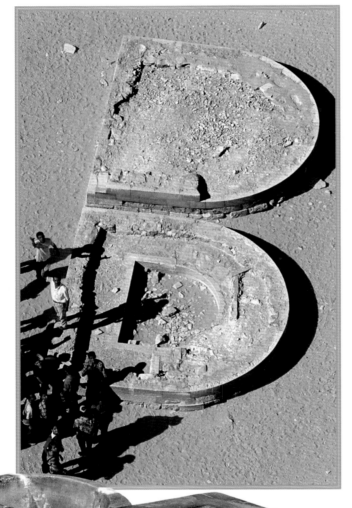

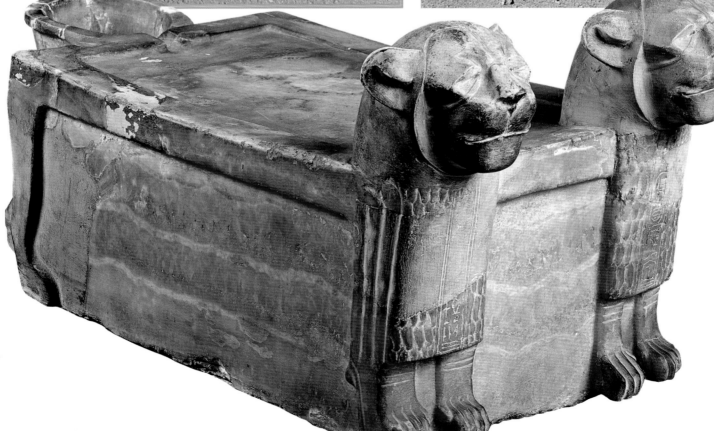

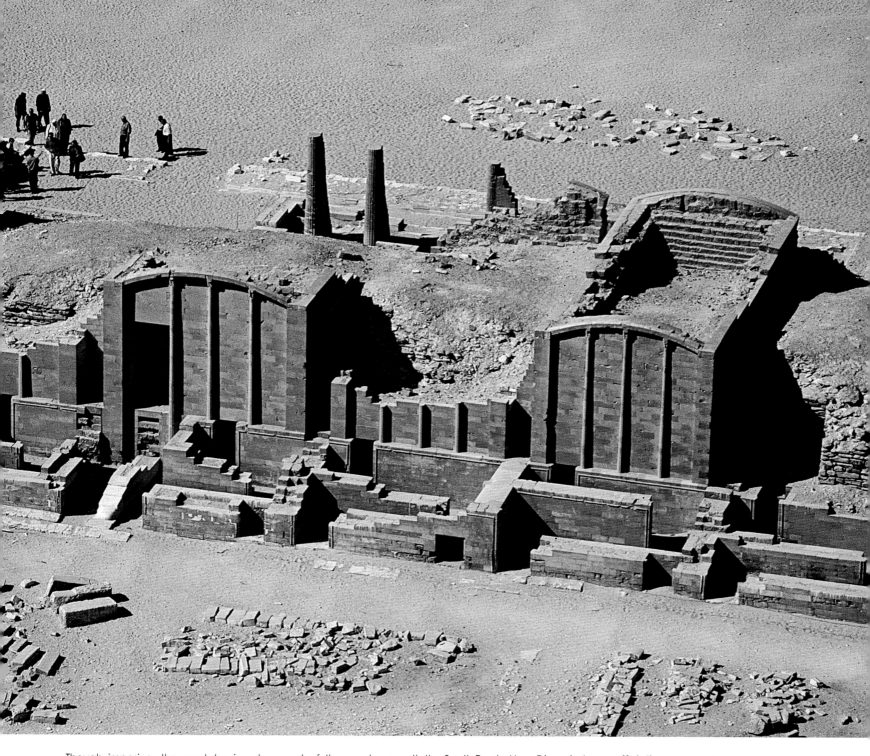

Though imposing, the *mastaba* is only a part of the royal tomb. It covers a vertical shaft almost 100 feet deep, at the bottom of which lies the granite-lined burial chamber in which Djoser rests. A series of corridors all around the chamber were partly used as a storage area where fragments of over 40,000 stone vases were found. Other corridors may have reproduced the pharaoh's palace. The walls are decorated by a series of very fine high-reliefs of Djoser performing various ceremonies, and by panels decorated with small tiles of a special type of blue ceramic called faïence, which were set in the yellow limestone of the walls.

The same type of decoration is seen in the corridors dug be-

neath the South Tomb. Here Djoser is shown officiating over part of the jubilee ceremony known as the *heb-sed*, during which the pharaoh gave proof of his strength and physical vigor by running round a certain circuit. Fitted with almost the same underground features as the pyramid, including the shaft and a small burial chamber (though too small to hold a human body), the South Tomb remains a mystery. Suggestions regarding its function include it being the burial place of a statue, or the pharaoh's internal organs, or the royal placenta, which had been conserved since his birth. Alternatively, it may have been a symbolic tomb for the pharaoh's *ka*, his 'vital force.'

44 TOP LARGE HORSESHOE-SHAPED FORMS, PERHAPS LINKED TO THE PHARAOH'S JUBILEE, EMERGE FROM THE SAND IN THE LARGE CENTRAL COURT.

44 BOTTOM EXCAVATION HAS UNCOVERED OBJECTS OF EXQUISITE MANUFACTURE, LIKE THIS ALABASTER ALTAR FROM THE SECOND DYNASTY.

44-45 MOST OF THE BUILDINGS BUILT INSIDE DJOSER'S FUNERARY COMPLEX HAVE BEEN REBUILT, LIKE THESE FACADES OF THE SOUTHERN CHAPELS.

46-47 THE LARGE ENCLOSURE THAT ENCIRCLED DJOSER'S BURIAL SITE CONSISTED OF A RECESSED AND PANELED WALL WITH A SINGLE ENTRANCE.

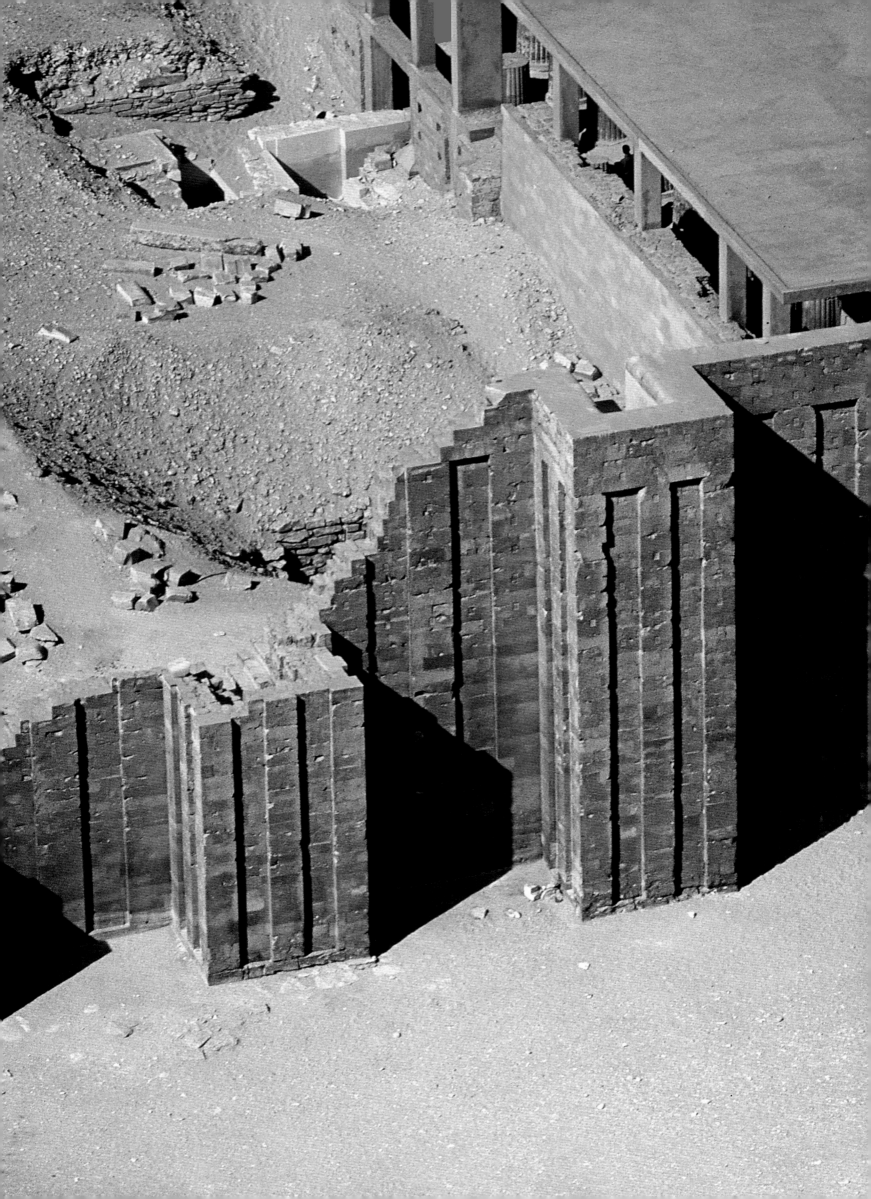

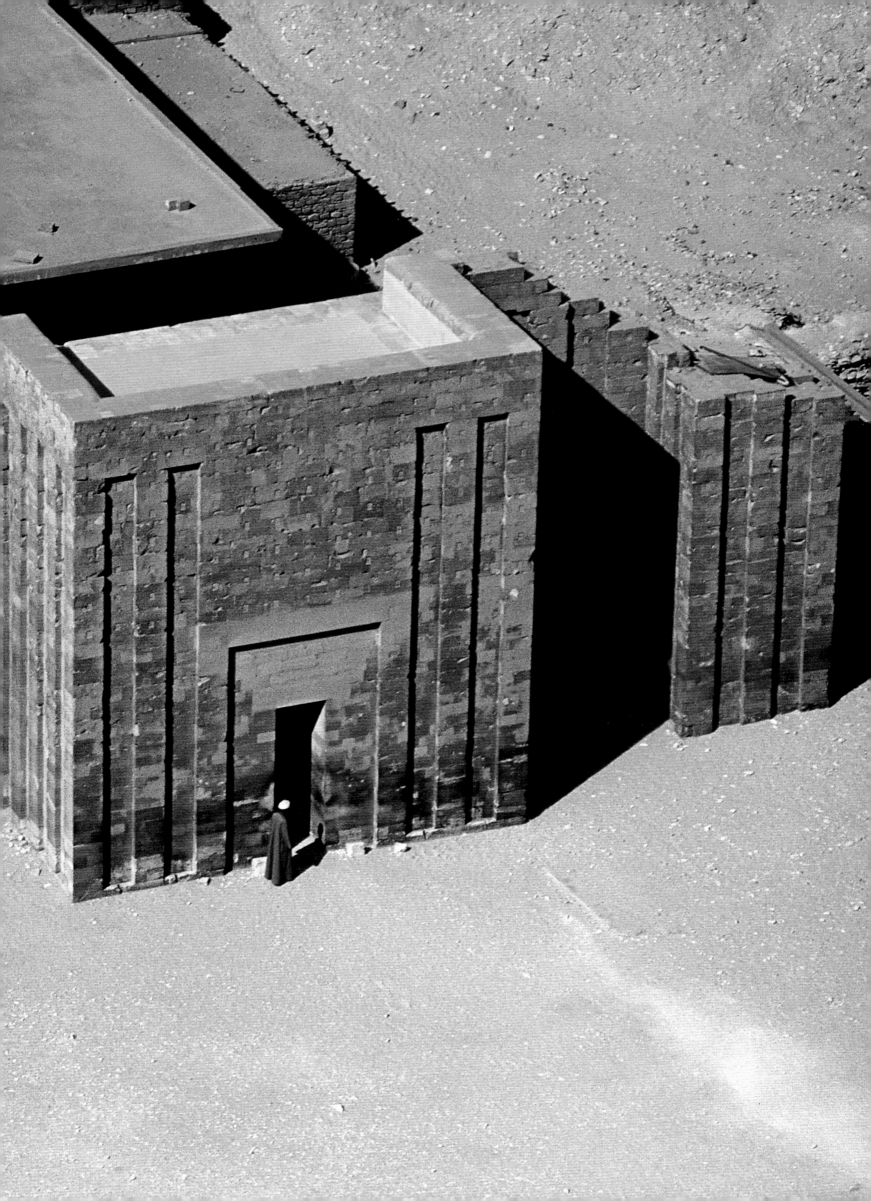

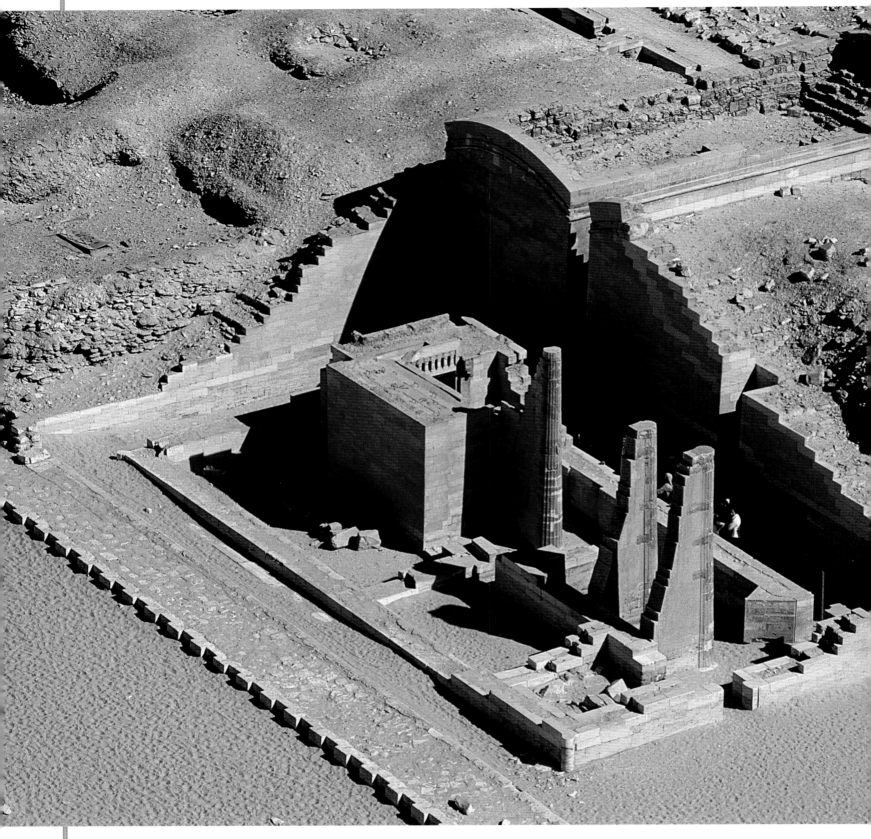

The pyramid and South Tomb were part of a vast funeral complex enclosed by a wall. The complex included a large number of small ritual buildings and, below ground, hundreds of rooms and corridors dug out of the rock. The faceted enclosure wall was decorated by a series of false doors but in fact had a single entrance in the southeast corner that led into a corridor lined by half-columns. The corridor led into a large court, at the far end of which stood the pyramid.

The long and meticulous study of the remains of the complex and their partial restoration by the French architect and Egyptologist Jean-Philippe Lauer confirmed that the entire set of buildings in the southeast quadrant of the complex was ded-icated to another important stage of the *heb-sed*: the repeti-tion of the coronation ceremony. The two rows of chapels that face one another along the sides of the long rectangular court were dedicated to various divinities of Upper and Lower Egypt that were required to renew their consent for the pharaoh to continue his rule. The new coronation then took place on a throne that stood on a stone platform, the remains of which lie in the south section of the court.

An unusual aspect of these buildings is that most of them have almost no internal space. With the exception of the twist-ing antechamber, the chapels were composed of a stone lin-ing around a solid block.

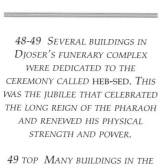

THE STEP PYRAMID OF SAQQARA

49

49 BOTTOM LEFT VASES LEFT IN DJOSER'S COMPLEX WERE MADE TO CELEBRATE SPECIAL EVENTS, LIKE THE PHARAOH'S JUBILEE.

49 BOTTOM RIGHT IN THE PASSAGES BENEATH THE STEPPED PYRAMID 40,000 ALABASTER VASES HAVE BEEN FOUND, LIKE THIS ONE. ALSO VASES MADE FROM SCHIST, PORPHYRY, BRECCIA STONE, QUARTZ CRYSTAL, AND SERPENTINO MARBLE.

48-49 SEVERAL BUILDINGS IN DJOSER'S FUNERARY COMPLEX WERE DEDICATED TO THE CEREMONY CALLED HEB-SED. THIS WAS THE JUBILEE THAT CELEBRATED THE LONG REIGN OF THE PHARAOH AND RENEWED HIS PHYSICAL STRENGTH AND POWER.

49 TOP MANY BUILDINGS IN THE COMPLEX OF THE STEPPED PYRAMID IN SAQQARA, LIKE THE SOUTH PAVILION, HAVE BEEN PARTIALLY REBUILT TO GIVE AN IDEA OF THEIR ORIGINAL APPEARANCE.

THE STEP PYRAMID
OF SAQQARA

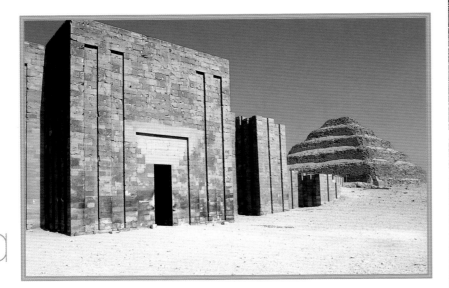

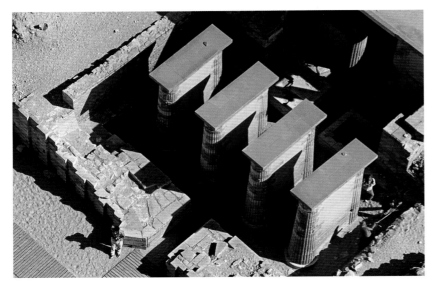

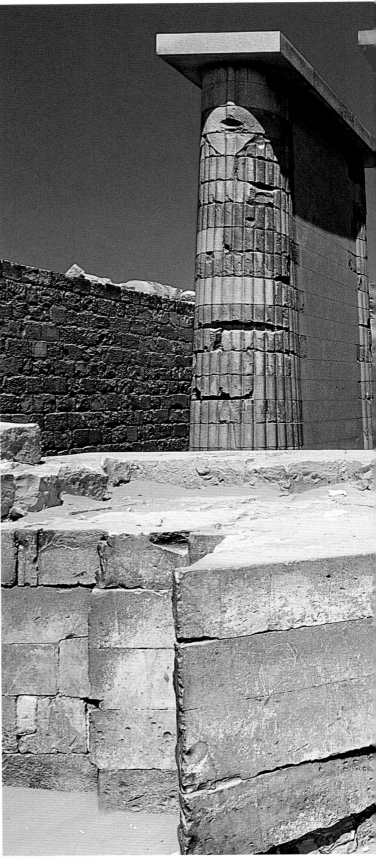

They were probably actual-size stone representations of buildings traditionally built of light materials like wood and matting. As this was the first time that Egyptian architects experimented with stone to construct an entire funerary complex, at this first attempt they simply rebuilt the old architectural forms with the new material.

The traditional distinction between Upper (southern) and Lower (northern) Egypt was reflected by the existence of a South and North Pavilion. Here too the elaborate façades led in-to an internal space that was only symbolic, and surrounded by a solid pile of débris. Not all the buildings in the complex were false, however, which suggests that next to the fictitious ones were real buildings with a practical function, one probably linked to the funerary cult of the pharaoh. One of the 'real' buildings was Temple T, which stood next to the court dedicated to the *heb-sed* ceremony, and the North Temple, which consisted of a small maze of corridors, chambers and courts.

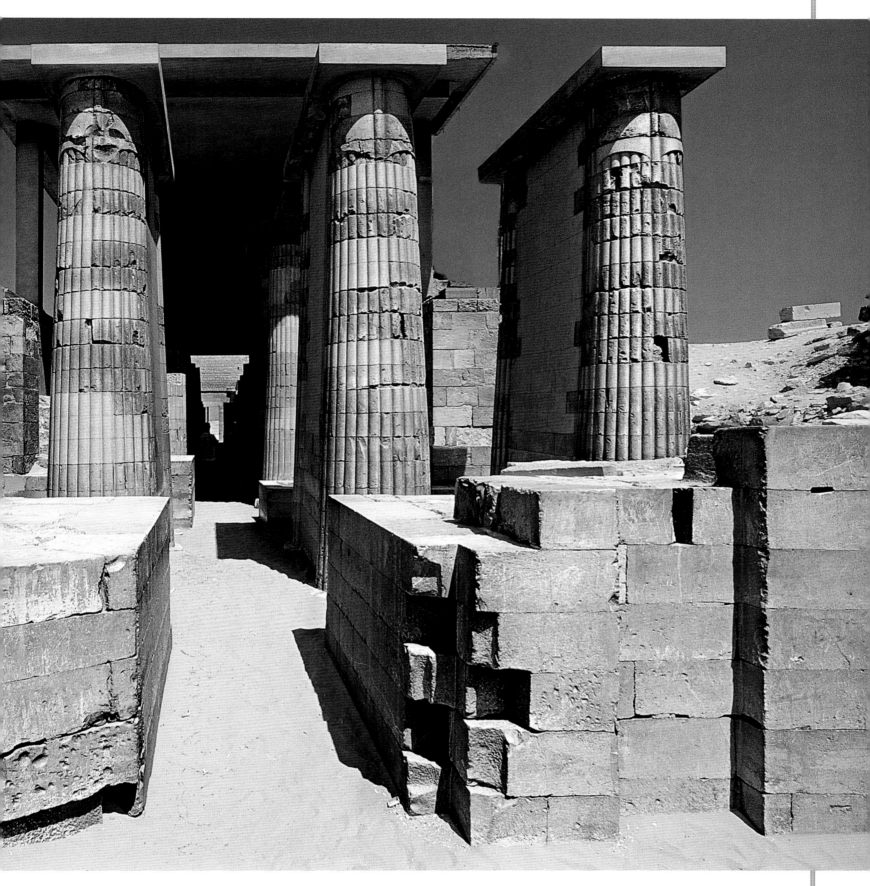

To the north of the pyramid and North Temple lies an open area still partially covered by sand and débris, whereas the entire west side of the funerary complex is set in three rows of rectangular stone masses beneath which an impressive battery of underground storerooms lies.

A central corridor connects more than 400 rooms, taking the total length of the passages dug out of the rock inside the enclosure to 3.5 miles.

50-51 THE PASSAGE FROM THE ENTRANCE TO THE COURT IN DJOSER'S FUNERARY SITE IS CHARACTERIZED BY A CORRIDOR LINED BY HALF-COLUMNS. TODAY THE CORRIDOR HAS BEEN RESTORED AND IS PROTECTED BY A MODERN COVERING.

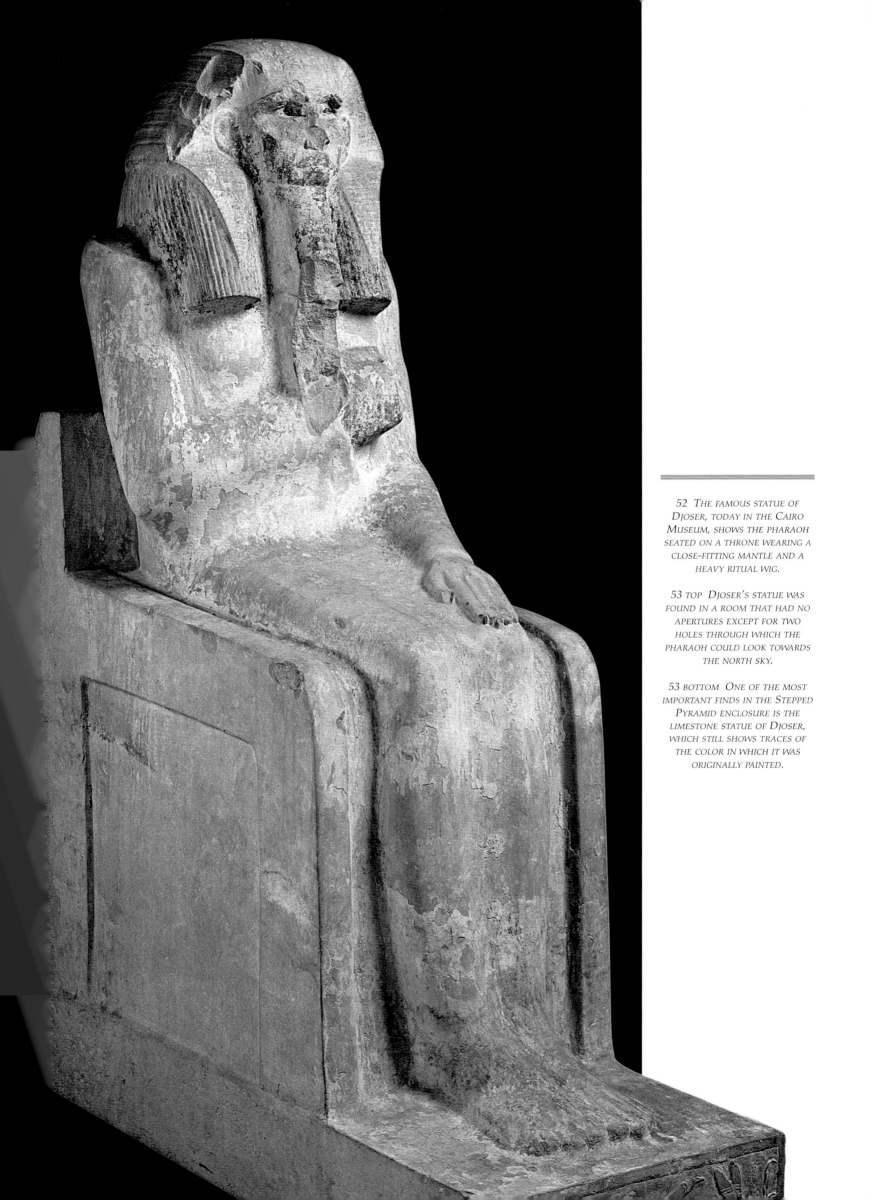

52 *The famous statue of Djoser, today in the Cairo Museum, shows the pharaoh seated on a throne wearing a close-fitting mantle and a heavy ritual wig.*

53 *top Djoser's statue was found in a room that had no apertures except for two holes through which the pharaoh could look towards the north sky.*

53 *bottom One of the most important finds in the Stepped Pyramid enclosure is the limestone statue of Djoser, which still shows traces of the color in which it was originally painted.*

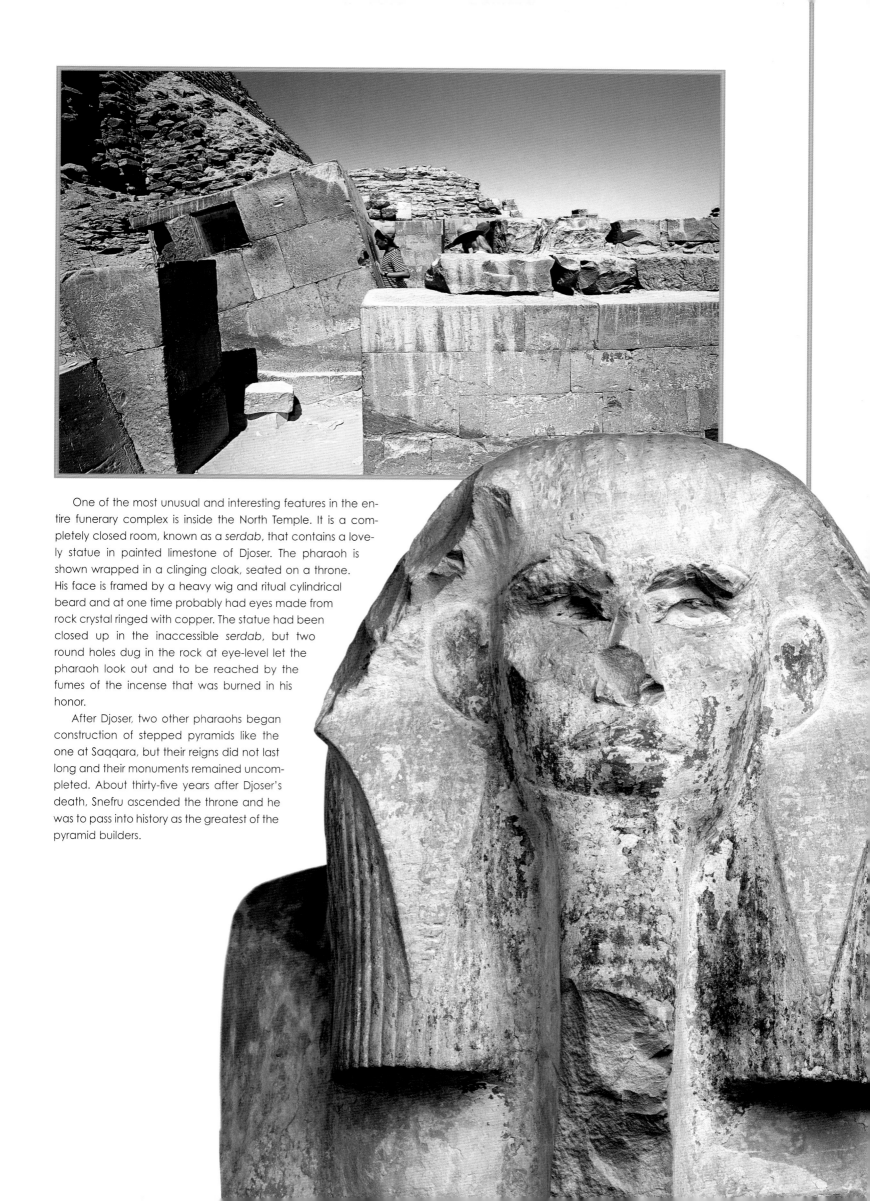

One of the most unusual and interesting features in the entire funerary complex is inside the North Temple. It is a completely closed room, known as a *serdab*, that contains a lovely statue in painted limestone of Djoser. The pharaoh is shown wrapped in a clinging cloak, seated on a throne. His face is framed by a heavy wig and ritual cylindrical beard and at one time probably had eyes made from rock crystal ringed with copper. The statue had been closed up in the inaccessible *serdab*, but two round holes dug in the rock at eye-level let the pharaoh look out and to be reached by the fumes of the incense that was burned in his honor.

After Djoser, two other pharaohs began construction of stepped pyramids like the one at Saqqara, but their reigns did not last long and their monuments remained uncompleted. About thirty-five years after Djoser's death, Snefru ascended the throne and he was to pass into history as the greatest of the pyramid builders.

THE PYRAMID OF MEIDUM

Snefru, the first pharaoh in the Fourth Dynasty, reigned for twenty-four years, during which time he built three large pyramids: one at Meidum in the desert between the Nile Valley and Fayum, and two at Dahshur, on the plateau to the south of Saqqara. It was during Snefru's reign that Egyptian pyramid design underwent another, very important change: the evolution to construction of smooth-faced structures.

From an architectural standpoint, Snefru's reign was a period of great innovation and daring experimentation in terms of construction techniques and the shape of the royal tomb. The pyramid at Meidum, for example, was conceived and built as a pyramid with seven steps but it was immediately enlarged and transformed into an eight-stepped pyramid. The simple funerary apartment had a descending corridor, two recesses to lodge the enormous blocks of stone that would later be used to block the burial corridor, and a single burial chamber. For the first time it was here that the system of progressively projecting stone blocks was used to create a false vault in the form of an upturned V. This design was also used with success in later pyramids.

Next to the royal pyramid have been found the remains of an almost completely destroyed small secondary pyramid that had the same function as the South Tomb in Djoser's complex. Almost all later pharaohs followed this tradition and built their own pyramids with the addition of a miniature companion that today is known as a 'satellite pyramid.' The funerary complex at Meidum was completed with the construction of a series of large *mastabas* that were probably used for the burials of princes and other members of the royal family.

54 This life-size statue is of pharaoh Snefru, the first sovereign of the Fourth Dynasty.

55 e 57 The curious appearance of Meidum pyramid, built by Snefru, is given by a partial collapse of the outer structure. This reveals the original core composed of steps like Djoser's pyramid built at Saqqara.

56 left A system of internal room coverings based on a series of projecting stones was used for the first time in the pyramid at Meidum.

56 right A long corridor descends to the funerary apartment inside Meidum pyramid, the first of the three built by Snefru.

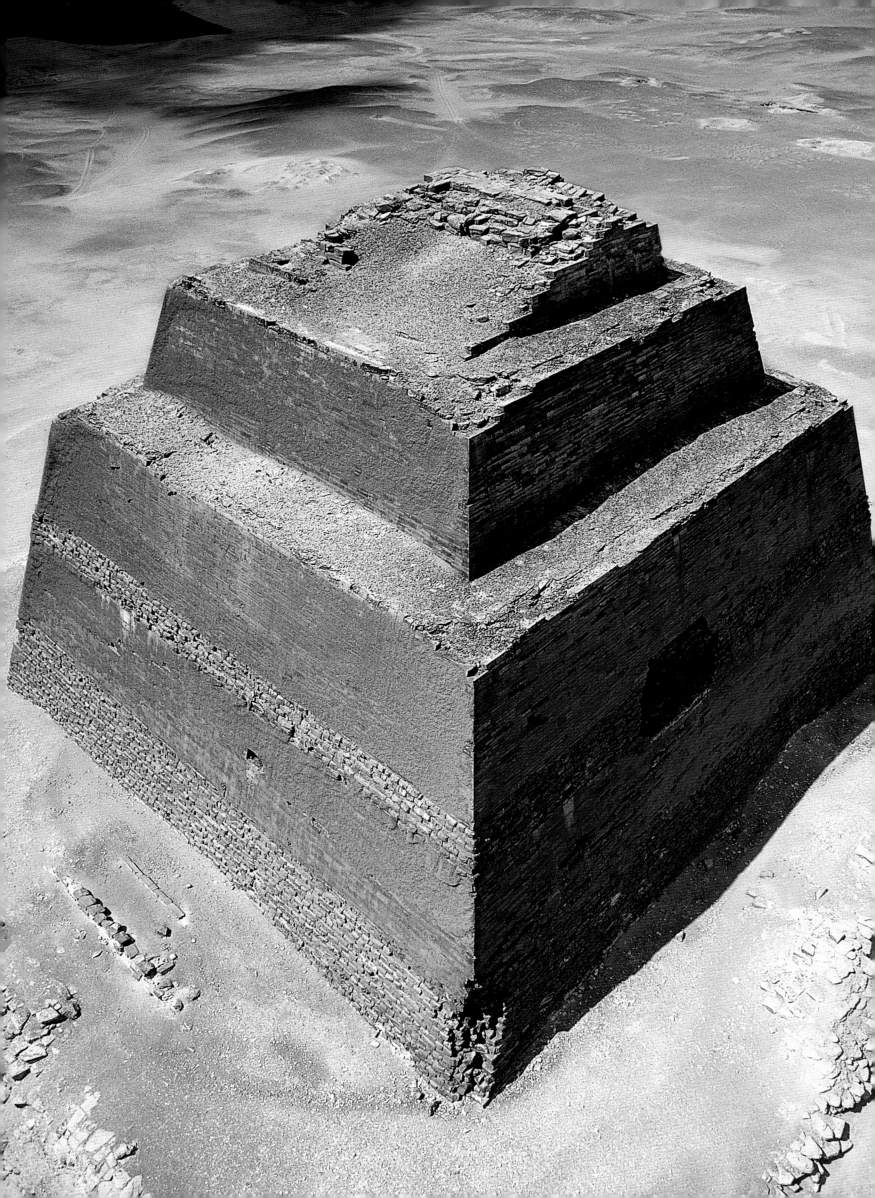

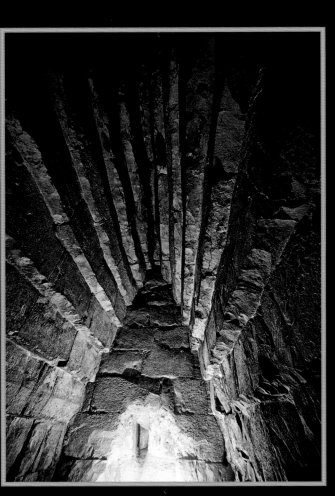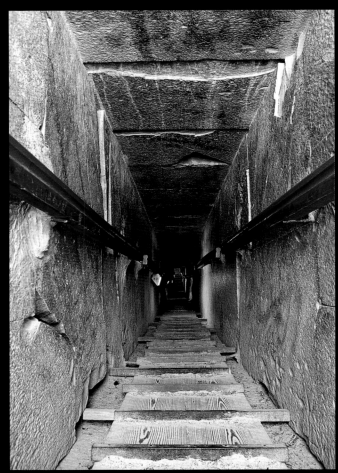

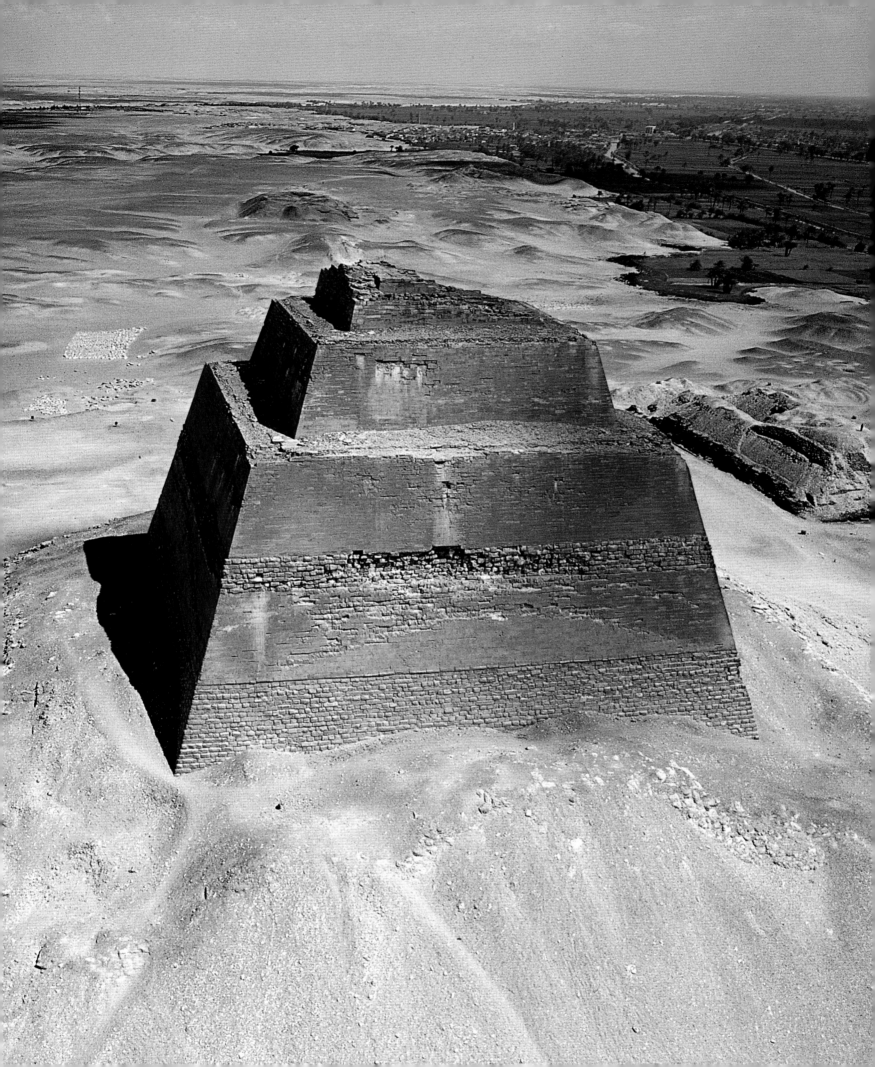

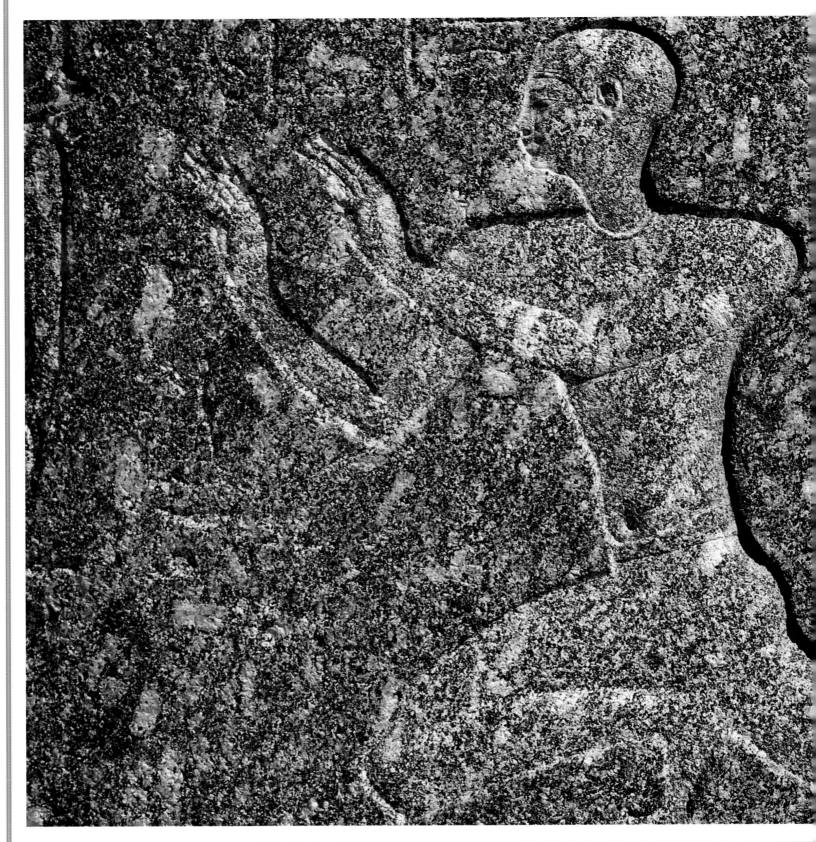

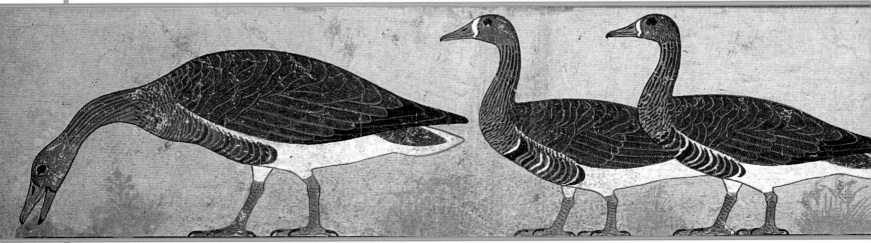

THE PYRAMID OF MEIDUM

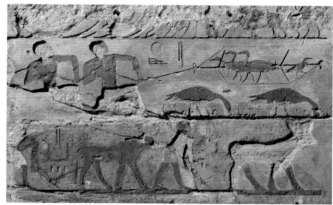

58-59 TOP A NUMBER OF STONE BLOCKS COVERED WITH LOW RELIEFS HAVE BEEN FOUND NEAR THE PYRAMID AT MEIDUM.

58-59 BOTTOM THE PYRAMID OF MEIDUM WAS SURROUNDED BY A NECROPOLIS FOUND TO CONTAIN IMPORTANT ARCHAEOLOGICAL OBJECTS, LIKE THE FAMOUS PAINTING KNOWN AS THE "GEESE OF MEIDUM." THIS WAS DISCOVERED IN THE TOMB OF NEFERMAAT AND ATET.

59 TOP FROM THE MASTABA OF PRINCE NEFERMAAT, ONE OF SNEFRU'S SONS, COME TWO FRAGMENTS OF WALL LINING NOW IN THE CAIRO MUSEUM. THEY WERE DECORATED WITH LOW RELIEFS FILLED WITH COLORED PASTE DEPICTING A GROUP OF MEN HUNTING BIRDS WITH A NET, AND THREE FOXES CHASED BY A DOG THAT BITES THE NECK OF THE LAST FOX.

60-61 ONE OF THE MOST OUTSTANDING MASTERPIECES AT MEIDUM, AND IN ALMOST PERFECT CONDITION, WAS A PAIR OF STATUES OF PRINCE RAHOTEP AND HIS WIFE NOFRET MADE FROM PAINTED LIMESTONE. THEIR EYES WERE MADE FROM QUARTZ AND ROCK CRYSTAL.

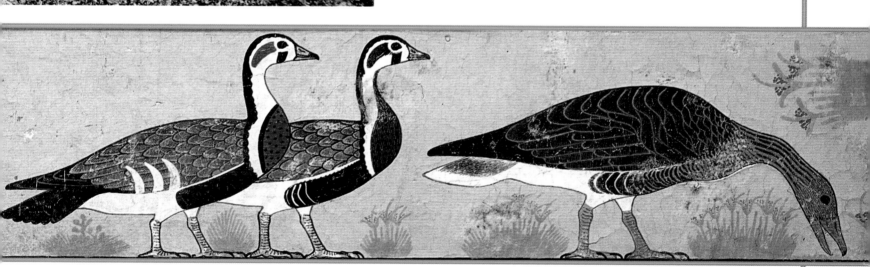

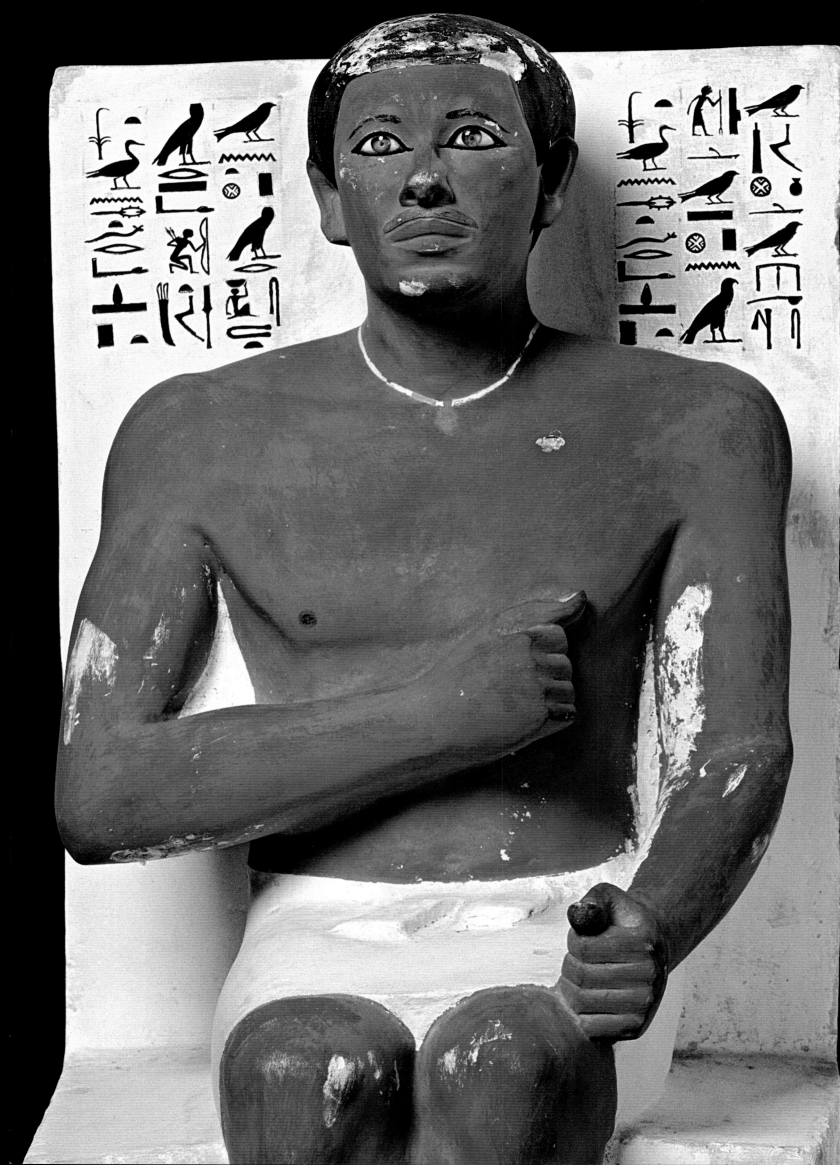

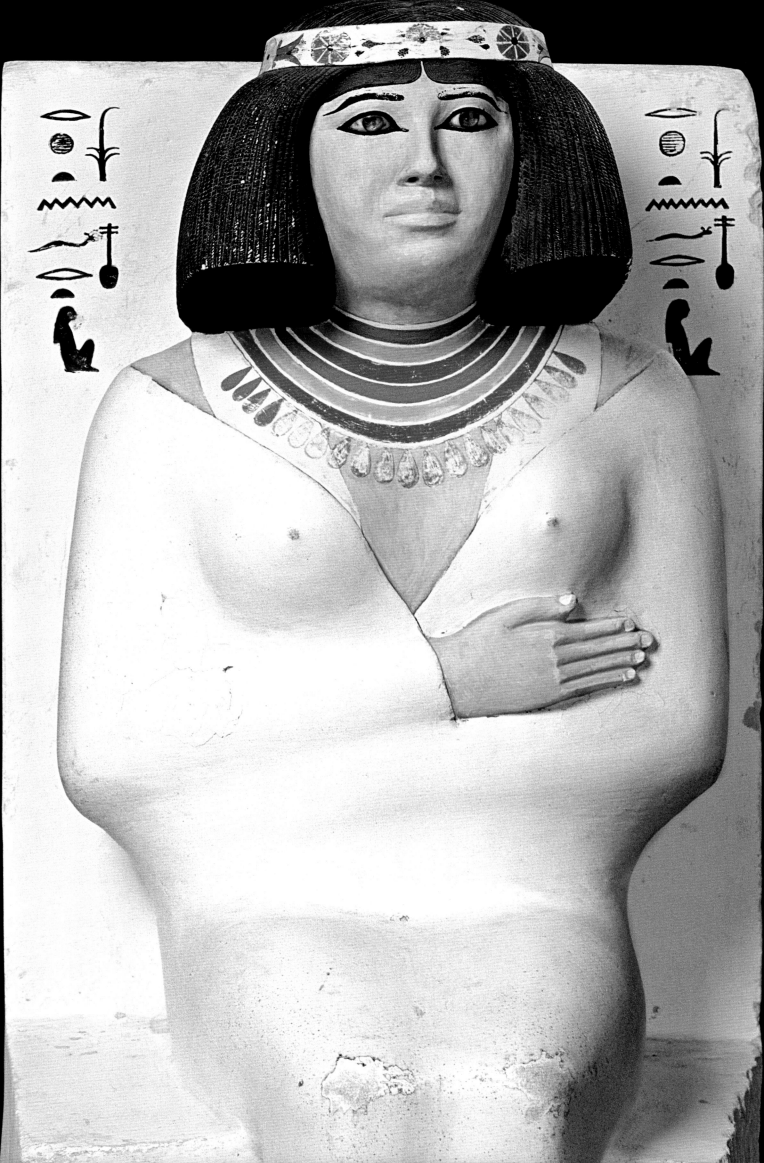

THE PYRAMIDS
OF DAHSHUR

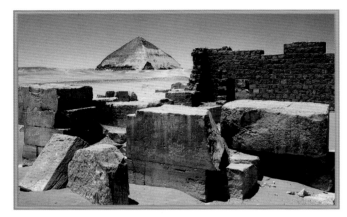

After fifteen or so years on the throne, Snefru abandoned Meidum and began construction of a new pyramid at Dahshur. This was new, not just in terms of its position, but also its shape: it was conceived as a smooth-faced pyramid, the first in a long series.

During the construction of this first pyramid a series of difficulties was encountered that resulted in the so-called Bent Pyramid, so called because its lower-section slope is steeper than its upper-section slope. This decided change in inclination, however, was not the first problem the architects were obliged to tackle during construction. The careful exploration the Italian experts Vito Maragioglio and Celeste Rinaldi made of the underground corridors showed that the Bent Pyramid has another pyramid, smaller but steeper, inside it.

When the original pyramid had reached a considerable height, an internal section of the construction subsided, perhaps due to the lack of resistance provided by the desert beneath.

The architects understood that the structure would not be upright and so built a wider, less steep pyramid around it. Unfortunately further structural subsidence occurred and the ar-

chitects finally decided to reduce drastically the slope of the pyramid's faces and therefore complete the upper structure using a smaller quantity of stone that had been planned.

Though the initial phase of construction is hidden inside the pyramid, the other two are clearly visible from the outside: the lower section represents the second design and the top section represents the third. The pyramid was completed with the construction of a chapel on the north side, a satellite pyramid to the south, and an enclosure wall.

A ramp more than 220 yards long connected the enclosure to a small rectangular temple built at the mouth of a wadi (a dried-up river bed) that may have been reached by the annual flood of the Nile.

This layout was the original model on which later pyramid constructions were based: a funerary temple built next to the main pyramid up on the desert plateau, and a valley temple constructed lower down where the vegetation gave way to the desert. A ramp or Ceremonial Way connected the two temples.

The funerary apartment hidden inside the Bent Pyramid was served by two descending corridors, one on the north side and the other on the west side. The apartment was made up of three staggered rooms covered by the corbelled system of projecting stones adopted at Meidum. Two stone slabs were prepared to block access to the upper room, which may have been designed to hold the body of the pharaoh.

62 THE SECOND PYRAMID BUILT BY SNEFRU IS KNOWN AS THE BENT PYRAMID. IT HAD A TEMPLE AND A CHAPEL FLANKED BY TWO STELAE.

63 THE BENT PYRAMID COMPLEX INCLUDES A SATELLITE PYRAMID BUILT ON THE SAME AXIS AS THE LARGER ONE AND EQUIPPED WITH ITS OWN SMALL PLACE OF WORSHIP.

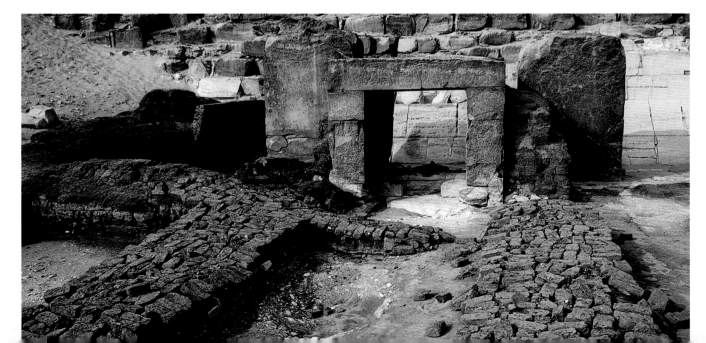

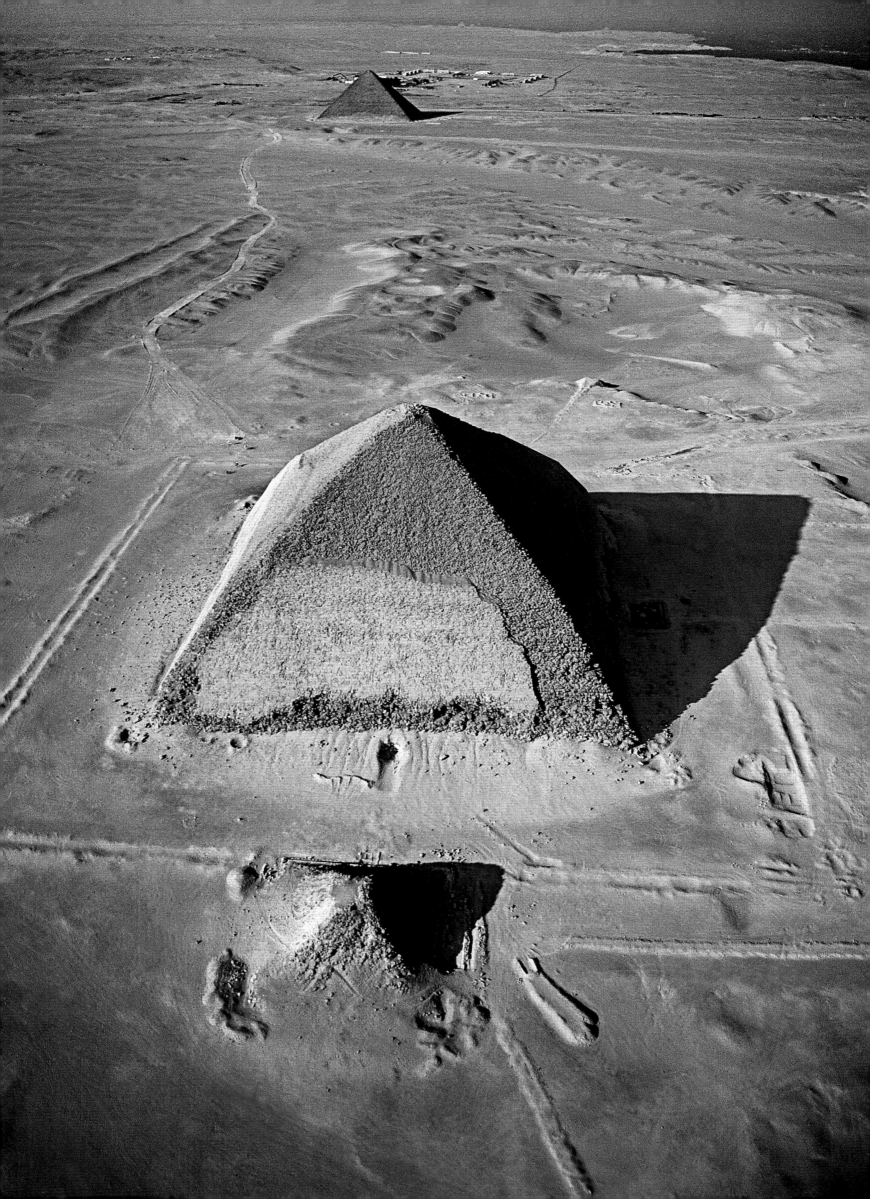

THE PYRAMIDS OF DAHSHUR

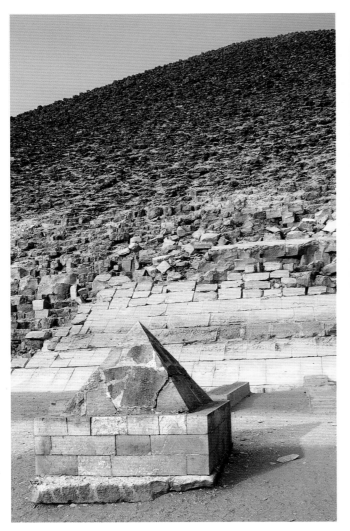

In the meantime, though, Snefru began construction of a third pyramid, the one in which he may have been buried. This one is simply called the North Pyramid or Red Pyramid, from the color of the stone used. For this pyramid, the architects took no risks and they used the same steepness of inclination they had adopted in the upper part of the Bent Pyramid, with the result was that it was built without complications. The funerary apartment is simple and linear, with a sloping corridor that leads to two almost identical antechambers and to the burial chamber itself, all of which are covered with the standard system of a corbelled vault. The few remaining traces of the temples associated with this pyramid suggest that they were finished in a hurry, perhaps because Snefru had already died.

In the final years of his reign, Snefru also returned to Meidum and turned the Stepped Pyramid built there into one with smooth faces by filling in the steps and lining it with limestone. The pyramid's curious appearance today—the central section remains standing surrounded by piles of débris—is owed to the fact that for centuries its stone was pilfered for other purposes. Paradoxically, the partial destruction of the pyramid has allowed archaeologists the rare opportunity of studying its internal structure and the possibility of understanding the various phases that occurred during its construction.

At the end of his reign, Snefru left three enormous pyramids, the last of which was stepped and the first smooth, and two smaller ones. Together they total the impressive sum of more than 4.5 million cubic yards of solid rock. He was succeeded by his son, who was equally determined and ambitious, and also destined to enter history with a funerary monument. His name was Khufu.

64 LEFT FRAGMENTS HAVE BEEN FOUND AT DAHSHUR OF A PYRAMIDION – THE CROWNING STONE OF A PYRAMID – WHICH LAY AT THE FOOT OF SNEFRU'S THIRD PYRAMID.

64 RIGHT THE CEILING OF THE THREE ROOMS IN THE FUNERARY APARTMENT OF THE RED PYRAMID WAS BUILT USING THE TECHNIQUE OF PROGRESSIVELY PROJECTING STONES.

65 BEFORE COMPLETING THE BENT PYRAMID, SNEFRU BEGAN CONSTRUCTION OF THE "NORTHERN" PYRAMID; THIS IS MORE COMMONLY KNOWN AS THE RED PYRAMID DUE TO THE COLOR OF THE STONE.

66-67 AND 68-69 A PATH WINDS OVER THE RUBBLE ON THE NORTH SIDE OF THE RED PYRAMID TO THE ENTRANCE OF THE CORRIDOR. ON THE BACKGROUND IS THE BENT PYRAMID.

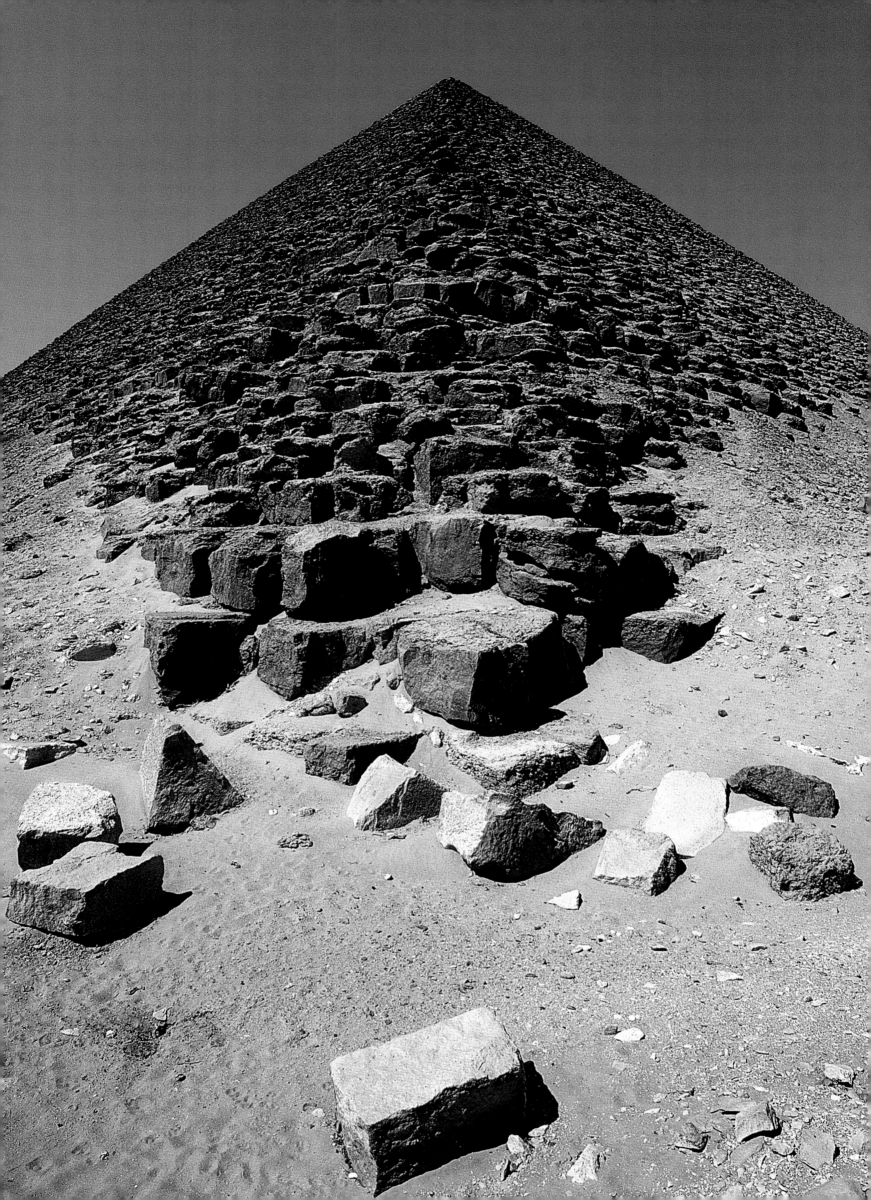

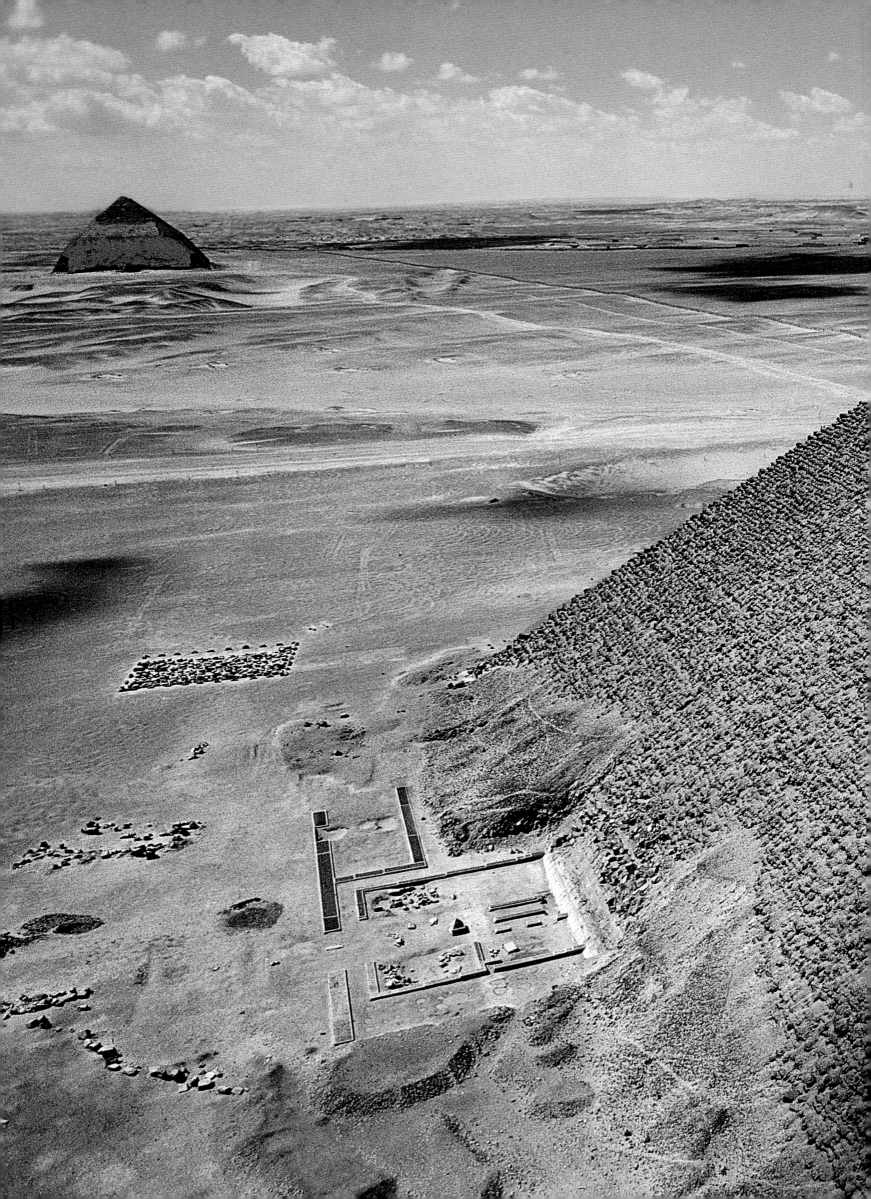

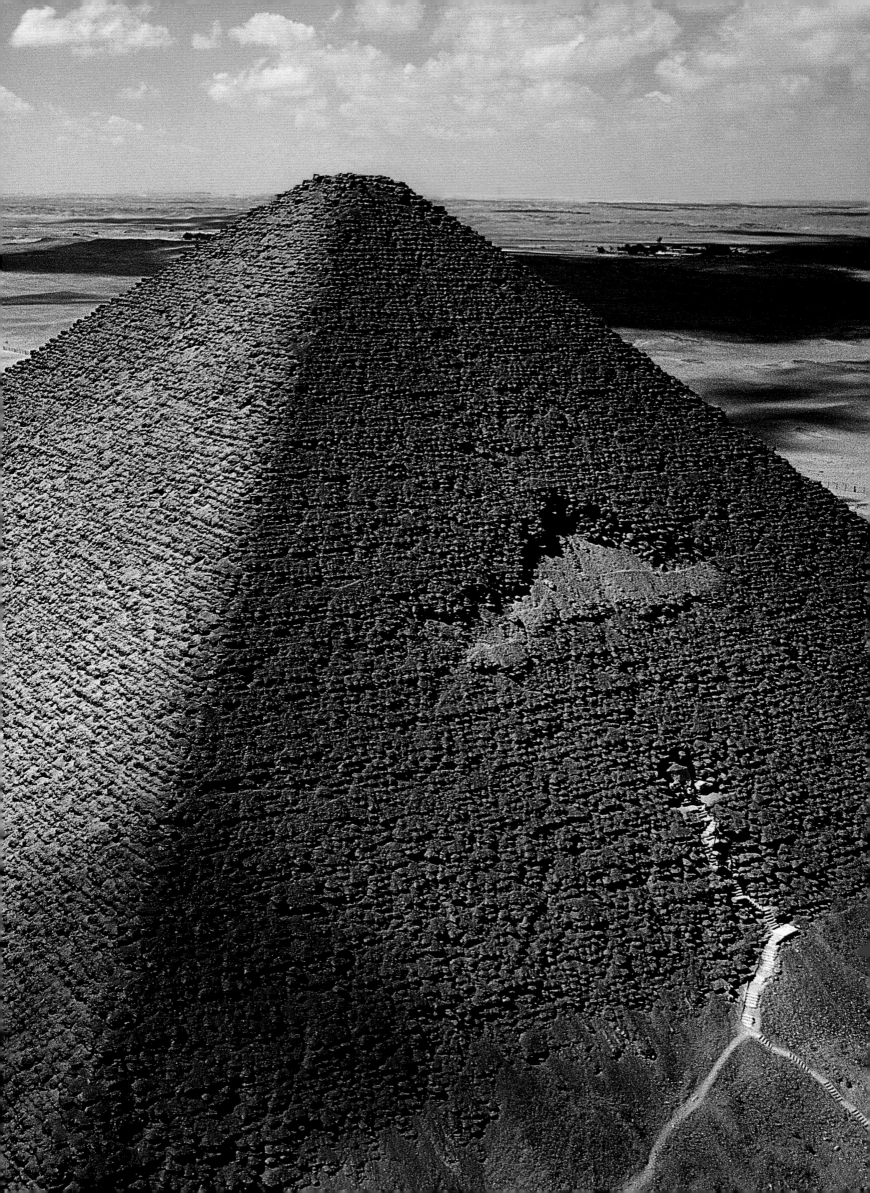

THE PLATEAU

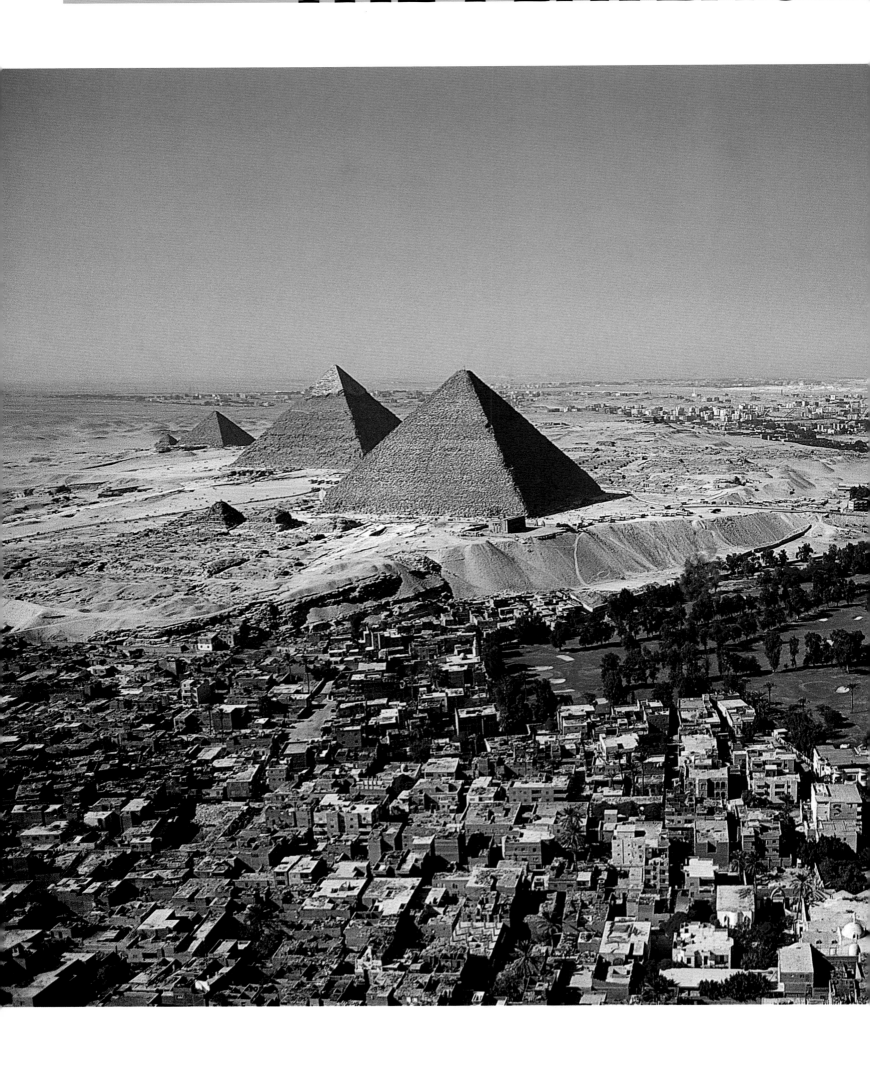

OF GIZA

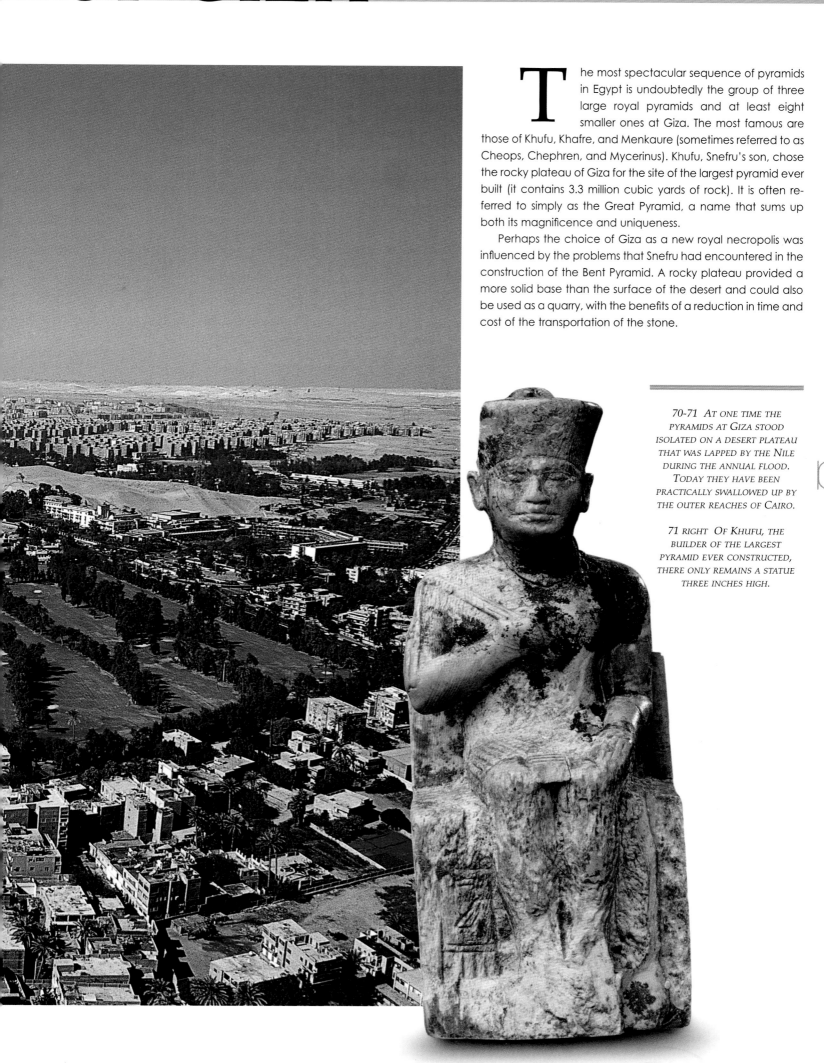

The most spectacular sequence of pyramids in Egypt is undoubtedly the group of three large royal pyramids and at least eight smaller ones at Giza. The most famous are those of Khufu, Khafre, and Menkaure (sometimes referred to as Cheops, Chephren, and Mycerinus). Khufu, Snefru's son, chose the rocky plateau of Giza for the site of the largest pyramid ever built (it contains 3.3 million cubic yards of rock). It is often referred to simply as the Great Pyramid, a name that sums up both its magnificence and uniqueness.

Perhaps the choice of Giza as a new royal necropolis was influenced by the problems that Snefru had encountered in the construction of the Bent Pyramid. A rocky plateau provided a more solid base than the surface of the desert and could also be used as a quarry, with the benefits of a reduction in time and cost of the transportation of the stone.

70-71 AT ONE TIME THE PYRAMIDS AT GIZA STOOD ISOLATED ON A DESERT PLATEAU THAT WAS LAPPED BY THE NILE DURING THE ANNUAL FLOOD. TODAY THEY HAVE BEEN PRACTICALLY SWALLOWED UP BY THE OUTER REACHES OF CAIRO.

71 RIGHT OF KHUFU, THE BUILDER OF THE LARGEST PYRAMID EVER CONSTRUCTED, THERE ONLY REMAINS A STATUE THREE INCHES HIGH.

THE PYRAMID OF KHUFU

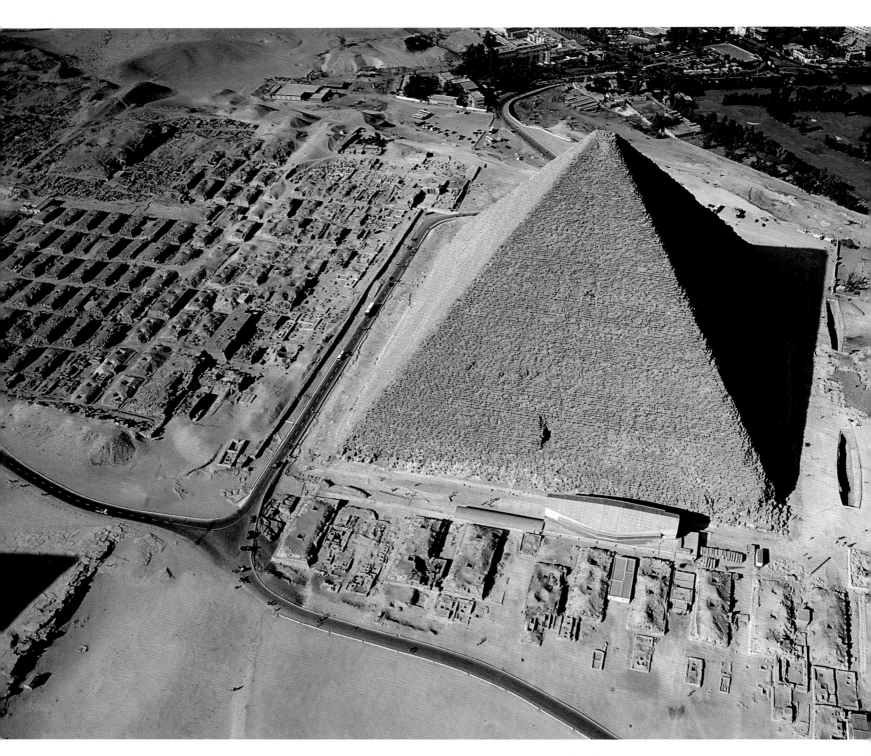

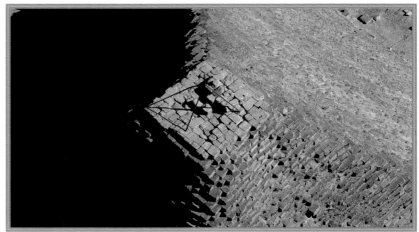

S everal of the internal features of Khufu's pyramid are unique in the history of Egyptian pyramids. As in other pyramids of the Old Kingdom, the funerary apartment was formed by three rooms, but these are set out one above the other and each served by a different means of access. The room below ground level, which was left uncompleted, is reached by a long, narrow sloping corridor from which, at a certain point, an upward-sloping corridor branches off. The middle room, mistakenly referred to as the 'Queen's Chamber,' was probably used for the ritual burial of a statue of the pharaoh in the same way that the famous statue of Djoser (to-day in Cairo Museum) stood in the *serdab* behind the Stepped Pyramid at Saqqara.

72 BOTTOM *THIS SPECTACULAR PHOTOGRAPH SHOWS THE VERTICAL ON TOP OF KHUFU'S PYRAMID.*

73 *THE BASE OF THE GREAT PYRAMID REVEALS THE WORK THAT WAS REQUIRED TO LEVEL THE GROUND AND POSITION THE BLOCKS EXACTLY.*

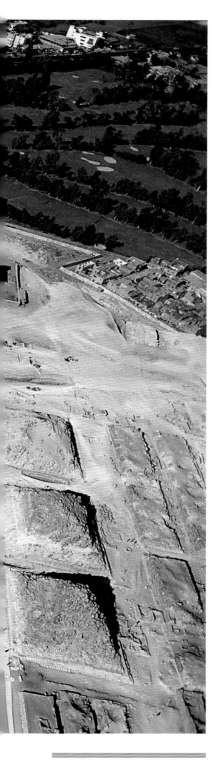

72-73 *HERE THE GREAT PYRAMID IS SEEN IN ALL ITS MAJESTY, FLANKED BY THE MUSEUM OF THE SUN BARK, THE PITS OF THE OTHER BARKS, THE SATELLITE PYRAMIDS AND THE NECROPOLIS OF THE PHARAOH'S FUNCTIONARIES.*

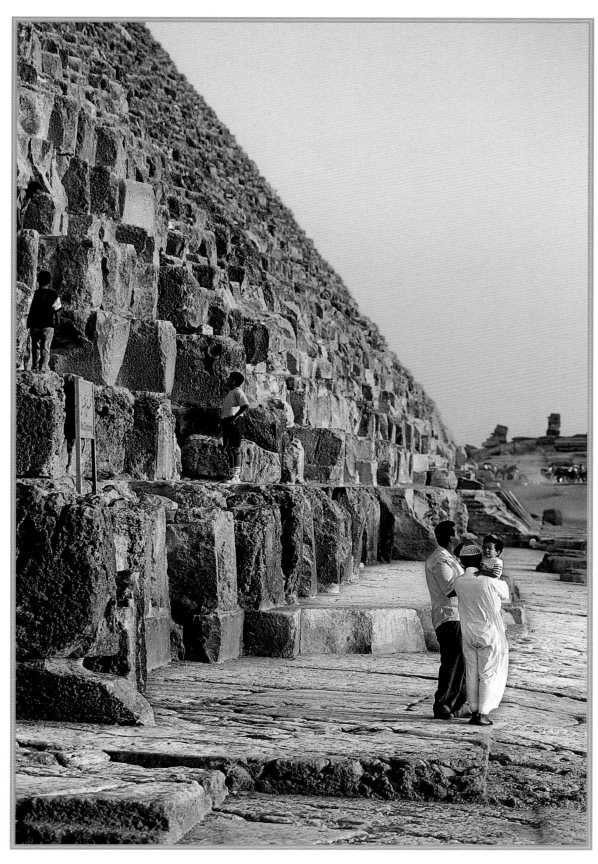

THE PYRAMID OF KHUFU

74 LEFT HERE WE SEE ONE OF THE PASSAGEWAYS INSIDE THE GREAT PYRAMID.

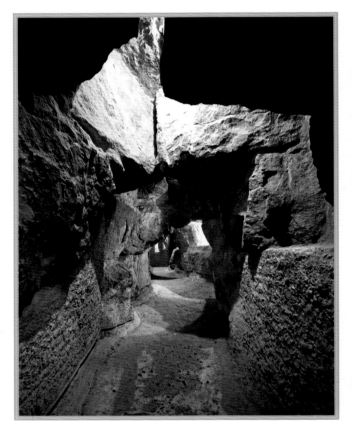

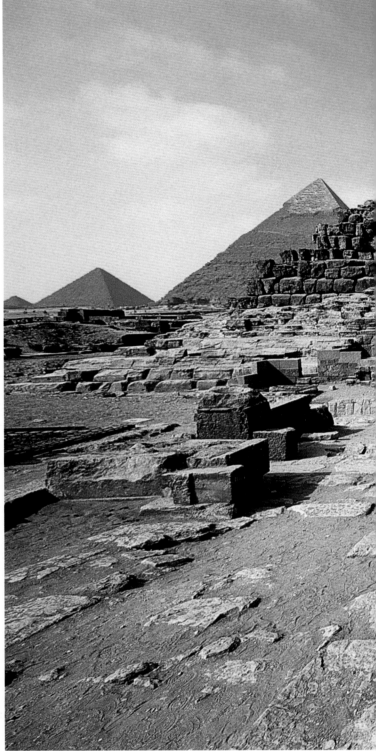

The chamber in which Khufu was actually buried is reached along a spectacular upward-sloping corridor called the Grand Gallery: 157 feet long, over 6 feet wide and 28 feet high, it too was built with a corbelled vault of projecting sides used, though on a smaller scale, inside Snefru's pyramids. The appearance of the Grand Gallery is astounding, with its oblique sides of dark stone that converge as they rise, yet it seems that the purpose of this huge space was essentially functional. The corridor was probably used as a temporary store for enormous blocks of stone used in the construction of the pyramid and which, once the pharaoh was buried, were allowed to slide down the sloping corridor to prevent access to those intending to either rob or profane the tomb.

The Grand Gallery led into the burial chamber. This was entirely built of red granite, including the sarcophagus, and protected by three stone slabs. Invisible to the eye of the visitor, five empty spaces, one above the other above the ceiling, lighten the weight pressing down on the chamber.

Pairs of small conduits depart diagonally from both this chamber and the middle one. They cross the body of the pyramid southward and northward pointing towards stars that played an important role in Egyptian astronomy and religion. The function of the conduits was to allow the spirit of the pharaoh to reach the firmament. Both simple methods and high-tech instruments have been used to study these mysterious passages. The French archaeologist Georges Goyon, using an orange, first demonstrated that the upper room was connected without any interruption to the exterior of the pyramid. When Goyon dropped the orange into the outlet on the side of the pyramid, it rolled all the way down to the

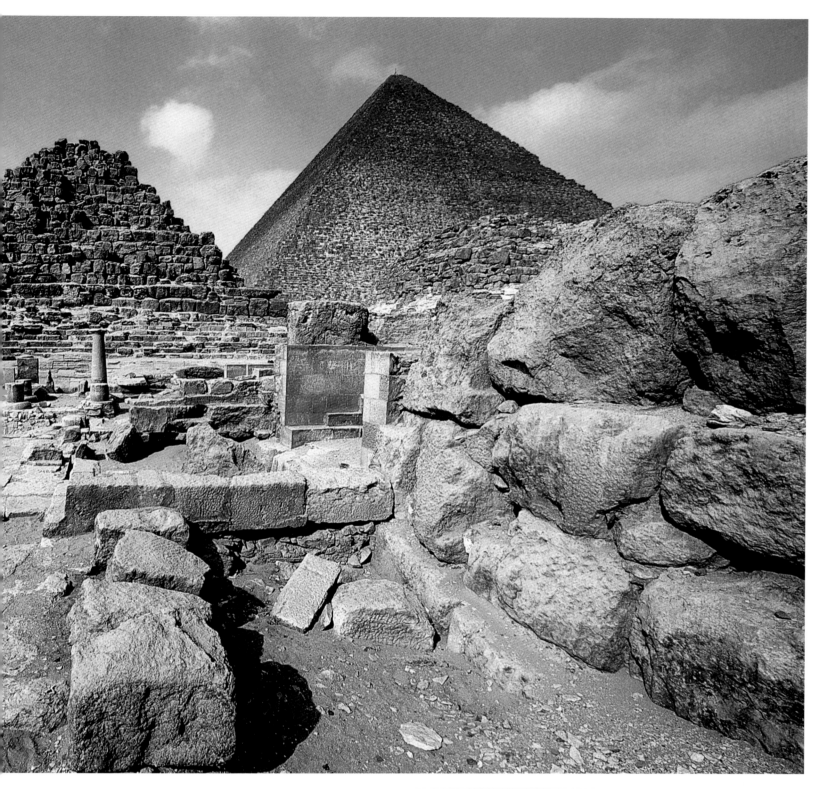

burial chamber. The south conduit in the middle room has been explored only recently under the direction of Zahi Hawass; a specially-built robot was fitted with a video camera and succeeded in crawling 215 feet before coming up against the stone slab that closes the passage.

Like the interior, the exterior too has been the object of careful study, revealing the precision of the monument's dimensions and construction. Today very little of the smooth limestone lining remains, but during the Middle Ages the Arab scholar Abd al-Latif wrote that the outer stones were so well joined that it did not seem possible to insert either a needle or hair between them. Recent measurements have confirmed that the rock base on which the pyramid was built had been leveled so well that the maximum variation on a side over 250 yards long was less than one inch.

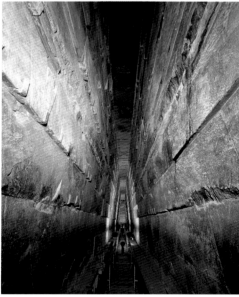

74-75 BESIDES HIS IMMENSE PYRAMID, KHUFU HAD THREE TINY PYRAMIDS CONSTRUCTED FOR HIS THREE WIVES, EACH OF WHICH HAD A SMALL FUNERARY APARTMENT AND CHAPEL FOR THE WORSHIP OF THE DECEASED.

75 BOTTOM IN KHUFU'S PYRAMID THE TECHNIQUE OF PROJECTING STONE BLOCKS WAS USED ONCE ONLY TO COVER THE MAGNIFICENT, LONG SLOPING CORRIDOR KNOWN AS THE GREAT GALLERY.

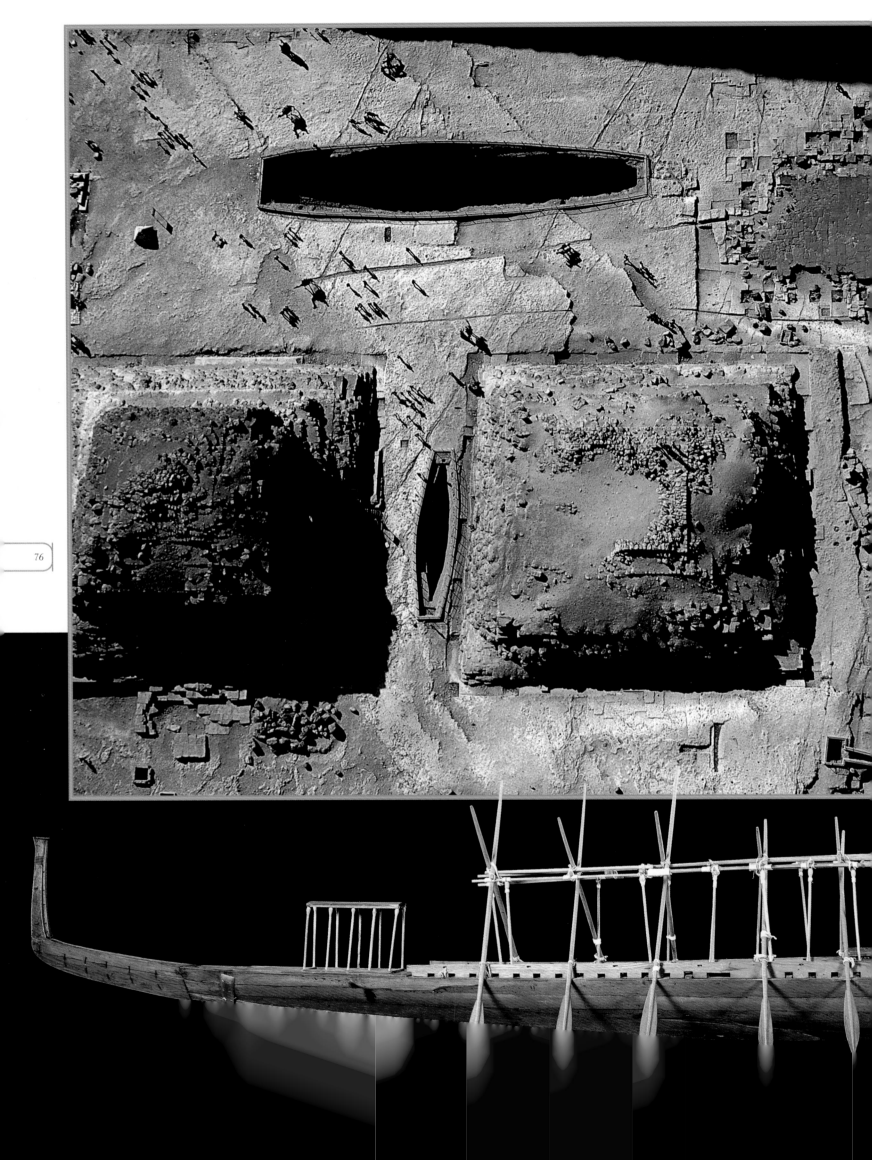

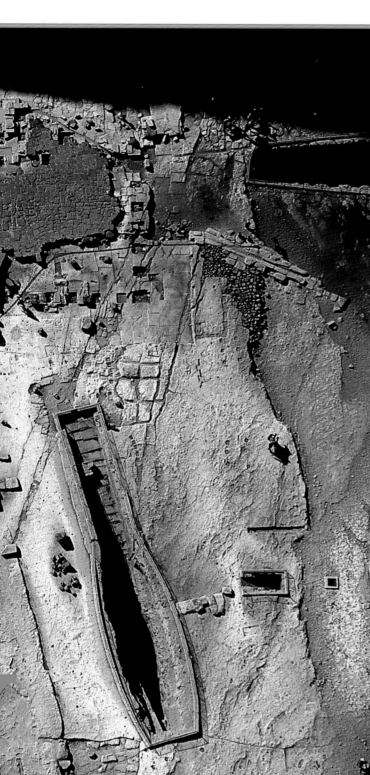

THE PYRAMID OF KHUFU

Although it was unquestionably the most important, the Great Pyramid was one element among several in a large funerary complex that included a small satellite pyramid and three pyramids for three queens. Little or nothing remains of the Funerary Temple that stood beside the Great Pyramid, the Valley Temple that may have stood on the edges of the Nile's flood waters, or the long Ceremonial Way that connected them. An exceptional find was made next to the pyramid: buried in a pit was an entire wooden boat that had been disassembled and conserved after being used—it is hypothesized—to carry the body of the pharaoh to the Valley Temple. Restored by Hagg Ahmed Yussef, an Egyptian restoration expert, the boat is over 130 feet long and now displayed in a specially built museum on the south side of the pyramid. The insertion of a TV camera in one of the other pits discovered around the Great Pyramid has revealed the existence of another boat, though this still remains buried.

76-77 TOP THE AERIAL VIEW REVEALS THE POSITION OF TWO OF THE SMALLER PYRAMIDS AND FOUR OF THE PITS THAT CONTAINED THE SACRED BARKS.

76-77 BOTTOM ONE OF THE PITS NEXT TO KHUFU'S PYRAMID CONTAINED A LARGE, COMPLETELY DISASSEMBLED WOODEN BOAT. PATIENTLY REBUILT BY AN EGYPTIAN CRAFTSMAN, TODAY IT CAN BE ADMIRED FROM ALL SIDES IN THE MUSEUM THAT WAS BUILT ESPECIALLY FOR IT NEXT TO ITS BURIAL PLACE.

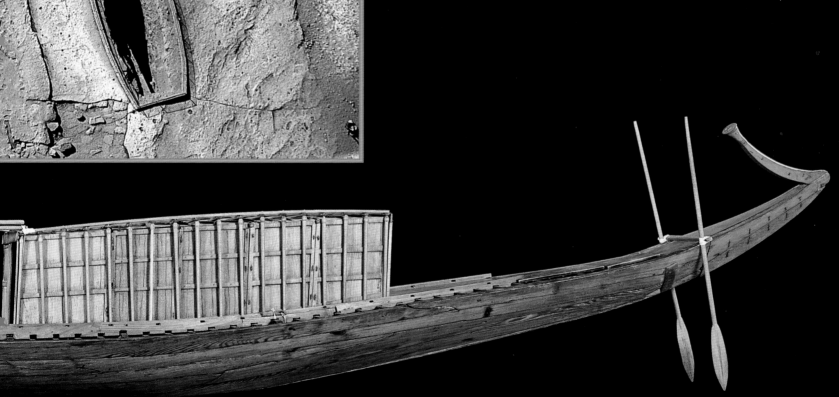

THE PYRAMID OF KHAFRE

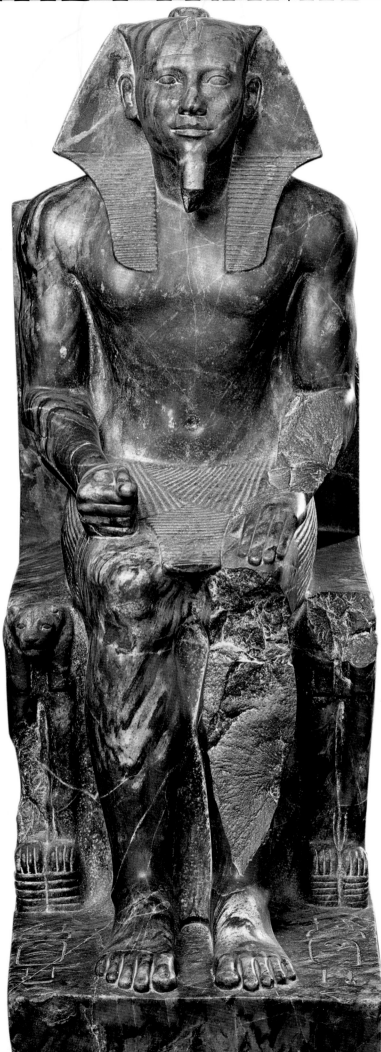

After the short reign of Djedefre—Khufu's successor who left his own small pyramid at Abu Rawash uncompleted—Khafre returned to Giza to build the second largest pyramid in the history of ancient Egypt. With its sides shorter than those of the Great Pyramid, Khafre's monument also has a smaller volume, little more than 2.9 million cubic yards of stone. However, due to its slightly steeper sides, it reached a height just 10 feet lower than that of Khufu's pyramid.

The interior of Khafre's pyramid has a descending corridor that leads to a secondary chamber, exits the chamber upward, then levels out to enter a simple burial chamber that held the pharaoh's sarcophagus. The presence of a second corridor connected to the first may have been caused by a change of plan during construction.

In addition to the pyramid, Khafre's funerary complex has the famous Sphinx, a large Funerary Temple that still stands at the top of the Ceremonial Way, and a Valley Temple in which the main room was lined with red granite, alabaster, and sixteen single-block granite pillars. A beautiful statue of Khafre, now in the Cairo Museum, was found in the temple. It shows the pharaoh dressed only in a short skirt and seated on the throne with his hands resting on his knees. Horus, in the form of a falcon, perches behind the king's head and spreads his wings to protect his neck. The sculpture was made of dark gneiss with pale-colored marbling that was quarried in the Western Desert, north of Abu Simbel, an area that lies more than 620 miles from Giza up the Nile.

78 LEFT THE STATUE OF KHAFRE PROTECTED BY THE GOD HORUS IS ONE OF THE MASTERPIECES OF THE STATUARY OF THE OLD KINGDOM.

78 RIGHT THE SIMPLE BURIAL CHAMBER IS LINED WITH STONE SLABS.

79 BESIDES BUILDING EGYPT'S SECOND LARGEST PYRAMID, KHAFRE CONSTRUCTED A LARGE FUNERARY TEMPLE, CONNECTED BY A LONG RAMP TO A VALLEY TEMPLE, PLUS THE SPHINX WITH ITS OWN TEMPLE.

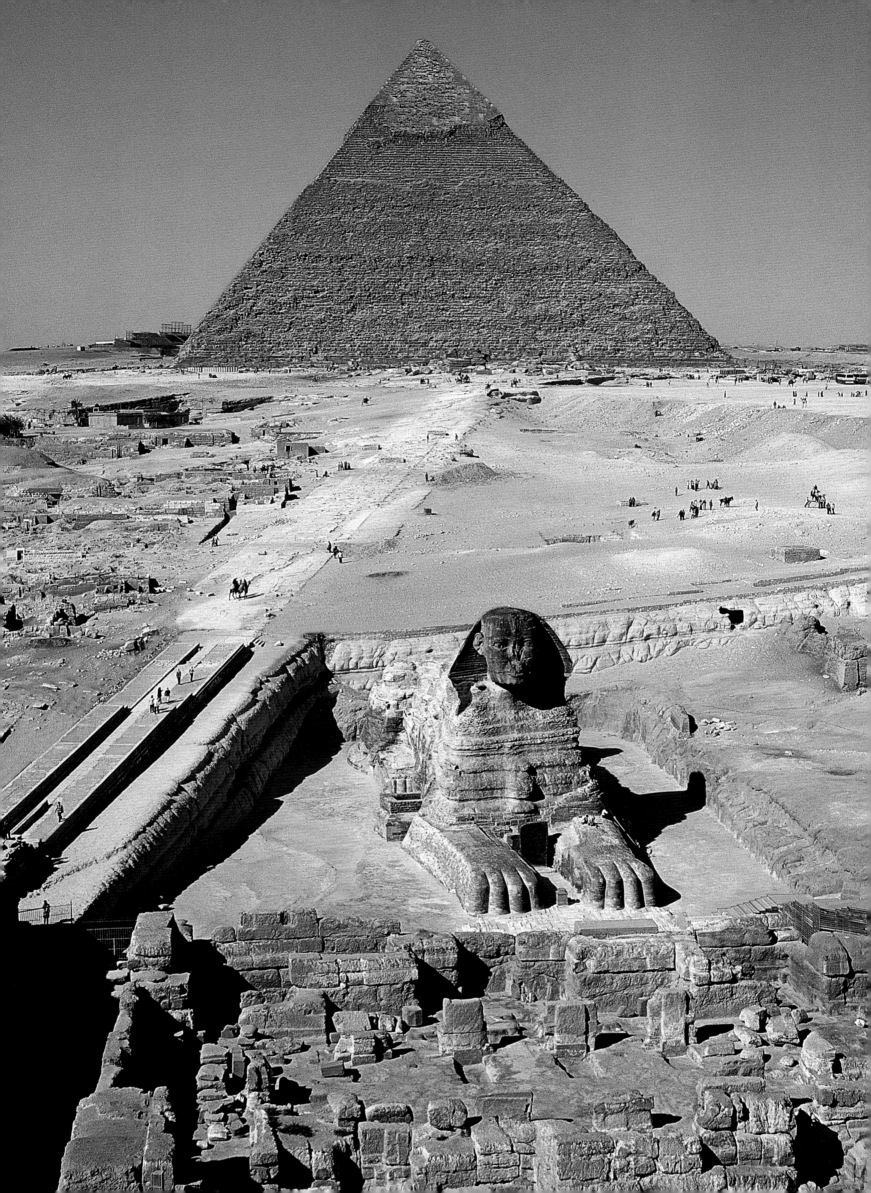

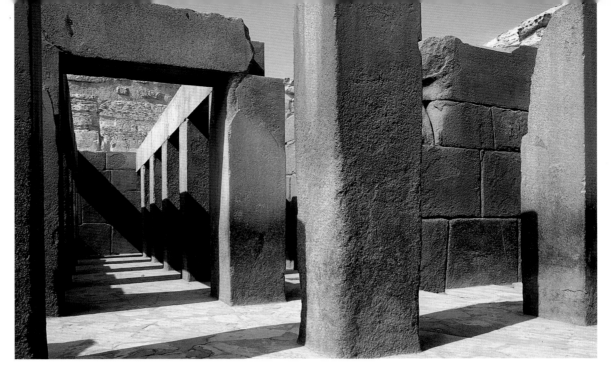

80 top The Valley Temple in Khafre's funerary complex was built from enormous blocks of stone, including sixteen monolithic pillars made of black granite that supported equally large architraves.

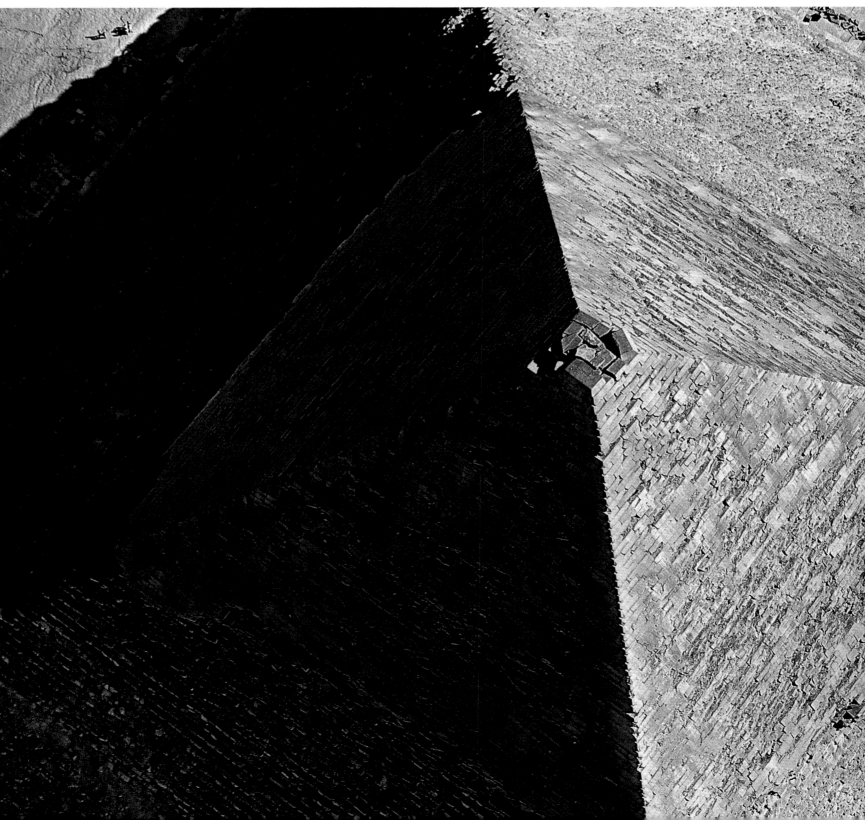

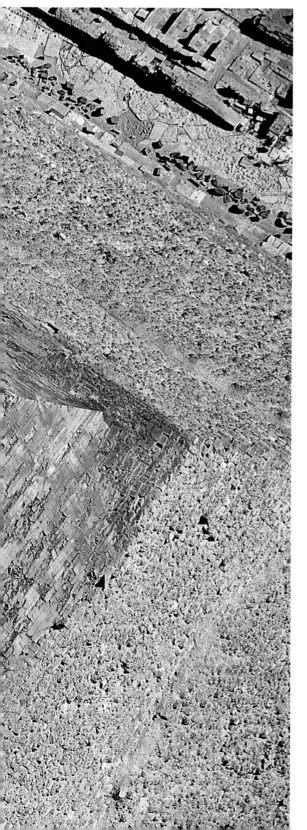

THE PYRAMID OF KHAFRE

80-81 *The upper part of Khafre's pyramid still has a part of its original lining, sufficient to give us an idea of the precision and regularity of the construction and its original appearance.*

81 *top and bottom The walls of Khafre's Valley Temple were covered with perfectly interlocking red granite slabs. The floor was originally covered by alabaster slabs.*

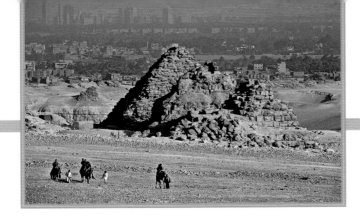

THE PYRAMID

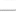

82 TOP OF THE THREE SECONDARY PYRAMIDS BUILT FOR MENKAURE'S THREE QUEENS, PERHAPS TWO WERE STEPPED PYRAMIDS AND THE THIRD COVERED WITH A SMOOTH LINING.

82-83 THE THIRD PYRAMID AT GIZA WAS BUILT BY MENKAURE AND WAS FLANKED BY THREE SECONDARY PYRAMIDS FOR HIS THREE QUEENS, A FUNERARY TEMPLE, AND A VALLEY TEMPLE.

The third pyramid at Giza is smaller but no less important than the others. Pharaoh Menkaure had it built in the last open area on the rocky plateau. With a volume of roughly one tenth that of Khufu's pyramid, the third royal monument at Giza was accompanied by three smaller pyramids for three queens and given large, elaborate temples in which statues were found that are considered the greatest masterpieces of the Old Kingdom. These are the dyad of Menkaure and his most important wife (Museum of Fine Arts, Boston) and the triads of Menkaure accompanied by pairs of

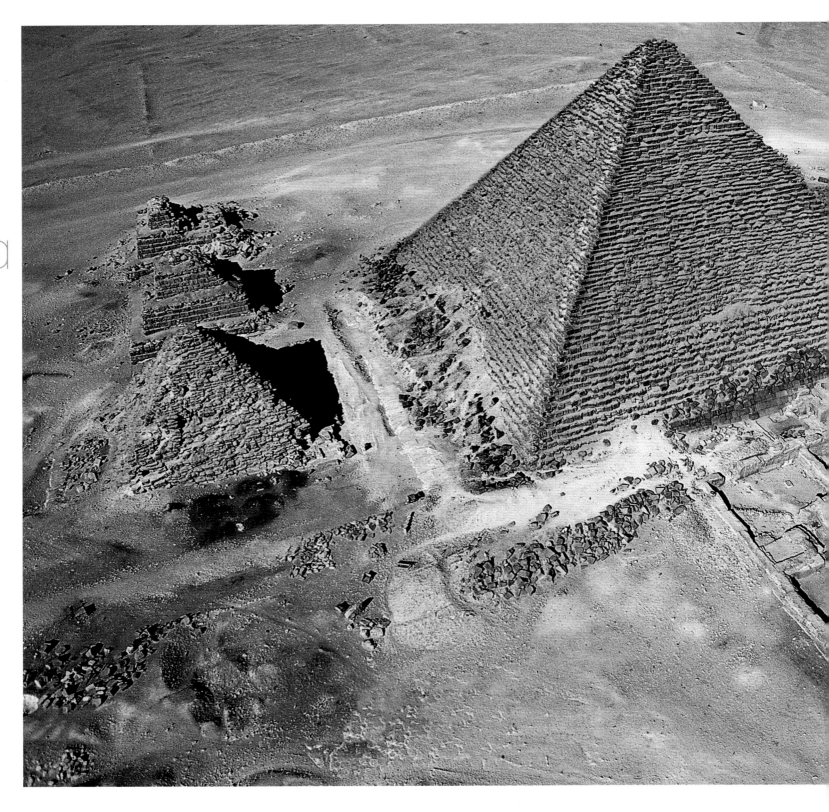

OF MENKAURE

gods and personifications of the provinces of the kingdom (Cairo Museum).

The richness of the funerary complex is reflected in the extensive use of granite. This hard stone is difficult to work and therefore more costly than limestone, particularly as it had to come from the distant quarries of Upper Egypt. Granite was used to line the lower part of the pyramid even though the work remained unfinished.

The facing blocks were positioned on the pyramid with the outer face still rough, then they were smoothed to give a polished finish. Menkaure died before the facing had been com-

pleted and only the pyramid surface around the entrance to the funerary apartment was smoothed for his funeral.

The inside of the pyramid is equally complex, with a series of small rooms on staggered levels and a corridor that leads nowhere. It was probably abandoned following a change of plan during construction.

In the first half of the nineteenth century, the British military officer Howard Vyse entered the pyramid and found a beautiful decorated sarcophagus in the burial chamber. It was removed and loaded on a ship bound for England but was lost when the ship sank.

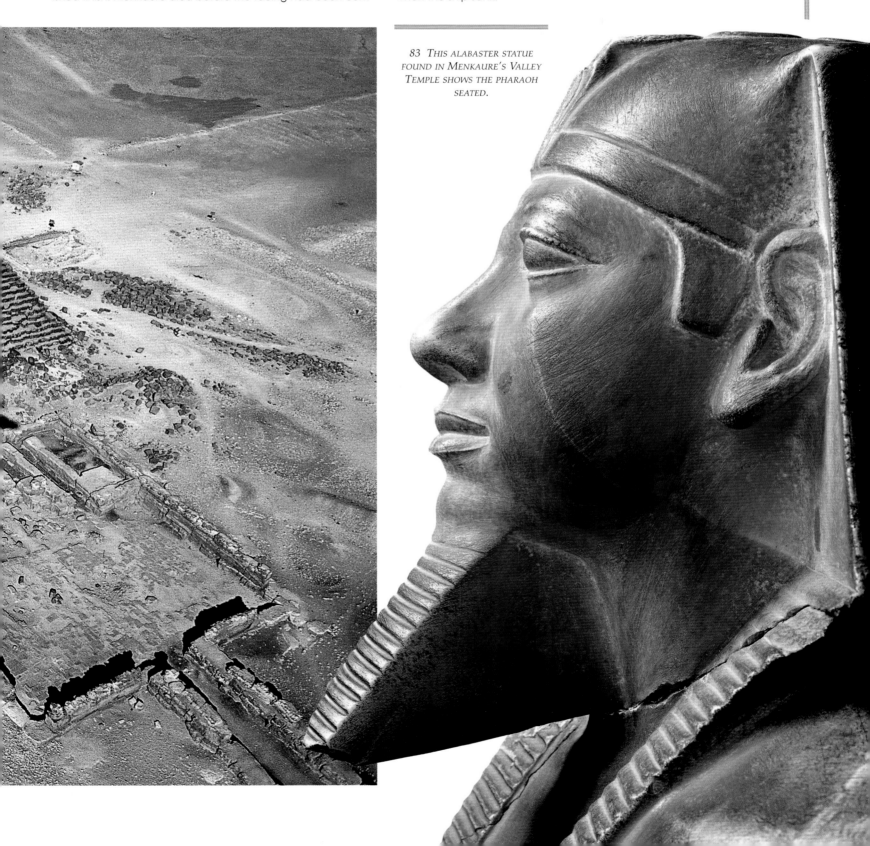

83 THIS ALABASTER STATUE FOUND IN MENKAURE'S VALLEY TEMPLE SHOWS THE PHARAOH SEATED.

The Giza plateau is not just the setting for the large tombs of the pharaohs and their consorts but also for a vast necropolis where members of the royal family and nobles who had the honor to accompany the king to the Afterworld were buried. Here the world of the dead merged with the land of the living as the plateau was visited every day by thousands of workers busy in constructing the pyramids and quarrying the rock, by craftsmen who sculpted the statues and decorations, and by the supporting workforce responsible for providing the workers with food and lodging. The American archaeologist Mark Lehner has recently disinterred the remains of a large number of ovens capable of producing vast quantities of bread, and long low benches on which tons of fish were prepared. Bread and fish, washed down by beer, formed the basic diet of the workers on the immense site. For an entire century Giza was the theater of a huge enterprise, the remains of which still amaze the world.

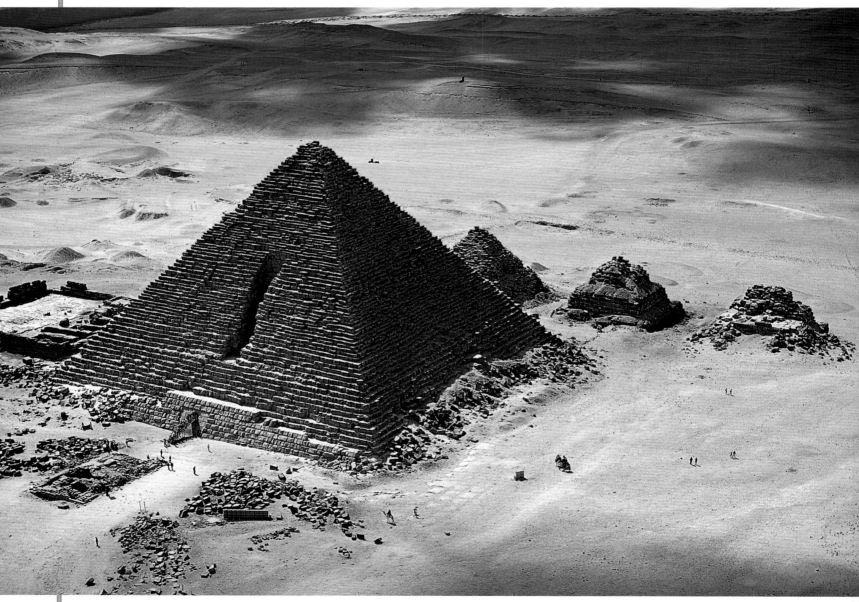

84 TOP HERE WE SEE THE GRANITE MASSES IN THE INTERNAL ROOMS OF MENKAURE'S PYRAMID.

84 BOTTOM THE AERIAL PHOTOGRAPH SHOWS A DIFFERENT PERSPECTIVE OF THE SMALLEST OF THE THREE PYRAMIDS AT GIZA.

85 THE GRAYISH-GREEN SCHIST TRIADS OF MENKAURE WITH THE GODDESS HATHOR AND THE THREE FIGURES THAT REPRESENT THE PROVINCES OF THE KINGDOM WERE FOUND IN THE VALLEY TEMPLE.

86-87 THE HUGE BULK OF THE THREE PYRAMIDS AT GIZA DWARFS EVERYTHING ELSE BUILT BY MAN AND HAS BECOME AN INTEGRAL PART OF THE LANDSCAPE.

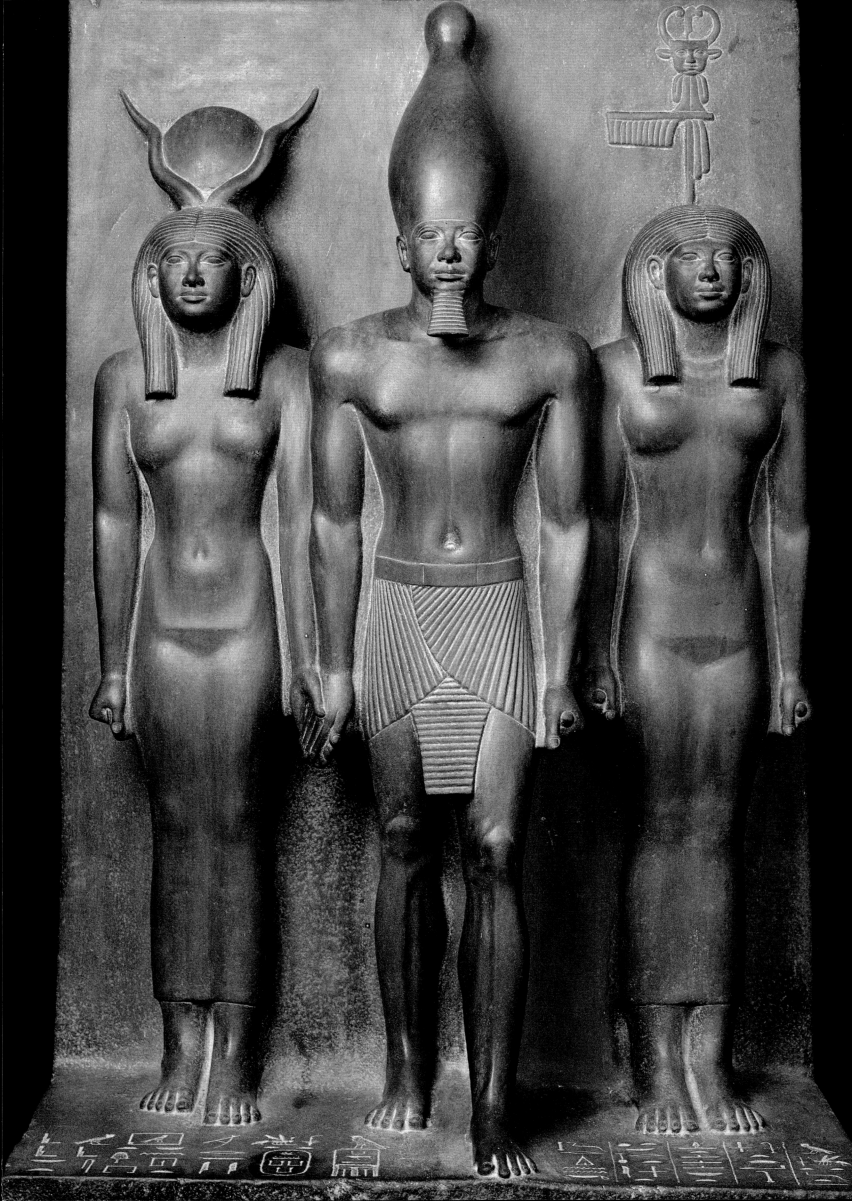

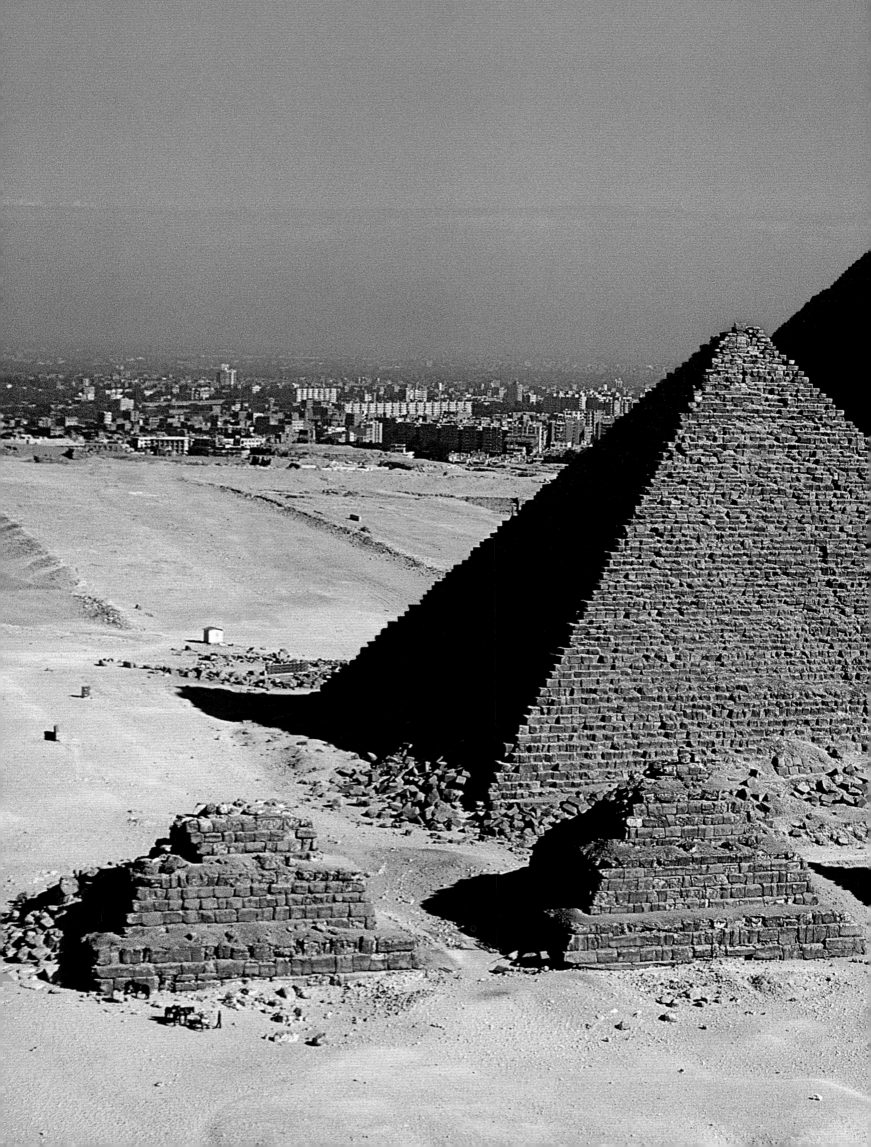

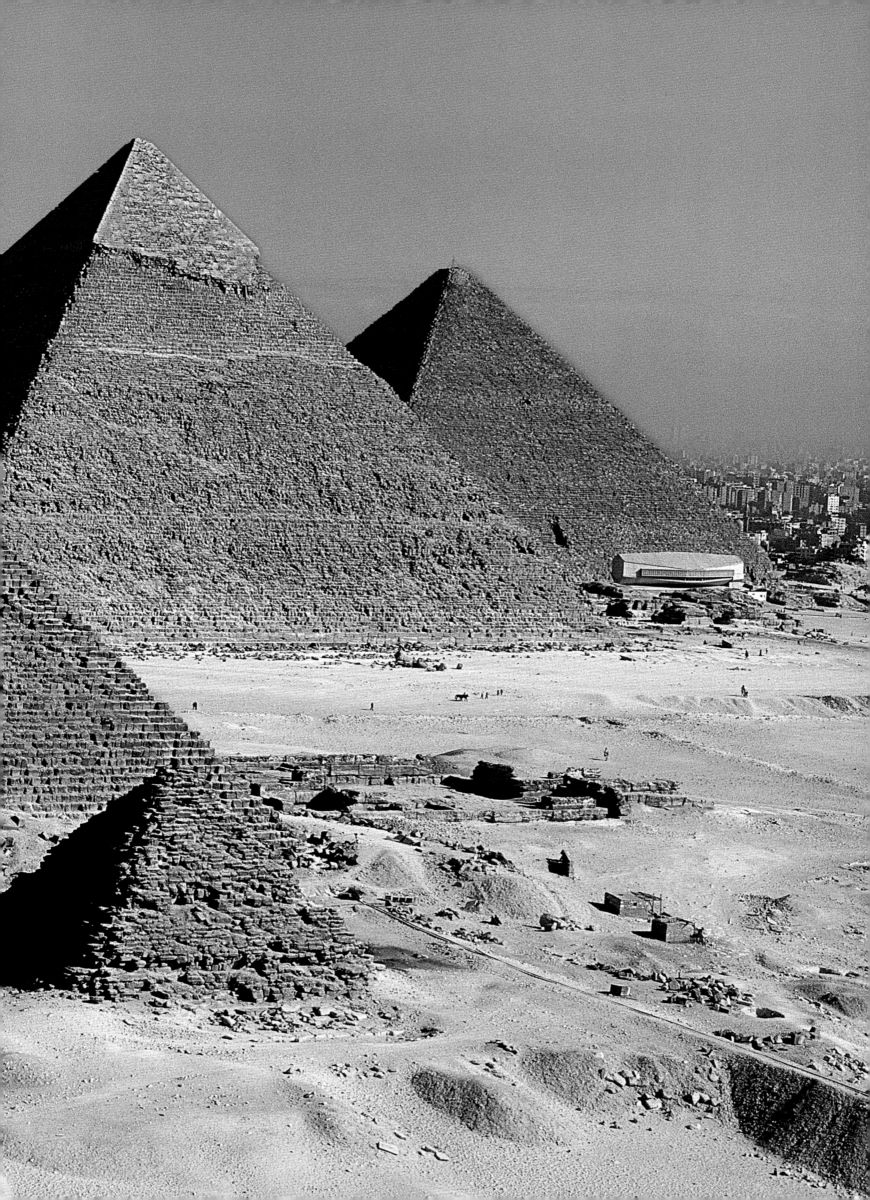

THE SPHINX

The Sphinx , one of the most significant elements of Khafre's funerary complex, is also one of the most famous symbols of the royal necropolis at Giza. Carved next to the Valley Temple at the foot of the Ceremonial Way, the Sphinx portrays the face of Khafre on the body of a crouching lion with its paws extended in front. As powerful as an enormous lion, the pharaoh continued to watch over his land even from the tomb.

The scale of the Sphinx is larger than that of any other sculpture from the Old Kingdom; it can be compared only to the colossal statues produced 1,200 years later by pharaohs like Amenhotep III, who was responsible for the Colossi of Memnon, and Ramesses II, who had colossal statues of himself carved at Abu Simbel and elsewhere. With a length of 187 feet and a height of 66, the Sphinx was modeled by removing limestone from around his body, with the cut-away stone then used to construct the temple dedicated to the creature. During the period in which the Sphinx was neglected, the empty space around his body filled completely with sand, which is why, in so many famous pictures of Giza, including those in the *Description de l'Egypte* which in the early nineteenth century reported and illustrated the Napoleonic expedition of 1798, only the head and upper part of the back of the Sphinx are visible.

The rock out of which the Sphinx is carved is not uniform, which is why the condition of parts of the sculpture differs. The body is formed from a layer of soft limestone with light and dark bands, and this has suffered more over the years than the head, which was carved from a layer of harder limestone. The pharaoh's serene face is framed by the *nemes* headdress, which was made from material drawn tight across the forehead and tied behind the back of the neck, allowing two large folds to fall at the sides.

The details of the entire monument have been made indistinct by time and pollution and the face has also been disfigured by the loss of the nose. What remains of the Sphinx's face seems to suggest that someone deliberately removed the nose with picks and hammers. It is not known when exactly this damage was done, but it is thought it happened in the Middle Ages when the pyramids began to be used to provide building materials for buildings in Cairo. Even the beard that once hung from the Sphinx's chin became detached. Of two fragments found, one is in the Cairo Museum and the other in the British Museum.

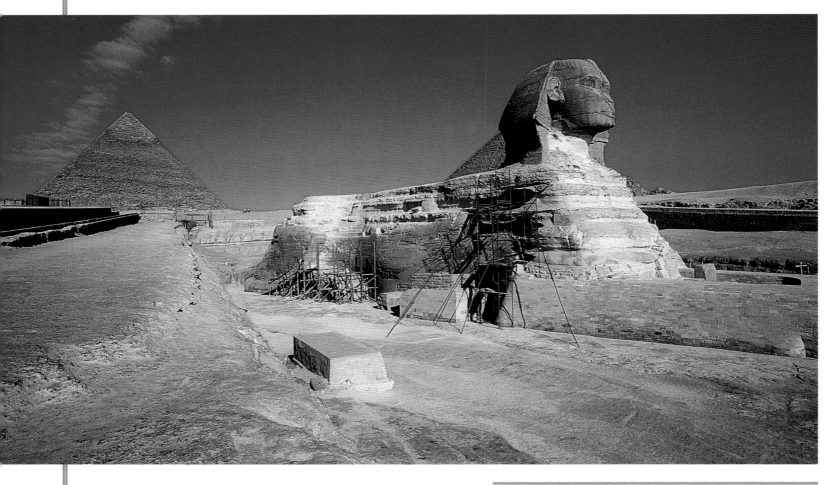

88 THE RECENT RESTORATION OF THE SPHINX'S BODY IS JUST THE MOST RECENT IN A SEQUENCE THAT BEGAN IN THE EIGHTEENTH DYNASTY, WHEN THUTMOSIS IV FREED IT FROM THE SAND.

89 THE FACE OF THE SPHINX, DAMAGED BY THE ELEMENTS AND HAND OF MAN, PORTRAYS KHAFRE, THE PHARAOH WHO HAD THE COLOSSUS BUILT AS PART OF HIS FUNERARY COMPLEX.

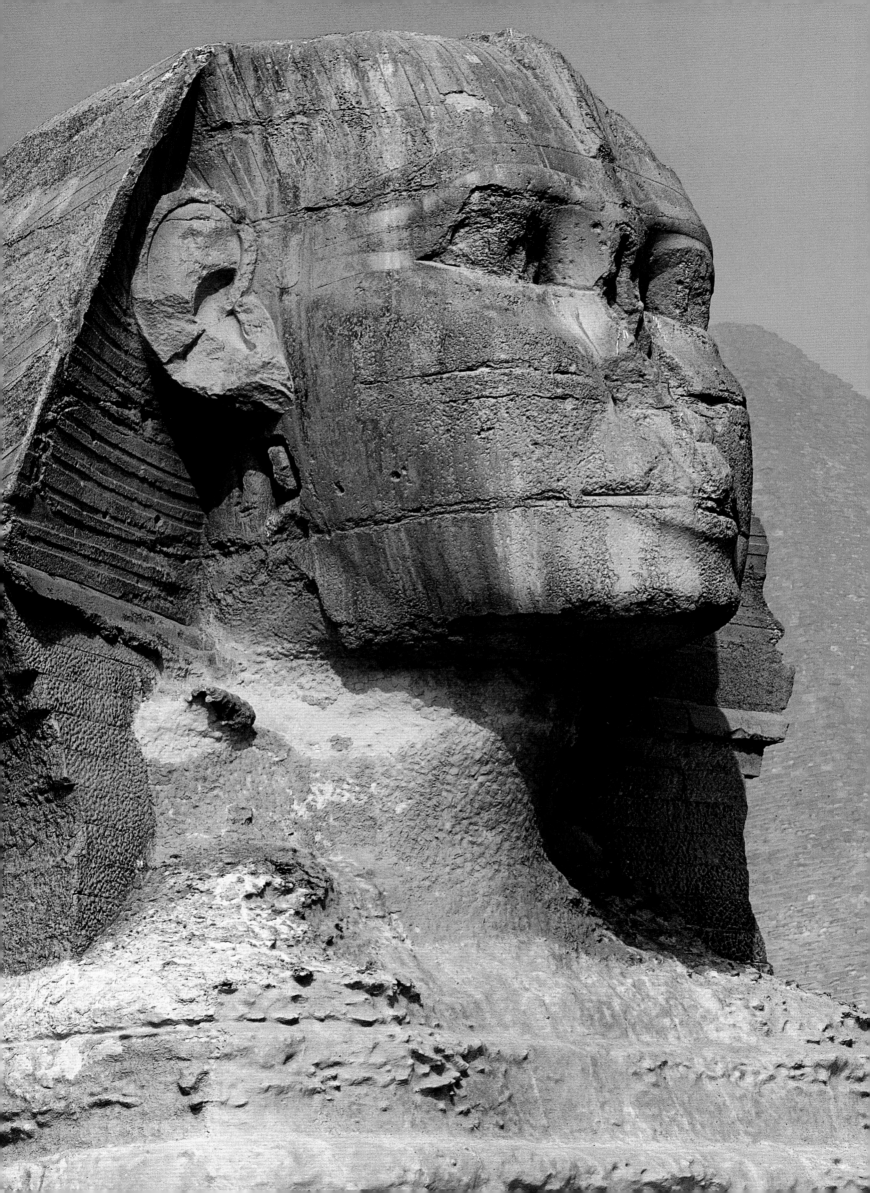

THE SPHINX

90 This limestone doorway is part of the Eighteenth-Dynasty temple built by Amenhotep II.

91 The bird's-eye view shows the Sphinx's temple and, on the left, the temple of Amenhotep II.

92-93 In front of the Sphinx's paws stands a temple probably dedicated to the statue, which included a courtyard surrounded by twenty-four red granite monolithic pillars

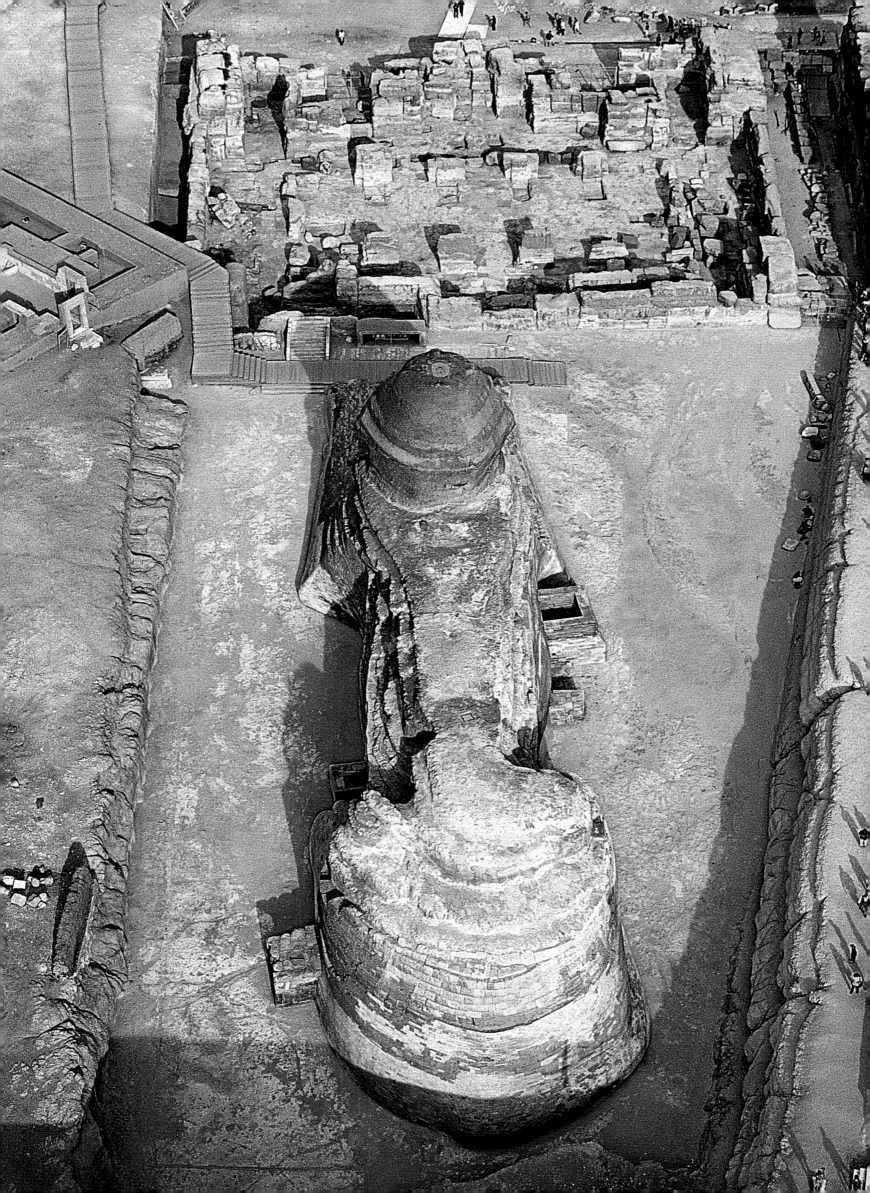

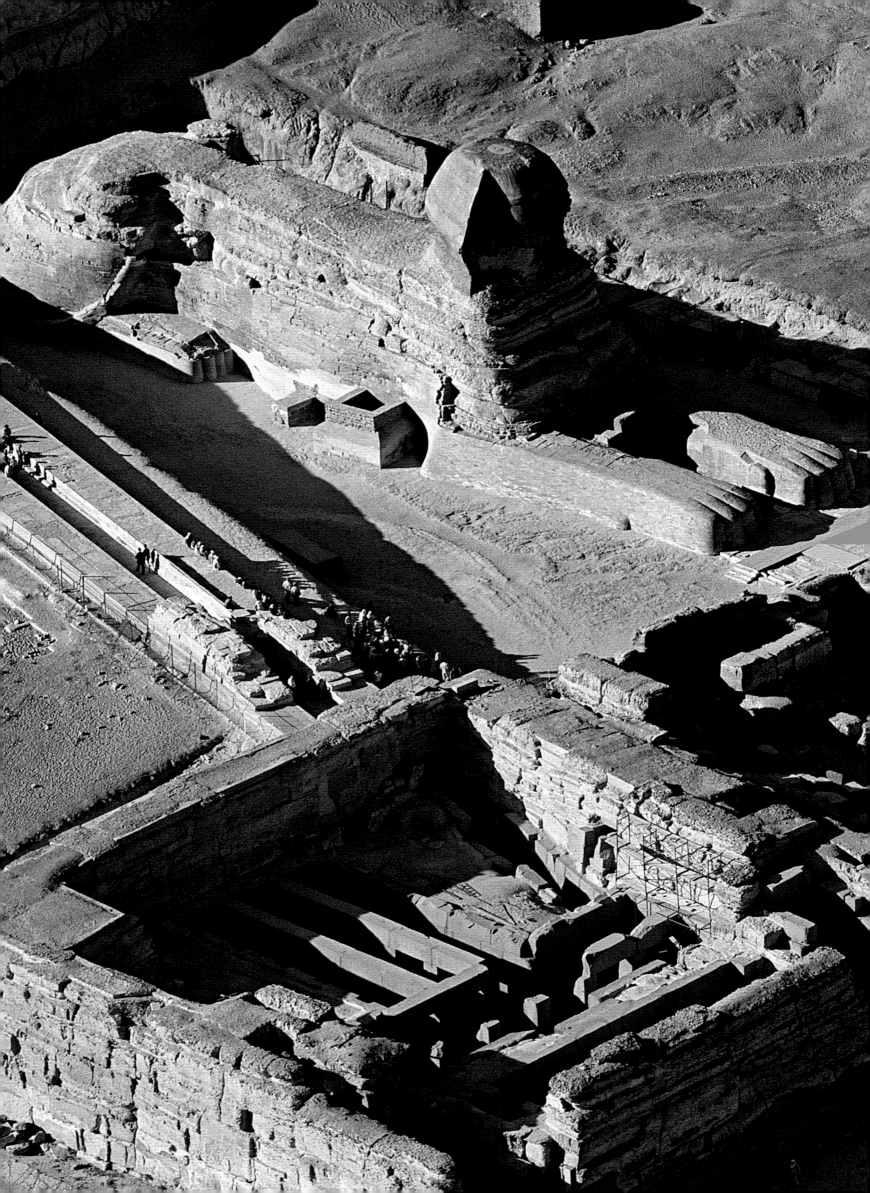

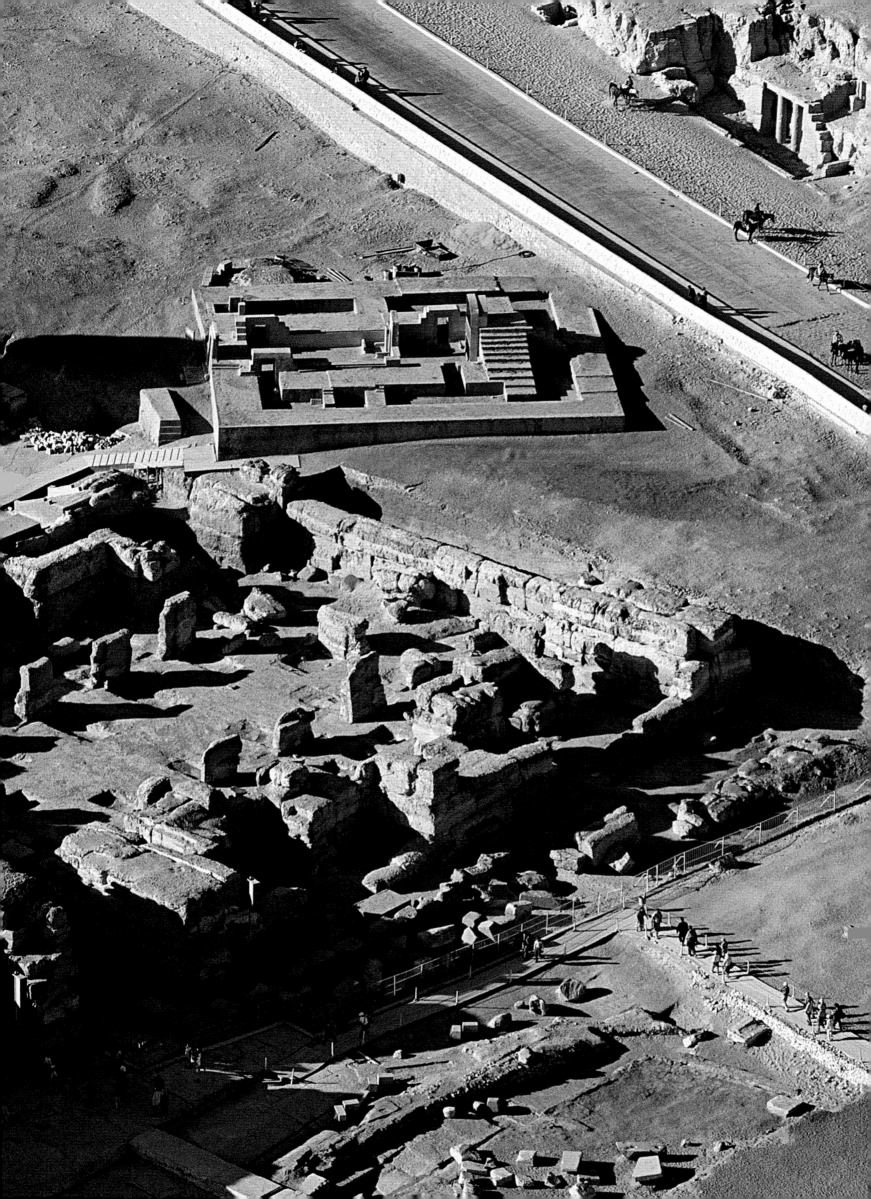

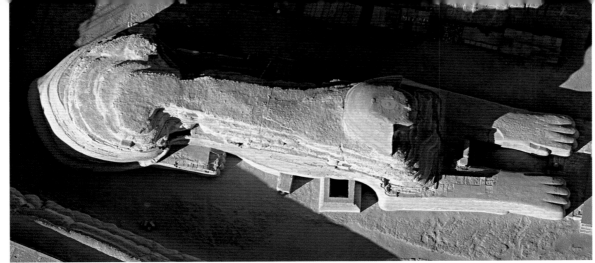

THE SPHINX

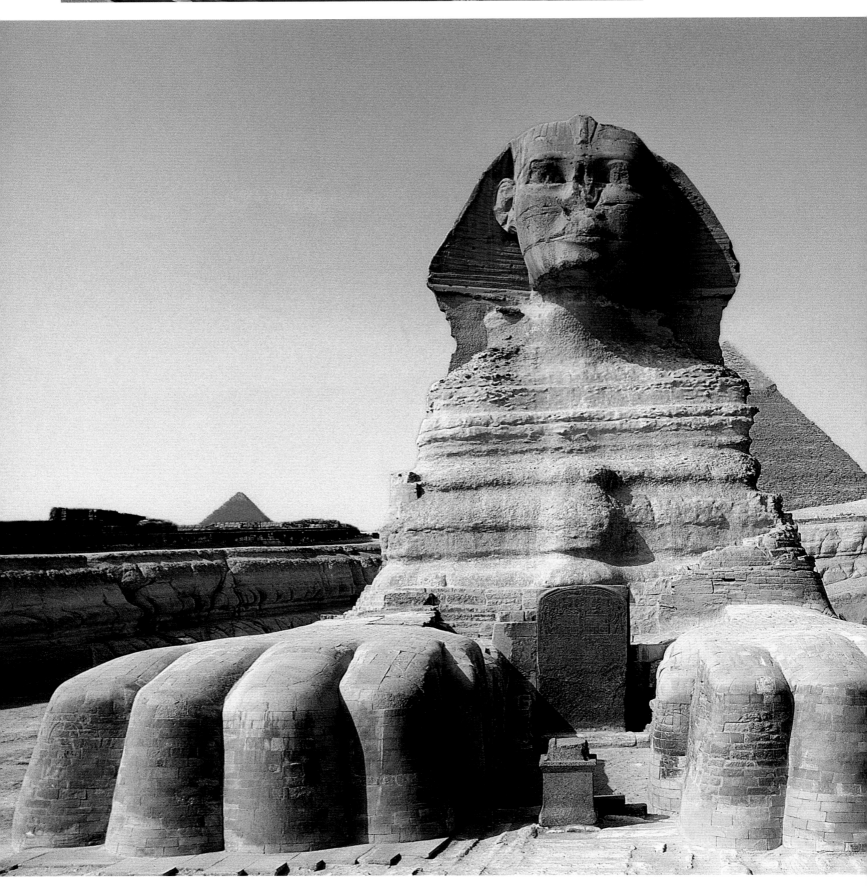

THE STELE BETWEEN THE SPHINX'S FEET WAS PLACED THERE BY THUTMOSIS IV AND CALLED THE "STELE OF THE DREAM." IT RECOUNTS THAT THE YOUNG PRINCE STOPPED TO REST IN THE SHADE OF THE HUGE HEAD AND THAT THE SPHINX APPEARED TO HIM IN A DREAM, ANNOUNCING THE YOUNG MAN'S ASCENT TO THE THRONE. IN GRATITUDE, THUTMOSIS CLEARED THE SAND AWAY FROM THE COLOSSUS AND REPAIRED THE DAMAGED SECTIONS.

The monument was first restored during the New Kingdom, as a stele erected by Thutmosis IV between the Sphinx's paws records, then again during the Twenty-sixth Dynasty and the Greco–Roman period. Modern restoration began in the 1920s and still continues. Using photogrammetry, Mark Lehner made a highly detailed study of the colossal statue over a period of five years with the aim of discovering the original appearance of the monument. The missing nose has been rebuilt virtually on the basis of the profile of the famous statue of Khafre protected by the falcon Horus.

A temple dedicated to the Sphinx stood in front of the creature's feet, next to Khafre's valley temple. Its symmetrical plan included two sanctuaries, one in front of the other, that faced a rectangular court. Twenty-four monolithic red granite pillars stood here on the alabaster-covered floor. Perhaps the two sanctuaries, one to the west and the other to the east, were dedicated to the sun's daily round and the twenty-four pillars in the central court represented the twenty-four hours of the day. Lehner has noted that the east–west axis of the Temple of the Sphinx is aligned with the point at which the sun sets at the base of Khafre's pyramid on the days of the equinoxes. The Sphinx, its temple, and the pyramid were therefore part of a large design based on the cult of the sun, one that remodeled the appearance of the entire plateau.

96-97 CARVED WITH A LION'S BODY AND HUMAN HEAD, THE SPHINX SEEMS TO GUARD KHAFRE'S FUNERARY COMPLEX AS IT LOOKS TOWARD THE RISING SUN.

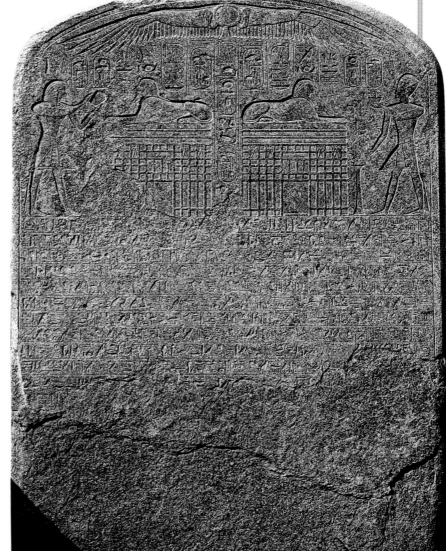

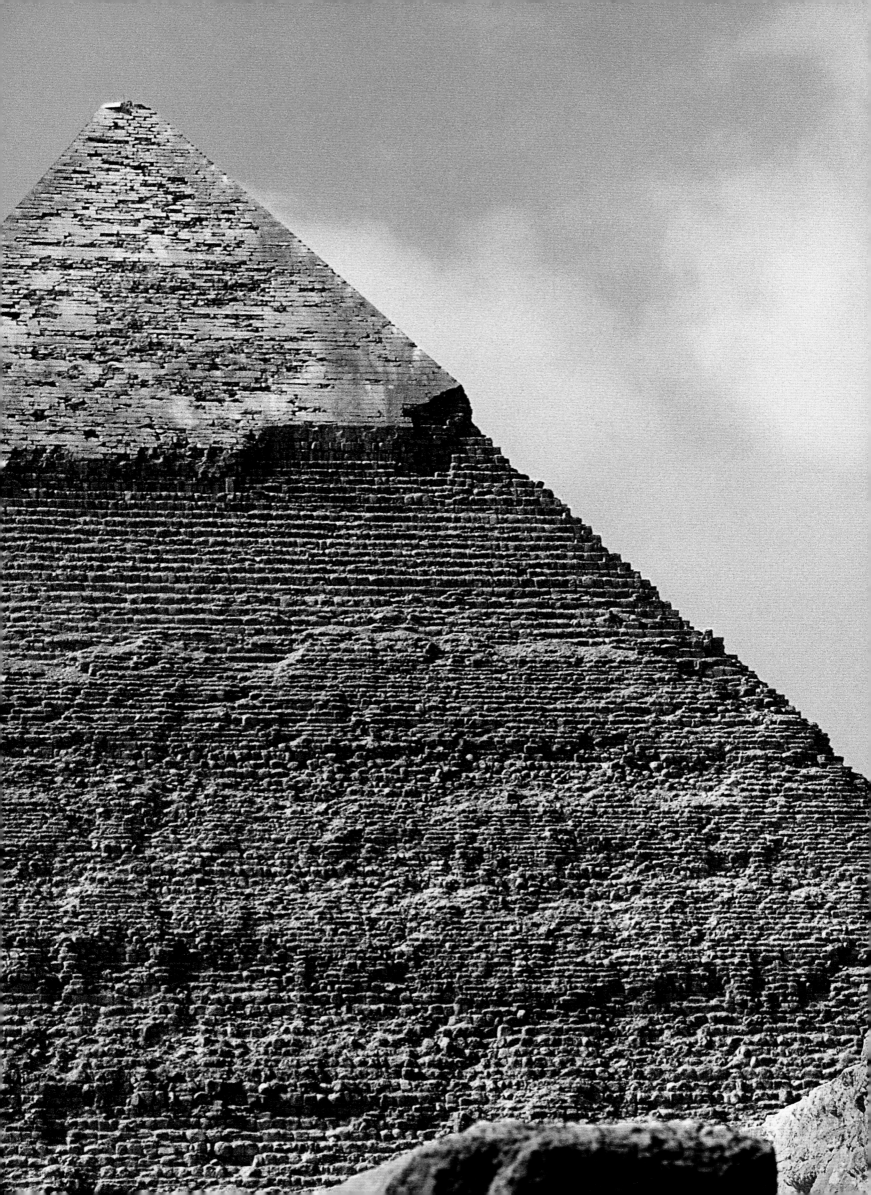

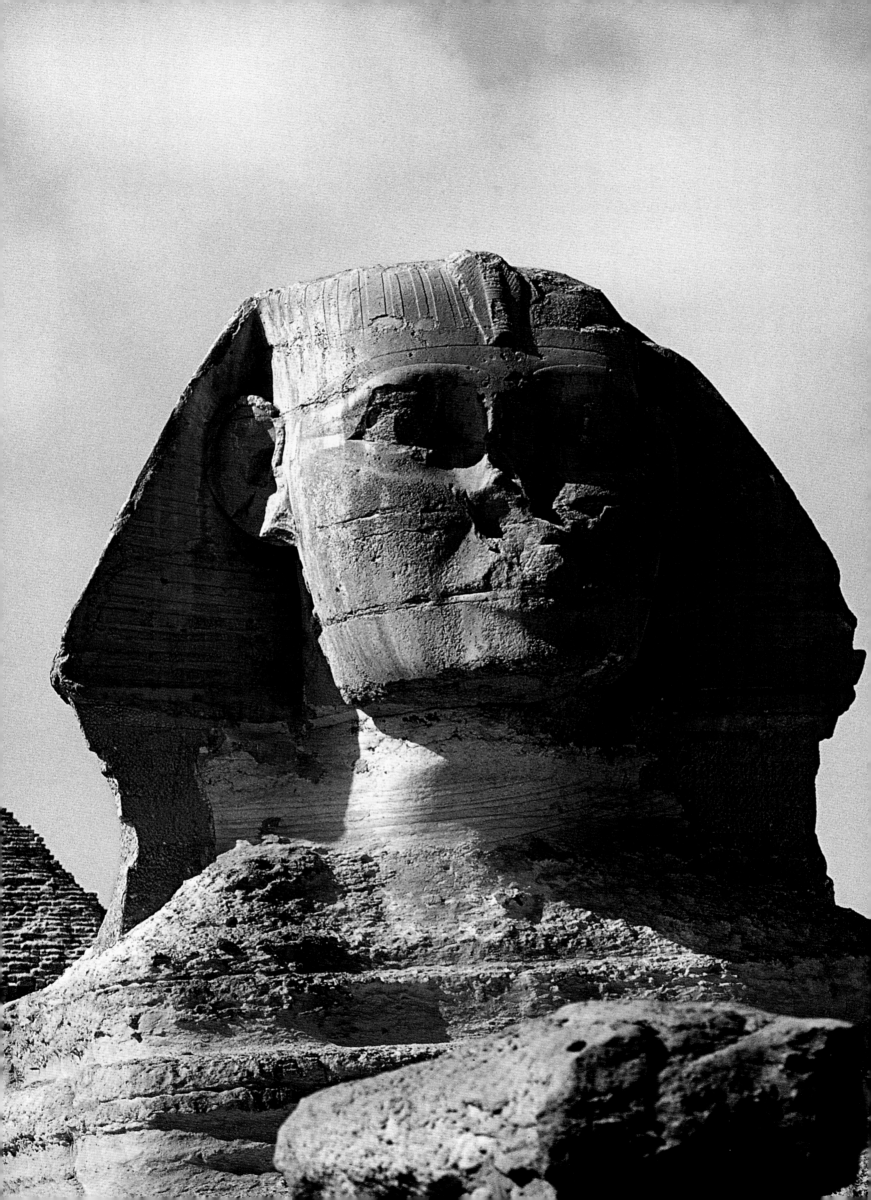

THE TOMBS OF GIZA

98-99 GIZA PLATEAU IS NOT THE SETTING FOR JUST THE LARGE FUNERARY COMPLEXES OF KHUFU, KHAFRE, AND MENKAURE BUT ALSO HUNDREDS OF TOMBS OF NOBLES.

99 TOP LEFT AND CENTER MOST OF THE DIGNITARIES' TOMBS AT GIZA WERE MASTABAS, SEVERAL OF WHICH HAD IMPOSING ENTRANCES.

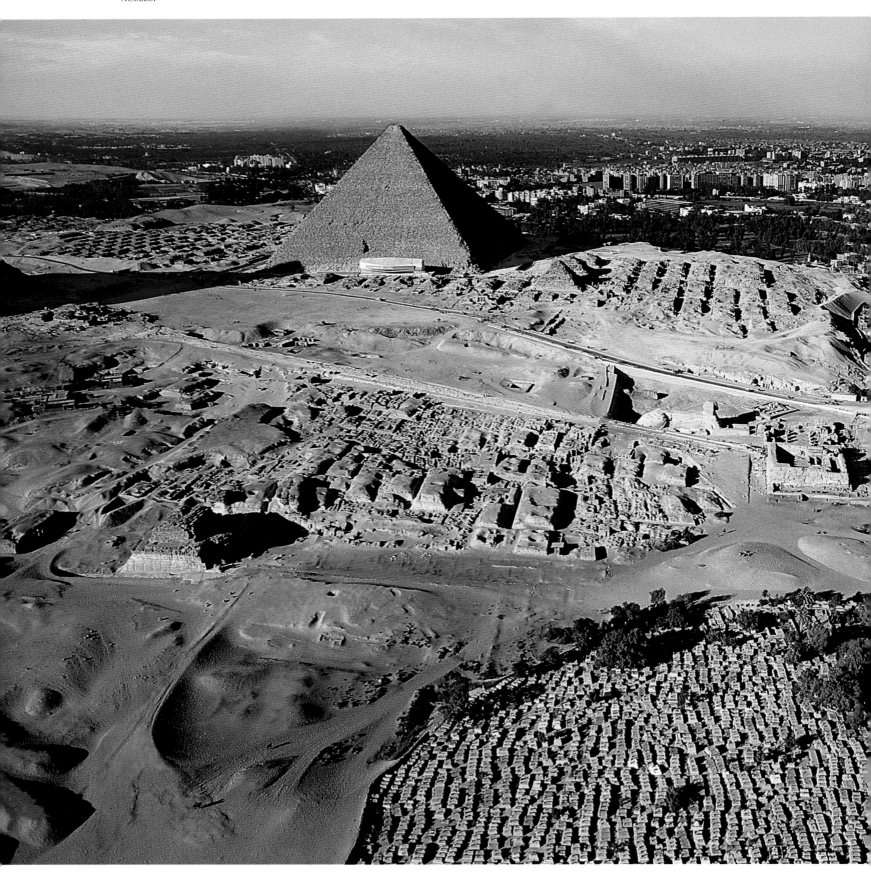

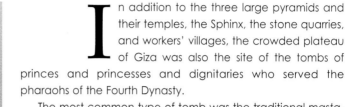

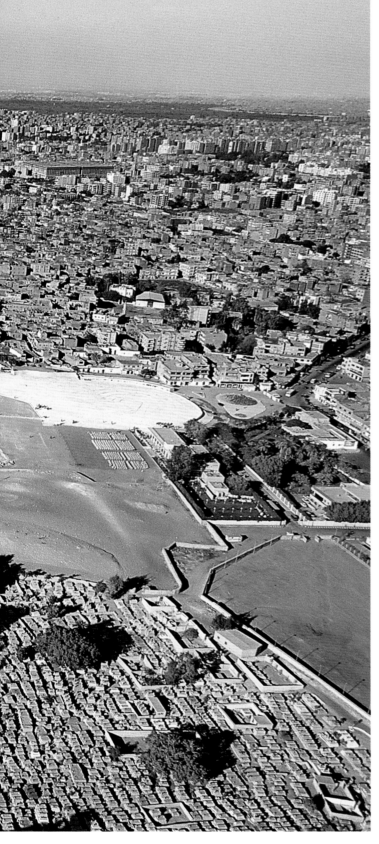

In addition to the three large pyramids and their temples, the Sphinx, the stone quarries, and workers' villages, the crowded plateau of Giza was also the site of the tombs of princes and princesses and dignitaries who served the pharaohs of the Fourth Dynasty.

The most common type of tomb was the traditional *mastaba*. This rectangular stone structure contained a room used to make offerings and worship the deceased, and the burial chamber itself at the bottom of a vertical shaft carved out of the rock beneath. The first cemeteries around the pyramids were organized on a grid pattern in which the *mastabas* were separated by narrow roadways. With time, the original layout was altered by the addition of new tombs and external chapels that filled almost all the space available.

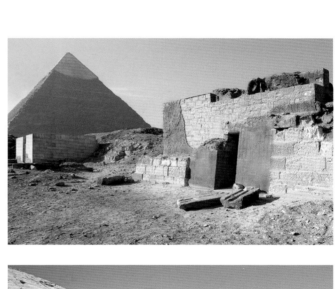

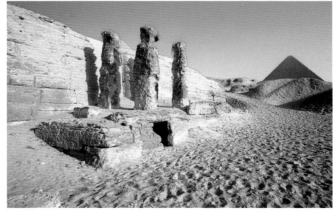

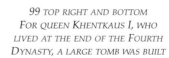

99 TOP RIGHT AND BOTTOM FOR QUEEN KHENTKAUS I, WHO LIVED AT THE END OF THE FOURTH DYNASTY, A LARGE TOMB WAS BUILT AT GIZA CONSISTING OF A TWO-STEP MASTABA PARTLY DUG OUT OF THE ROCK AND PARTLY BUILT USING BLOCKS OF MODELED STONE.

THE TOMB OF KHUFUKHAF I

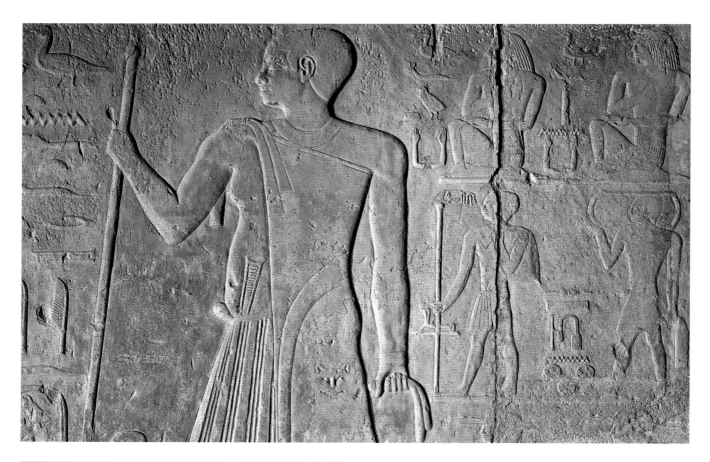

100 TOP, BOTTOM LEFT, AND 101 PRINCE KHUFUKHAF I, A SON OF KHUFU, BUILT FOR HIMSELF IN GIZA A LARGE, MAGNIFICENTLY DECORATED TOMB WITH VERY ELEGANT HIGH RELIEFS THAT

SHOW HIM WITH HIS RETINUE AND HIS FAMILY.

100 BOTTOM RIGHT THE PHOTOGRAPH SHOWS THE STRUCTURE OF KHUFUKHAF I'S TOMB.

The abundant decoration that covers the tomb walls allows many of the deceased buried at Giza to be identified and their links with the pharaoh to be understood. For example, the rich funerary chapel of Prince Khufukhaef I, the son of Khufu, portrays the prince with his mother and wife.

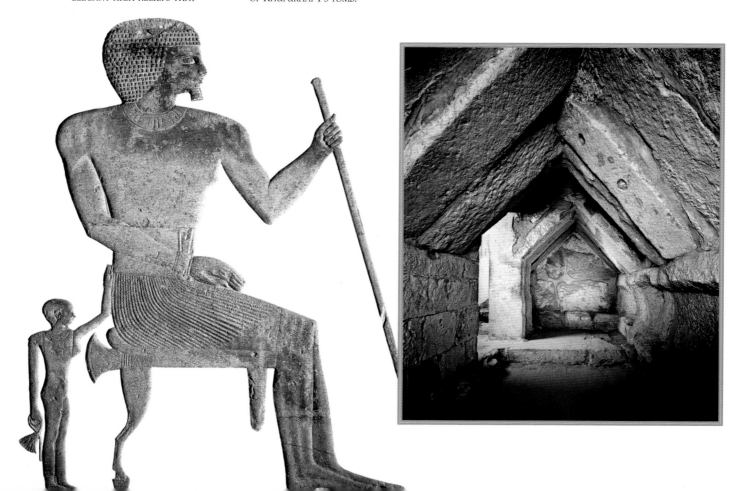

What three part
serve as objective
pronoun and adject

What are the two
complements? pedicat
predicate nominative

THE TOMB OF MERESANKH III

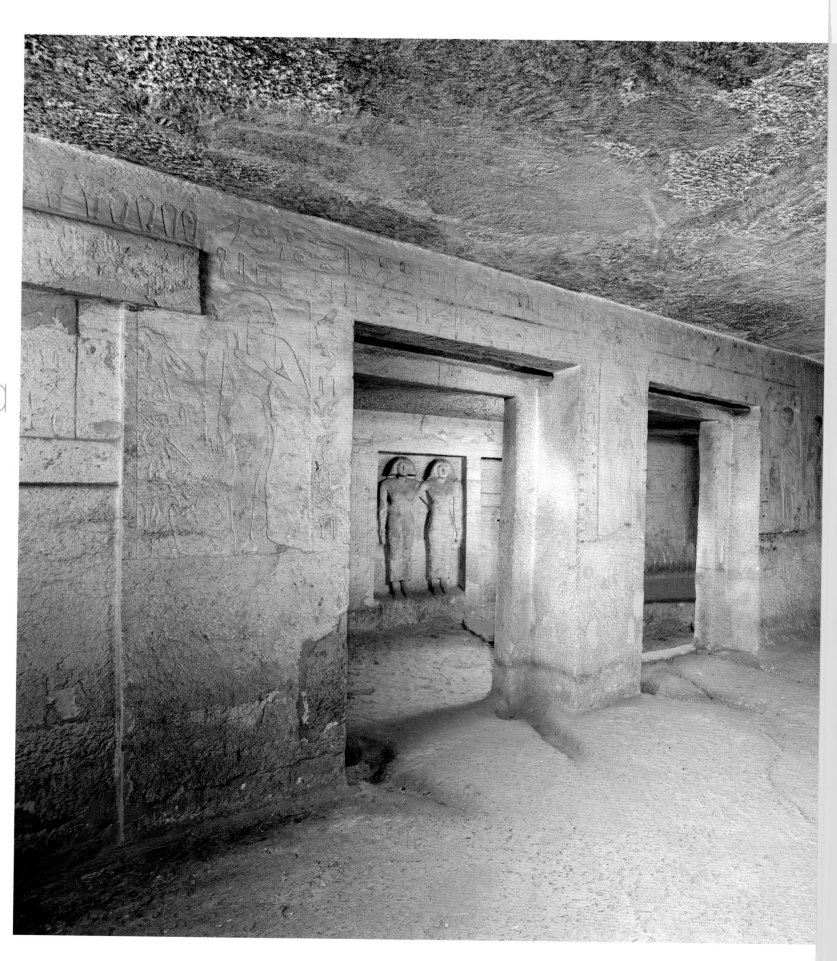

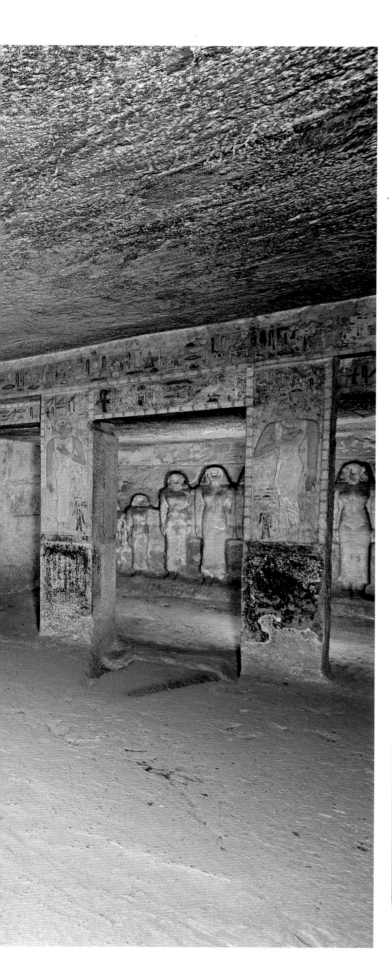

T he tomb of Queen Meresankh III, the granddaughter of Khufu and wife of Khafre, has high-reliefs showing the queen with her mother and son, plus a row of female figures representing the women of the family.

102-103 MERESANKH III WAS ACCOMPANIED BEYOND THE GRAVE BY A SERIES OF LIFE-SIZE STATUES OF VARIOUS MEMBERS OF HIS FAMILY. THESE WERE CARVED DIRECTLY IN NICHES ALONG THE WALLS OF HIS TOMB.

103 TOP MERESANKH III WAS THE NIECE OF KHUFU AND WIFE OF KHAFRE.

103 BOTTOM THE WALLS OF THE QUEEN'S TOMB ARE LINED BY SCENES OF OFFERINGS' PROCESSIONS AND THE TRAPPING OF WILD BIRDS WITH THE HELP OF NETS.

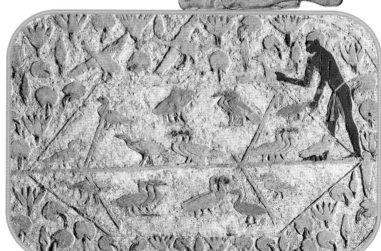

THE TOMB OF MERESANKH III

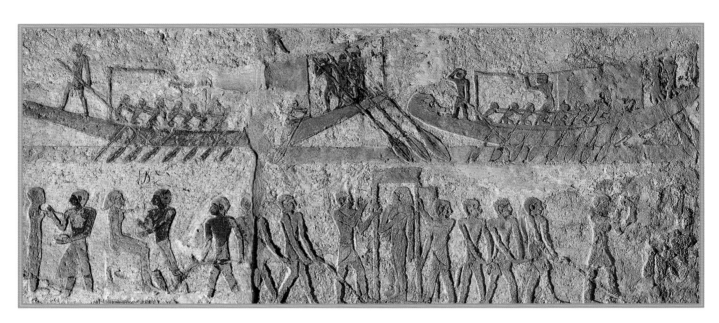

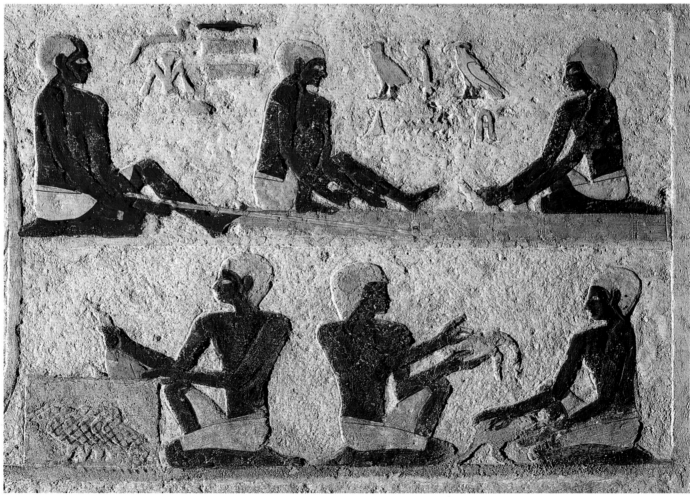

104 THE ROOMS OF MERESANKH III'S ROCK TOMB WERE DECORATED WITH DIFFERENT SCENES. ON THE UPPER REGISTER

THERE ARE BOATS AND ON THE LOWER SCULPTORS AT WORK. IN THE BOTTOM PHOTOGRAPH, FOOD IS BEING PREPARED.

105 VARIOUS MEMBERS OF MERESANKH III'S FAMILY ARE PORTRAYED IN THE PAINTED HIGH RELIEFS ON THE WALLS OF THE CHAPEL. HERE WE SEE HER MOTHER AND THE QUEEN HERSELF.

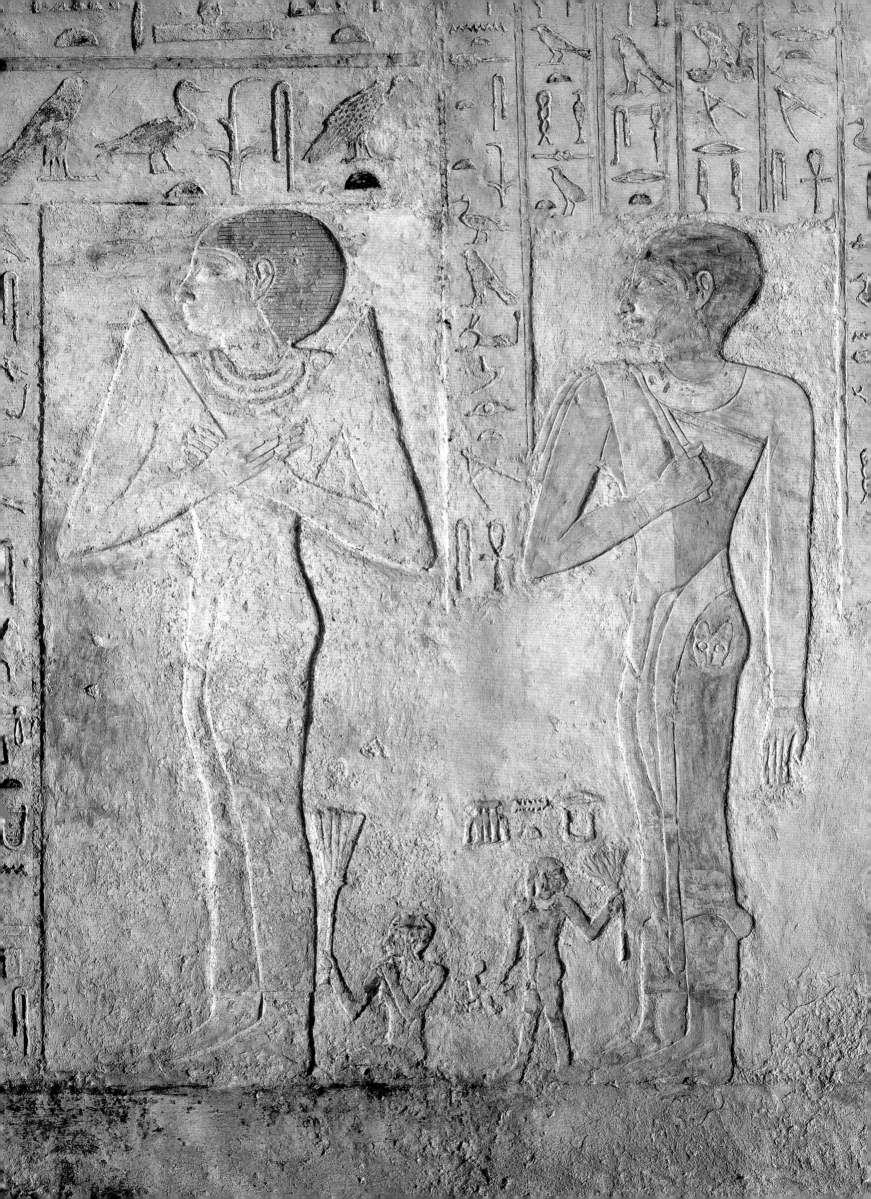

THE GRAVE GOODS

Also discovered at Giza were the grave goods of Queen Hetepheres, the wife of Snefru and mother of Khufu, though her tomb still harbors several mysteries. The queen's furniture, including a bed, litter, armchair, canopy, and various objects like a decorated wooden box, some bowls, and a series of inlaid bracelets, were found at the bottom of a shaft. Lined with gold leaf, the furniture was restored by Hagg Ahmed Yussef and is now displayed in the Cairo Museum.

The tomb also contained canopic jars containing the queen's internal organs but the alabaster sarcophagus in which archaeologists expected to find her body was mysteriously empty. Moreover, the digging of the tomb seems to date to the Second or Third Dynasty rather than the Fourth, and therefore the doubt arises whether this was the tomb originally meant for Hetepheres. It is possible that the first of the three smaller pyramids next to Khufu's pyramid was meant for her but for some reason at a certain point her grave goods were moved to the tomb in which she was found. The absence of her body, though, remains a mystery.

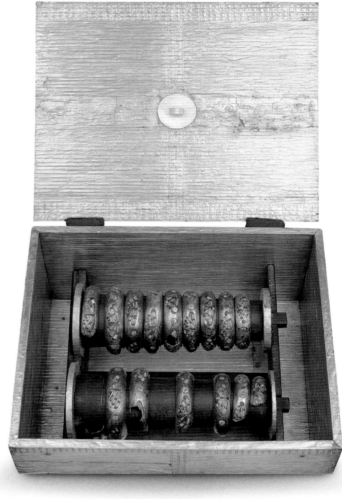

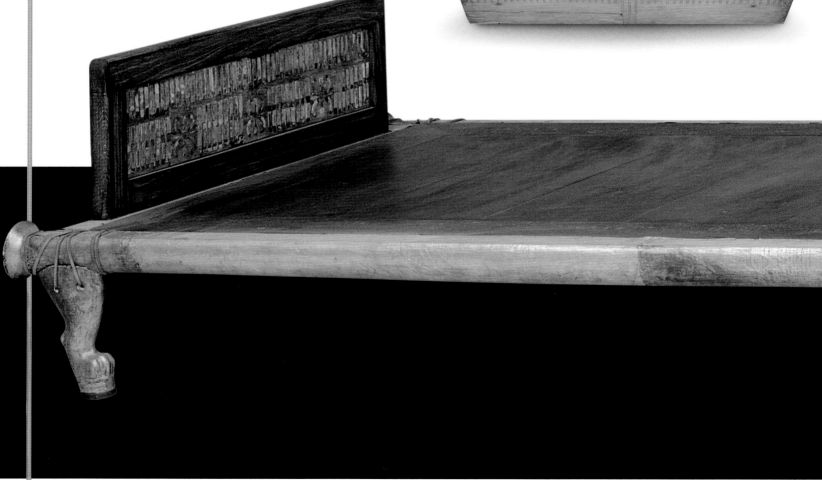

106 TOP AMONG THE OBJECTS PLACED IN THE TOMB PREPARED FOR QUEEN HETEPHERES WAS A GOLD-LINED BOX FILLED WITH SILVER BRACELETS SET WITH CORNELIANS, LAPIS LAZULI, AND TURQUOISES.

106-107 THE TOMB OF HETEPHERES CONTAINED PIECES OF FURNITURE BELONGING TO THE QUEEN, INCLUDING A BED COVERED WITH GOLD-LEAF. RESTORED WITH OTHER ITEMS, IT IS NOW EXHIBITED IN THE CAIRO MUSEUM WITH THE REST OF HER GRAVE GOODS.

107 TOP THIS WOODEN ARMCHAIR COVERED WITH GOLD-LEAF BELONGED TO QUEEN HETEPHERES, THE WIFE OF SNEFRU AND MOTHER OF KHUFU, FOR WHOM AN UNDERGROUND TOMB WAS PREPARED AT GIZA.

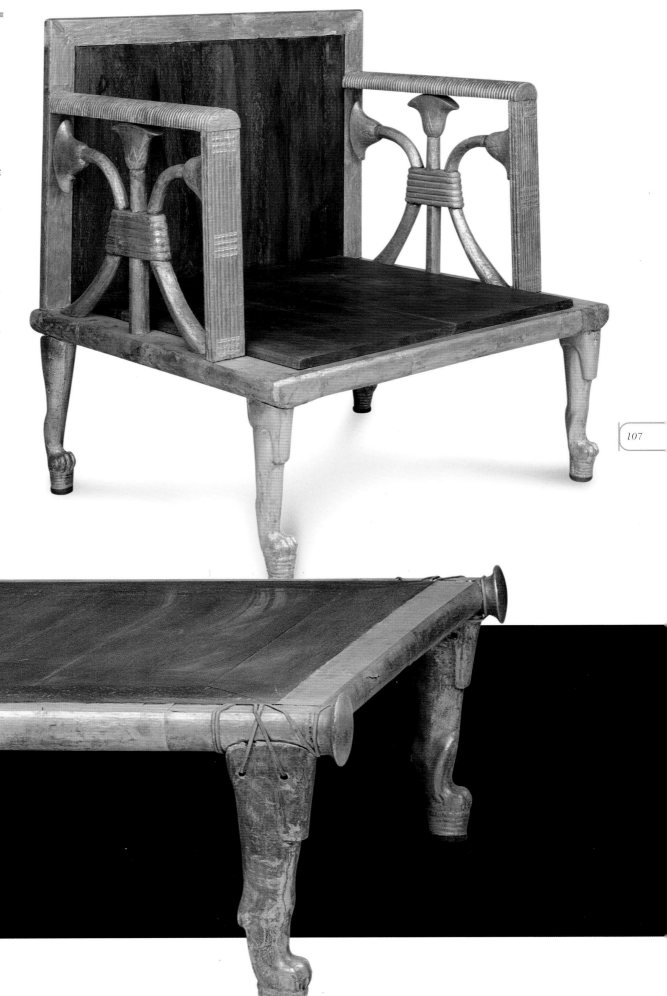

THE TOMB OF IASEN

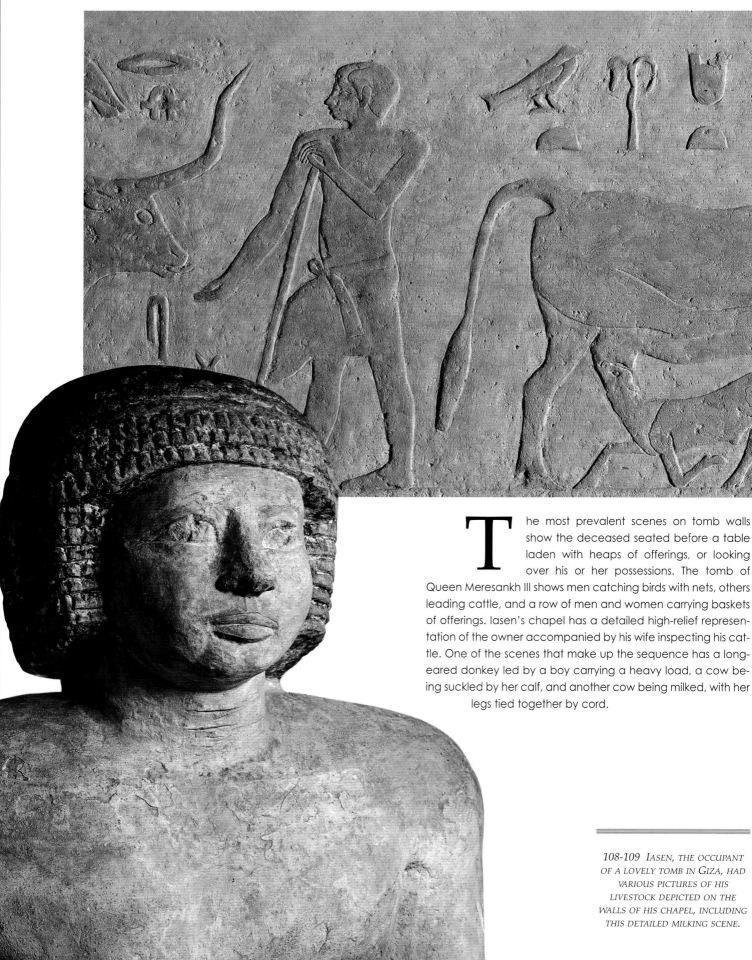

The most prevalent scenes on tomb walls show the deceased seated before a table laden with heaps of offerings, or looking over his or her possessions. The tomb of Queen Meresankh III shows men catching birds with nets, others leading cattle, and a row of men and women carrying baskets of offerings. Iasen's chapel has a detailed high-relief represen-tation of the owner accompanied by his wife inspecting his cat-tle. One of the scenes that make up the sequence has a long-eared donkey led by a boy carrying a heavy load, a cow be-ing suckled by her calf, and another cow being milked, with her legs tied together by cord.

108-109 IASEN, THE OCCUPANT OF A LOVELY TOMB IN GIZA, HAD VARIOUS PICTURES OF HIS LIVESTOCK DEPICTED ON THE WALLS OF HIS CHAPEL, INCLUDING THIS DETAILED MILKING SCENE.

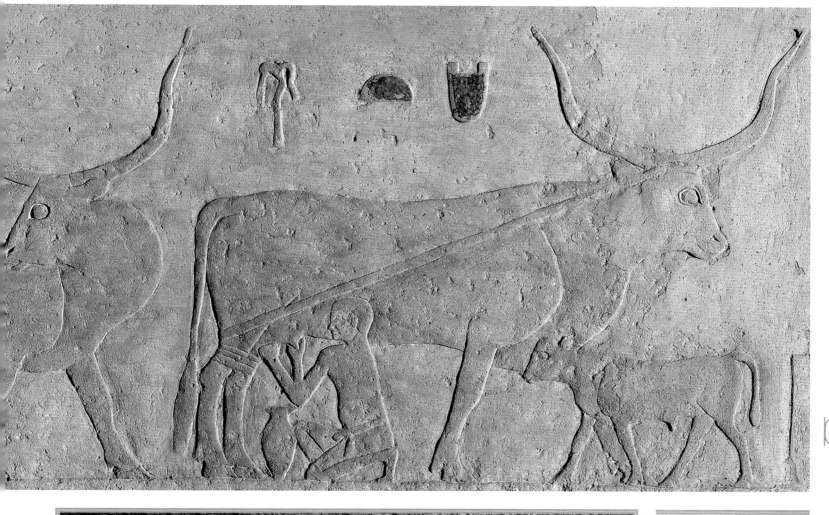

108 bottom On the west wall of the tomb is a niche in which a statue of Iasen stood.

109 bottom Iasen is shown in various guises and official poses on the walls of his tomb, for example, inspecting his large herds.

110 Iasen is seen here with his wife and one of his children.

110-111 In this low relief Iasen is seated beneath a canopy and receives offerings from his subordinates.

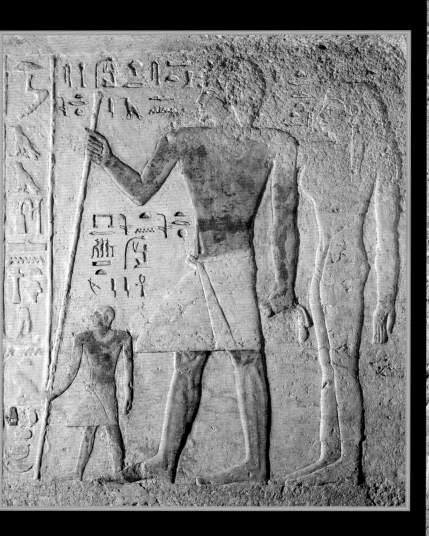
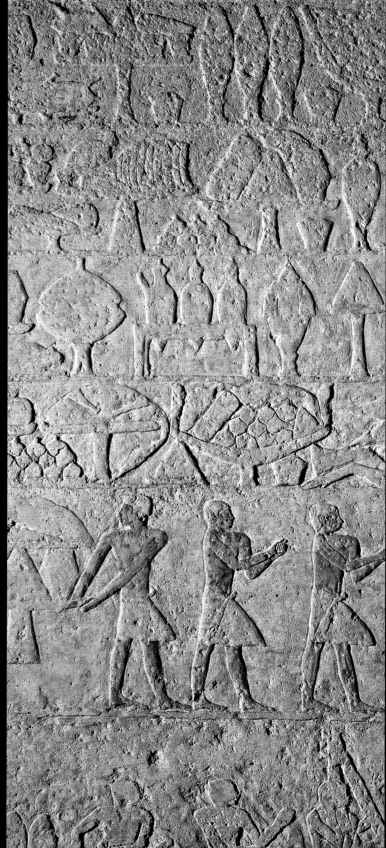

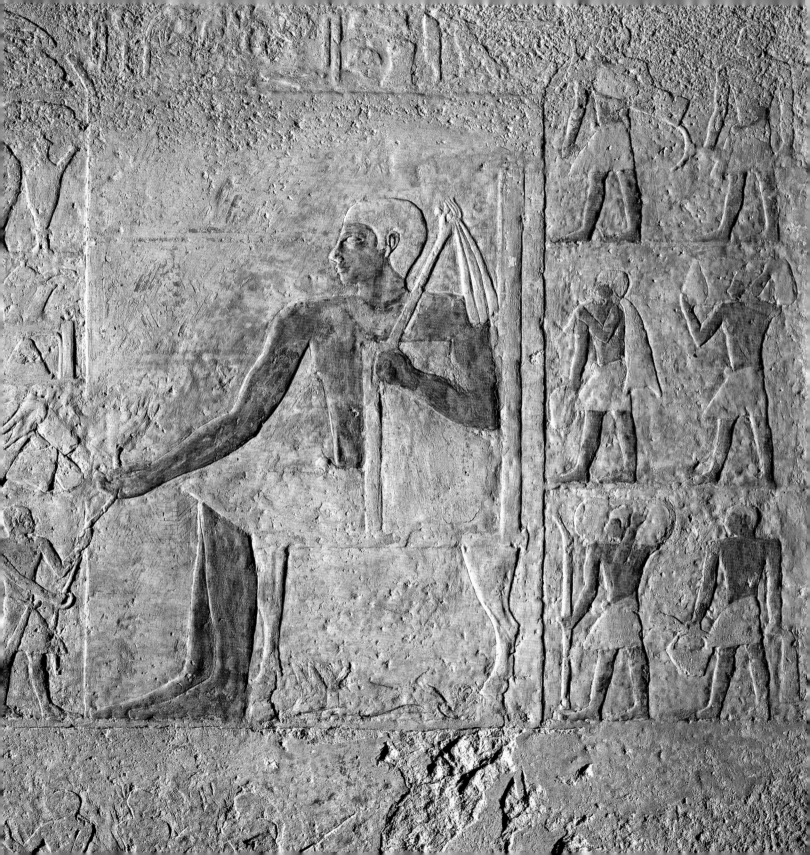

THE TOMB OF IYMERY

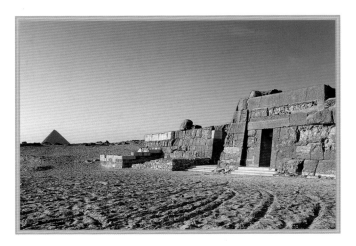

I ymery's chapel contains a scene in which two men are present at the birth of a calf, with one of them assisting the event. The same chapel has a vivid image of a fight between men armed with staffs balancing on small boats.

Taken together, the detailed vignettes that make up these scenes provide a great deal of information on the structure of society, organization of work, and the methods used in agriculture and stock-breeding. More generally, they illustrate the vitality, complexity, and daily toil of the large community that lived in the shadow of the pyramids more than four thousand years ago.

112 TOP IYMERY LIVED IN THE FIFTH DYNASTY AT THE SAME TIME AS THE PHARAOH NIUSERRE BUT HIS TOMB, WHICH HAS BEEN RESTORED AND OPENED TO THE PUBLIC, IS AT GIZA.

112 CENTER IN THIS INTERESTING RELIEF IN IYMERY'S CHAPEL A MAN HELPS A COW TO GIVE BIRTH WHILE ANOTHER MAN WATCHES ON.

112 BOTTOM THIS SCENE IN THE SECOND CHAMBER OF THE TOMB SHOWS A FIGHT BETWEEN MEN ARMED WITH CLUBS ON SLENDER PAPYRUS BOATS.

113 BOTH SIDES OF THE CORRIDOR IN IYMERY'S CHAPEL WERE DECORATED WITH PAINTED HIGH RELIEFS, INCLUDING SCENES OF DAILY LIFE.

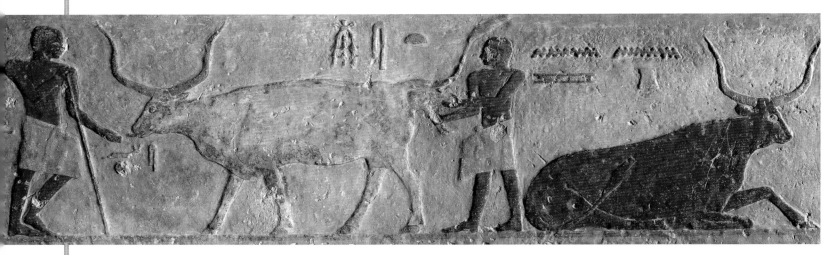

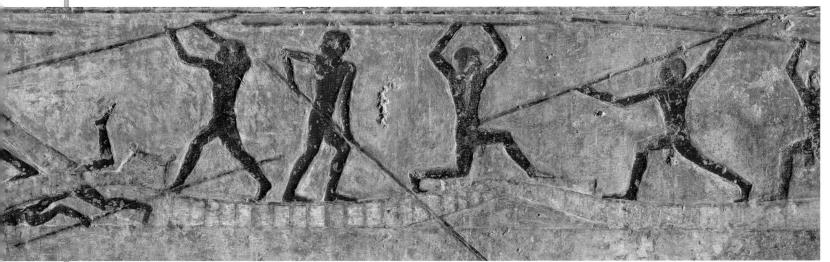

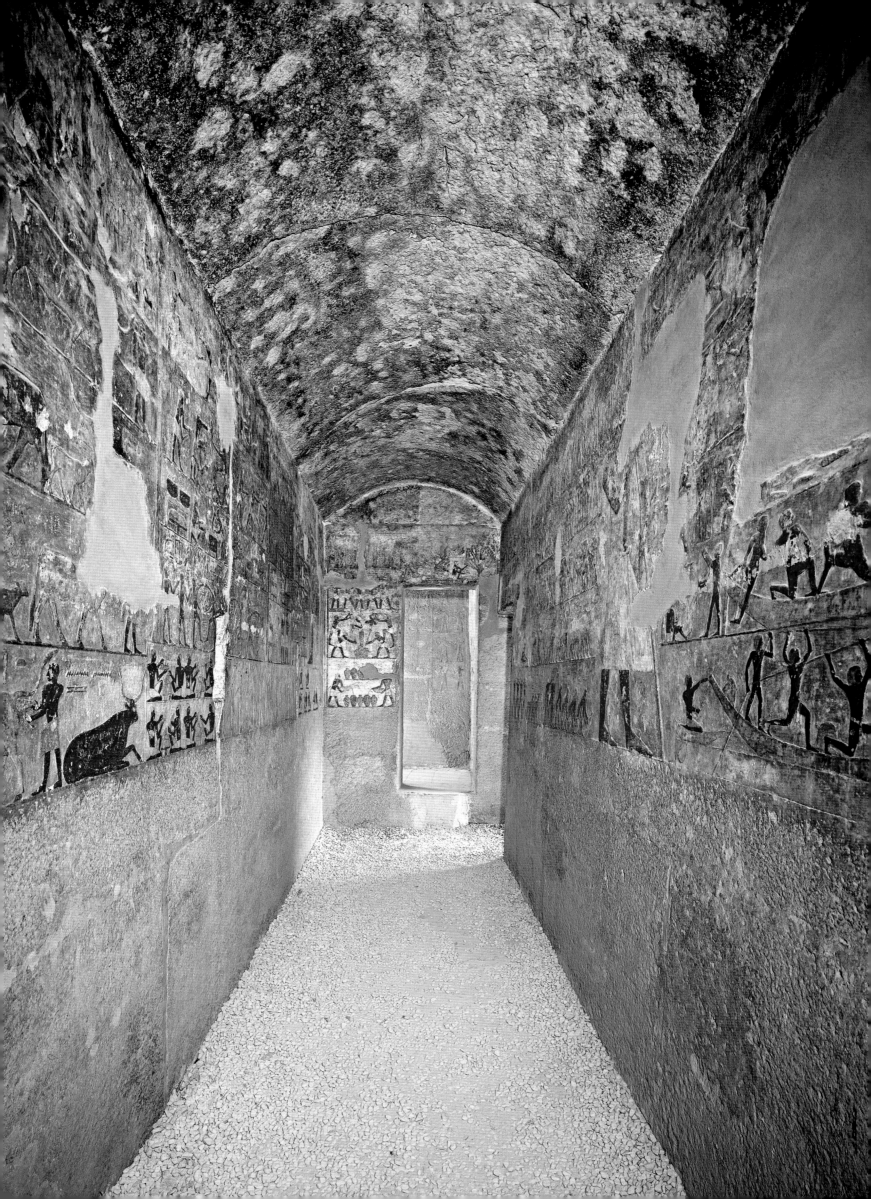

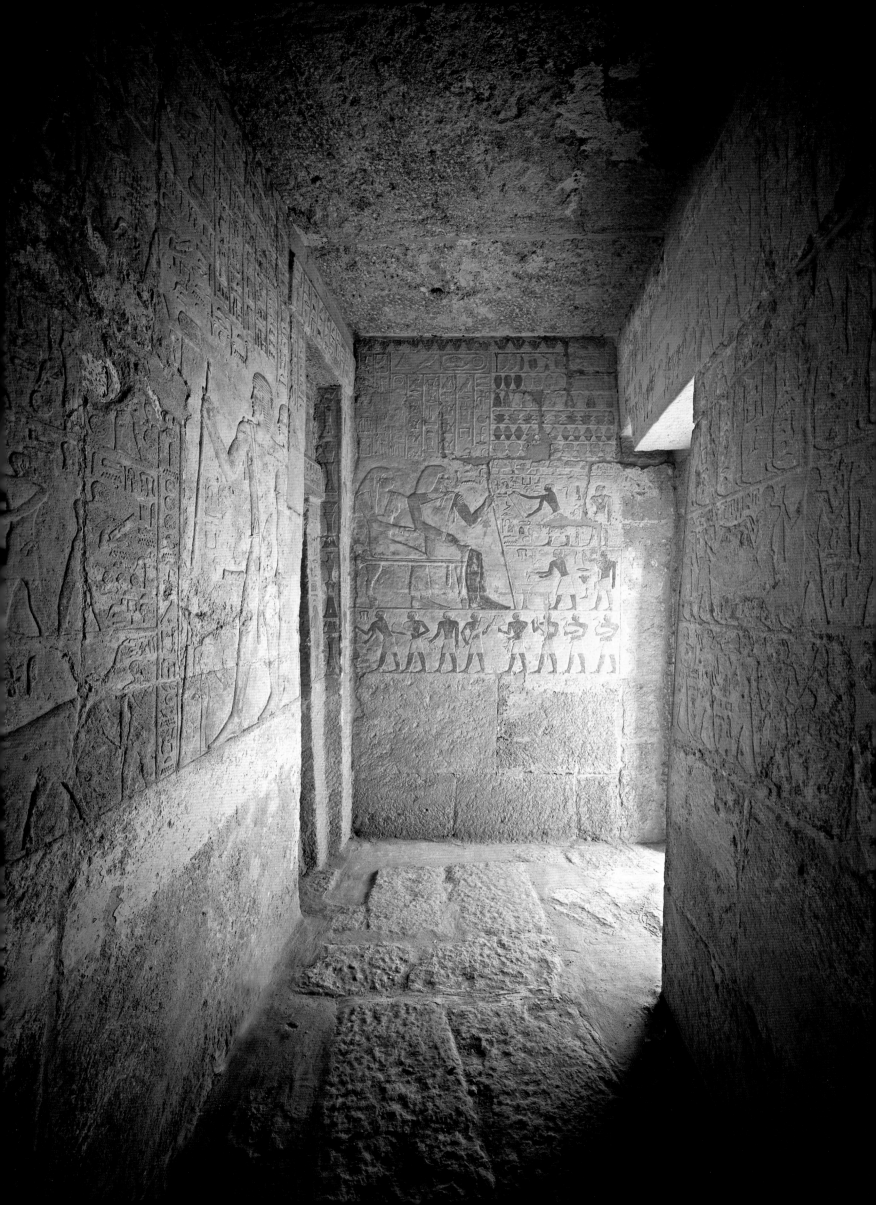

THE TOMB OF NISUTNEFER

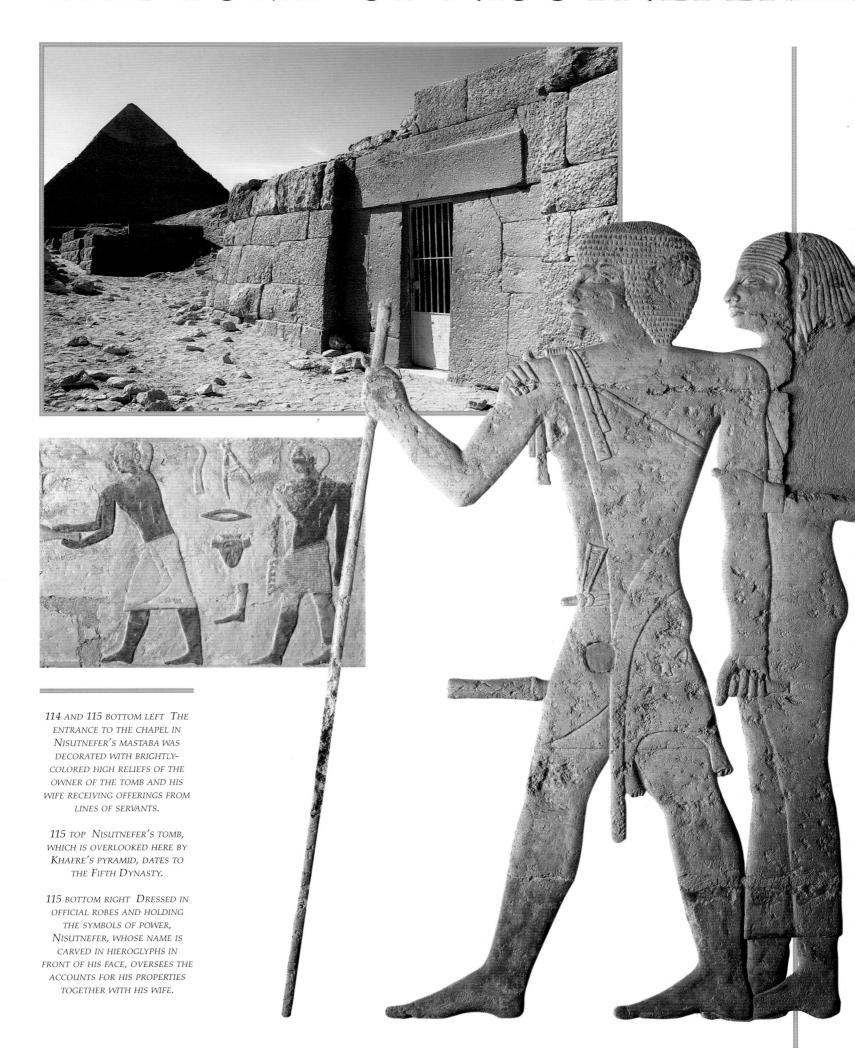

114 AND 115 BOTTOM LEFT THE ENTRANCE TO THE CHAPEL IN NISUTNEFER'S MASTABA WAS DECORATED WITH BRIGHTLY-COLORED HIGH RELIEFS OF THE OWNER OF THE TOMB AND HIS WIFE RECEIVING OFFERINGS FROM LINES OF SERVANTS.

115 TOP NISUTNEFER'S TOMB, WHICH IS OVERLOOKED HERE BY KHAFRE'S PYRAMID, DATES TO THE FIFTH DYNASTY.

115 BOTTOM RIGHT DRESSED IN OFFICIAL ROBES AND HOLDING THE SYMBOLS OF POWER, NISUTNEFER, WHOSE NAME IS CARVED IN HIEROGLYPHS IN FRONT OF HIS FACE, OVERSEES THE ACCOUNTS FOR HIS PROPERTIES TOGETHER WITH HIS WIFE.

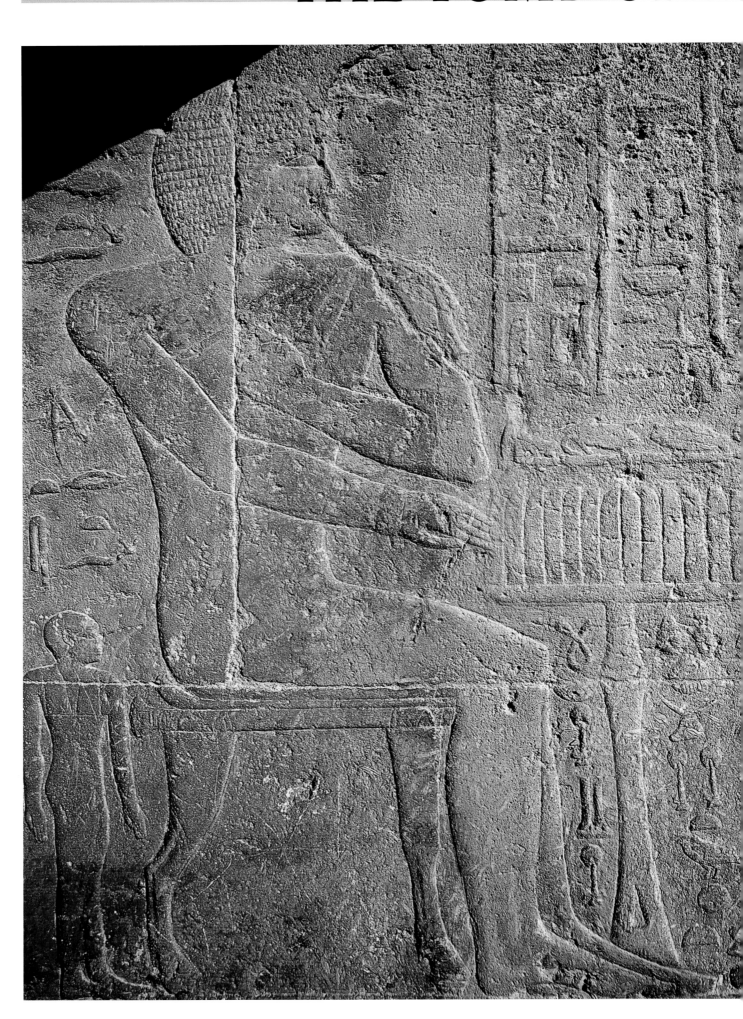

SESHATHETEP

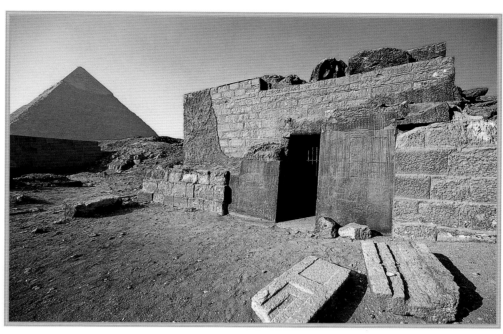

116-117 *SESHATHETEP IS SHOWN SEATED IN FRONT OF A TABLE OF OFFERINGS ON THE WALL OF THE ENTRANCE TO HIS TOMB.*

117 *TOP IN THIS PICTURE WE SEE KHAFRE'S PYRAMID AND THE MASTABA OF SESHATHETEP WHICH DATES TO THE LATE FOURTH AND EARLY FIFTH DYNASTY.*

117 *BOTTOM NOTE THE SIMPLE STRUCTURE OF SESHATHETEP'S TOMB, WHICH IS MORE INTERESTING FOR ITS RELIEFS THAN ITS ARCHITECTURE.*

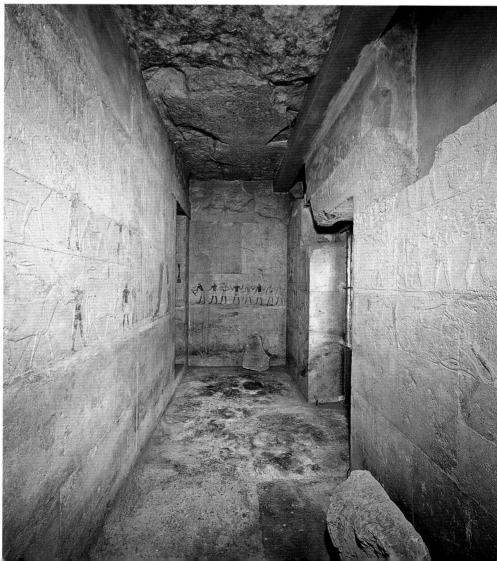

THE TOMB OF

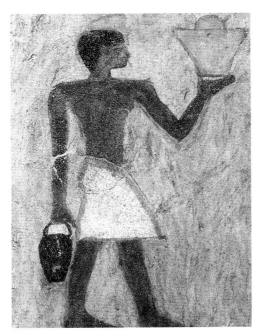

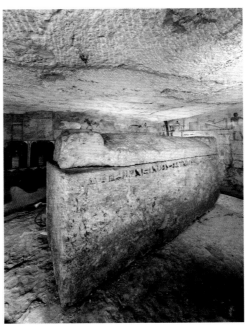

118 TOP LEFT AND 119 TOP
THE DECORATIONS IN
KHAYEMANKH'S TOMB INCLUDE
THE CLASSICAL THEMES OF THE
POSSESSIONS OF THE DECEASED
AND THE PRESENTATION OF
RITUAL OFFERINGS. THESE WERE
PAINTED DIRECTLY ONTO THE
PLASTERED WALLS.

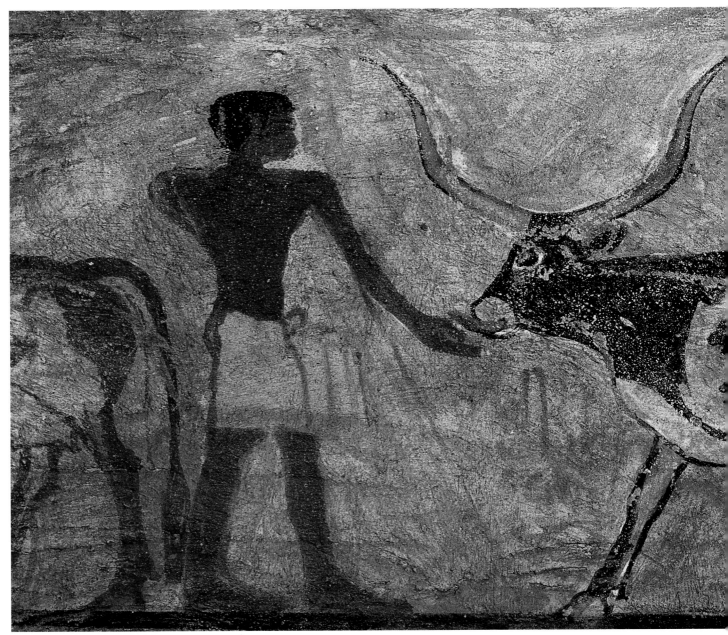

KHAYEMANKH

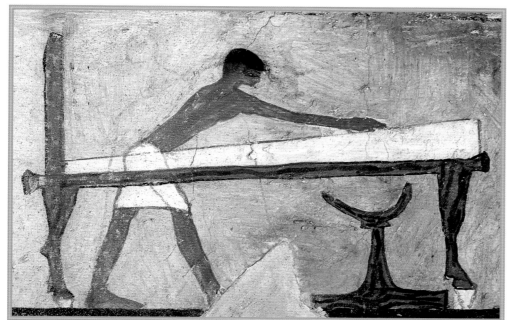

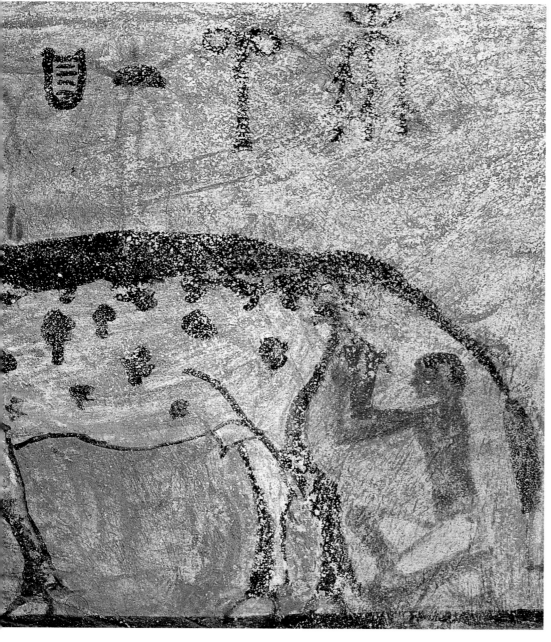

118 TOP RIGHT KHAYEMANKH'S BODY WAS PLACED AT THE CENTER OF THE TOMB IN A LARGE STONE SARCOPHAGUS DECORATED WITH A LINE OF HIEROGLYPHS AND SURROUNDED BY REPRESENTATIONS OF HIS POSSESSIONS.

118-119 AND 119 BOTTOM ACCORDING TO TRADITION, THE TOMB OF KHAYEMANKH (WHO LIVED IN THE SIXTH DYNASTY) INCLUDES SCENES OF RURAL LIFE AND MEN LOOKING AFTER THE LIVESTOCK.

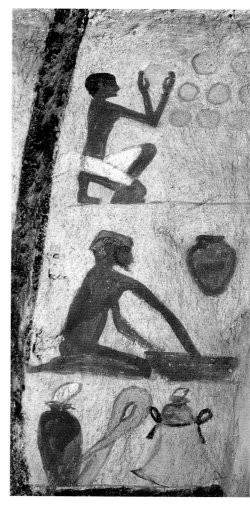

THE TOMB OF IDU

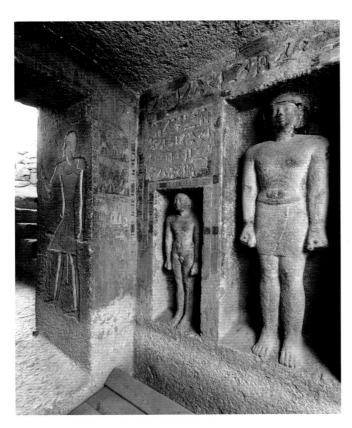

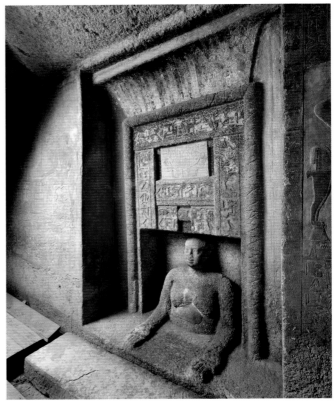

120 TOP LEFT AND 121 LIFE-SIZE STATUES OF IDU AND HIS FAMILY WERE CARVED INSIDE A ROW OF NICHES ON THE LONG SIDE OF THE CHAPEL.

120 TOP RIGHT FRAMED BY A FALSE DOOR IN THE WEST WALL OF HIS CHAPEL, IDU EMERGES FROM THE WORLD BEYOND THE GRAVE.

120 BOTTOM IDU WAS THE ROYAL SCRIBE FOR THE SIXTH-DYNASTY PHARAOH PEPI I. ON THE WALLS OF HIS HYPOGEAN TOMB HE IS

SHOWN SEATED BEFORE A TABLE GROANING WITH STYLIZED OFFERINGS AND LINES OF SERVANTS.

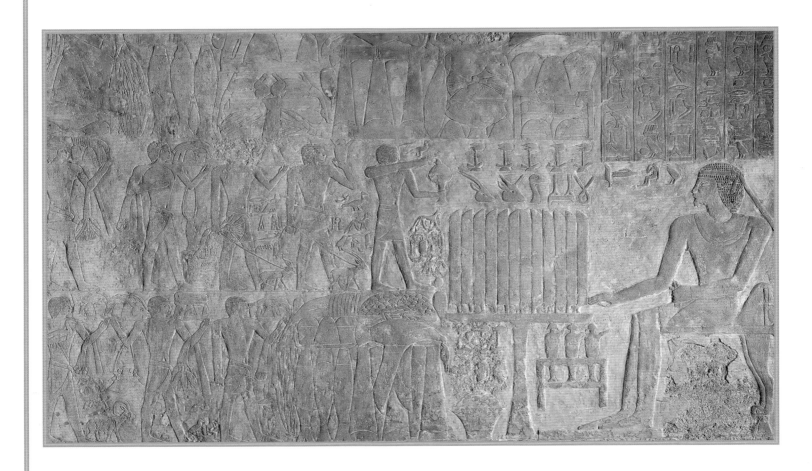

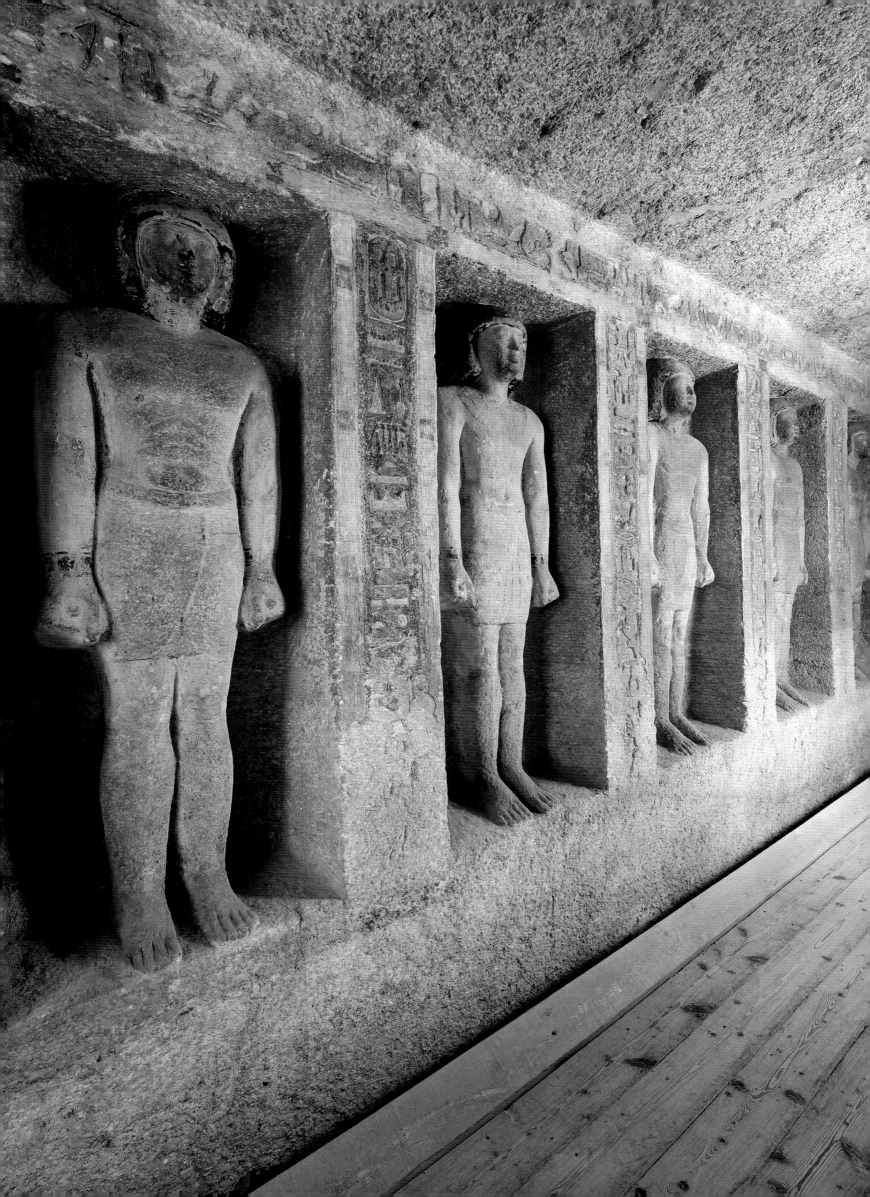

THE TOMB OF KAPUNISUT KAI

122 LEFT THIS POLYCHROME STATUE IS OF KAPUNISUT KAI WITH HIS WIFE AND A SON AT THE BOTTOM.

122 RIGHT THIS FALSE DOOR DECORATED WITH POLYCHROME LOW RELIEFS IS IN THE CHAPEL OF KAPUNISUT KAI.

123 THE TOMB OF KAPUNISUT KAI, PORTRAYED HERE WITH HIS WIFE AND OTHER FAMILY MEMBERS ON THE NORTH WALL OF HIS CHAPEL, DATES TO THE FIFTH DYNASTY.

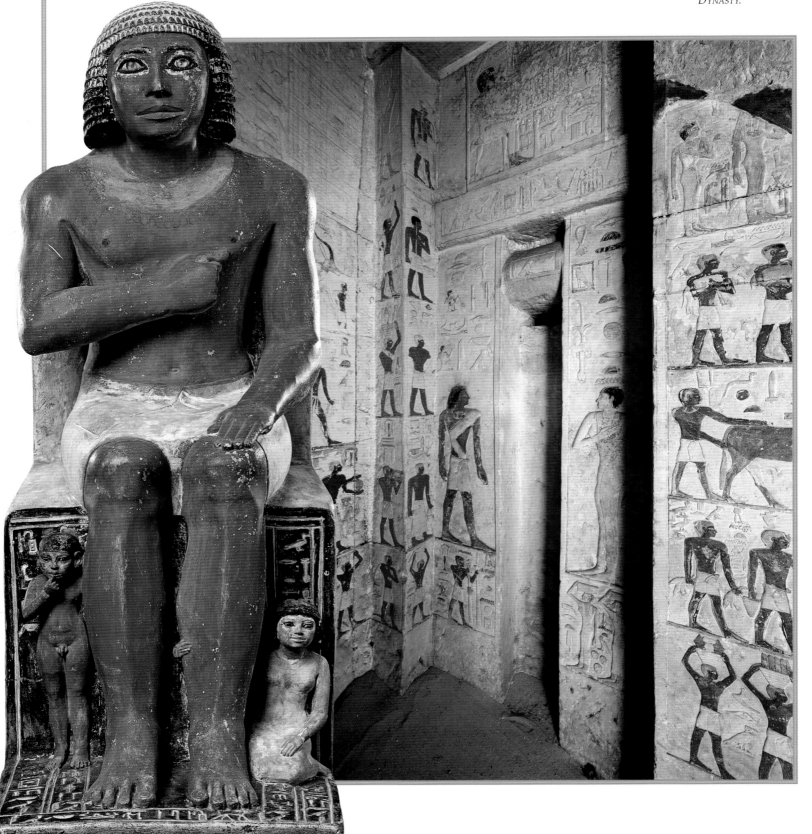

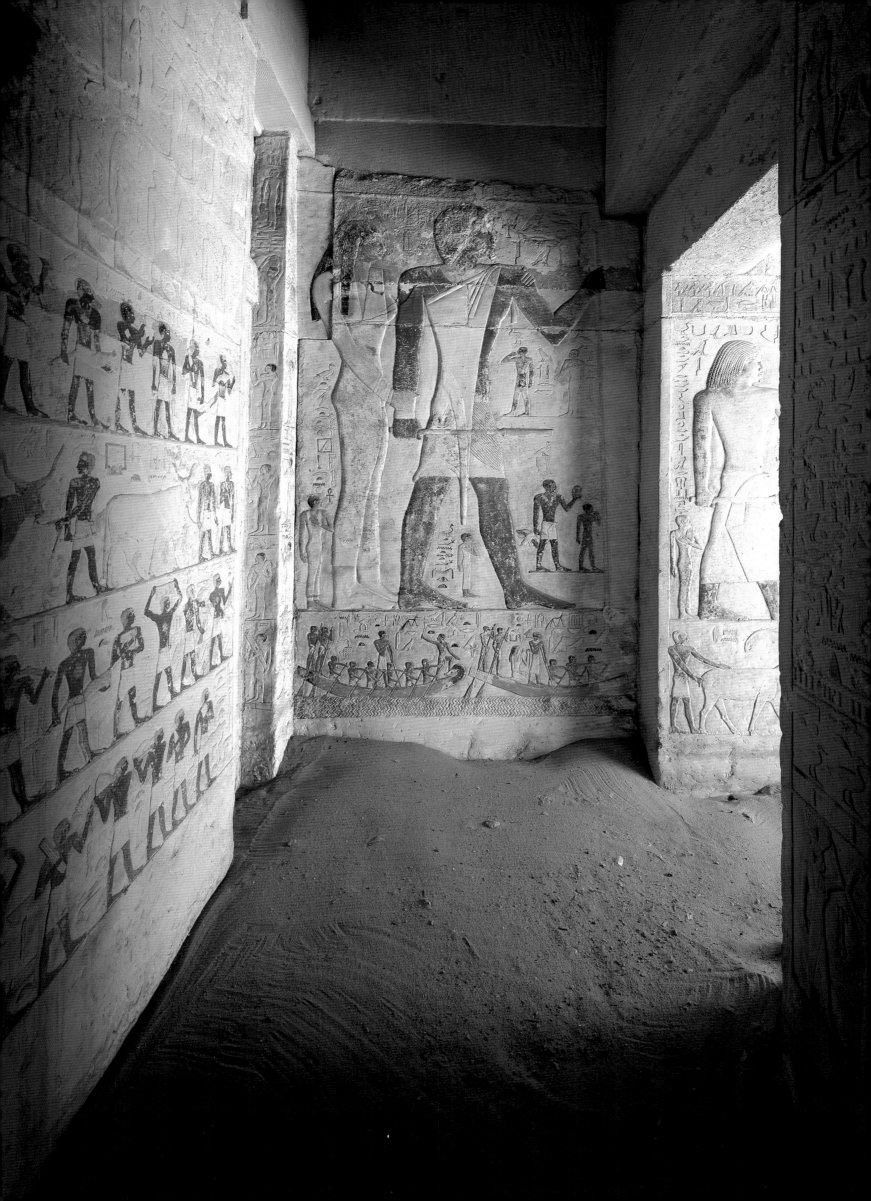

THE TOMB OF QAR

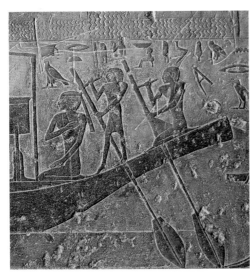

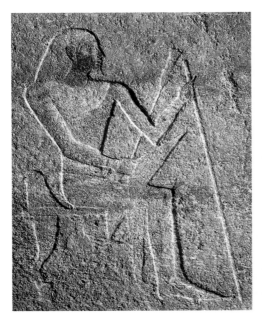

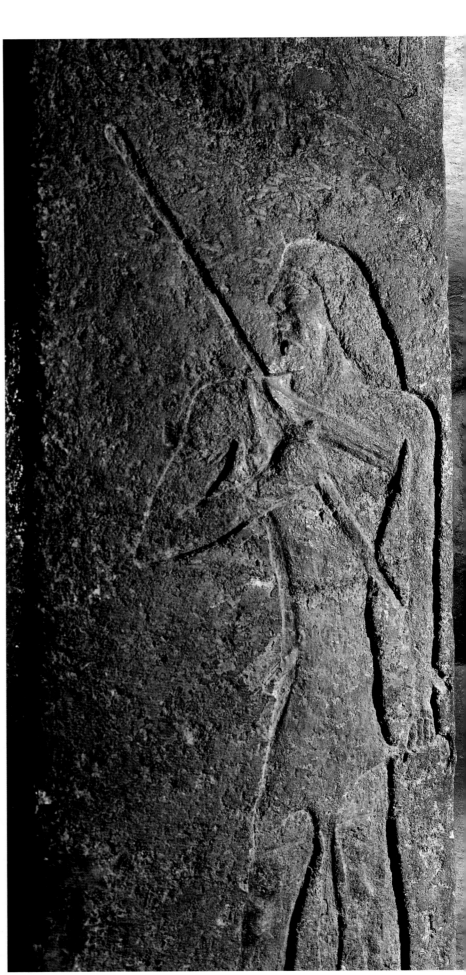

124 center The refinement of the execution and the skill of the artists who worked on Qar's tomb can be appreciated in this detail of two oarsmen and a boat on the river.

124 bottom Qar lived during the Sixth Dynasty. He had his tomb at Giza decorated with low and high reliefs showing himself in official situations and clothes.

124-125 In addition to scenes of everyday life and texts carved on the chapel walls, Qar's tomb also contains a series of life-size statues that stand at the back of a long niche.

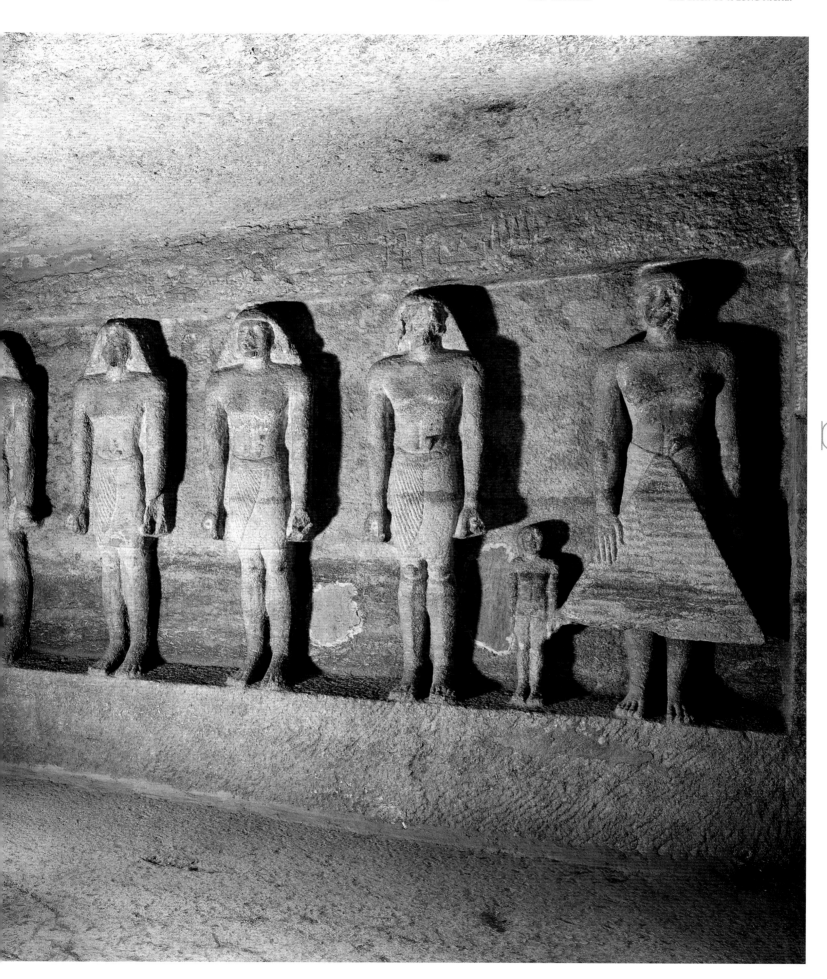

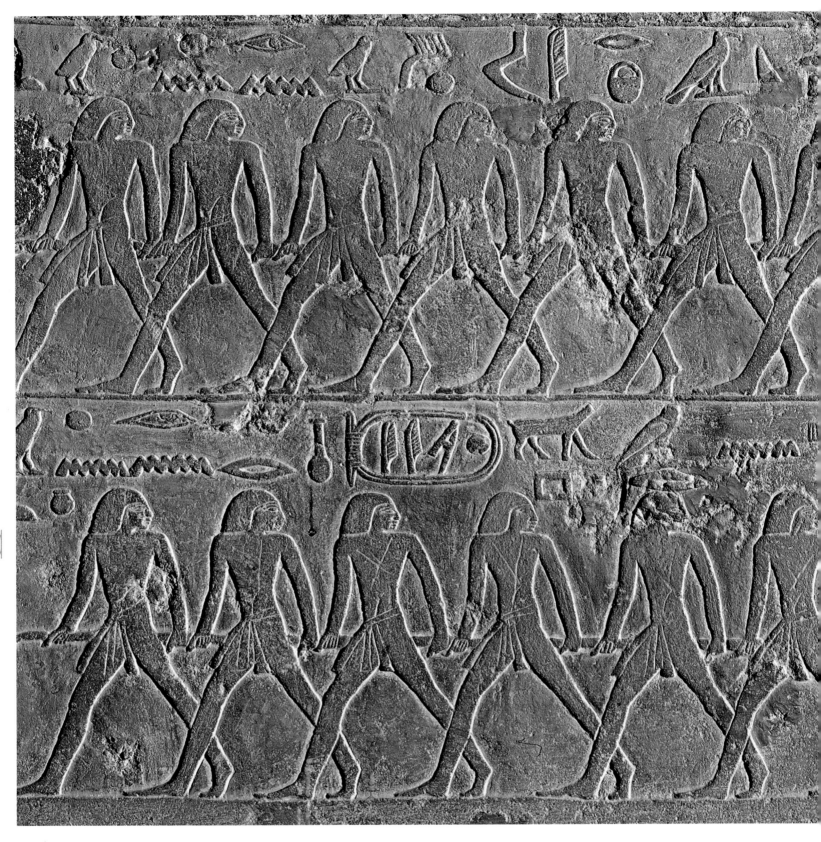

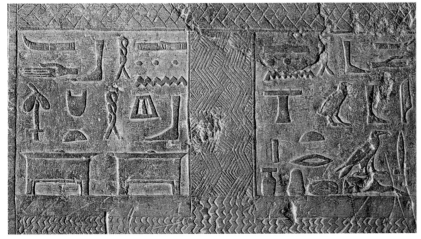

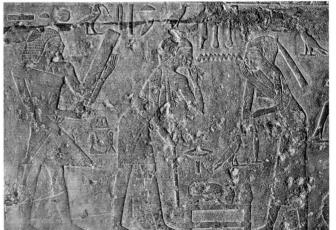

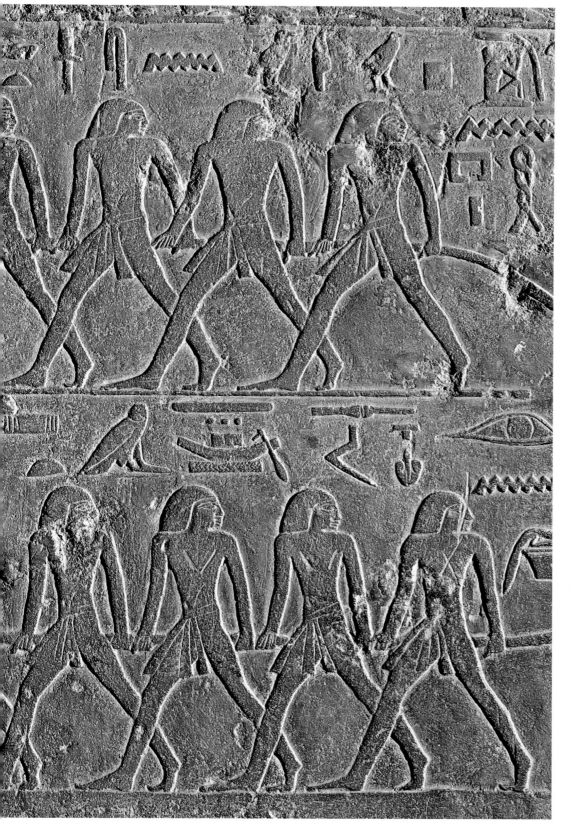

126-127 IN THIS UNUSUAL LOW RELIEF WE SEE TWO REGISTERS OF MEN DRAGGING THE FUNERARY BARK THAT TRANSPORTS QAR'S SARCOPHAGUS. THE FINAL DESTINATION OF THE CORTÈGE IS OF COURSE THE TOMB, WHICH WAS PROBABLY BUILT DURING THE REIGN OF PEPI I IN THE MIDDLE OF THE SIXTH DYNASTY.

126 BOTTOM AND 127 RIGHT THE RICH DECORATION OF QAR'S TOMB REVEALS THE MAN'S HIGH RANK. HE WAS THE SUPERINTENDENT OF THE PYRAMIDS OF KHUFU AND MENKAURE.

128-129 QAR'S TOMB HAS SEVERAL ROOMS, THE LAST OF WHICH HAS A FALSE DOOR THAT FUNCTIONED AS THE POINT OF CONTACT BETWEEN THE TWO WORLDS OF THE LIVING AND THE DEAD.

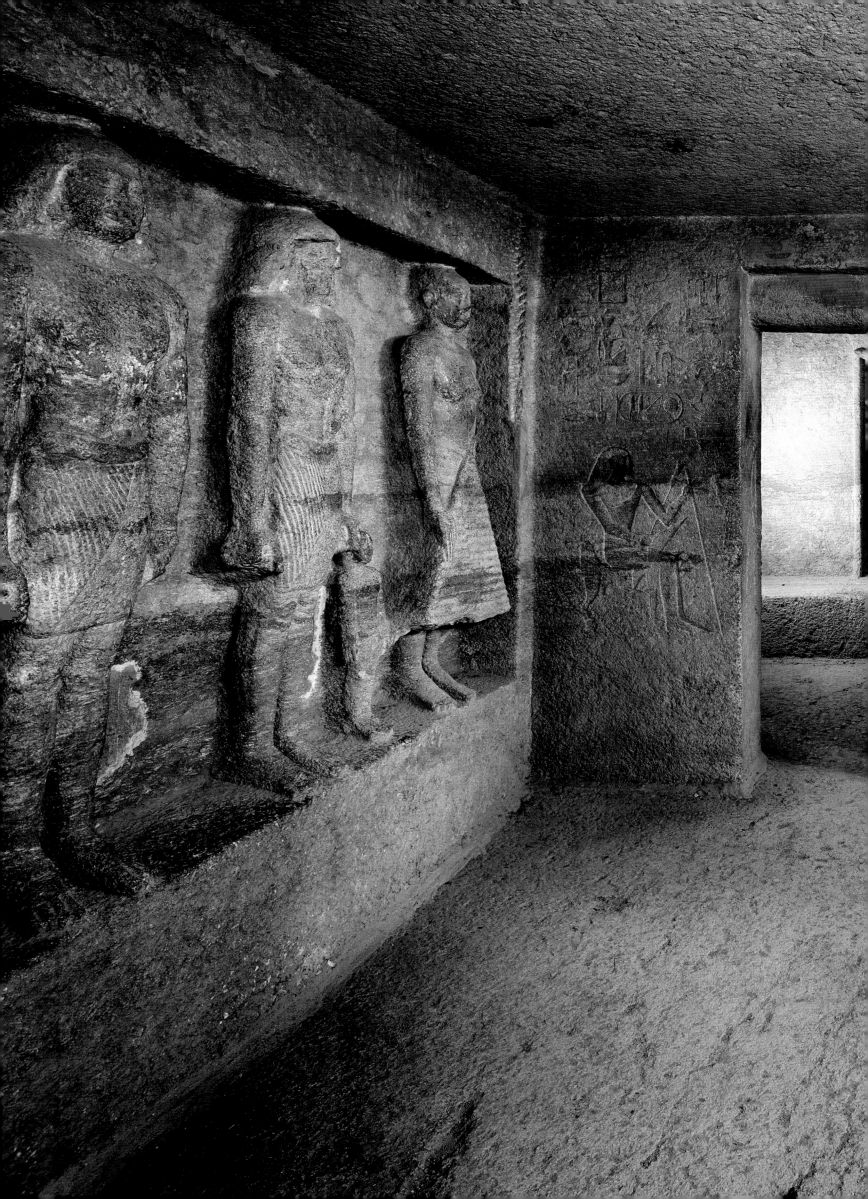

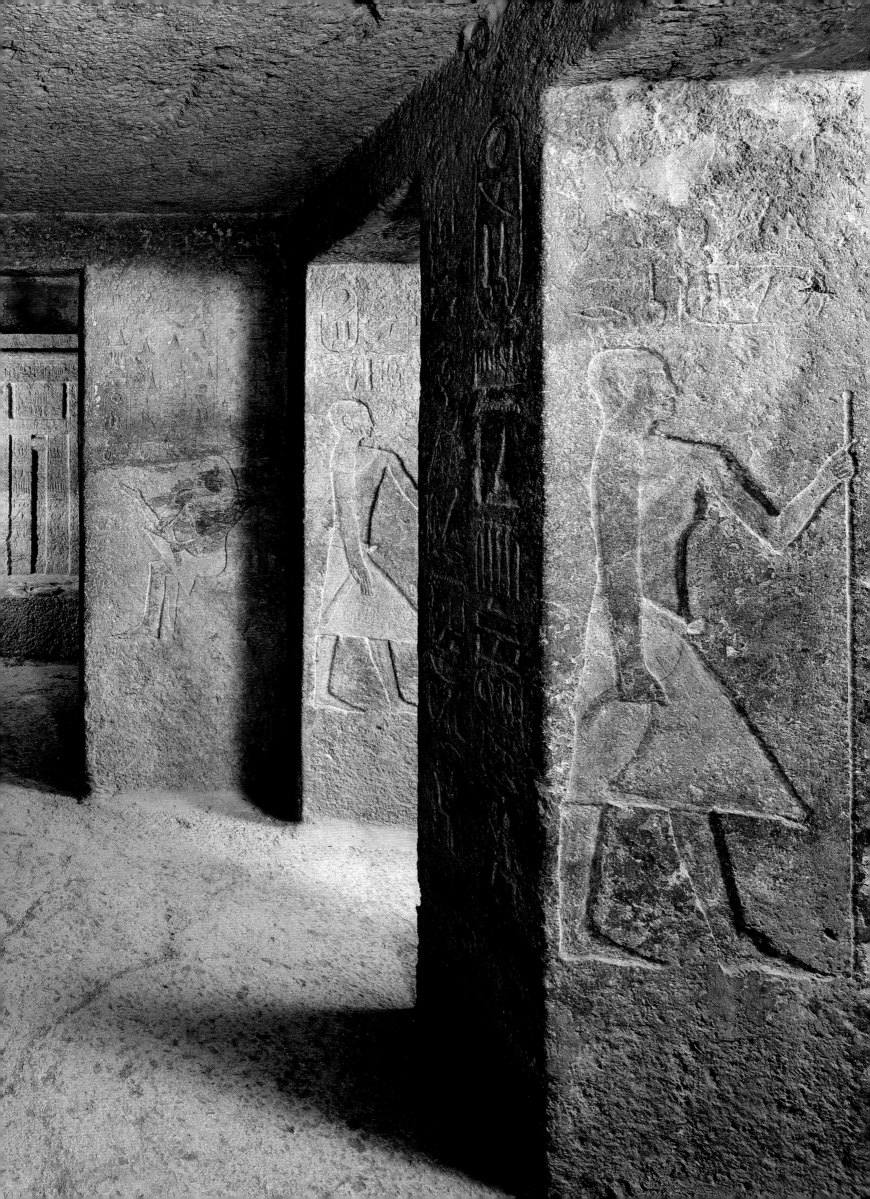

THE PYRAMIDS AND

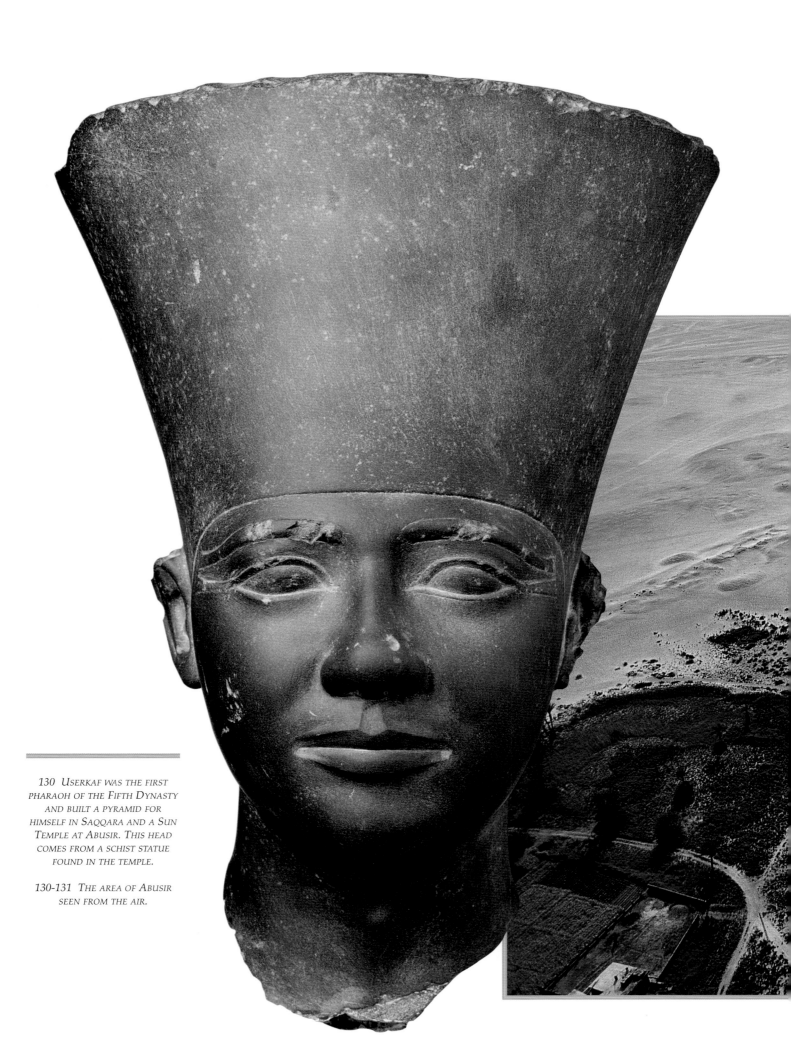

130 *Userkaf was the first pharaoh of the Fifth Dynasty and built a pyramid for himself in Saqqara and a Sun Temple at Abusir. This head comes from a schist statue found in the temple.*

130-131 *The area of Abusir seen from the air.*

TEMPLES OF ABUSIR

A few years after the death of Menkaure, Userkaf, the first pharaoh of the Fifth Dynasty, decided to abandon the necropolis of Giza and move south. He built his pyramid at Saqqara and chose the desert area of Abusir, a little north, to construct a new type of temple dedicated to Ra, the sun. Ancient texts seem to indicate that the pharaohs of the Fifth Dynasty built six sun temples in all, but other than Userkaf's, only the remains of the temple of Niuserre slightly to the north have been found. Of the temples of Sahure, Neferirkara, Ranefref, and Mankauhor we know only their suggestive names: "Field of Ra," "Place of the Pleasure of Ra," "Offerings Table of Ra," and "Horizon of Ra."

Userkaf's sun temple, called the "Stronghold of Ra," was substantially rebuilt by his successors, probably in parallel with the rapid evolution of the solar cult. In its final form, the complex included a large obelisk that stood on a pedestal, a court in front containing an altar, and a series of secondary buildings. The other surviving temple, the "Joy of Ra," was built by Niuserre and has the same component parts. The altar that stood in front of Niuserre's obelisk was designed to be read like a puzzle; it was made up of five slabs of alabaster, with a round one at the center and four rectangular ones around it. The central slab contained the hieroglyph *ra* (the name of the sun) and the outer elements were cut to form the hieroglyphic sign *hetep* (meaning, 'peace' or 'satisfied'). Therefore the forms of the altar seen from any direction had the meaning, "May Ra be satisfied."

The valley temple of Userkaf's solar complex stood on the northern offshoot of what used to be Lake Abusir.

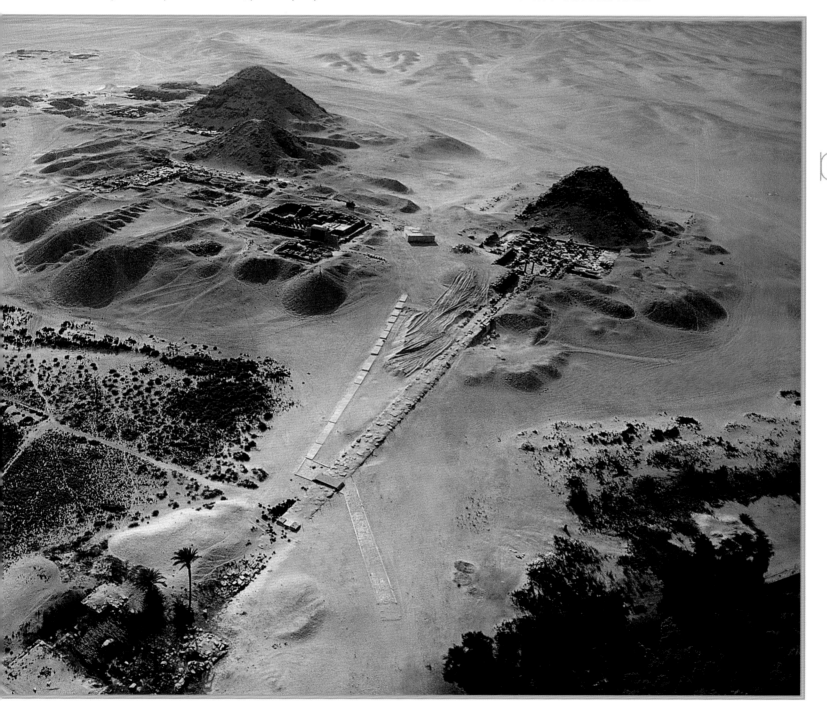

THE PYRAMIDS AND TEMPLES OF ABUSIR

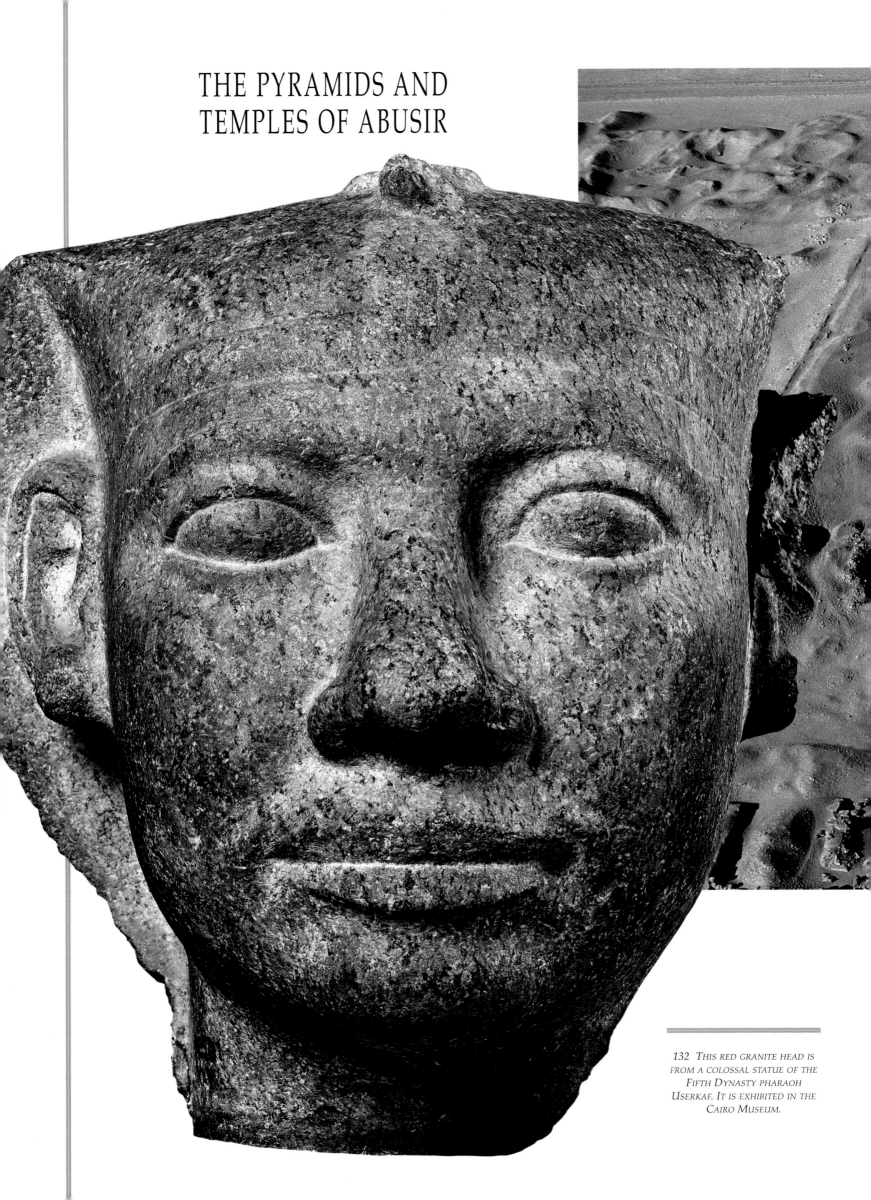

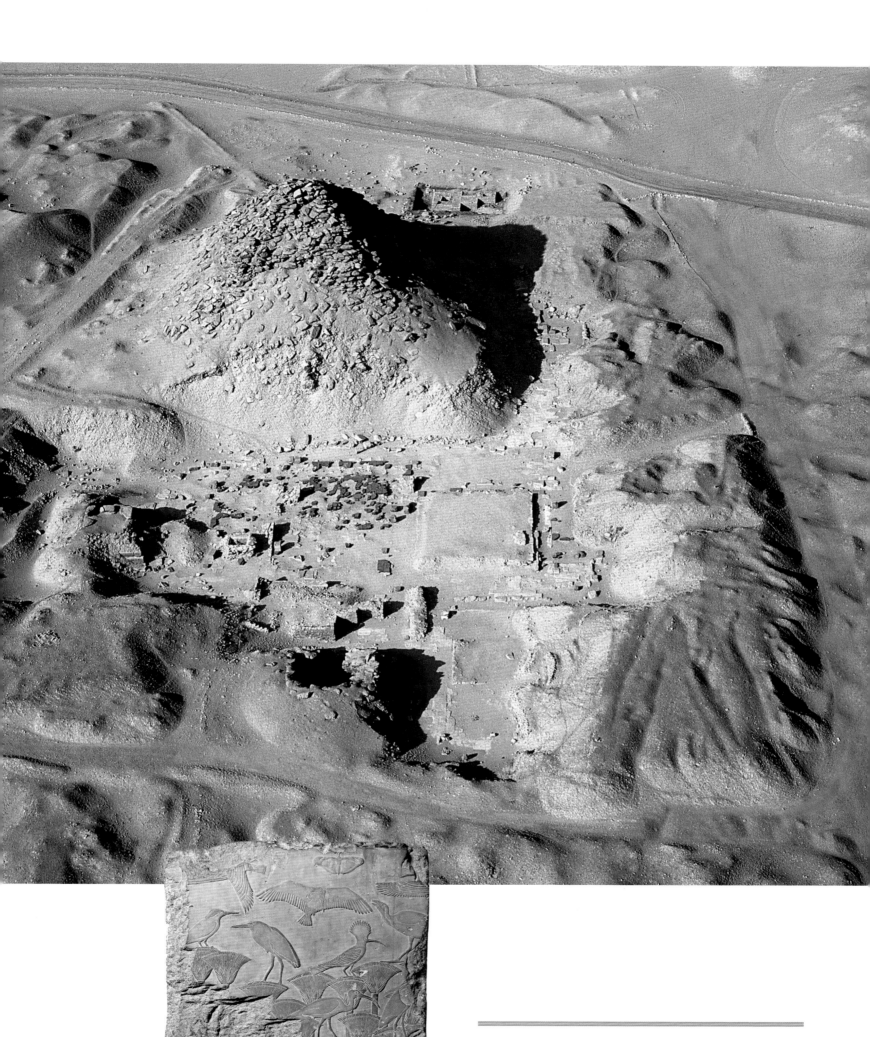

*132-133 USERKAF'S PYRAMID
WAS FLANKED BY A TEMPLE (OF
WHICH LITTLE REMAINS TODAY), A
SATELLITE PYRAMID [COMMA
AFTER PYRAMID] AND A SMALLER
PYRAMID FOR HIS QUEEN.*

*133 BOTTOM THIS RELIEF
FRAGMENT OF PAPYRUSES AND
BIRDS WAS FOUND IN USERKAF'S
FUNERARY TEMPLE AND IS KEPT IN
THE CAIRO MUSEUM.*

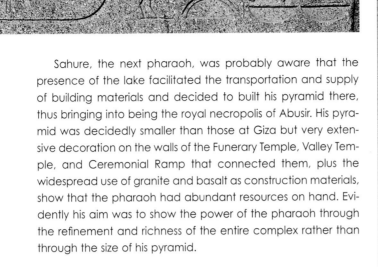

Sahure, the next pharaoh, was probably aware that the presence of the lake facilitated the transportation and supply of building materials and decided to built his pyramid there, thus bringing into being the royal necropolis of Abusir. His pyramid was decidedly smaller than those at Giza but very extensive decoration on the walls of the Funerary Temple, Valley Temple, and Ceremonial Ramp that connected them, plus the widespread use of granite and basalt as construction materials, show that the pharaoh had abundant resources on hand. Evidently his aim was to show the power of the pharaoh through the refinement and richness of the entire complex rather than through the size of his pyramid.

134 LARGE GRANITE BLOCKS AND COLUMN SHAFTS FOUND AMONG THE REMAINS OF A LARGE FUNERARY COMPLEX AT ABUSIR BEAR THE NAME AND TITLES OF SAHURA, THE SECOND PHARAOH OF THE FIFTH DYNASTY.

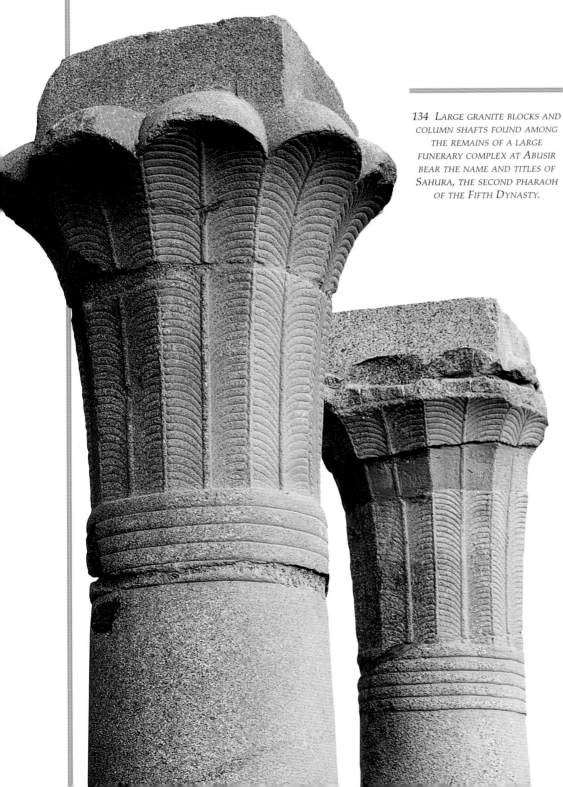

134-135 SAHURA'S PYRAMID AT ABUSIR HAD AN ELABORATE FUNERARY TEMPLE. A RAMP LED DOWN TO THE VALLEY TEMPLE THAT STOOD ON THE SHORE OF A LAKE THAT HAS SINCE DRIED UP.

135 BOTTOM A PROCESSION OF THE DIVINITIES OF LOWER EGYPT MAKING OFFERINGS TO THE PHARAOH IS SEEN IN THIS POLYCHROME RELIEF FOUND IN SAHURA'S FUNERARY TEMPLE.

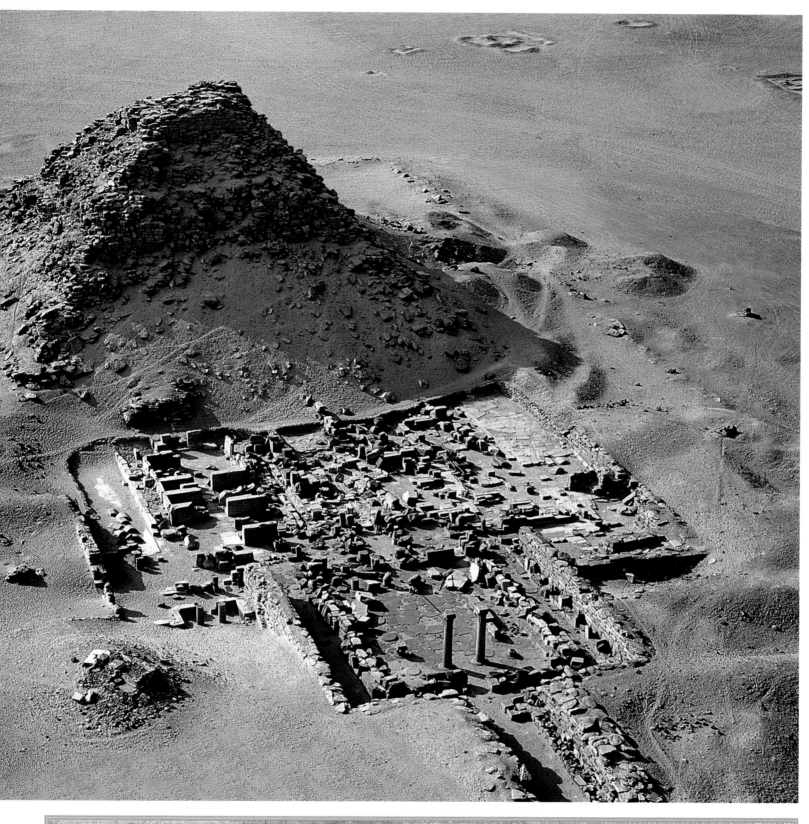

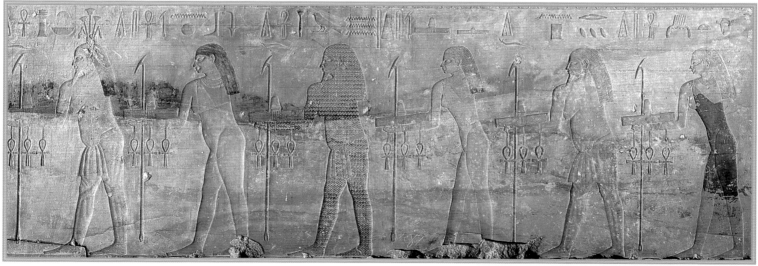

THE PYRAMIDS AND TEMPLES OF ABUSIR

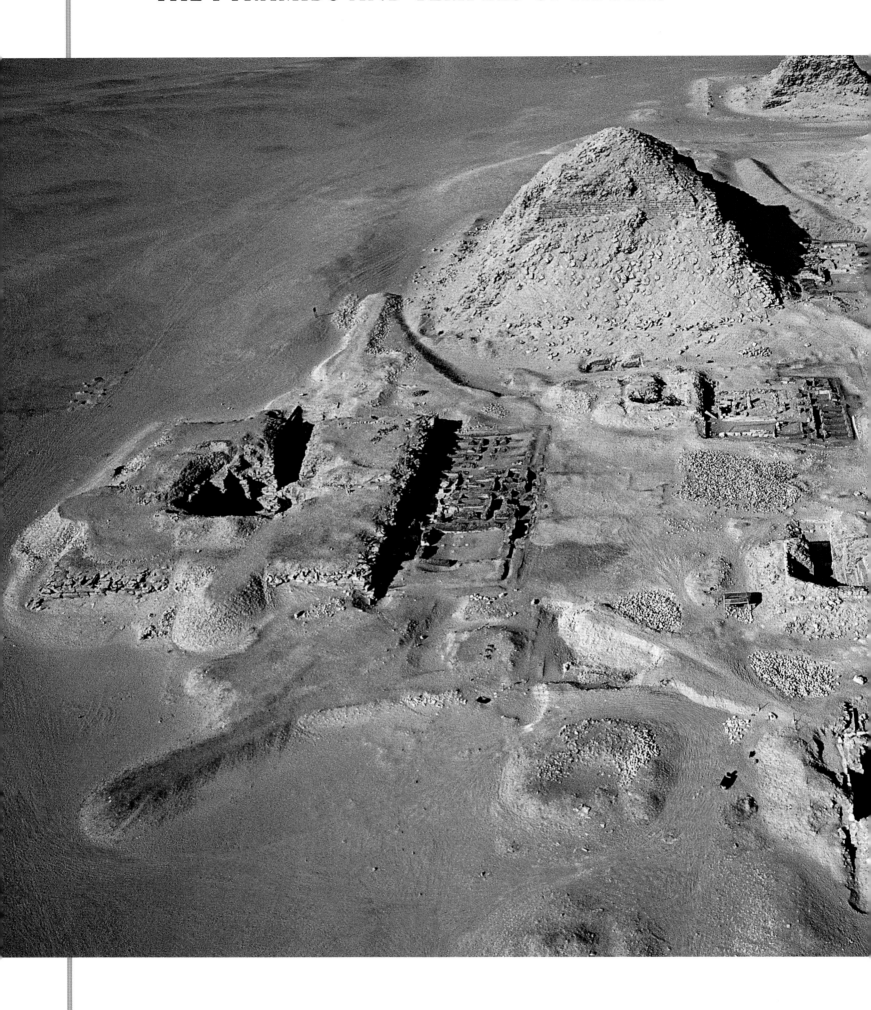

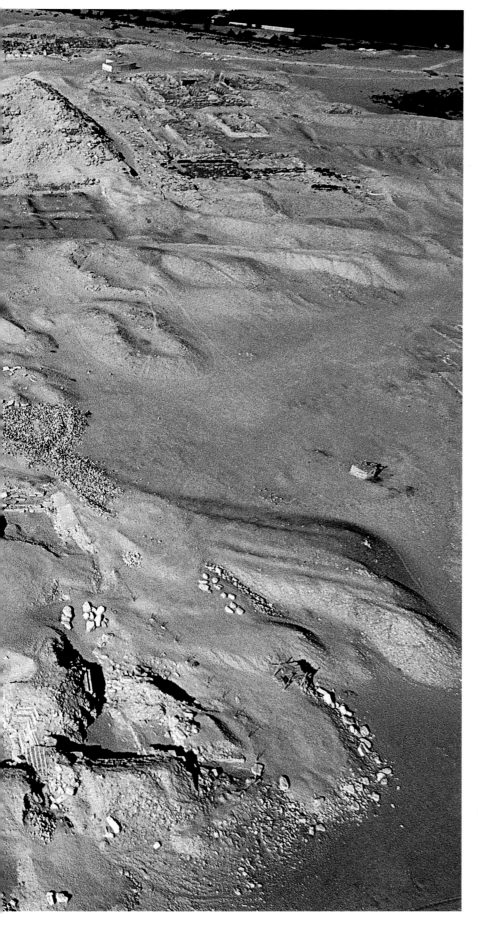

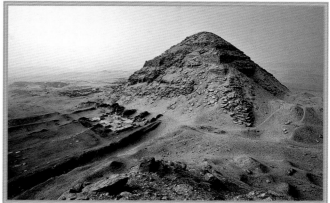

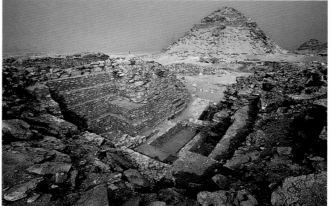

The funerary complex of Neferirkara, Sahure's successor, remained unfinished. His pyramid seems to have been built in steps on the model of Djoser's monument, but traces also suggest that the architects began to line the sides with smooth facing stone. The pharaoh, who may already have been old when he ascended the throne, died before the complex was ready, so that his Funerary Temple was completed in haste and construction of the Ceremonial Way halted after it had hardly begun. Nor did Neferirkara's successor, Ranefref, complete his pyramid. The structure's rather unattractive remains discouraged tomb robbers but provided interesting information to the archaeologists who studied it.

136-137 THE PYRAMID OF NEFERIRKARA SEENS TO DOMINATE ALL OF ABUSIR. BESIDES THE PYRAMIDS OF THE PHARAOHS OF THE FIFTH DYNASTY, THE SANDS ON ABUSIR PLATEAU ALSO HIDE THE REMAINS OF THE PYRAMID OF QUEEN KHENTKAUS II (BOTTOM LEFT IN THE PHOTOGRAPH AT LEFT) AND OTHER MINOR PYRAMIDS.

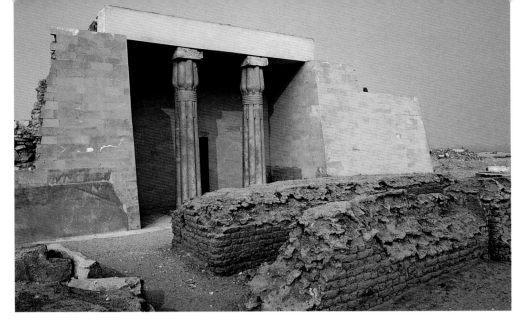

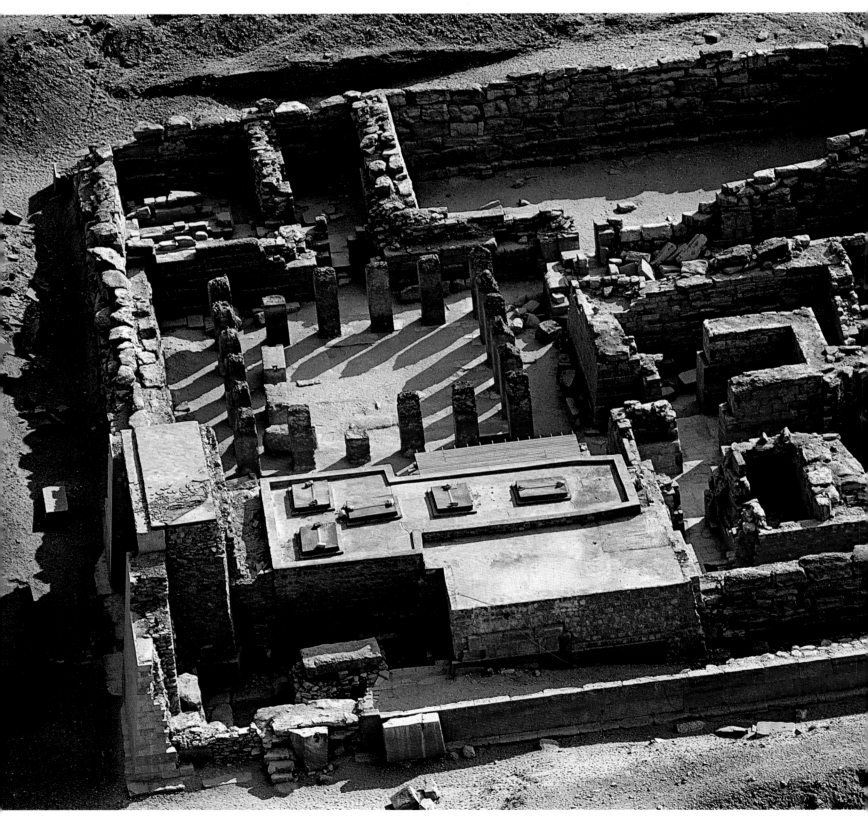

The next pharaoh, Niuserre, found himself with three pyramids to complete: that of his father Neferirkara, his mother Khentkawes, and the one begun by his brother Ranefref. For himself he built a pyramid next to that of his father and recycled the unfinished Ceremonial Way. As in Sahure's complex, Niuserre's Valley Temple had floors lined with black basalt, the lower section of the walls made from red granite and the walls themselves made from decorated, fine limestone. Next to his pyramid stands the enormous *mastaba* tomb built for his son-in-law Ptahshepses which, for the first time, incorporated in a noble tomb many elements that had till then been exclusive to royal funerary complexes.

Some of the most interesting finds in the area are the so-called Abusir papyruses, discovered at the start of the twentieth century. Identified as a portion of the archive of Neferirkara's temple, the papyruses are documents relating to the organization and management of the dynasty's funerary cults. Other sets of documents have been found more recently and are now being examined by experts. Abusir has been studied for years by the Czech Expedition directed by Miroslav Verner and boasts among its most important recent discoveries a series of finely decorated blocks from Sahure's Ceremonial Way. The scenes include one of a group of men dragging the *pyramidion*, the topmost block of the pyramid. This operation must have been one of the final stages of the long process of construction of a funerary monument and, as such, was rightly celebrated and immortalized on the walls of the complex.

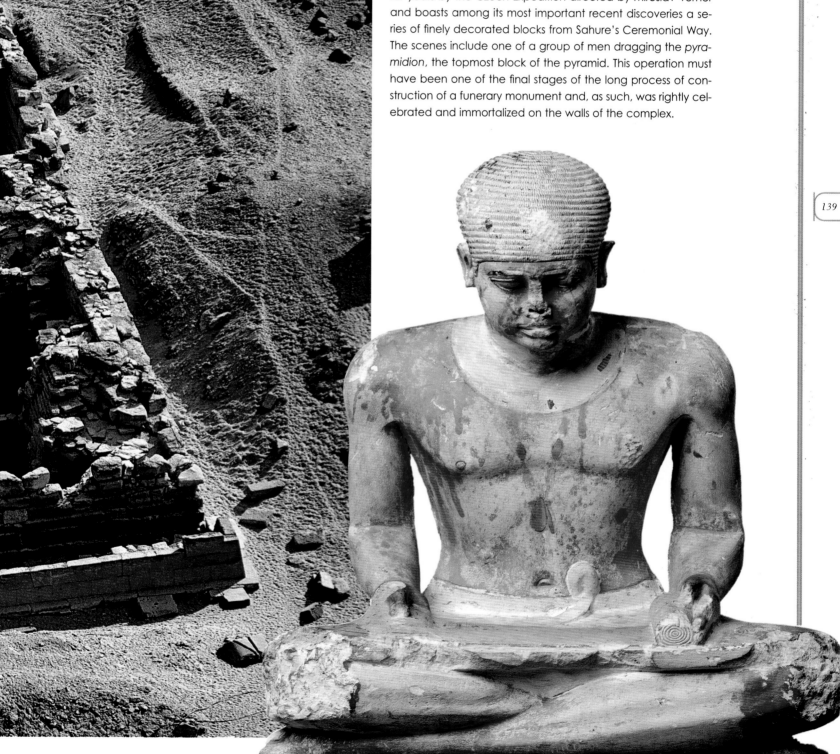

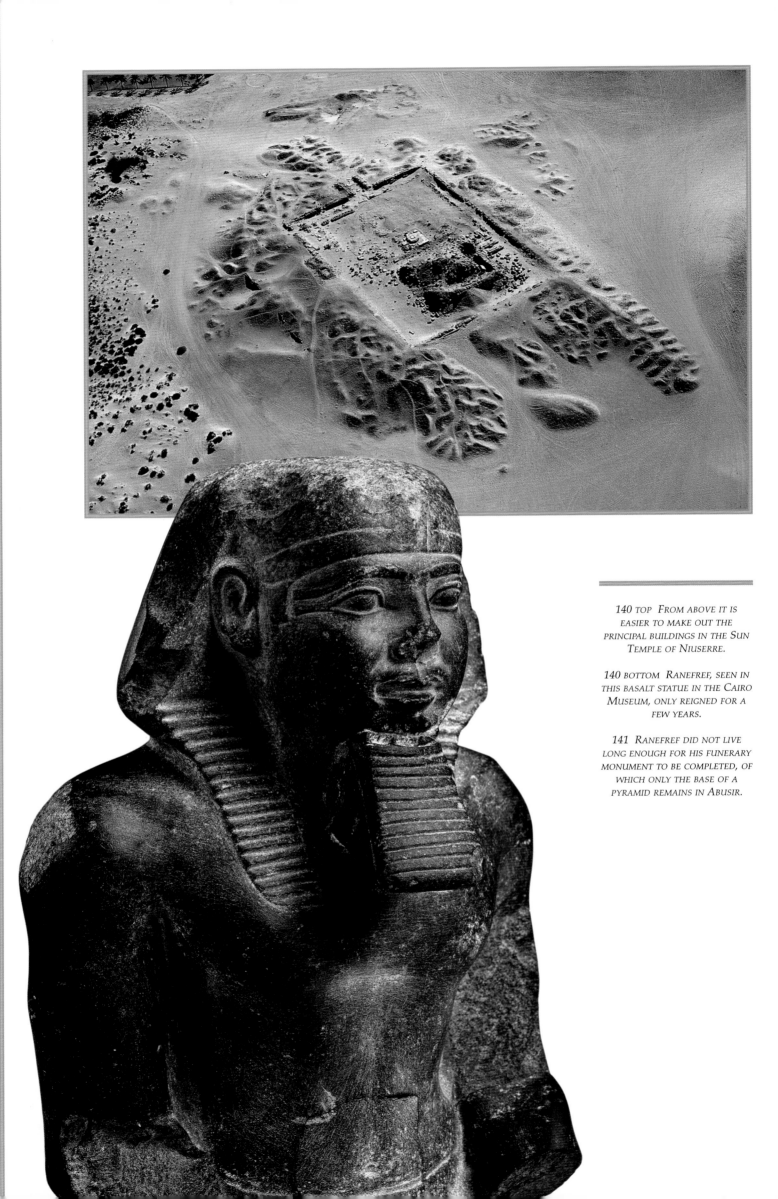

140 TOP *FROM ABOVE IT IS EASIER TO MAKE OUT THE PRINCIPAL BUILDINGS IN THE SUN TEMPLE OF NIUSERRE.*

140 BOTTOM *RANEFREF, SEEN IN THIS BASALT STATUE IN THE CAIRO MUSEUM, ONLY REIGNED FOR A FEW YEARS.*

141 *RANEFREF DID NOT LIVE LONG ENOUGH FOR HIS FUNERARY MONUMENT TO BE COMPLETED, OF WHICH ONLY THE BASE OF A PYRAMID REMAINS IN ABUSIR.*

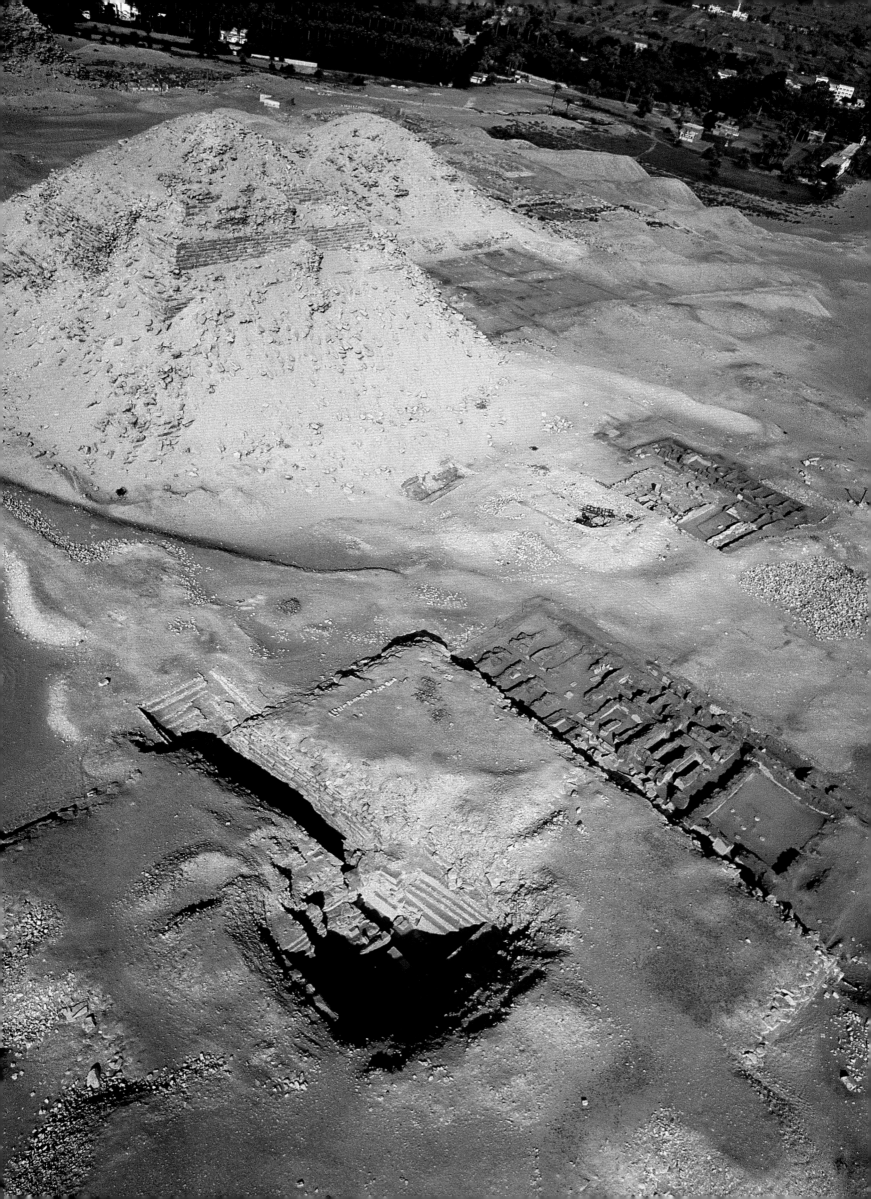

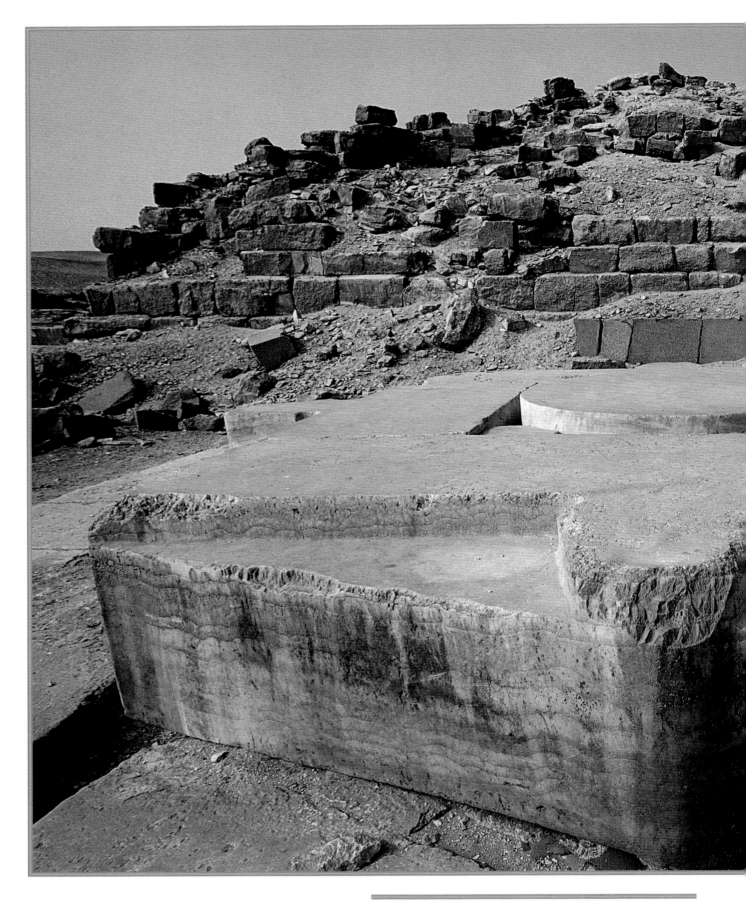

142-143 *In addition to his funerary complex, Niuserre also had a Sun Temple built. This included a large obelisk (today almost completely destroyed) in front of which once stood an alabaster altar.*

143 right *The fragment of a pink limestone statue in the Cairo Museum shows Ranefref with his symbols of power (only his scepter remains) and protected by the falcon-god Horus.*

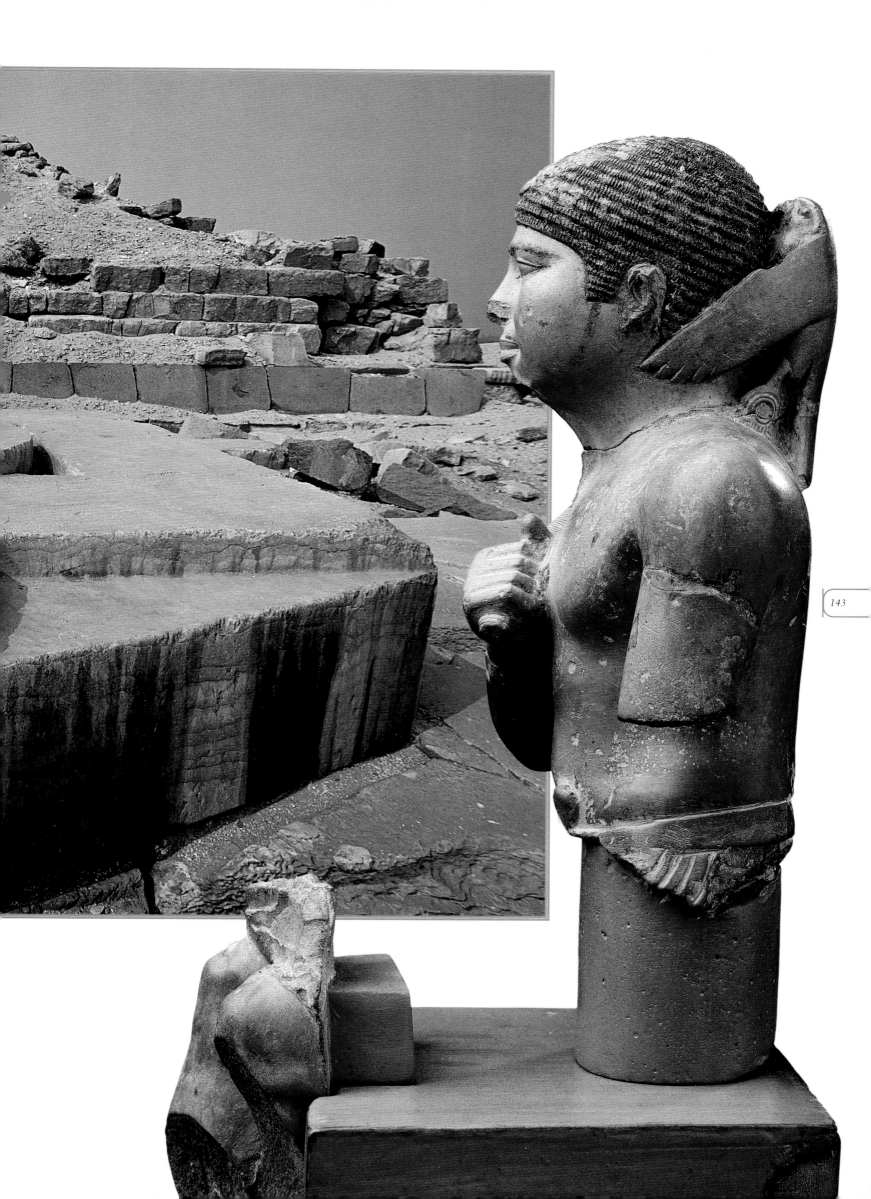

THE NECROPOLIS

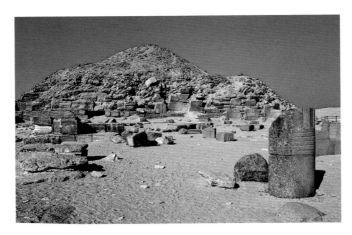

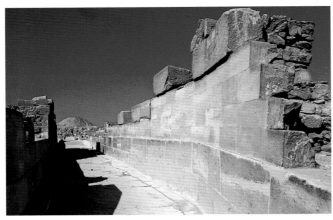

The importance of Saqqara as a necropolis has its roots in the first dynastic period. Djoser, who built the Stepped Pyramid, was not the first to choose the site for his eternal abode. On the edge of the plateau, directly above the probable site of the ancient capital of Memphis, a row of more ancient *mastaba* tombs was found, and their richness is evidence of the power that their owners enjoyed in life. One of the most elaborate was surrounded by dozens of cow-heads made from mud and real horns, perhaps to represent a large herd.

Due to the size and richness of the decoration of these monuments, the British archaeologist Walter Emery initially concluded that they were royal tombs, but it is probable that these *mastaba* tombs were built for high dignitaries who served the pharaohs of the First Dynasty. These kings were instead buried at Abydos, their land of origin. However, the site continued to be used as a necropolis during the Second and Third Dynasties, and it was in the Third Dynasty that Djoser built his own funerary complex there.

After the failed attempt by Sekhemkhet, Djoser's successor, to build a larger stepped pyramid than that of his predecessor, later pharaohs made use of the desert to the south and north of Saqqara. As has been described, Snefru built his monuments at Meidum and Dahshur, and Khufu, Khafre, and Menkaure chose Giza. Of the pharaohs of the Fifth Dynasty, four chose Abusir, whereas the first and last two returned to Saqqara. In particular, the first and last—Userkaf and Unas—built their small pyramids literally in the shadow of the Stepped Pyramid. The first stands insides Djoser's funerary enclosure and the second just outside the walls. The inside of Unas's pyramid is the first, after the Stepped Pyramid, to be decorated. Its walls were the first to be adorned with texts from the Pyramid Texts, a collection of ritual verses believed to accompany the deceased to the Afterworld.

144 Unas, the last pharaoh of the Fifth Dynasty, decided to leave Abusir and return to Saqqara where he built a pyramid, funerary temple, and valley temple covered with inscriptions and low reliefs.

145 The pharaohs of the Sixth Dynasty had their necropolises built on the sandy plateau at Saqqara overlooking the ancient capital of Memphis and with Djoser's Stepp Pyramid.

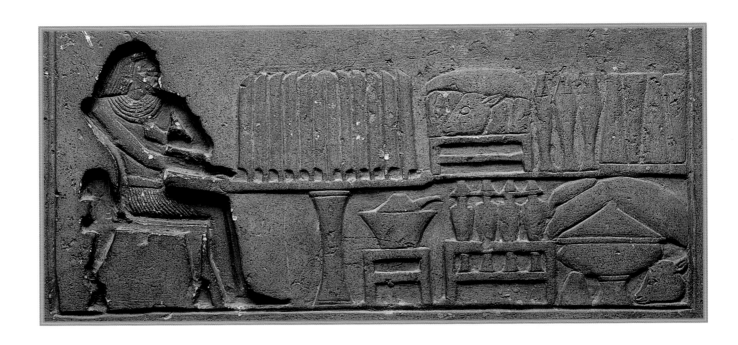

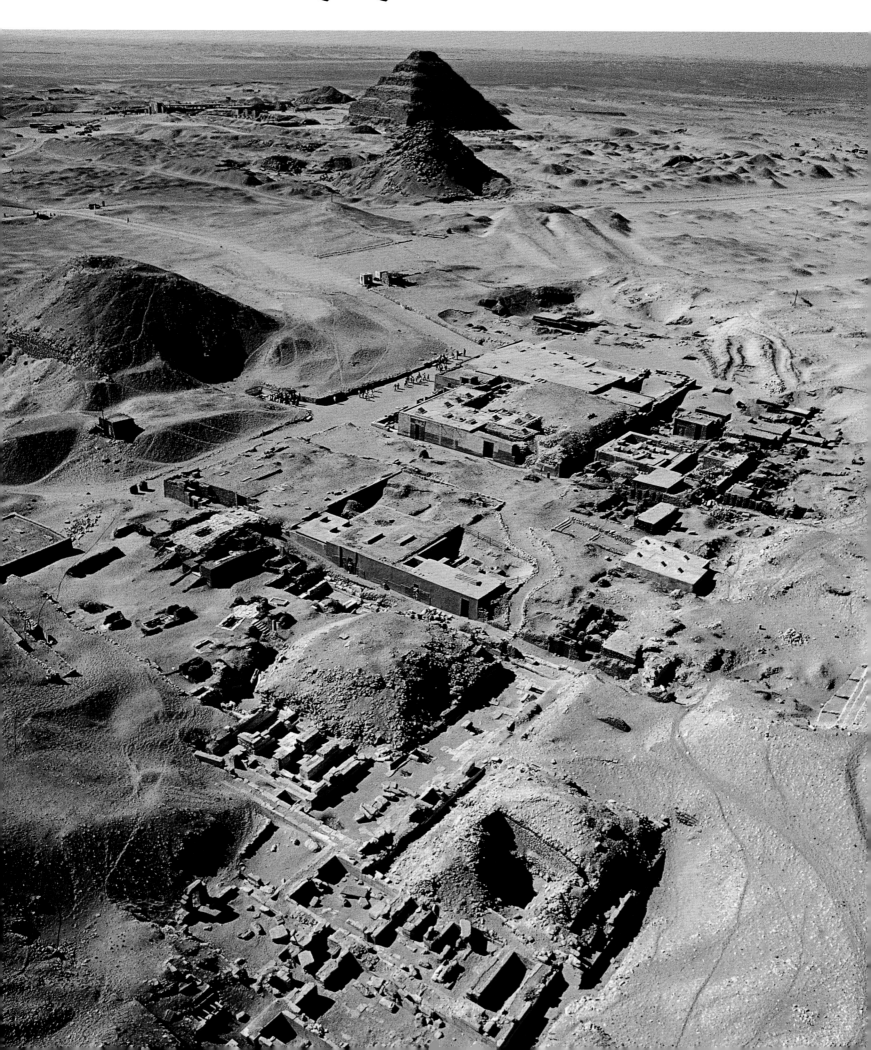

THE NECROPOLIS OF SAQQARA

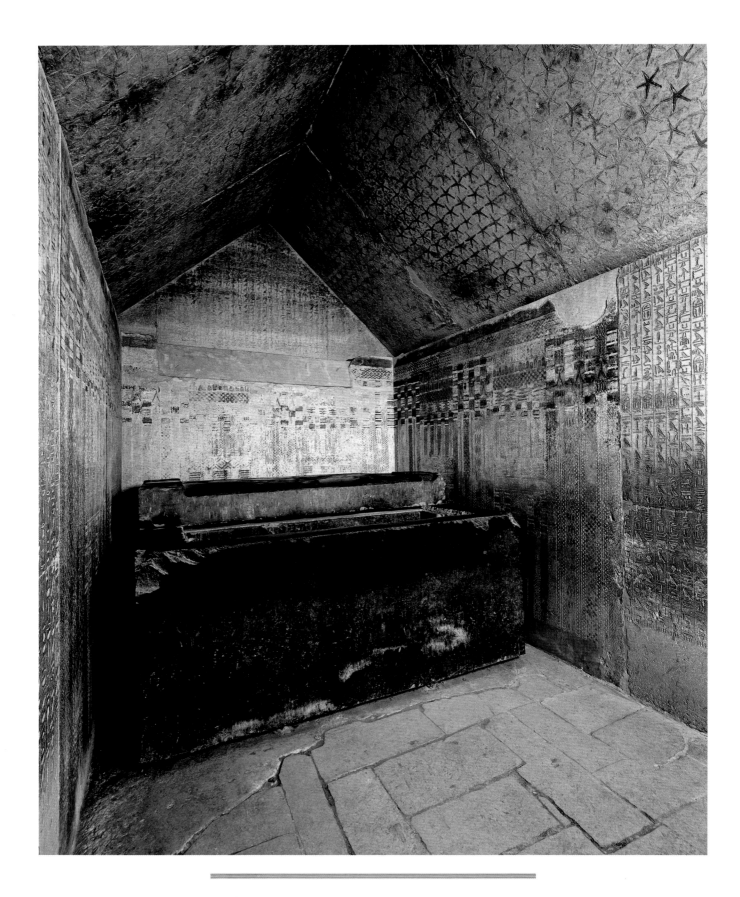

146 AND 147 *UNAS WAS THE*
FIRST PHARAOH TO HAVE THE
"PYRAMID TEXTS" INSCRIBED
ON THE WALLS OF THE BURIAL
CHAMBER IN HIS PYRAMID.

THESE WERE A COLLECTION OF
RITUAL PHRASES THAT
ACCOMPANIED THE DECEASED
TO THE WORLD BEYOND THE
GRAVE.

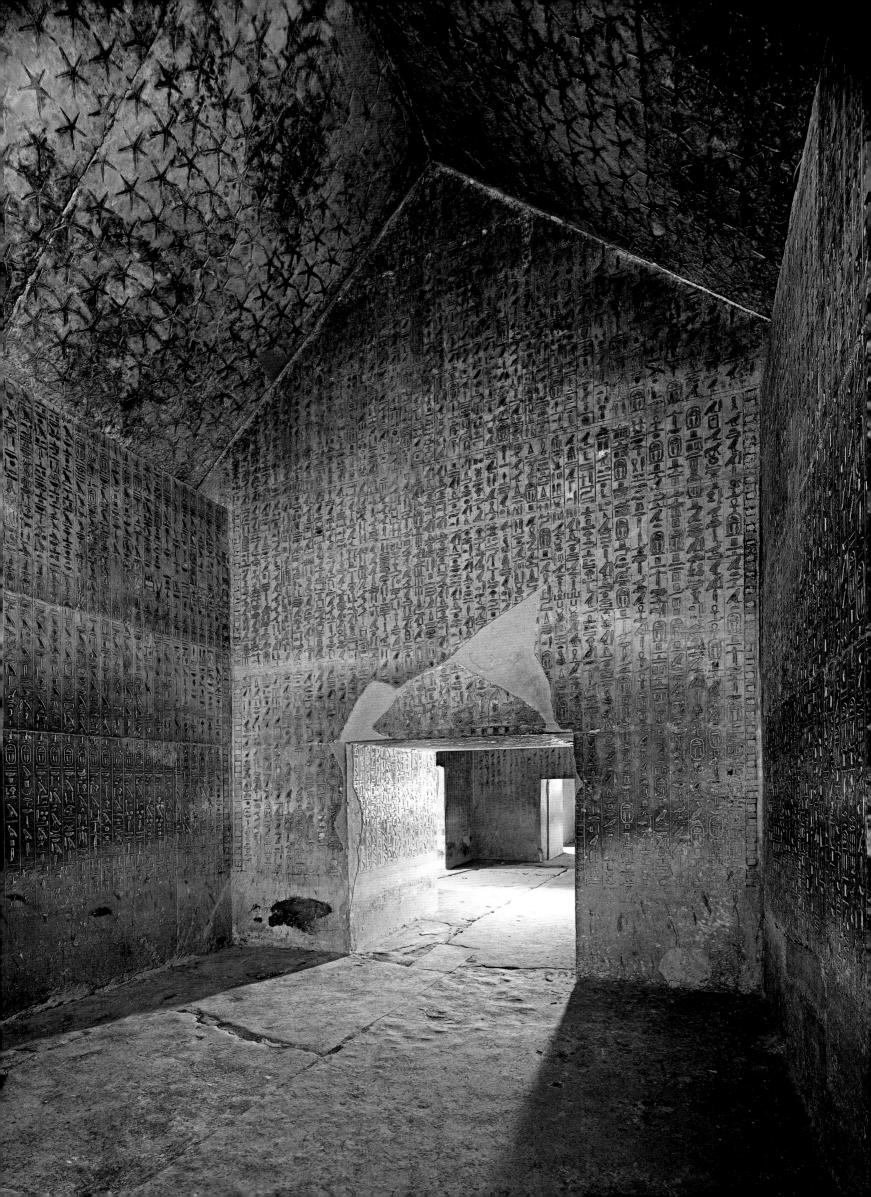

148 TOP AND 149 MANY OF THE
HIEROGLYPHS INSCRIBED ON THE
WALLS OF UNAS'S FUNERARY
APARTMENT WERE PAINTED BLUE
LIKE WATER, THE PRIMARY ELEMENT
FROM WHICH LIFE WAS CREATED.

148 BOTTOM A DELICATE
PAINTED RELIEF MOTIF IS SEEN
INSIDE THE BURIAL CHAMBER OF
UNAS'S PYRAMID.

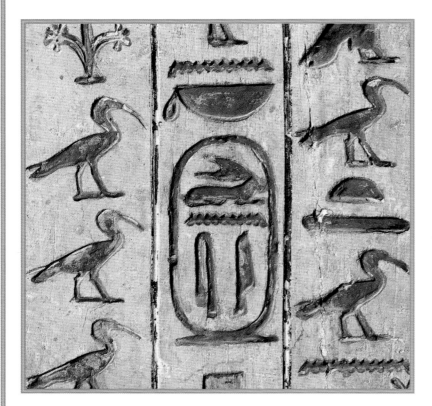

The pharaohs of the Sixth Dynasty did not move far away and built very similar pyramids and temples. The pyramids were relatively small but were completed by an elaborate funerary temple that had spaces dedicated to the cult of the pharaoh running down the middle; on either side were a series of store-rooms. The pyramid and temple were surrounded by an enclosure wall; in its southeast corner stood a small satellite pyramid. The ceilings of the burial chambers were covered by enormous stone slabs to form an upturned V and decorated with hundreds of gold stars on a blue ground. The walls were covered with rows of Pyramid Texts in hieroglyphs painted in blue or green to represent water, growth, renewal, and therefore life. Next to the royal pyramids miniature funerary complexes were built for the queens, each with its own enclosure and tiny satellite pyramid.

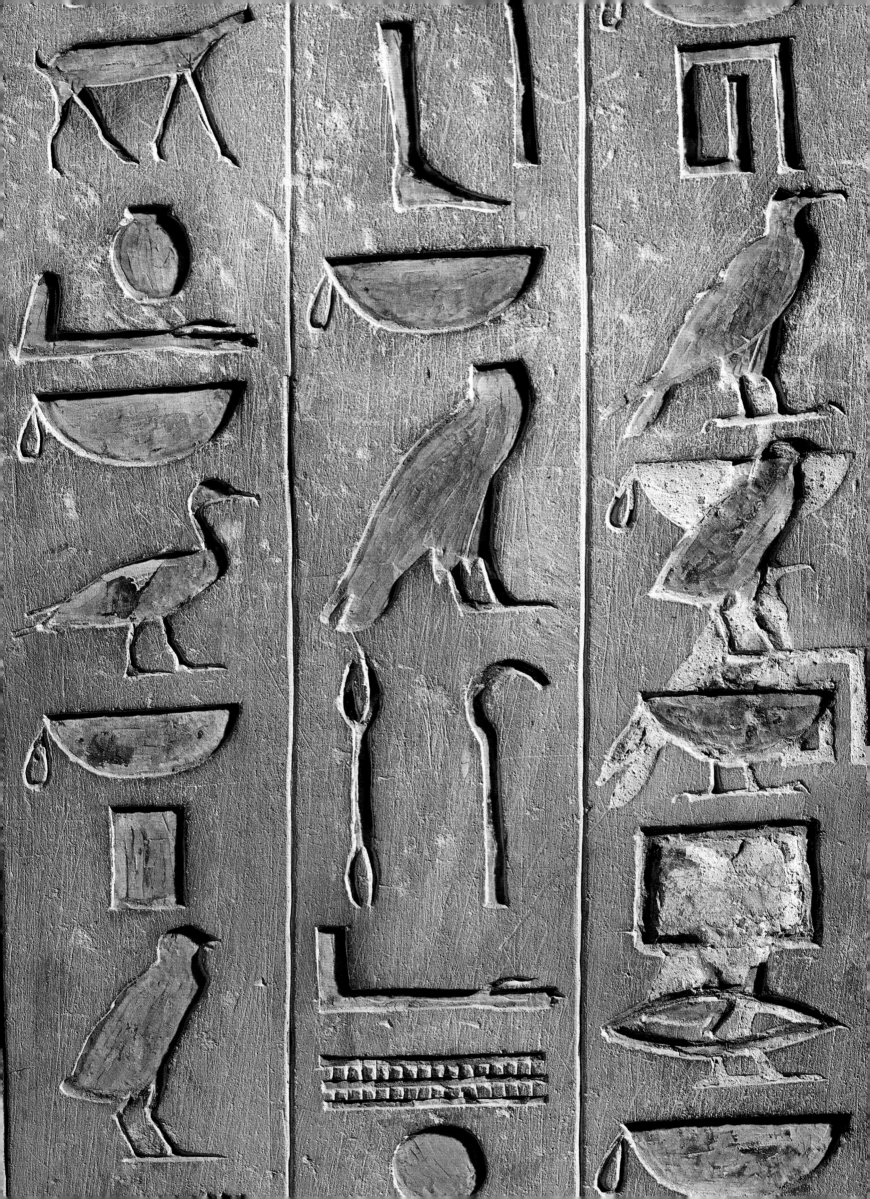

THE NECROPOLIS
OF SAQQARA

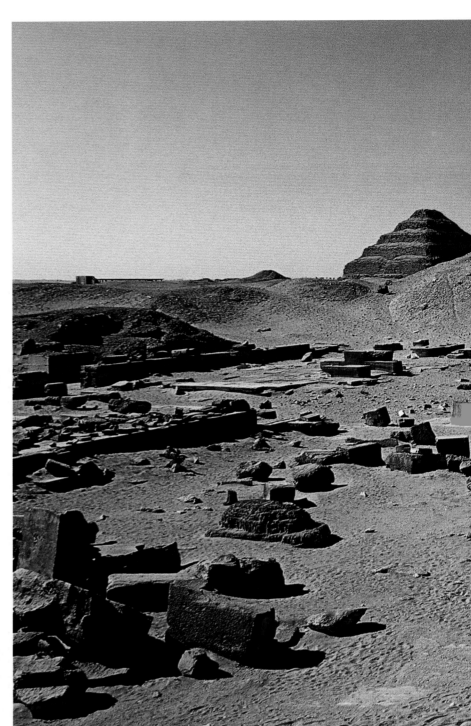

150 *The ceiling of the burial chamber in Teti's pyramid (first pharaoh of the Sixth Dynasty) was made using enormous stone slabs* *inscribed with hundreds of stars to depict the night sky. The pharaoh's sarcophagus still stands inside the funerary chamber.*

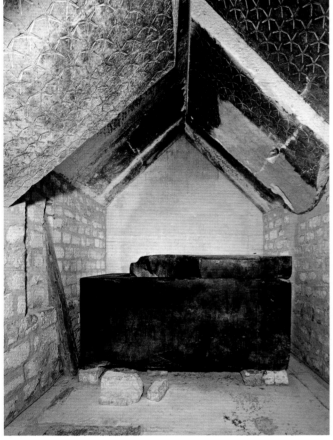

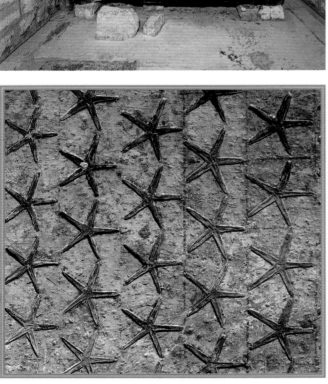

150-151 *and* 151 *bottom The superstructure of Teti's pyramid is now no more than a pile of stones and little remains of the Funerary* *Temple, though this was probably very similar to the temples of the other pharaohs of the same dynasty.*

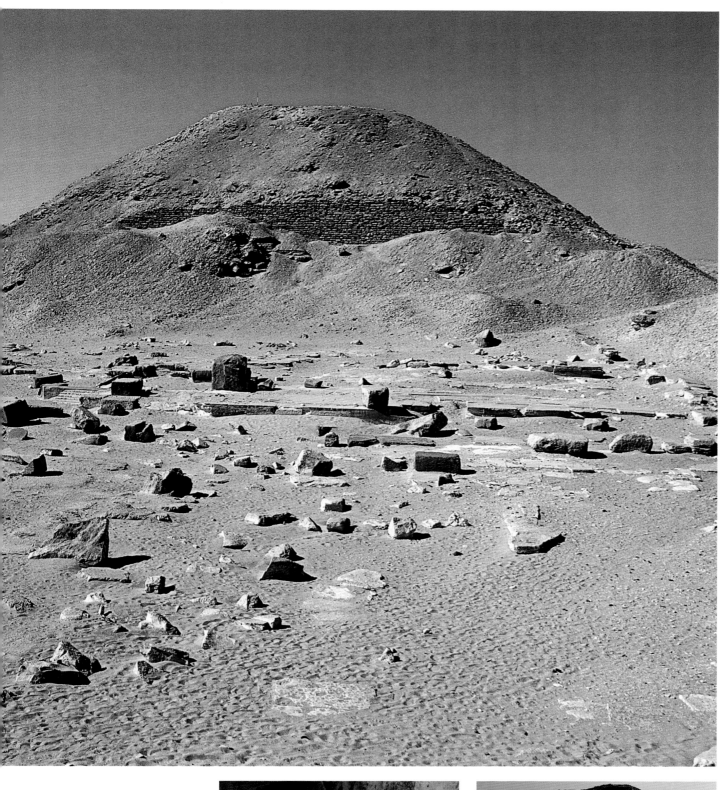

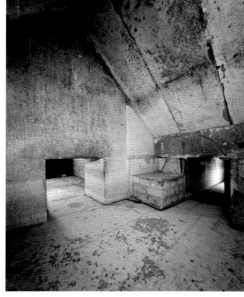

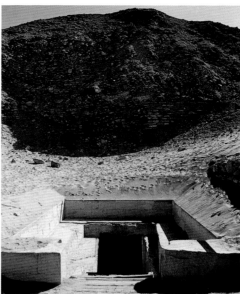

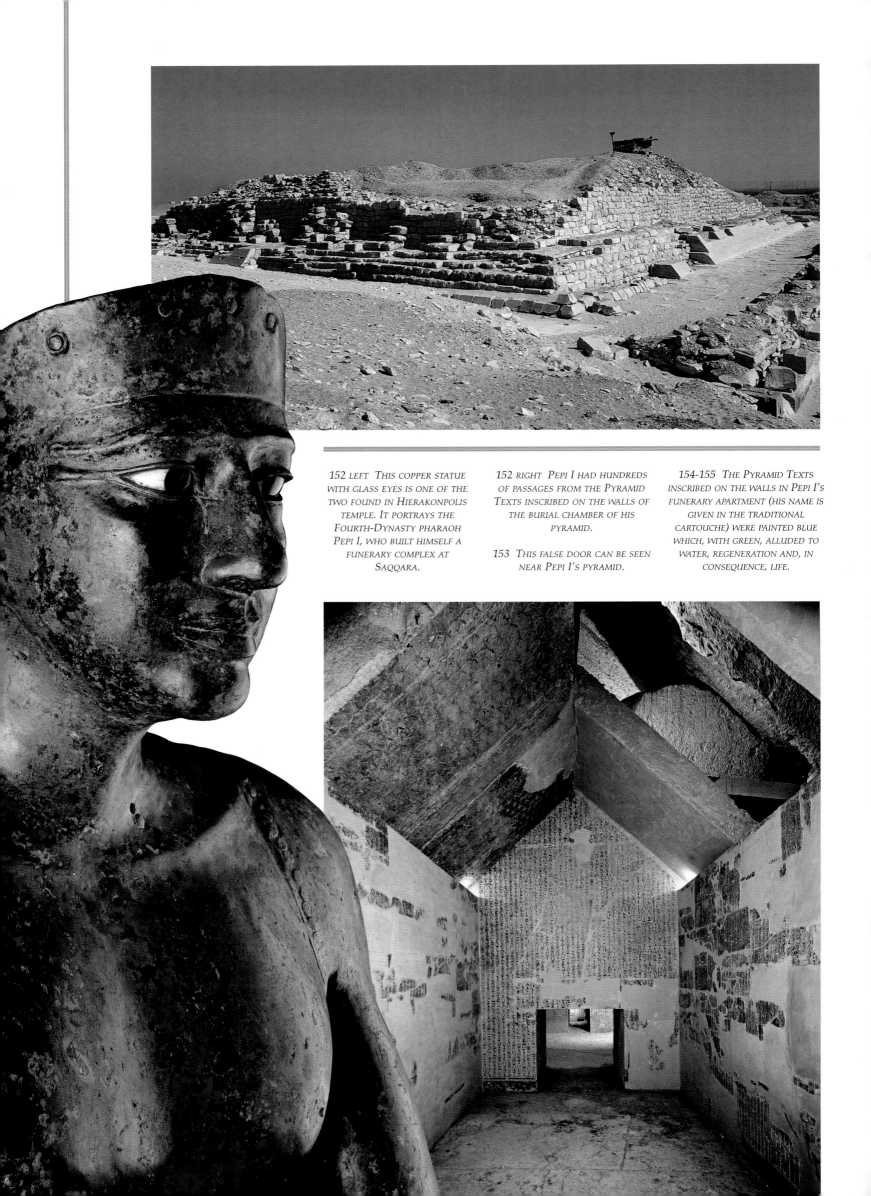

152 LEFT THIS COPPER STATUE WITH GLASS EYES IS ONE OF THE TWO FOUND IN HIERAKONPOLIS TEMPLE. IT PORTRAYS THE FOURTH-DYNASTY PHARAOH PEPI I, WHO BUILT HIMSELF A FUNERARY COMPLEX AT SAQQARA.

152 RIGHT PEPI I HAD HUNDREDS OF PASSAGES FROM THE PYRAMID TEXTS INSCRIBED ON THE WALLS OF THE BURIAL CHAMBER OF HIS PYRAMID.

153 THIS FALSE DOOR CAN BE SEEN NEAR PEPI I'S PYRAMID.

154-155 THE PYRAMID TEXTS INSCRIBED ON THE WALLS IN PEPI I'S FUNERARY APARTMENT (HIS NAME IS GIVEN IN THE TRADITIONAL CARTOUCHE) WERE PAINTED BLUE WHICH, WITH GREEN, ALLUDED TO WATER, REGENERATION AND, IN CONSEQUENCE, LIFE.

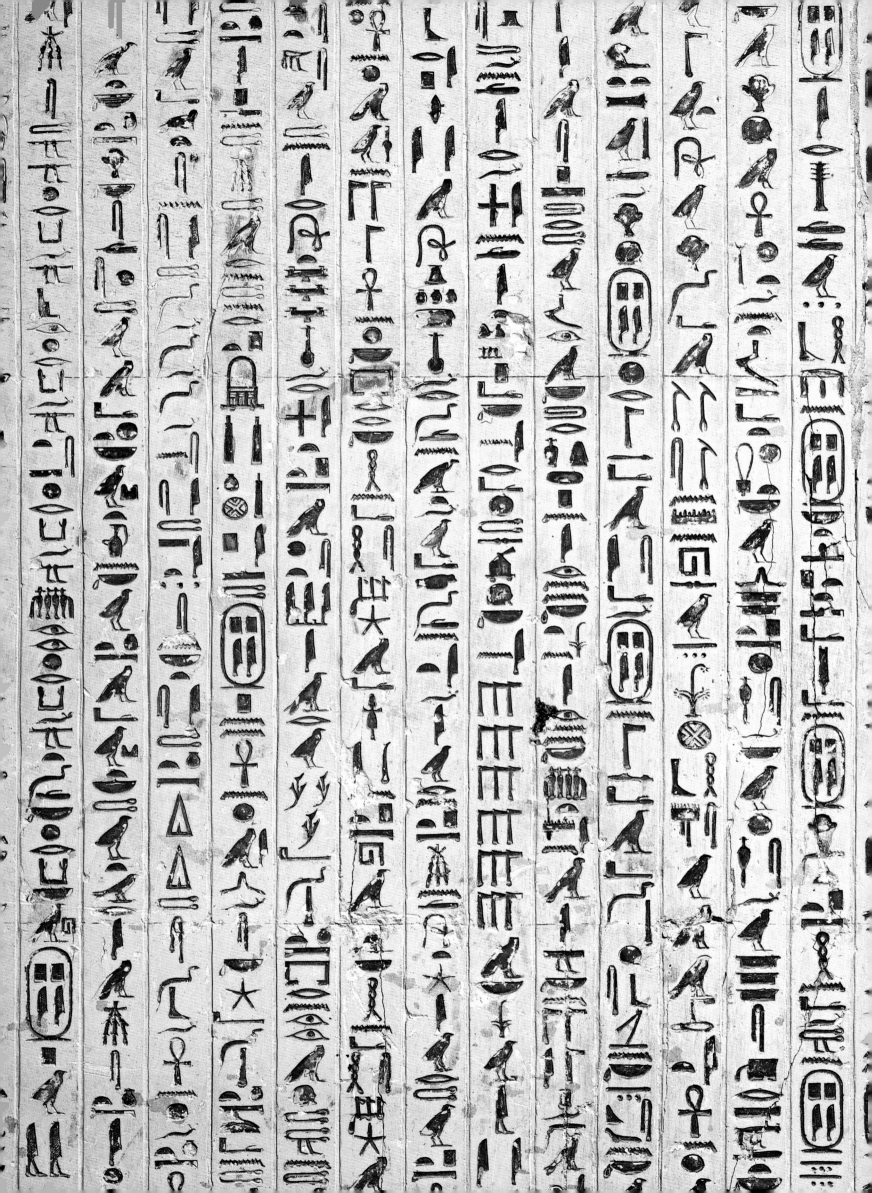

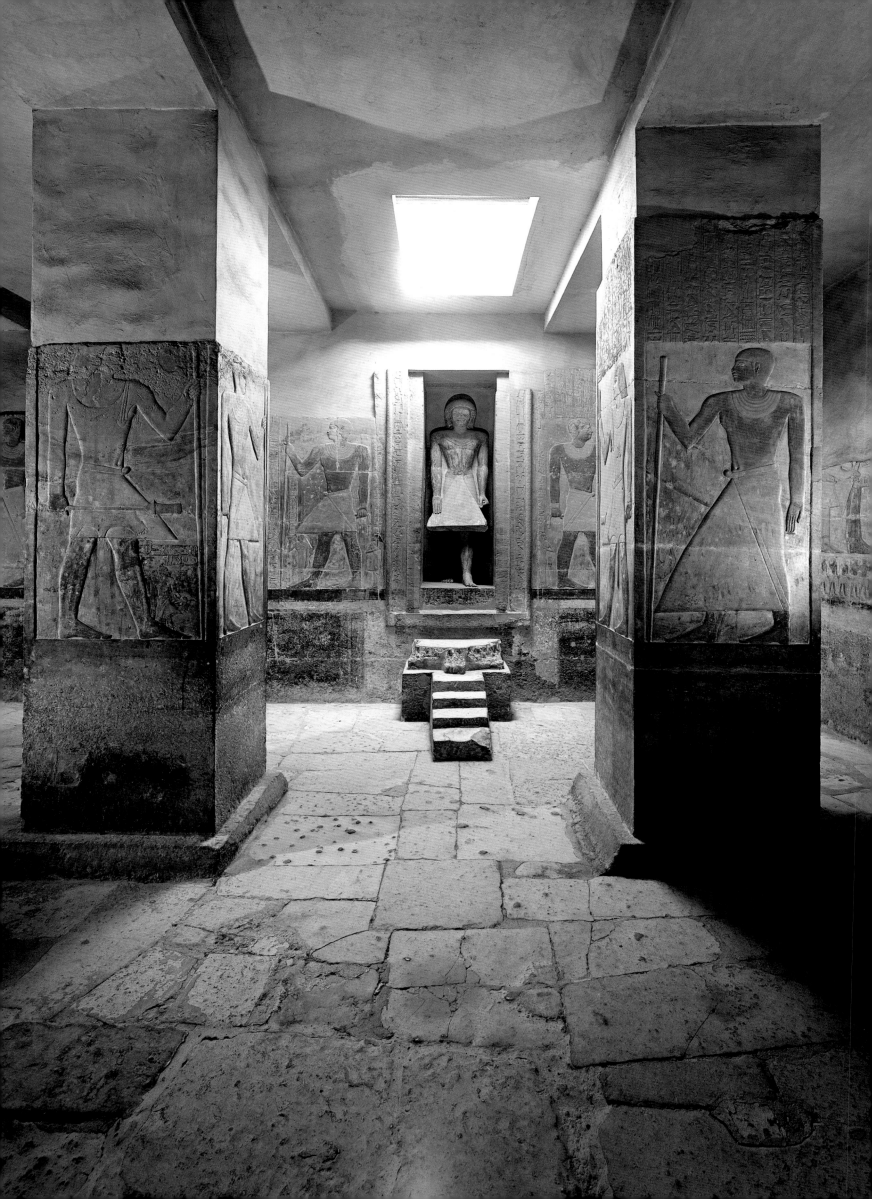

THE TOMB OF MERERUKA

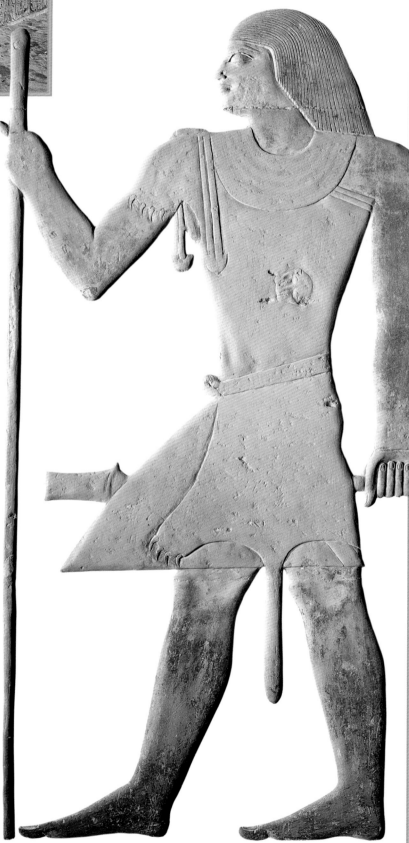

158-159 *Looking after the animals was an important part of managing the estates of large landowners like Mereruka. This scene depicts various types of cattle and even some hyenas.*

Saqqara necropolis also contained the tombs of dignitaries who served under the pharaohs of the Fifth and Sixth Dynasties; these were generally large *mastabas* with finely decorated interiors. One of the most spectacular is undoubtedly that of Mereruka, who was the vizier during the reign of Pharaoh Teti. The tomb has traditional scenes of offerings presented to the owner of the tomb and his consort, but also a very detailed scene of a hippopotamus hunt in which two groups of men approaching in a boat are armed with cords and harpoons. Part of the scene has as background a grove of papyrus plants in which various species of birds are seen nesting, and insects and frogs hide in the vegetation behind the group of hippos. The underwater world is illustrated in parallel, with a sequence of crocodiles, hippos, and fish following and attacking one another.

Mereruka's tomb has twenty-nine rooms, including a decorated and pillared chamber in which a statue of the deceased stands against the far wall to gather the offerings left to it. The body of the vizier was buried in a chamber with painted walls, but the decoration was not completed. On three walls illustrations of the offerings have been left outlined in black on a white background, and only part of the upper wall at the entrance was filled with bright colors.

156 and 157 left Mereruka, vizier and minister of justice at the time of Teti, had an imposing mastaba decorated with statues and low reliefs.

157 right Mereruka is shown several times on the walls of his tomb, performing official duties and relaxing with his family.

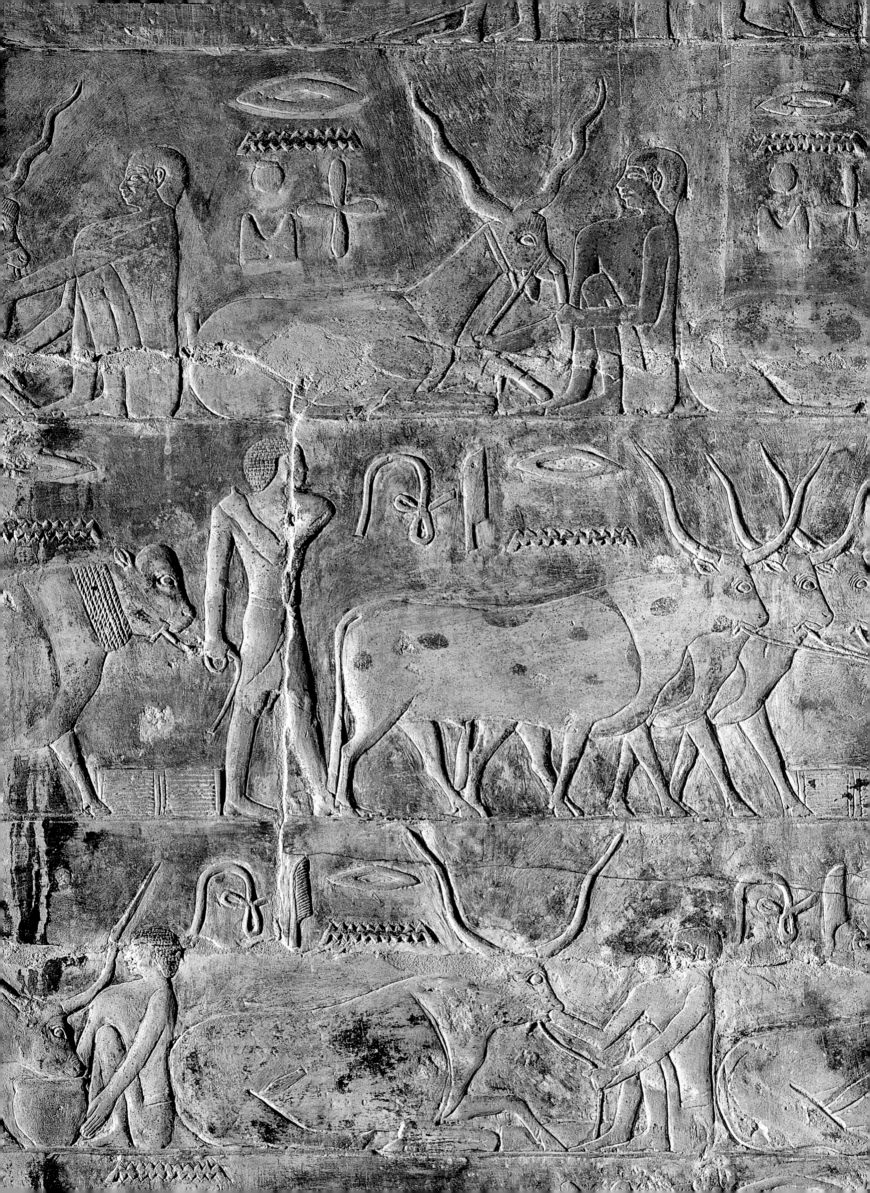

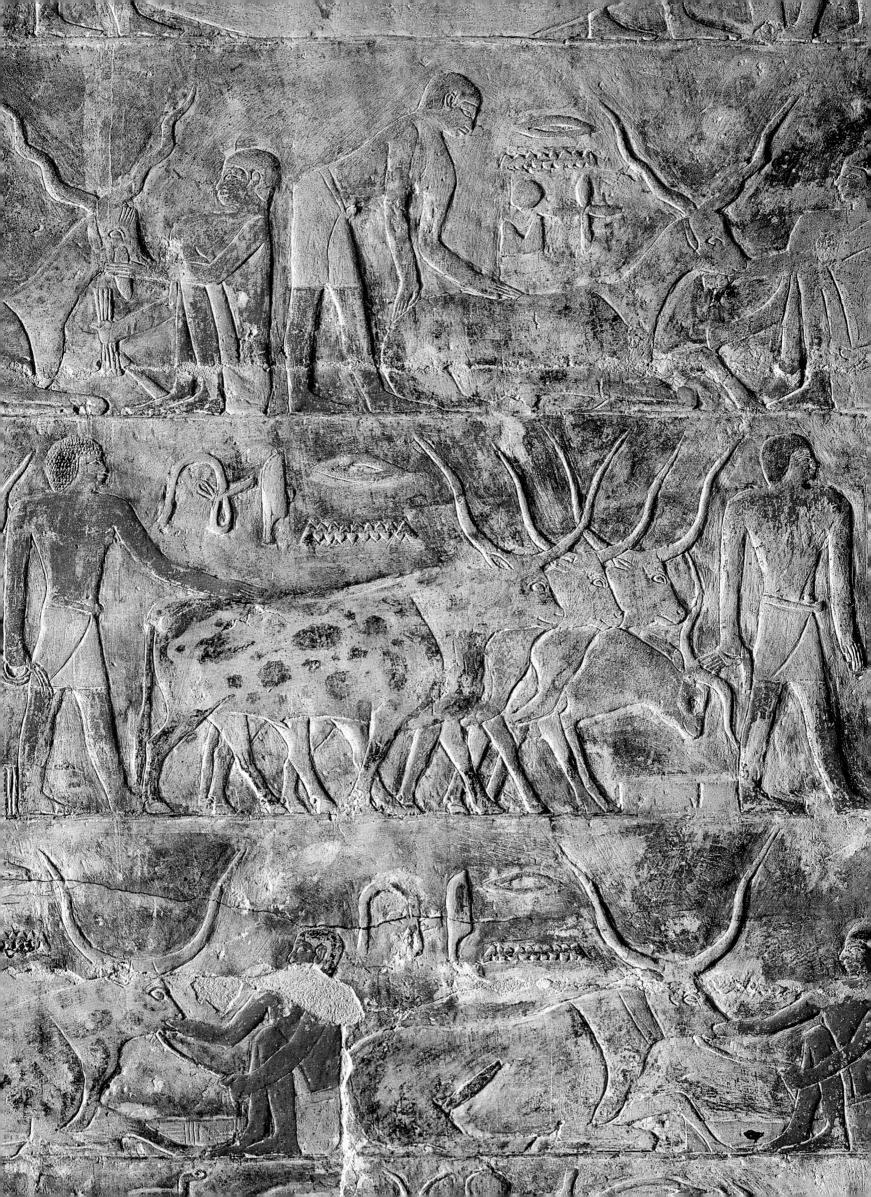

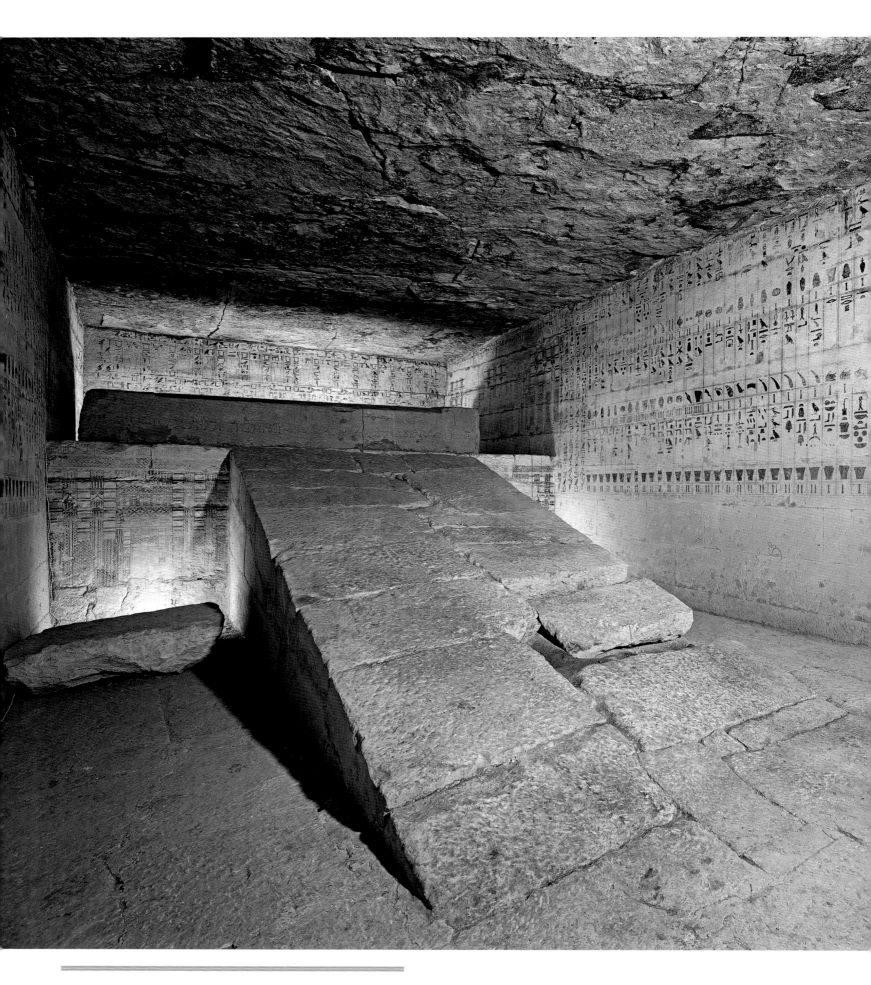

160-161 THE BURIAL
CHAMBER OF THE VIZIER
MERERUKA WAS NEVER
COMPLETED, HOWEVER, IT IS
POSSIBLE TO ADMIRE THE
DELICATE BLACK-AND-WHITE

WALL DECORATIONS OF
OFFERINGS FOR THE DECEASED.
UNFORTUNATELY, THESE
DRAWINGS WERE NEVER
COMPLETED WITH THE
ADDITION OF COLORS.

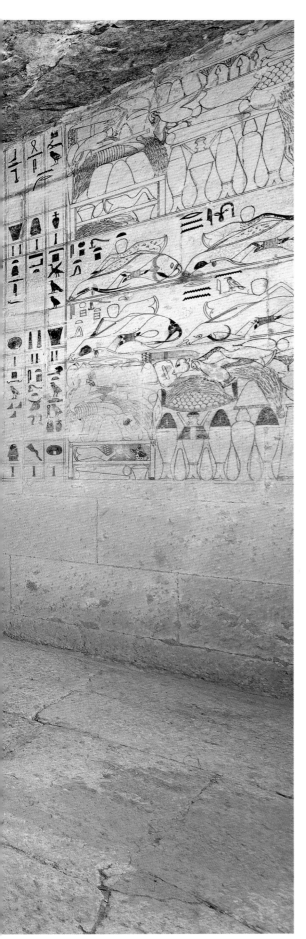

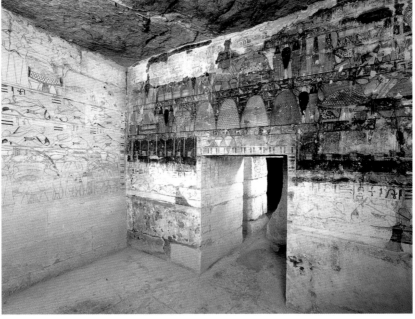

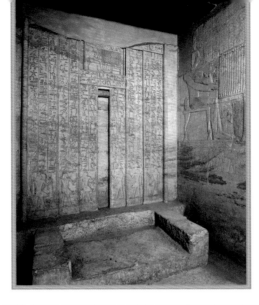

162 TOP THE FALSE DOOR CARVED
AT THE FAR END OF THIS CORRIDOR
HAS PICTURES OF MERITETI, THE
SON OF MERERUKA. MERITETI TOO
WAS A VIZIER AND JUDGE, AND THIS
PART OF THE TOMB WAS RESERVED
FOR HIM.

162-163 AND 163 TOP
SOME OF THE SCENES IN
MERERUKA'S MASTABA ARE
OF THE DAILY LIFE OF HIS
SUBORDINATES AND SERVANTS.

162 BOTTOM AND 163 BOTTOM
THE LOW RELIEFS ON THE WALLS OF
MERERUKA'S MASTABA HAVE MANY
CURIOUS DETAILS, LIKE THESE
TRANSPORT SCENES (LEFT) AND THE
CHILDREN PLAYING IN A RING.

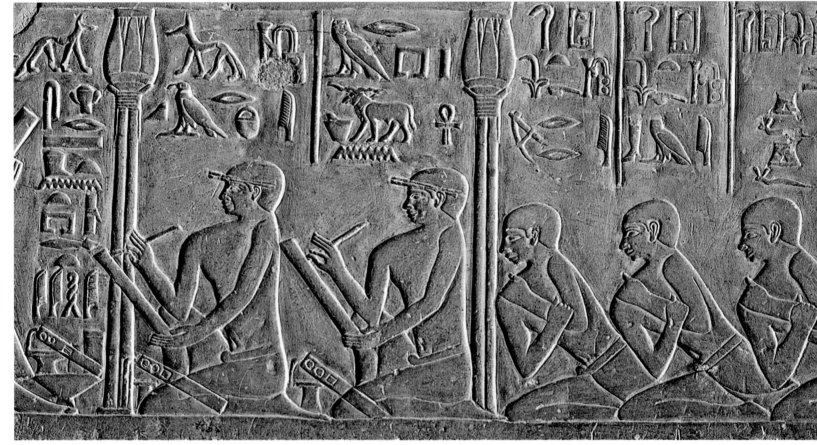

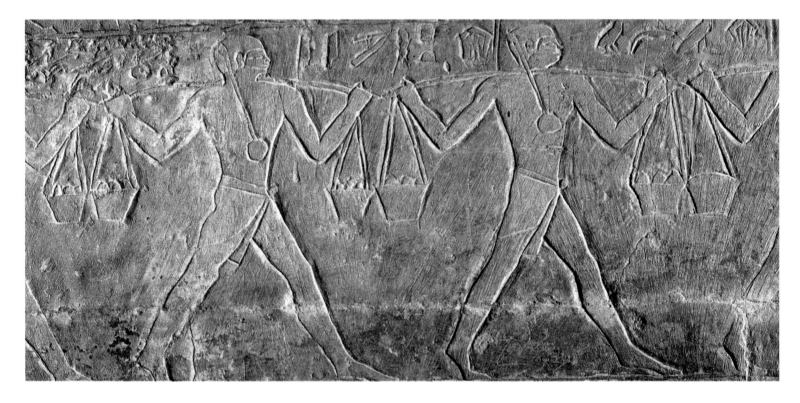

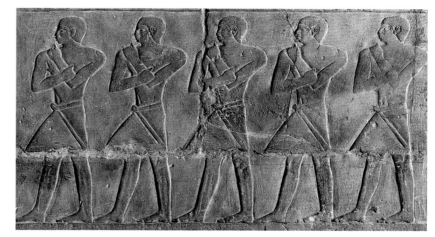

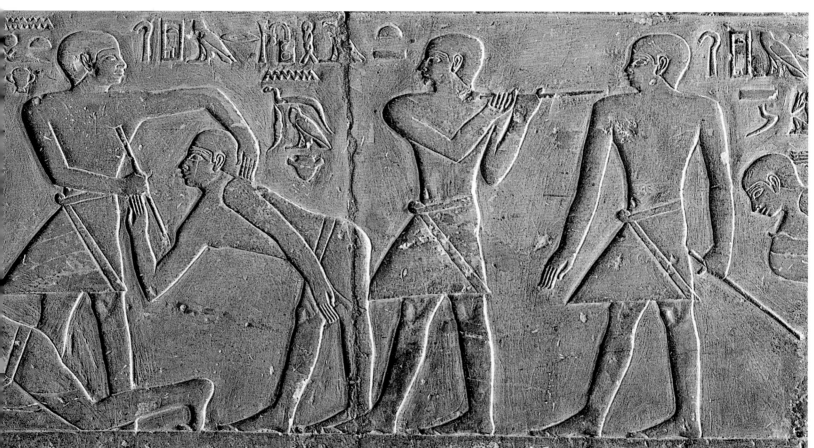

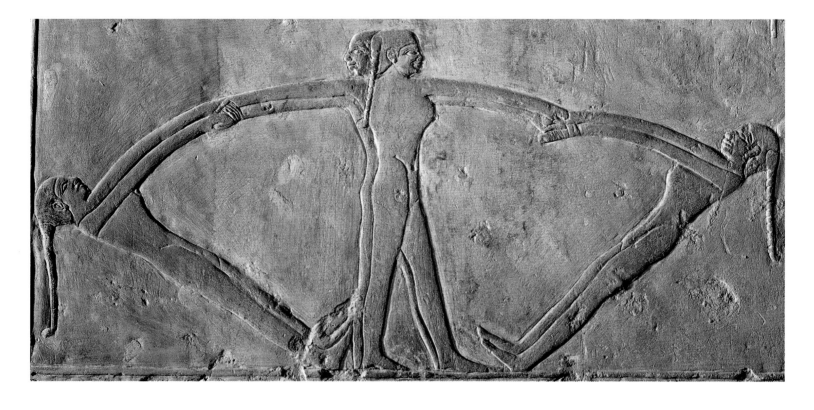

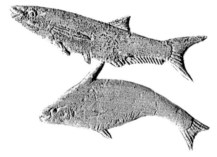

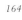

164-165 SOME OF THE MOST
VIVID SCENES IN MERERUKA'S
MASTABA ARE OF FISHING. IN ONE
A GROUP OF MEN HAUL IN AN
ENORMOUS NET WITH EFFORT IN
WHICH DIFFERENT TYPES OF FISH
HAVE BEEN CAUGHT; IN ANOTHER,
FOUR MEN ARE SEEN TRYING TO
CATCH SMALL FISH.

166-167 A FAMOUS SCENE FROM
MERERUKA'S MASTABA SHOWS A
VIOLENT HIPPOPOTAMUS HUNT.
THE ANIMALS ARE RESTING IN THE
VEGETATION WHEN ARMED MEN
ARRIVE IN A BOAT.

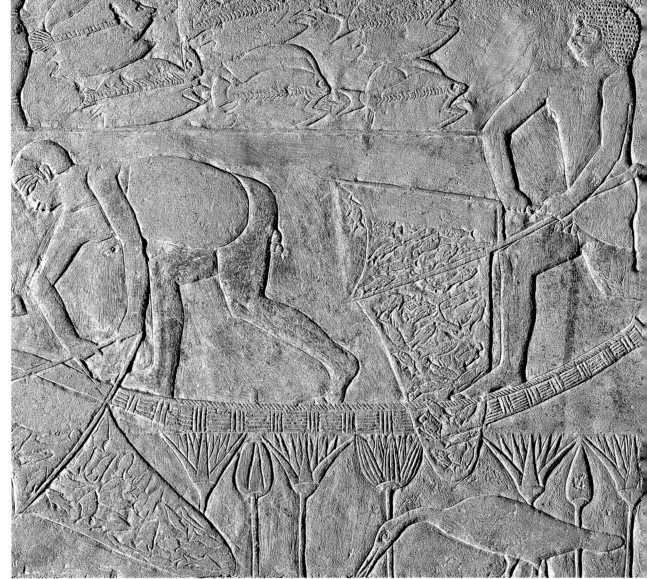

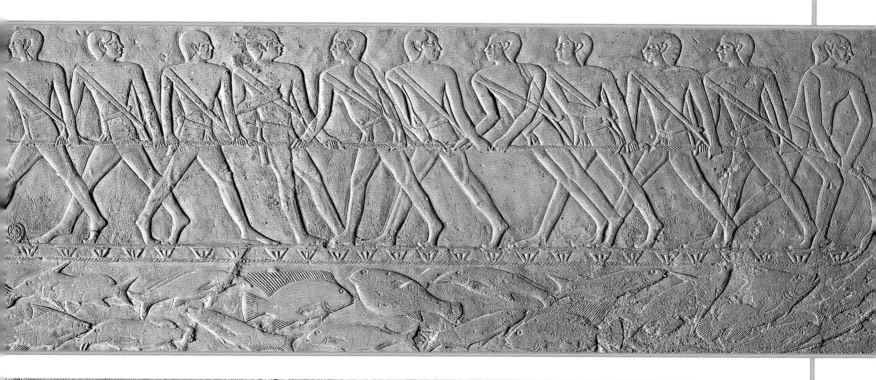

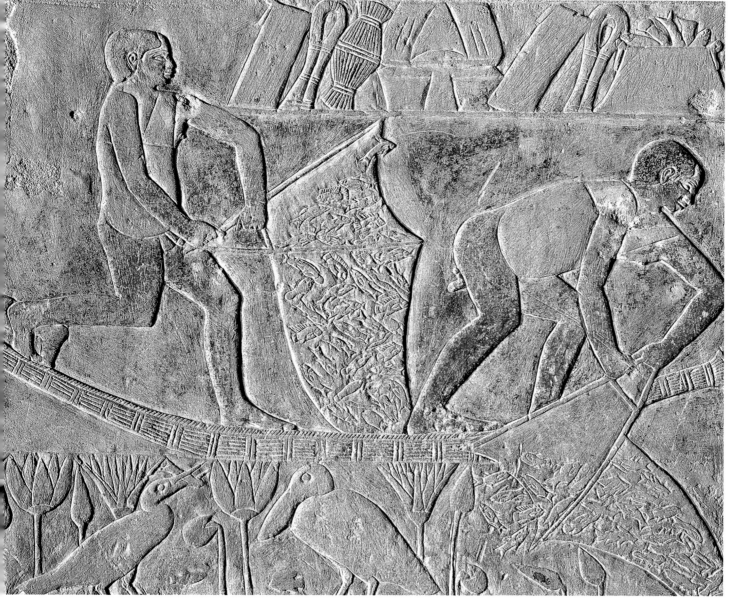

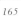

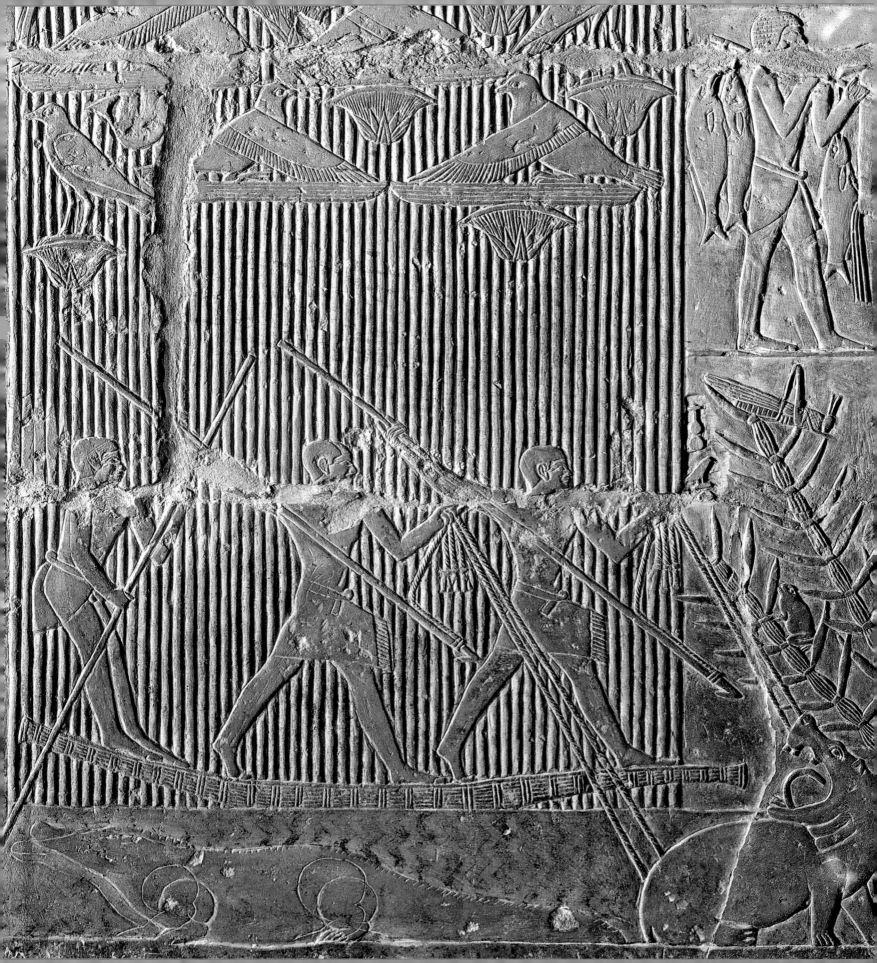

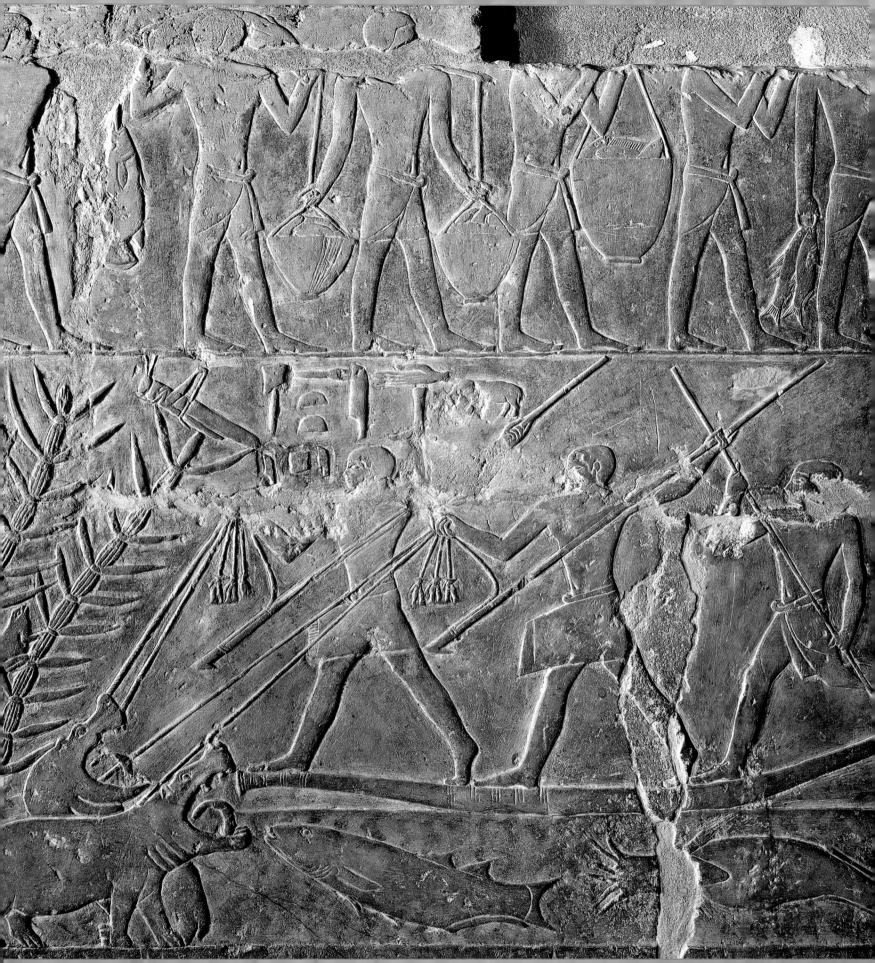

THE TOMB OF KAGEMNI

T he walls of the *mastaba* of Kagemni, who lived shortly before Mereruka, are densely decorated with low-reliefs of scenes of daily life and lines of bearers carrying offerings. An outstanding scene is of a herd of cattle fording a river led and aided by a group of men. The largest animals are up to their necks in water and the calves are carried on the men's shoulders or towed behind the boat. Hippopotamuses, crocodiles, and various sorts of fish inhabit the depths of the river.

168-169 KEGEMNI, A JUDGE AND VIZIER, HAD A HUGE AND LABYRINTHINE MASTABA BUILT BESIDE TETI'S TOMB. ITS WALLS ARE ENTIRELY COVERED WITH INSCRIPTIONS AND PICTURES DESCRIBING KEGEMNI'S LIFE AND ALL THE ACTIVITIES CONNECTED WITH HIS NUMEROUS PROPERTIES.

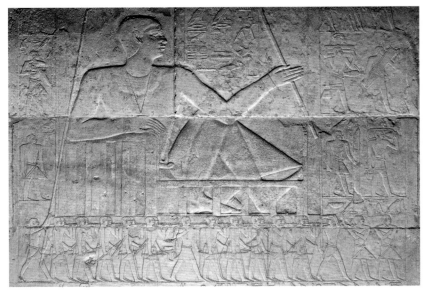

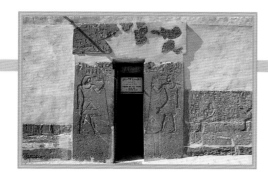

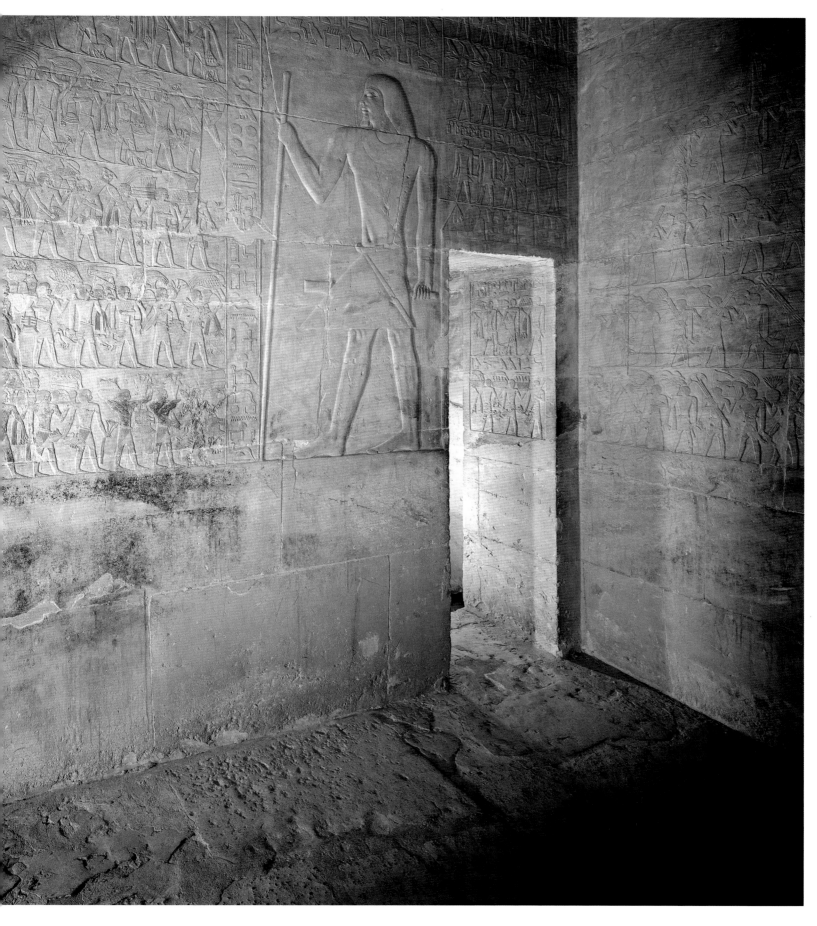

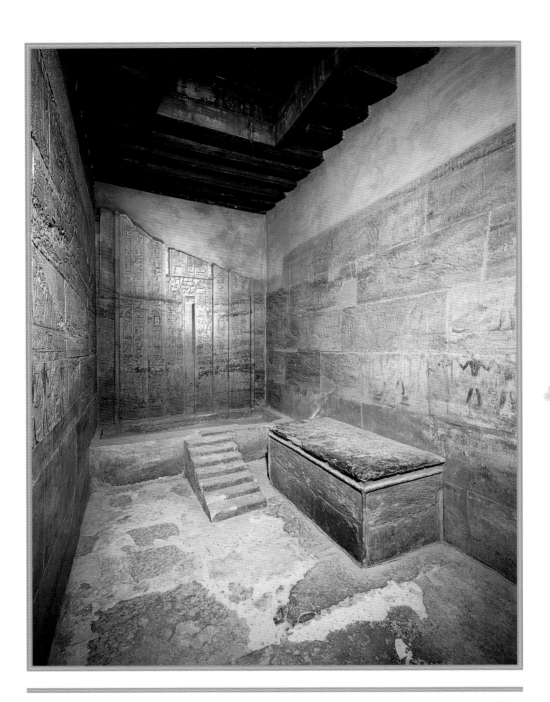

170 *top A huge false-door takes up the whole rear wall in this chamber of Kagemni's mastaba.*

170 *bottom Kagemni's tomb also has scenes of sailing, hunting, and fishing.*

171 *Kagemni is shown here before a long procession of bearers set out on seven registers.*

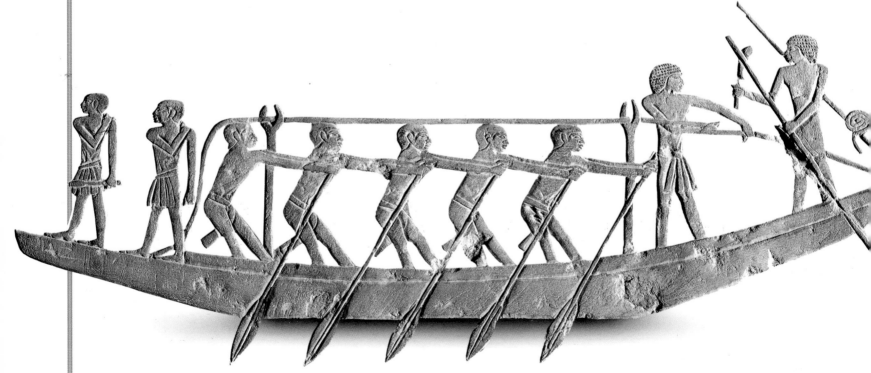

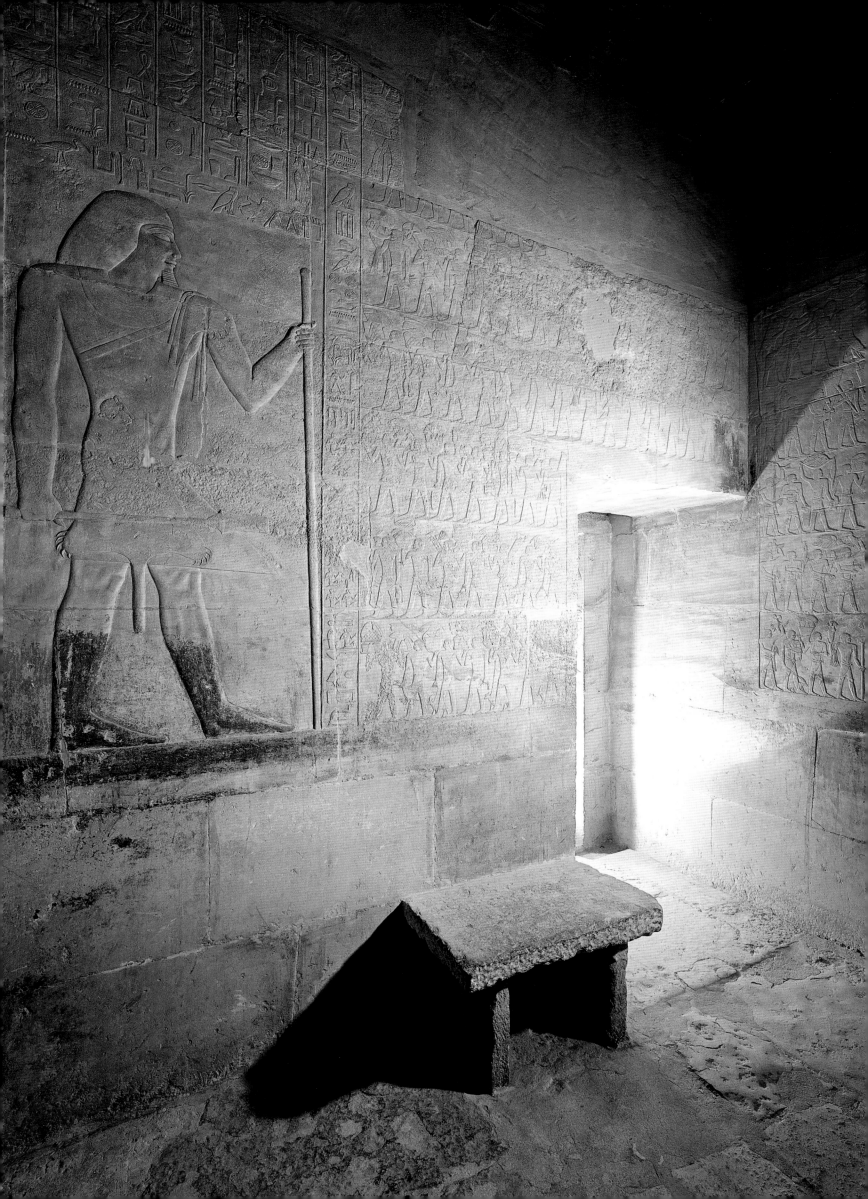

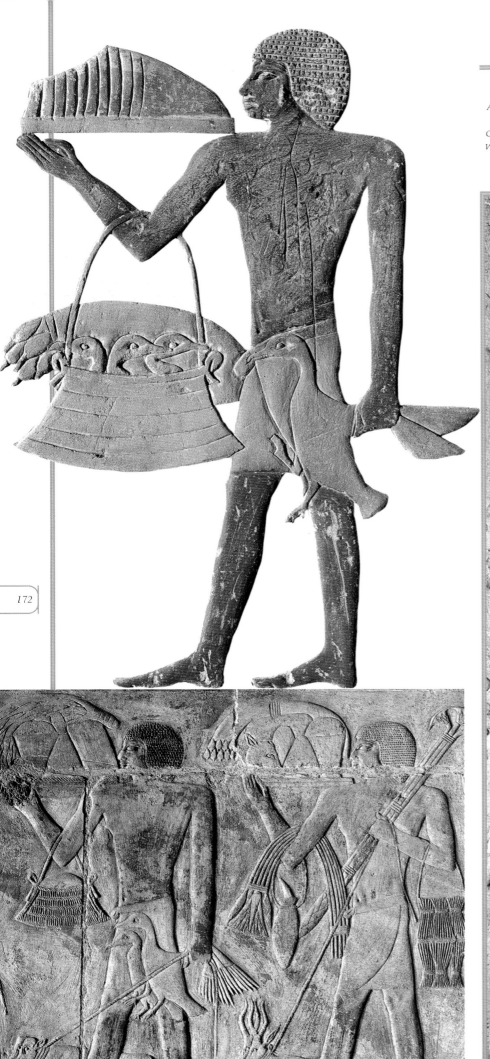

172 Domestic animals were an important asset and their care was recorded and carefully represented on the walls of the deceased's tomb. In some cases the animals were led to the owner as an offering, in others simply to be inspected. Other representations show milking and the slaughtering of cattle.

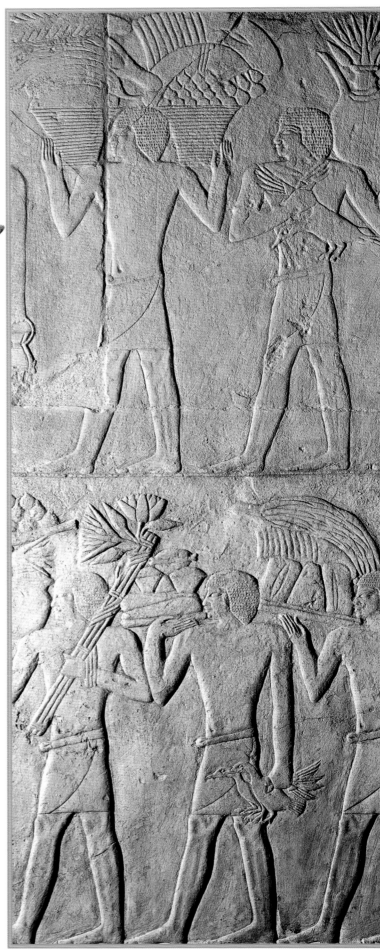

172-173 *In this delicate and carefully carved low relief, in which traces of color can still be seen, it is possible to see long lines of bearers bringing offerings.*

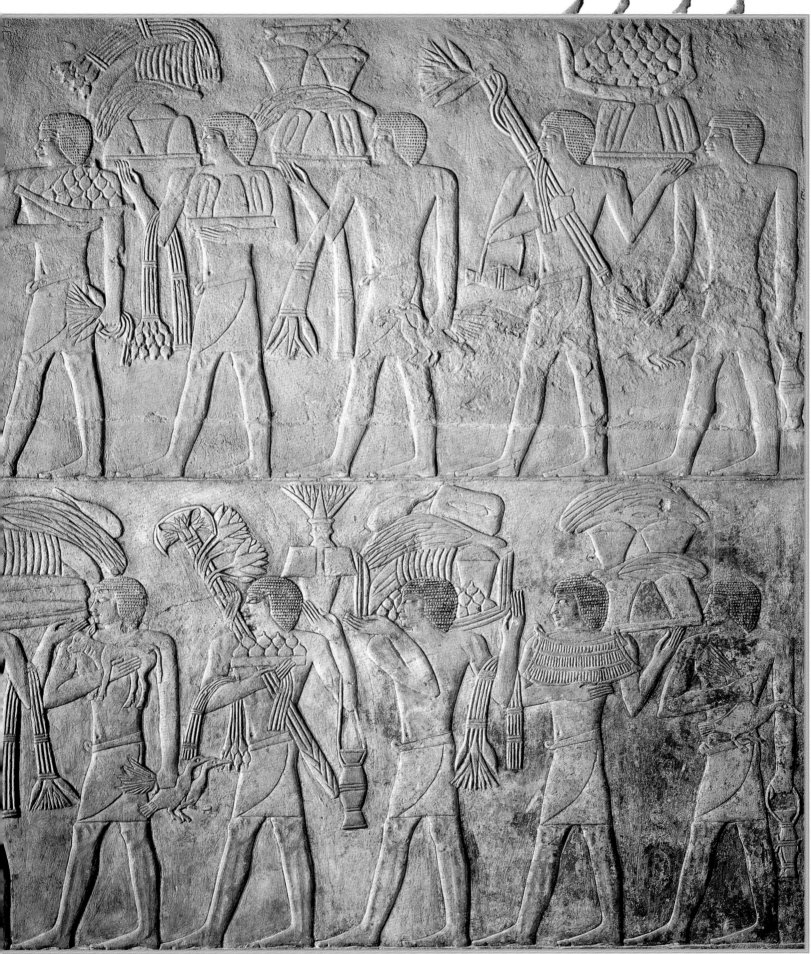

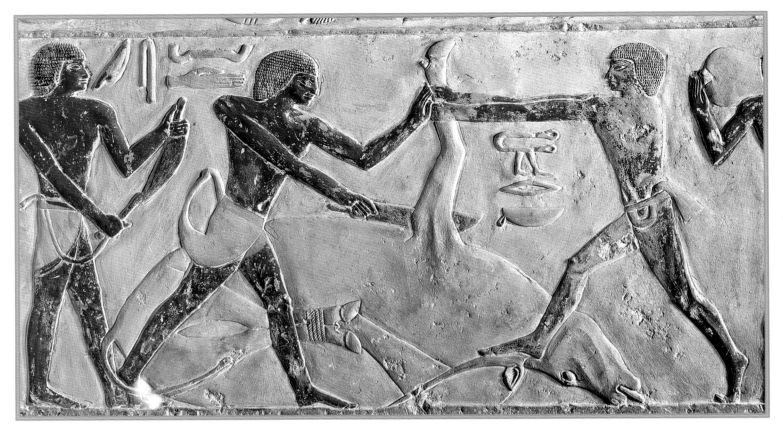

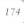

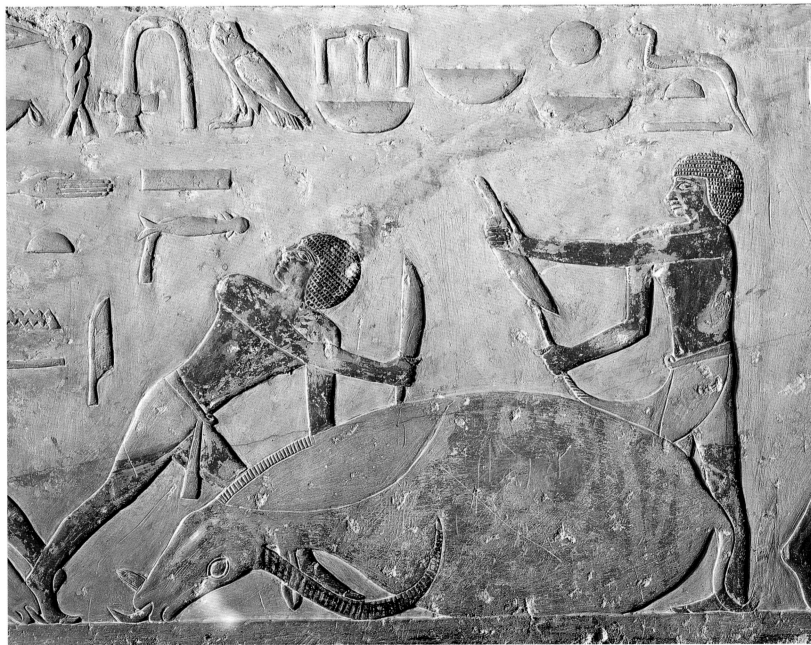

THE TOMB OF IDUT

174-175 *The artist has*
depicted slaughtering scenes
very realistically in the
tomb of Idut.

176-177 *The Nile is always*
shown in painted or
carved scenes in tombs.
In this case groups of men
on the upper register

transport birds and small
animals in light boats;
beneath, another group
in a boat leads large
cattle through the water.

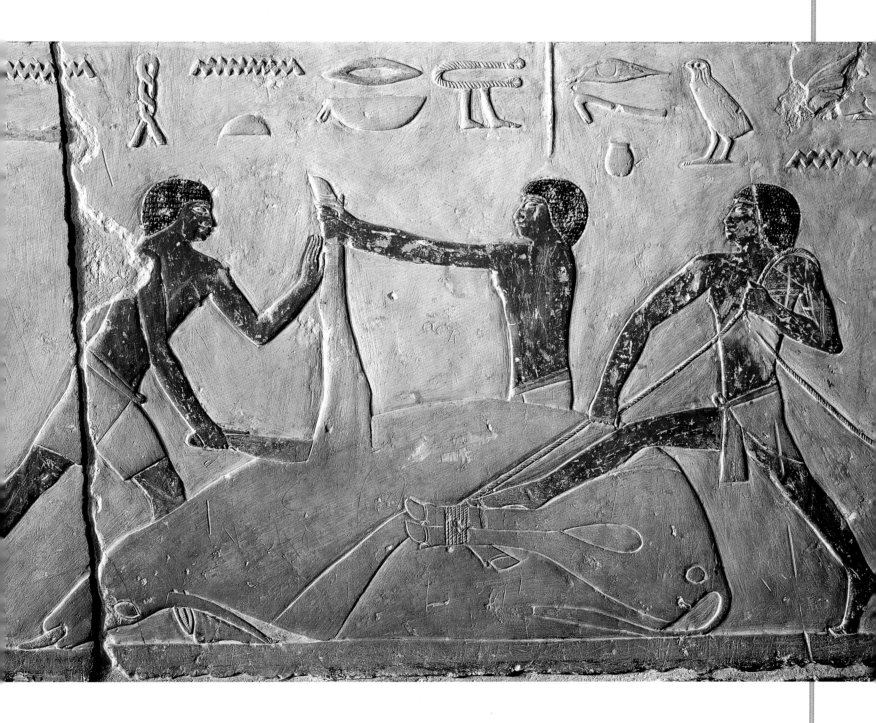

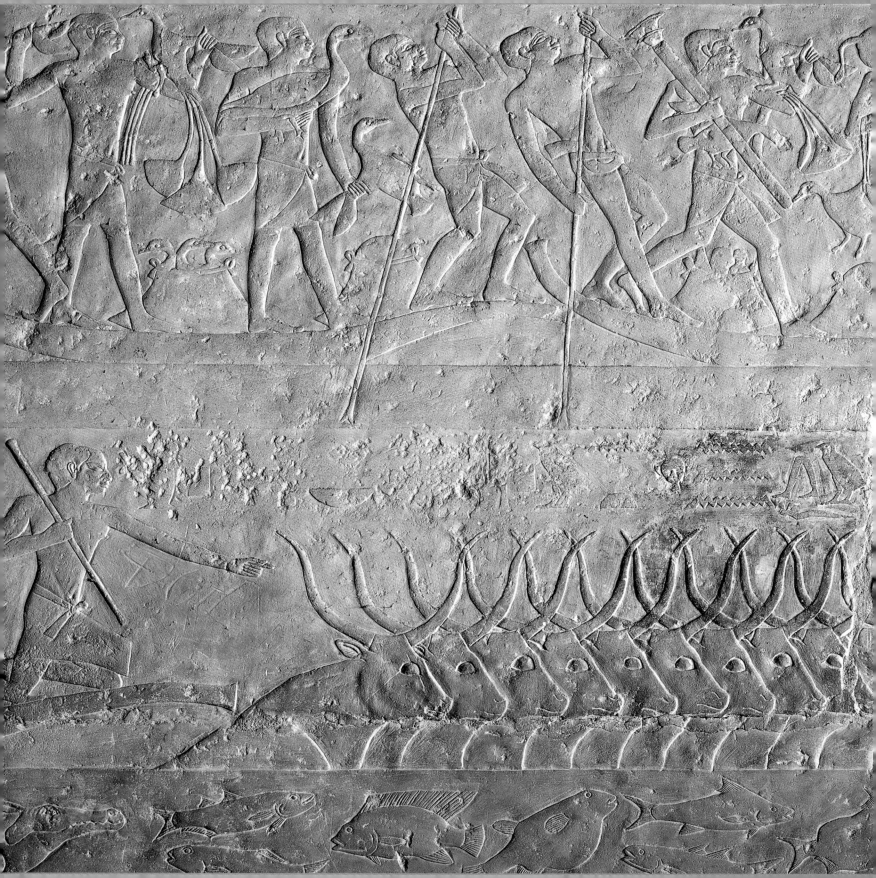

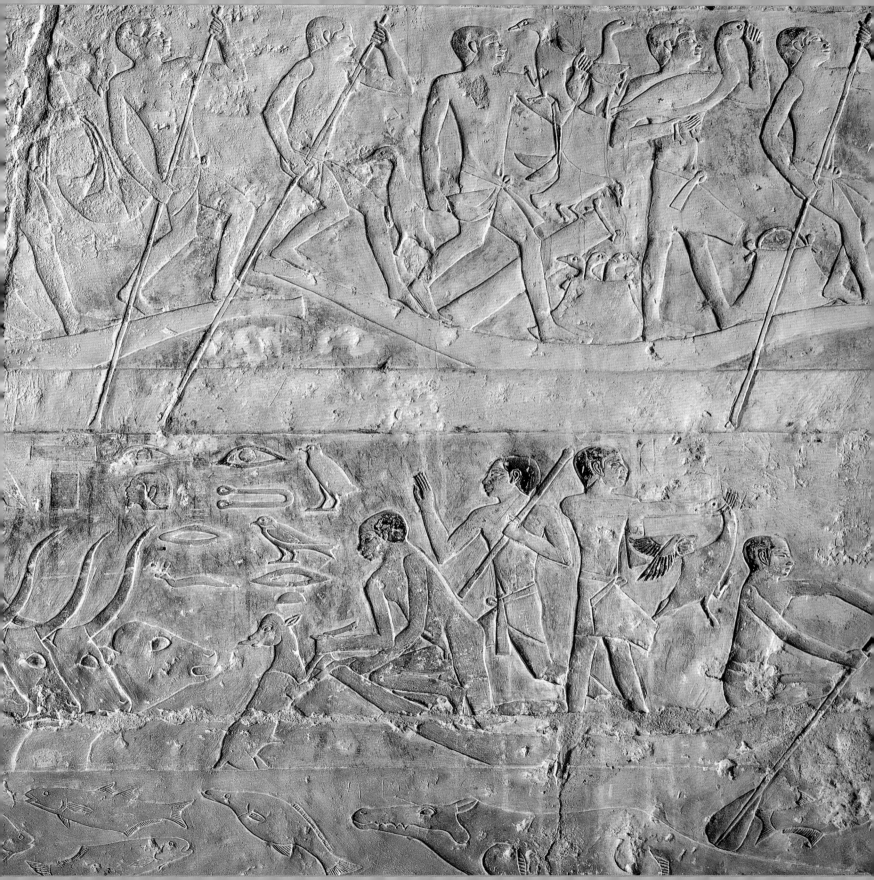

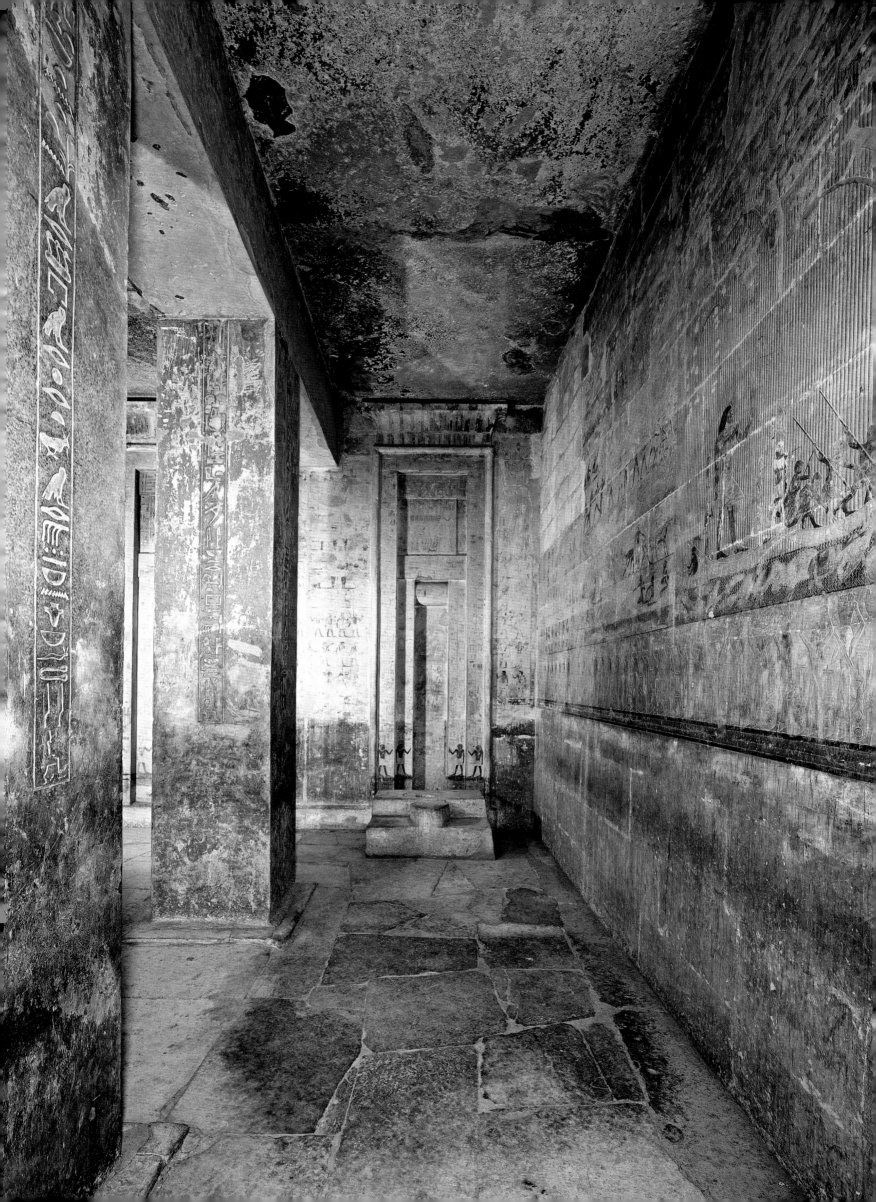

THE TOMB OF TI

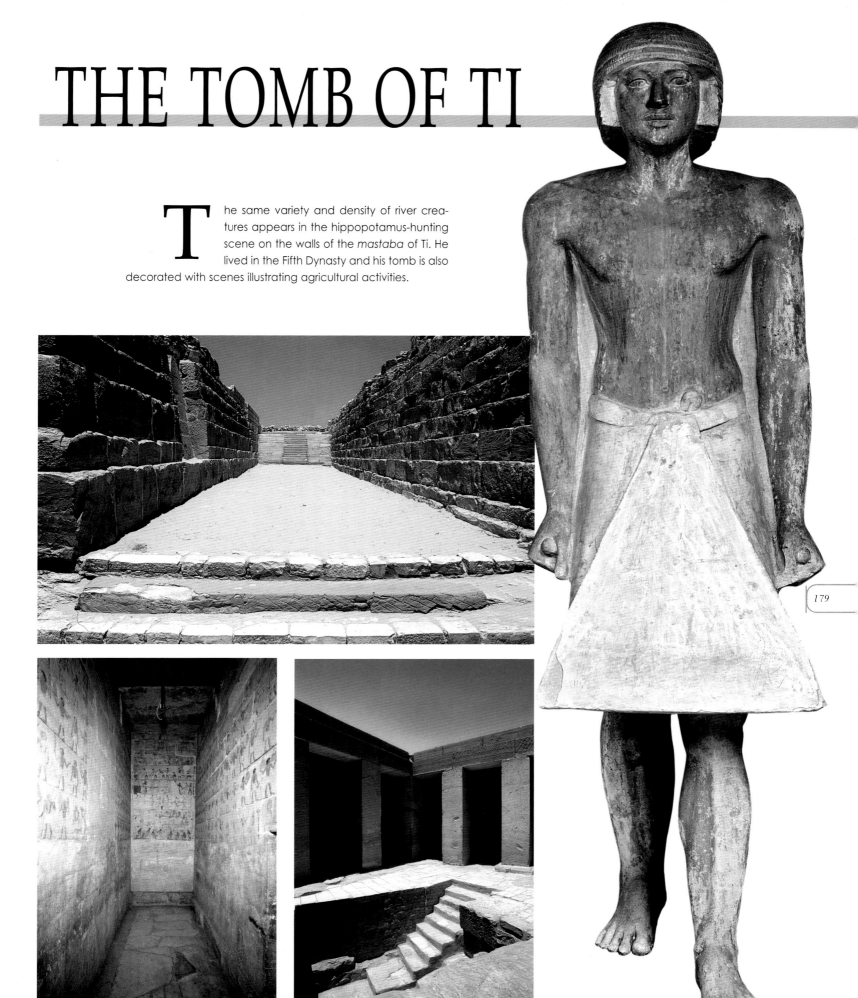

The same variety and density of river creatures appears in the hippopotamus-hunting scene on the walls of the *mastaba* of Ti. He lived in the Fifth Dynasty and his tomb is also decorated with scenes illustrating agricultural activities.

178 THE INTERIOR OF TI'S TOMB HAS A ROOM SUPPORTED IN THE CENTER BY TWO PILLARS DECORATED WITH INSCRIPTIONS AND PICTURES; AT THE BACK THERE IS A FALSE DOOR.

179 TOP LEFT AND BOTTOM CENTER THE MASTABA OF TI COMPRISES A WIDE APPROACH AND AN INNER COURT, SURROUNDED BY PILLARS, FROM WHERE THE BURIAL CHAMBER IS ACCESSED.

179 BOTTOM LEFT TI'S MASTABA IS FAMOUS FOR ITS BEAUTIFUL LOW-RELIEF DECORATIONS, WHICH ARE MASTERPIECES OF EGYPTIAN ART.

179 RIGHT TI, WHO LIVED IN THE FIFTH DYNASTY, WAS SUPERINTENDENT OF TWO PYRAMIDS AND FOUR SUN TEMPLES. FOR HIMSELF HE BUILT A TOMB NEXT TO DJOSER'S PYRAMID.

THE TOMB OF TI

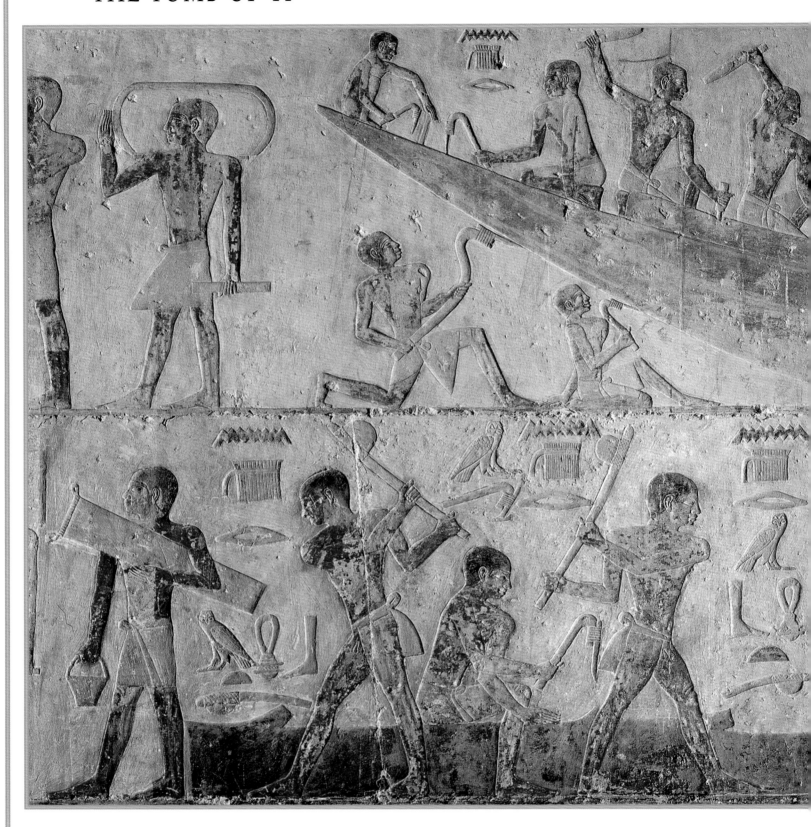

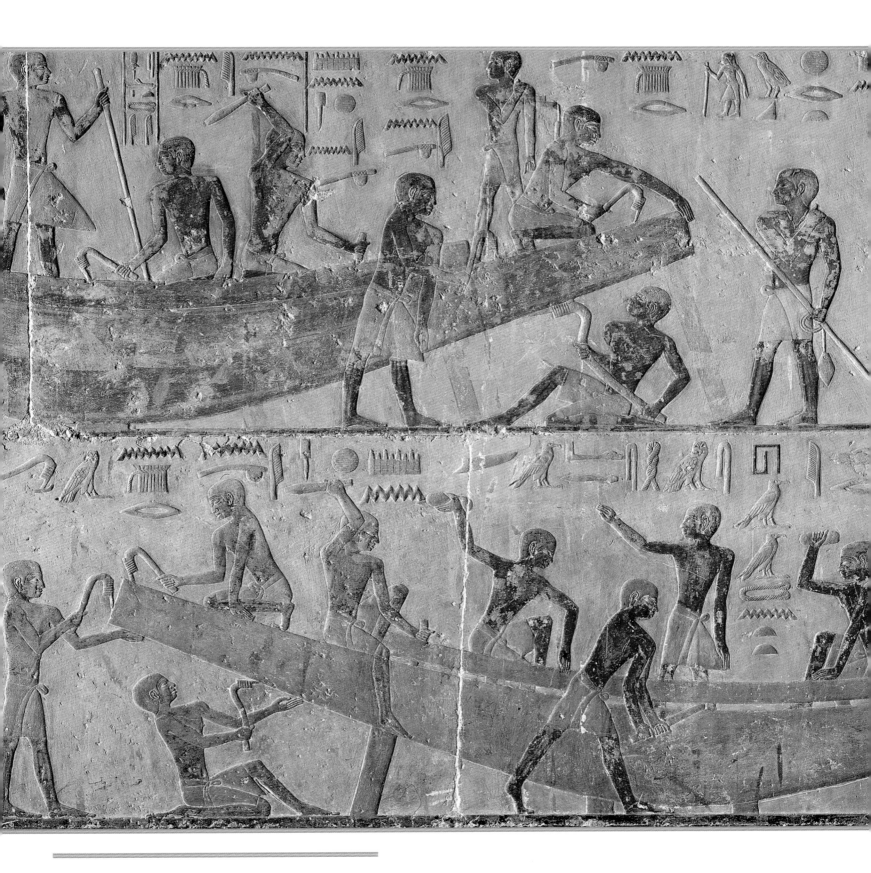

180-181 *This polychrome low relief in Ti's tomb shows how the construction and maintenance of the boats used on the Nile were important aspects of the management of resources and assets of rich landowners.*

182-183 *Ti's tomb has images of a hippopotamus hunt taking place in a thick cane thicket inhabited by birds and mongooses. Two groups of men in boats try to shoot the enormous creatures half-submerged in the water.*

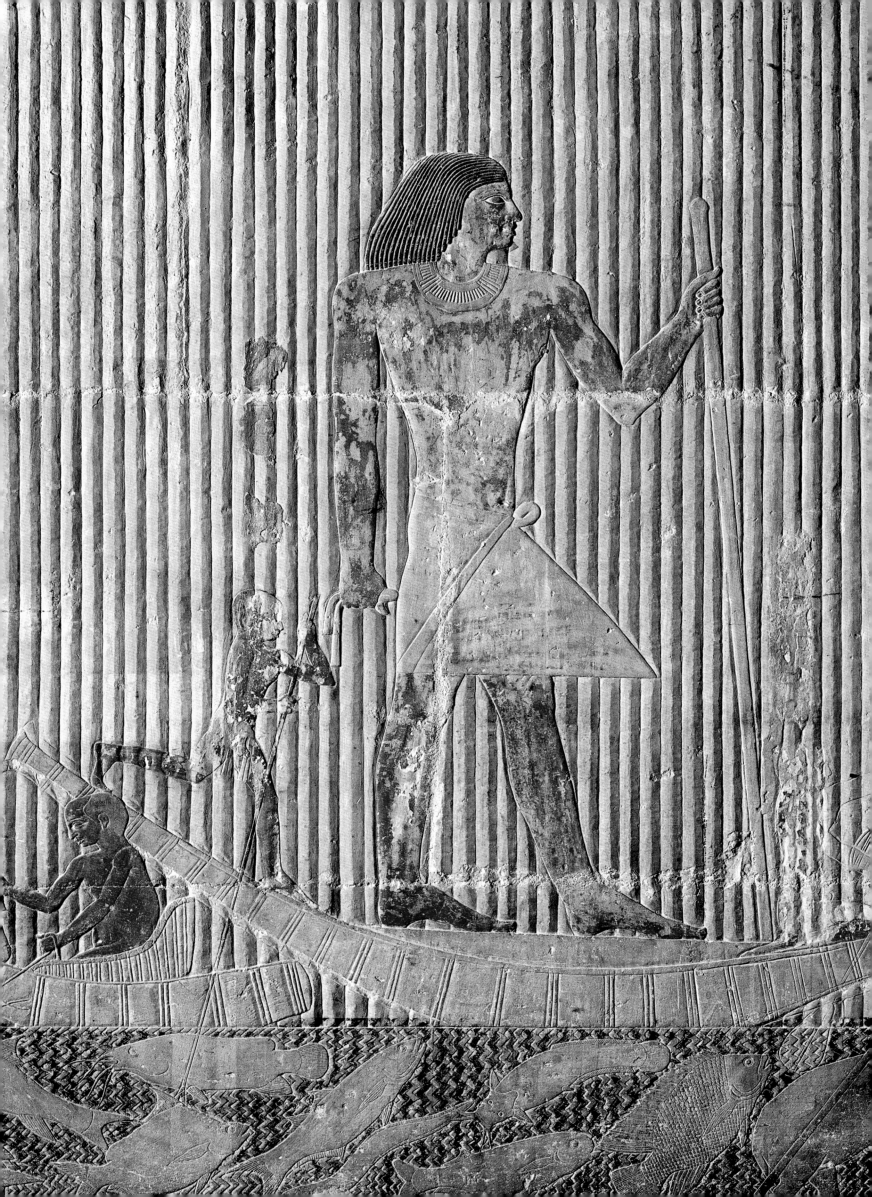

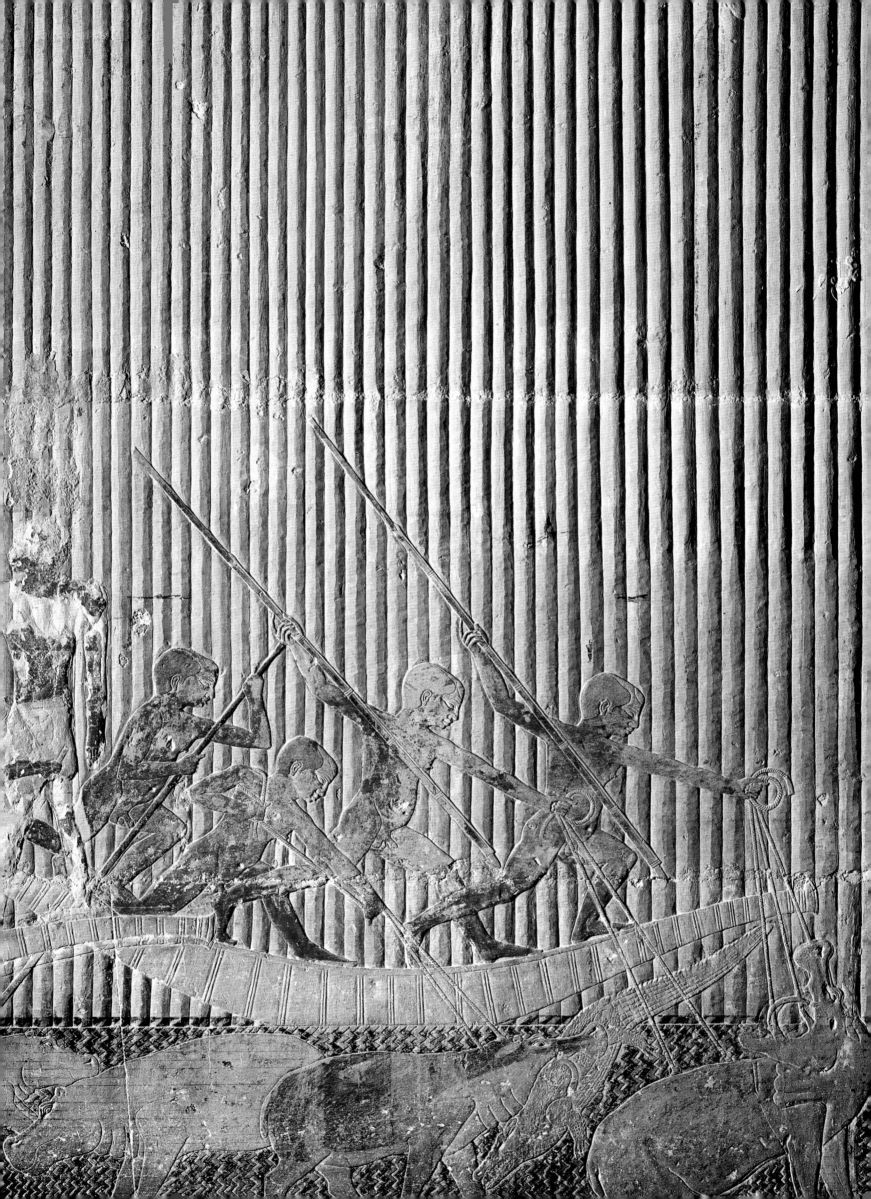

THE TOMB OF TI

*184 THE TWO IMAGES SHOW THE
CHIEF HAIRDRESSER IN TI'S COURT.
A SHRINE IS SEEN ABOVE, WHEREAS
BELOW HE IS ACCOMPANIED BY HIS
WIFE AND IS PRESENT AT AN
OFFERINGS CEREMONY.*

*184-185 ALL THE DELICACY
AND REFINEMENT OF EGYPTIAN
ART DURING THE OLD KINGDOM
IS APPARENT IN THIS DETAIL
OF A PROCESSION OF SERVANTS
BEARING OFFERINGS.*

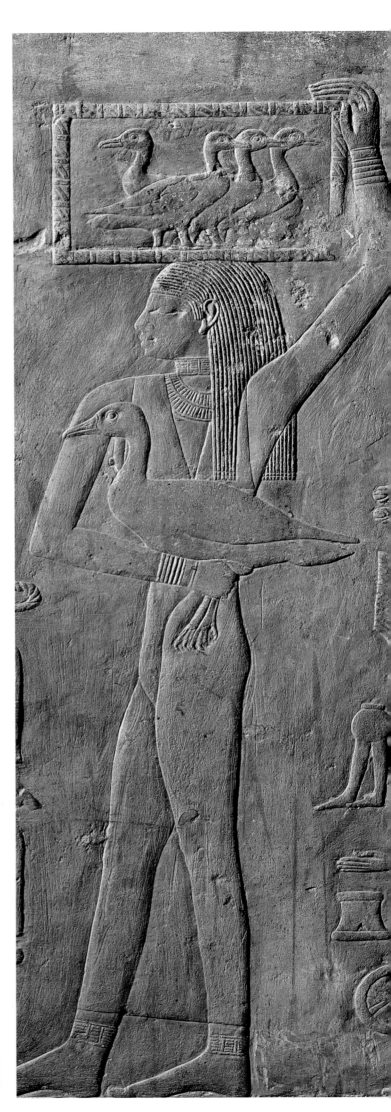

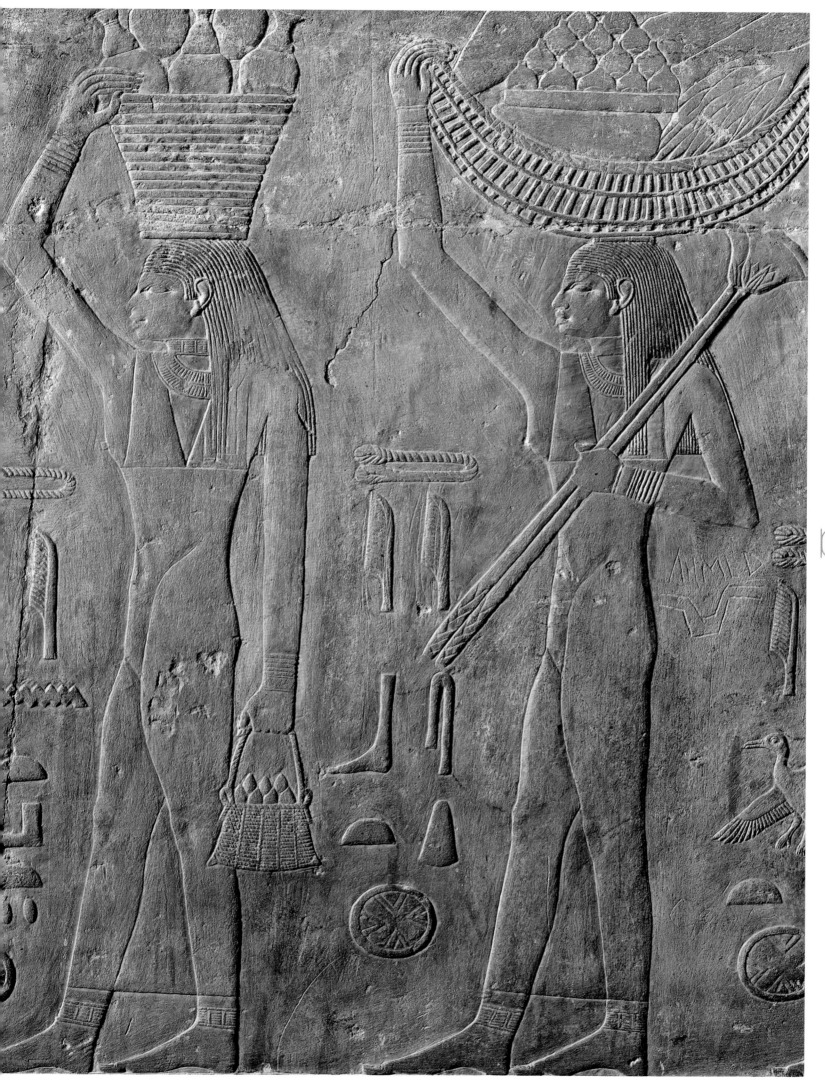

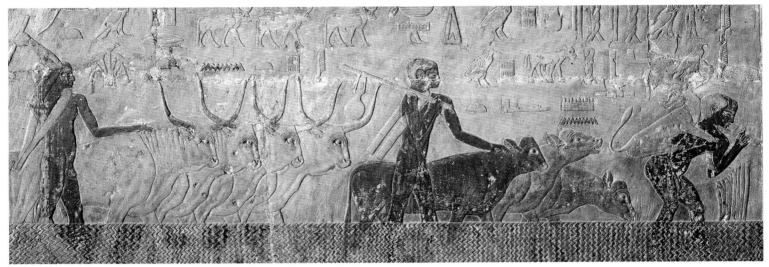

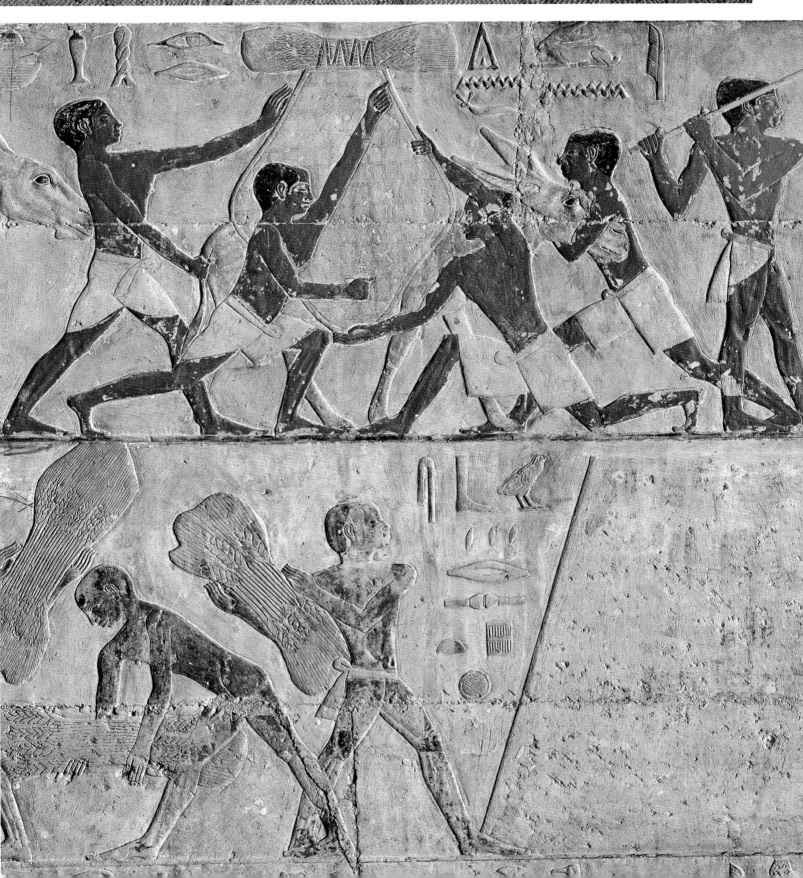

THE TOMB
OF TI

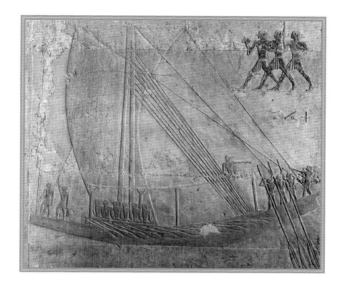

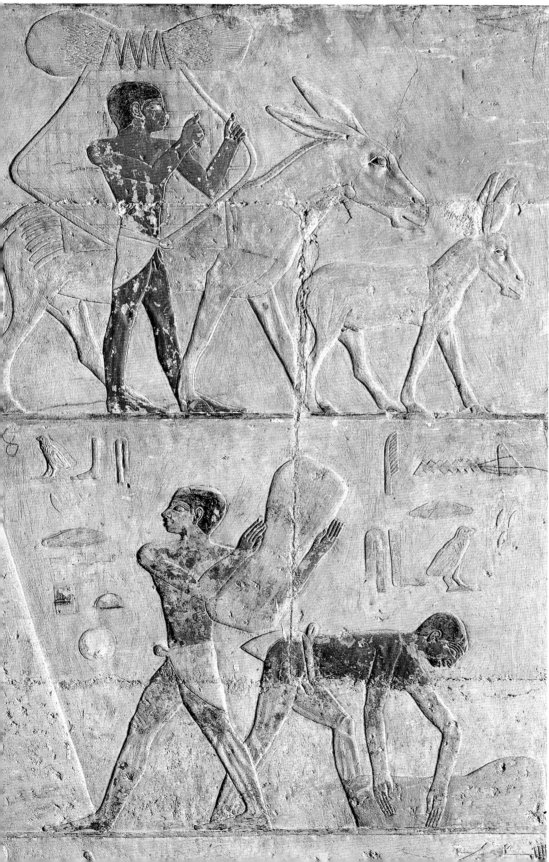

*186 AND 187 THE SCENES ON
THE WALLS OF THE TOMBS OF
EGYPTIAN DIGNITARIES HAVE
ALLOWED EXPERTS TO
UNDERSTAND MANY OF THE
CUSTOMS CURRENT IN ANTIQUITY.
HERE WE SEE THE FORDING OF A
STREAM BY PART OF A HERD (TOP
LEFT), VARIOUS SCENES OF WORK
IN THE FIELD (LEFT) AND SAILING
A BOAT (TOP).*

188 TOP *THE HIEROGLYPHS THAT COMPOSE THE NAME PTAHHOTEP ARE INSCRIBED ON AN ARCHITRAVE IN HIS TOMB; THE TOMB ITSELF IS COMPOSED OF SEVERAL COMMUNICATING ROOMS.*

188 BOTTOM *FALSE DOORS, WHICH IN PTAHHOTEP'S TOMB WAS ENTIRELY COVERED BY HIEROGLYPHS, SYMBOLIZED THE POINT OF CONTACT BETWEEN THE WORLDS OF THE LIVING AND THE DEAD.*

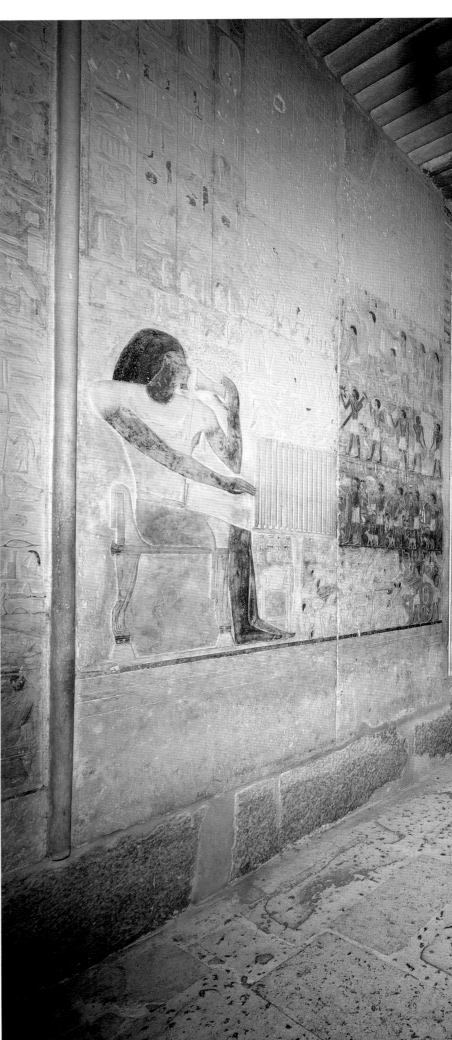

H unting and fishing are themes often seen on the walls of these tombs, but one on the wall of the *mastaba* of Ptahhotep (Fifth Dynasty) is particularly impressive. In this, fierce dogs sink their teeth into the throats of long-horned herbivores, a lion attacks a terrorized cow, an ichneumon (mongoose) sneaks through the low grass, and other animals feed and mate following the incessant cycle of life.

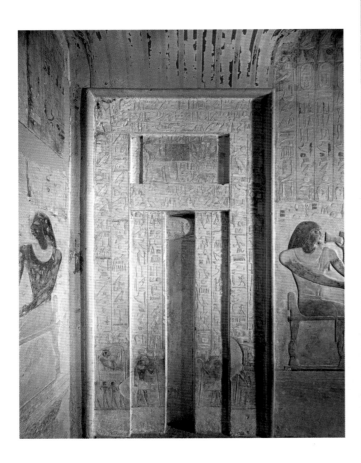

PTAHHOTEP

188-189 *PTAHHOTEP, WHOSE NAME MEANS "PTAH IS SATISFIED", WAS ONE OF THE MOST IMPORTANT NOBLES OF THE FIFTH DYNASTY AND BUILT A LARGE MASTABA TOMB FOR HIMSELF DECORATED WITH ELABORATE PAINTED LOW AND HIGH RELIEFS.*

189 *THE PICTURES SHOW TWO OF THE OUTERMOST ROOMS IN PTAHHOTEP'S MASTABA WHICH WERE RESERVED FOR TWO IMPORTANT DIGNITARIES – AKHETHOTEP AND PTAHHOTEP II – FATHER AND SON RESPECTIVELY AT THE END OF THE FIFTH DYNASTY.*

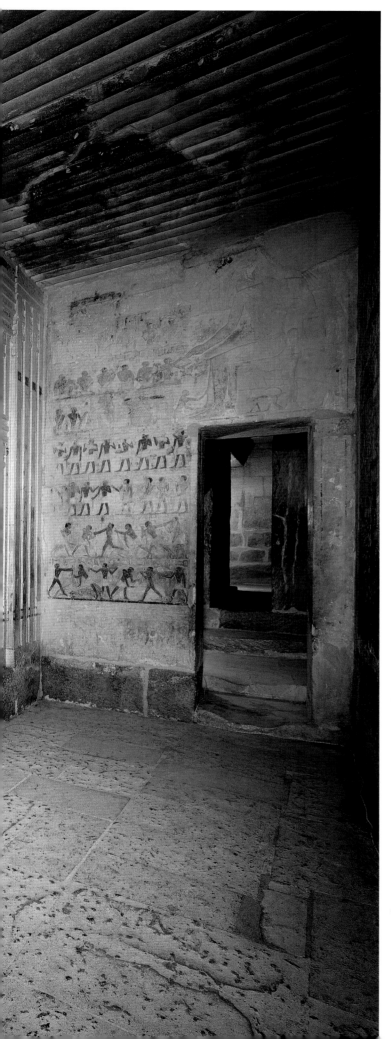

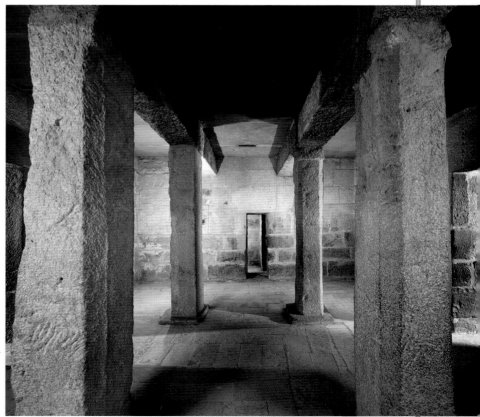

THE TOMB OF PTAHHOTEP

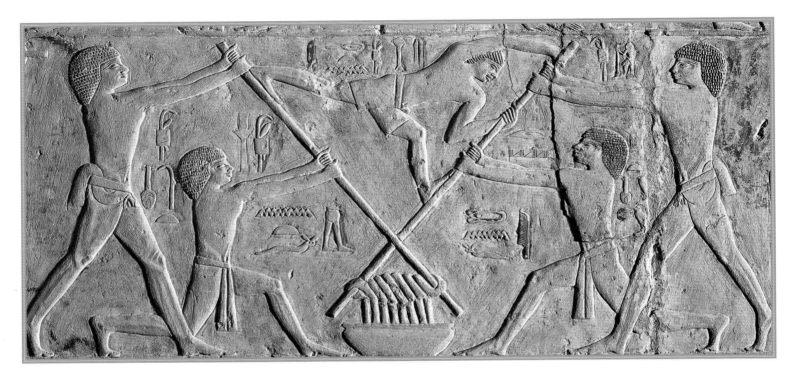

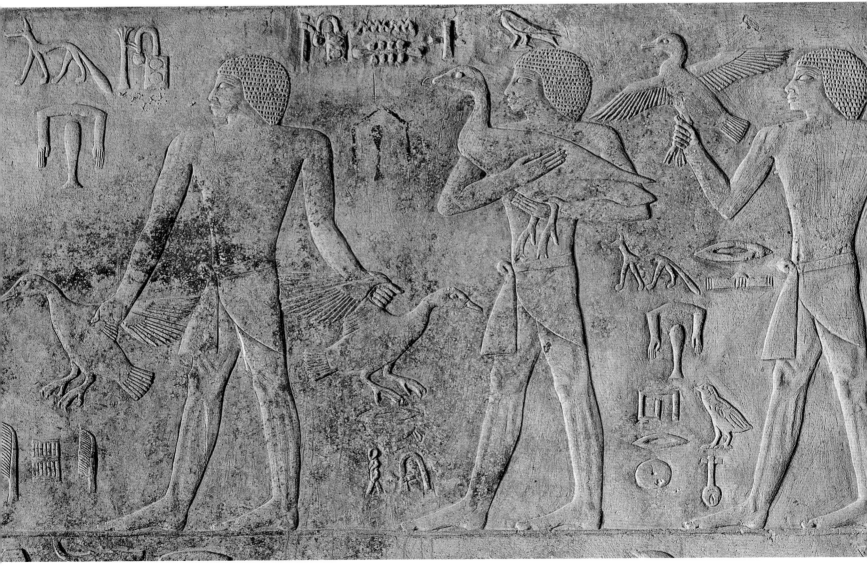

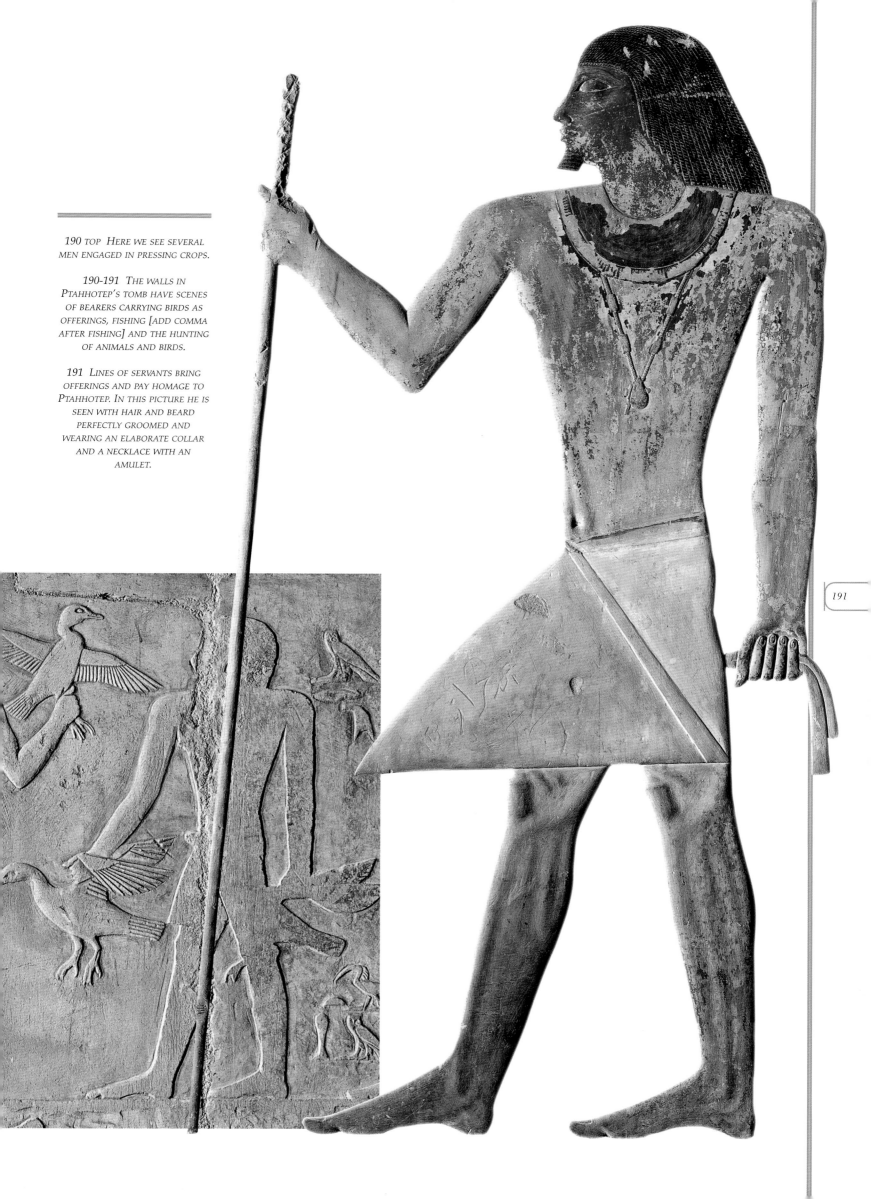

190 TOP HERE WE SEE SEVERAL
MEN ENGAGED IN PRESSING CROPS.

190-191 THE WALLS IN
PTAHHOTEP'S TOMB HAVE SCENES
OF BEARERS CARRYING BIRDS AS
OFFERINGS, FISHING [ADD COMMA
AFTER FISHING] AND THE HUNTING
OF ANIMALS AND BIRDS.

191 LINES OF SERVANTS BRING
OFFERINGS AND PAY HOMAGE TO
PTAHHOTEP. IN THIS PICTURE HE IS
SEEN WITH HAIR AND BEARD
PERFECTLY GROOMED AND
WEARING AN ELABORATE COLLAR
AND A NECKLACE WITH AN
AMULET.

192-193 TOP THE HIEROGLYPHS CARVED NEXT TO THE HEADS OF THE BIRDS ARE NUMBERS AND REFER TO THE VARIOUS GROUPS. THE PHYSICAL DIFFERENCES BETWEEN THE BIRDS ARE RENDERED IN DETAIL.

192-193 BOTTOM THE LONG SCENE SHOWING WILD ANIMALS CHASING ONE ANOTHER AND MATING IN THE DESERT IS CONCLUDED WITH A HUNTER WHO CAPTURES THEM WITH A TRAP.

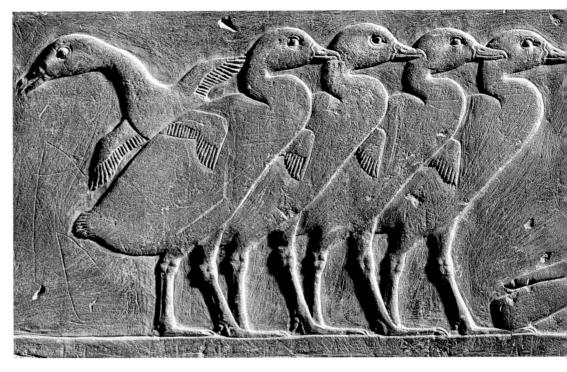

194-195 ONE OF THE MOST VIVID SCENES IN PTAHHOTEP'S TOMB IS OF THE LIFE OF VARIOUS WILD ANIMALS. IN ONE, A LION ATTACKS A TERRORIZED COW.

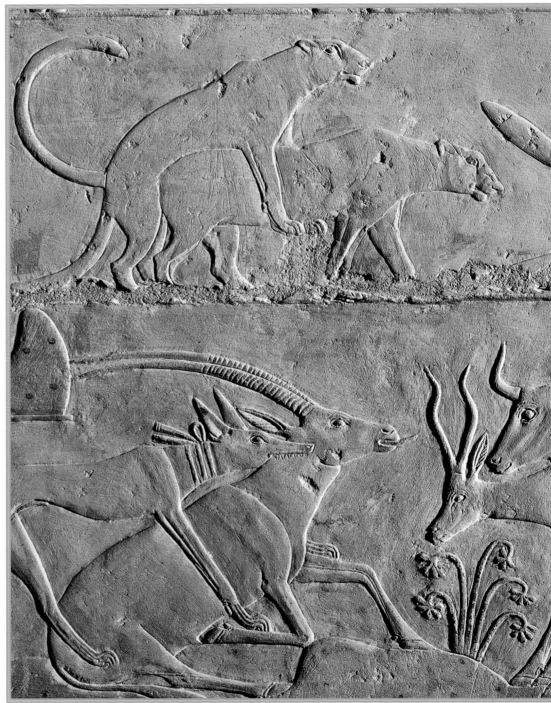

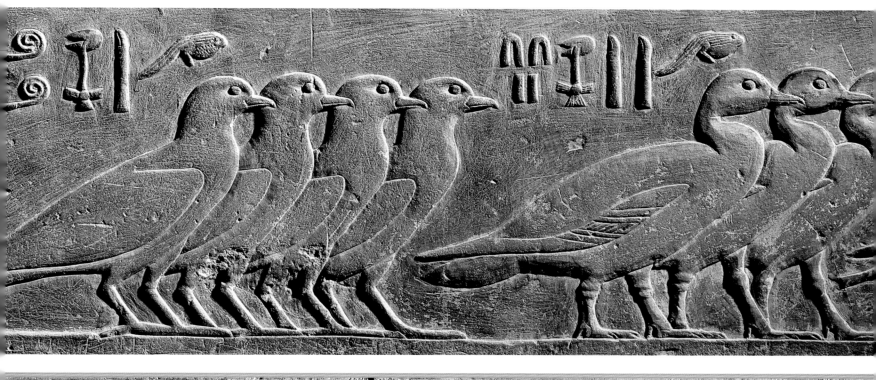

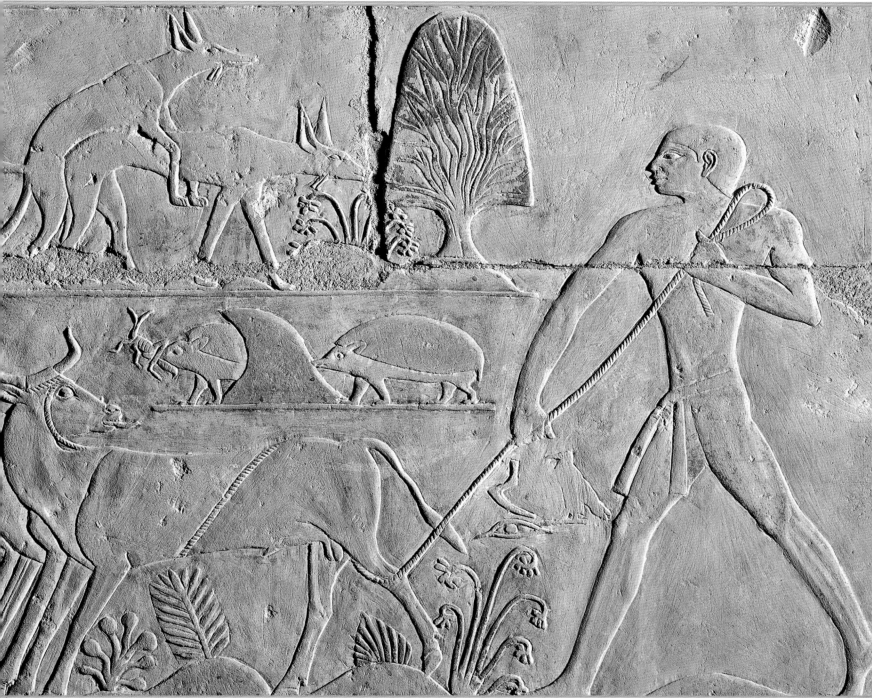

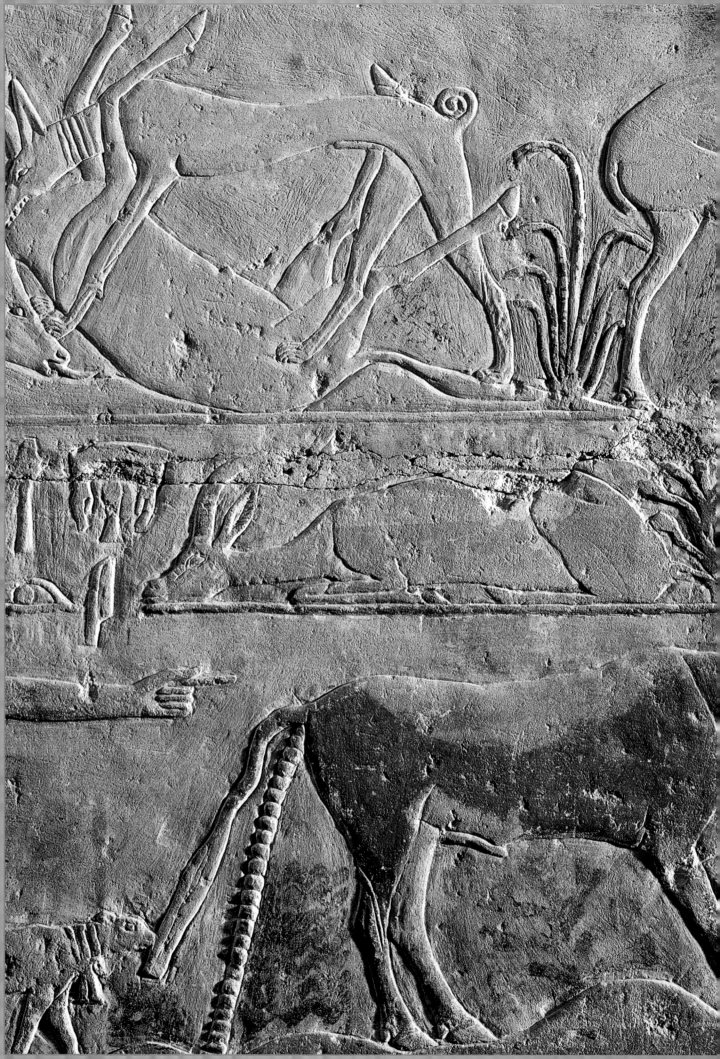

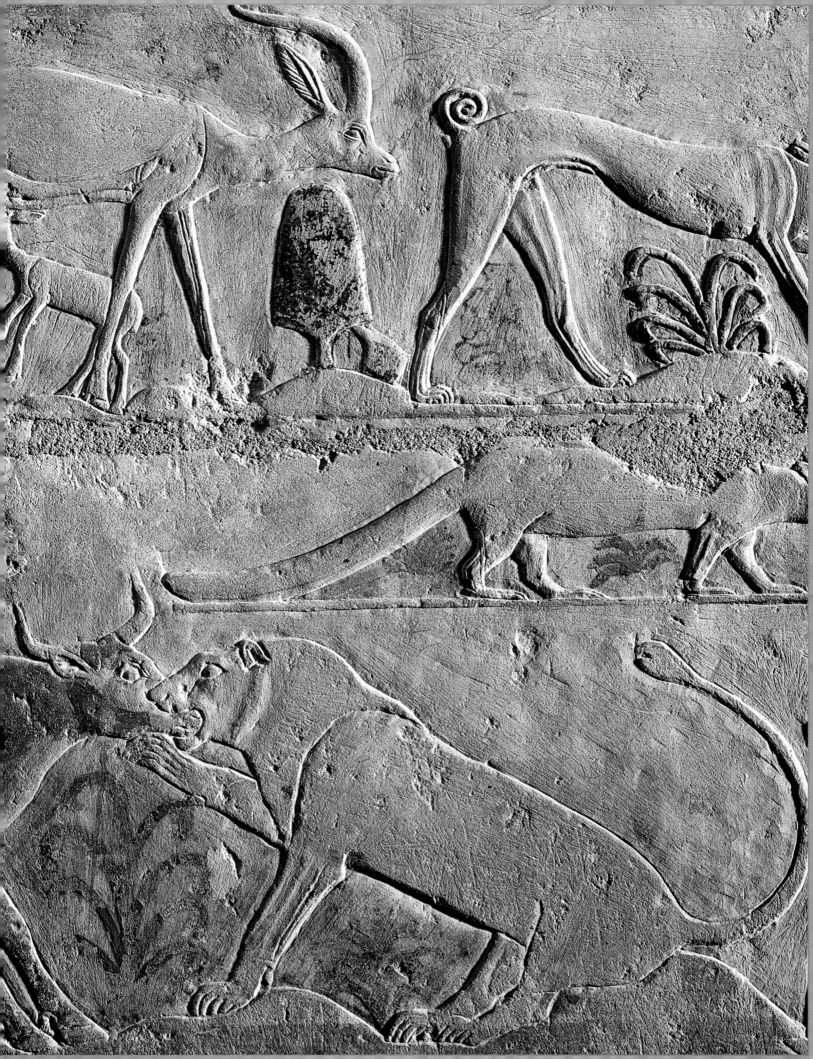

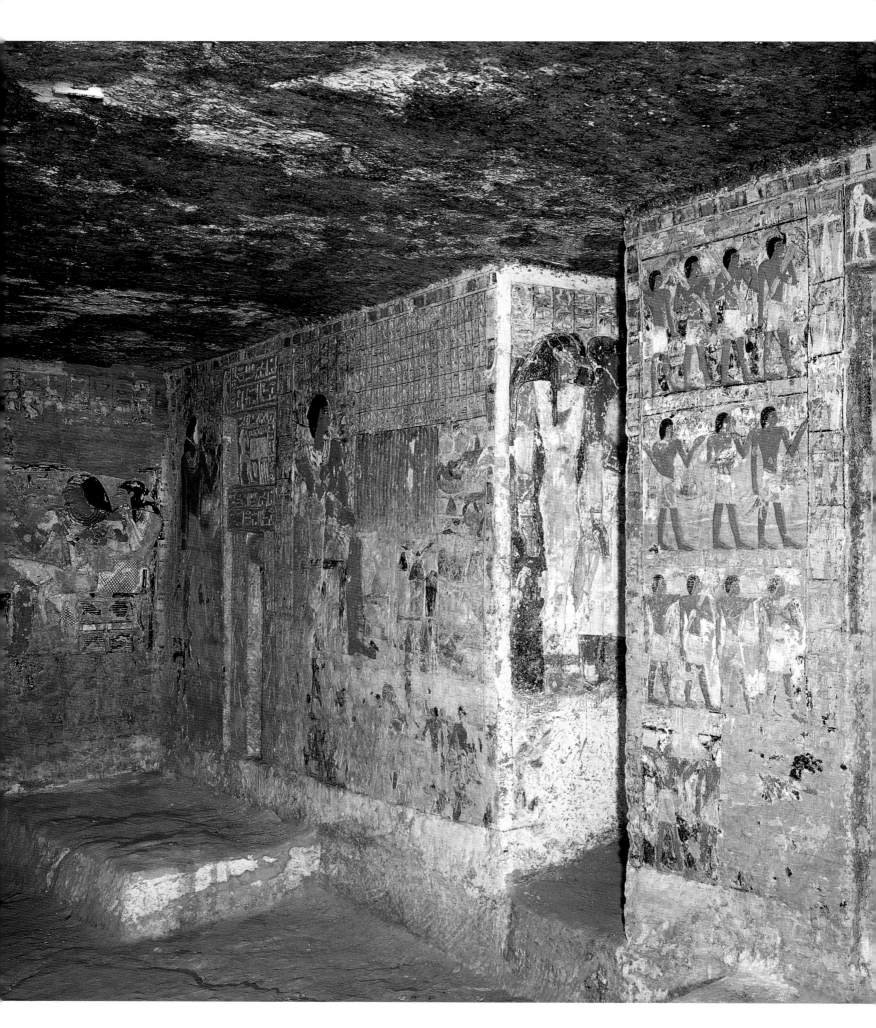

MEREFNEBEF

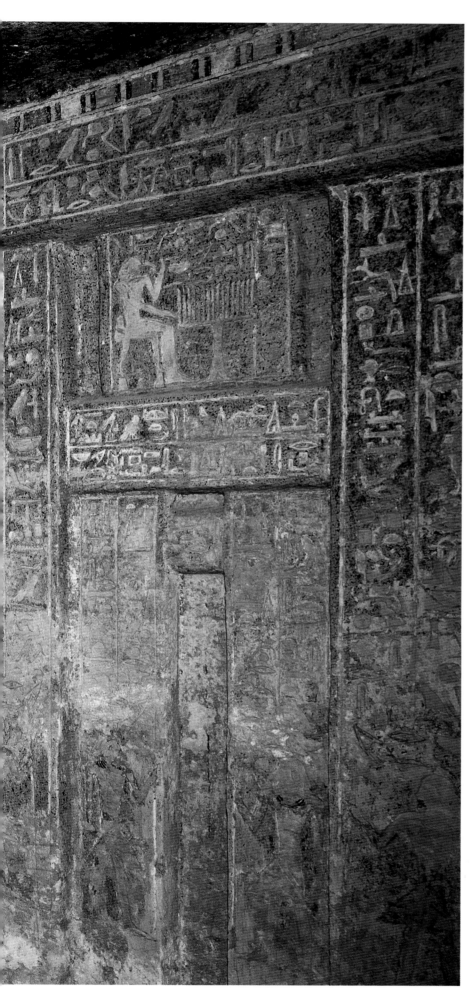

O f the many other richly decorated *mastabas* excavated at Saqqara, that of Merefnebef (Sixth Dynasty) stands out for its bright colors. The rock used to build the funerary apartment was not of the best quality and the paintings have not been very well preserved but, where the colors have endured, they are vivid. In a scene showing the deceased with a woman, it is possible to admire the skill with which the artist rendered the various materials of the clothes and the green and blue geometric patterns behind the heads of the two figures. The same bright green appears in the ritual hunting scene that has dense foliage as a background.

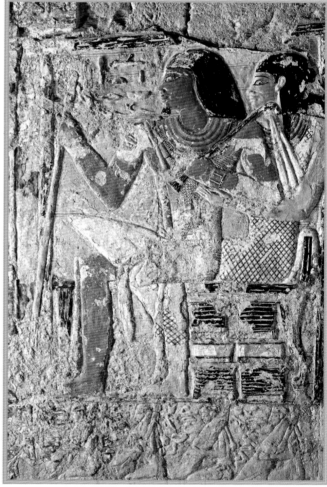

196-197 MEREFNEBEF'S RICHLY DECORATED MASTABA STILL HAS ITS ORIGINAL BRIGHT COLORING. THE PHOTOGRAPH SHOWS THE WEST WALL OF THE CHAPEL.

197 THE GRAND VIZIER MEREFNEBEF LIVED DURING THE FIRST HALF OF THE SIXTH DYNASTY. HE IS PORTRAYED HERE WITH A LADY, PROBABLY HIS WIFE.

THE TOMB OF NIANKHKHUM

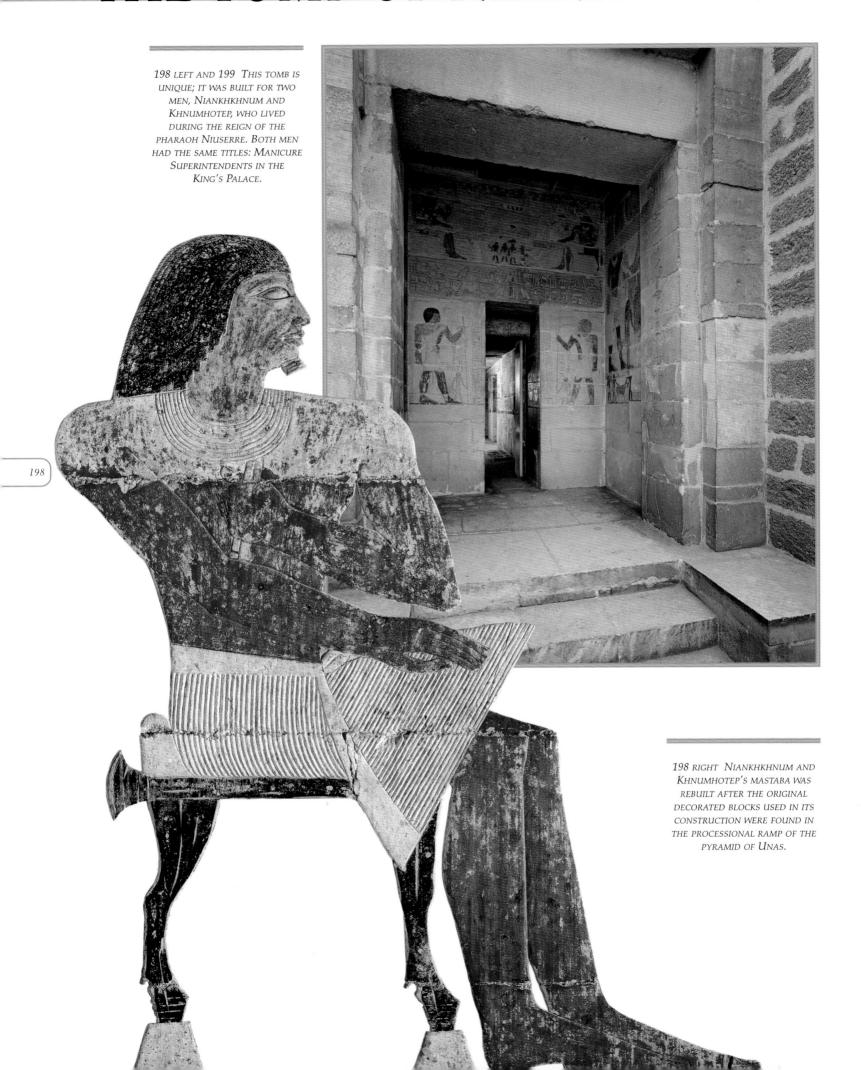

198 LEFT AND 199 *THIS TOMB IS UNIQUE; IT WAS BUILT FOR TWO MEN, NIANKHKHNUM AND KHNUMHOTEP, WHO LIVED DURING THE REIGN OF THE PHARAOH NIUSERRE. BOTH MEN HAD THE SAME TITLES: MANICURE SUPERINTENDENTS IN THE KING'S PALACE.*

198 RIGHT *NIANKHKHNUM AND KHNUMHOTEP'S MASTABA WAS REBUILT AFTER THE ORIGINAL DECORATED BLOCKS USED IN ITS CONSTRUCTION WERE FOUND IN THE PROCESSIONAL RAMP OF THE PYRAMID OF UNAS.*

AND KHNUMHOTEP

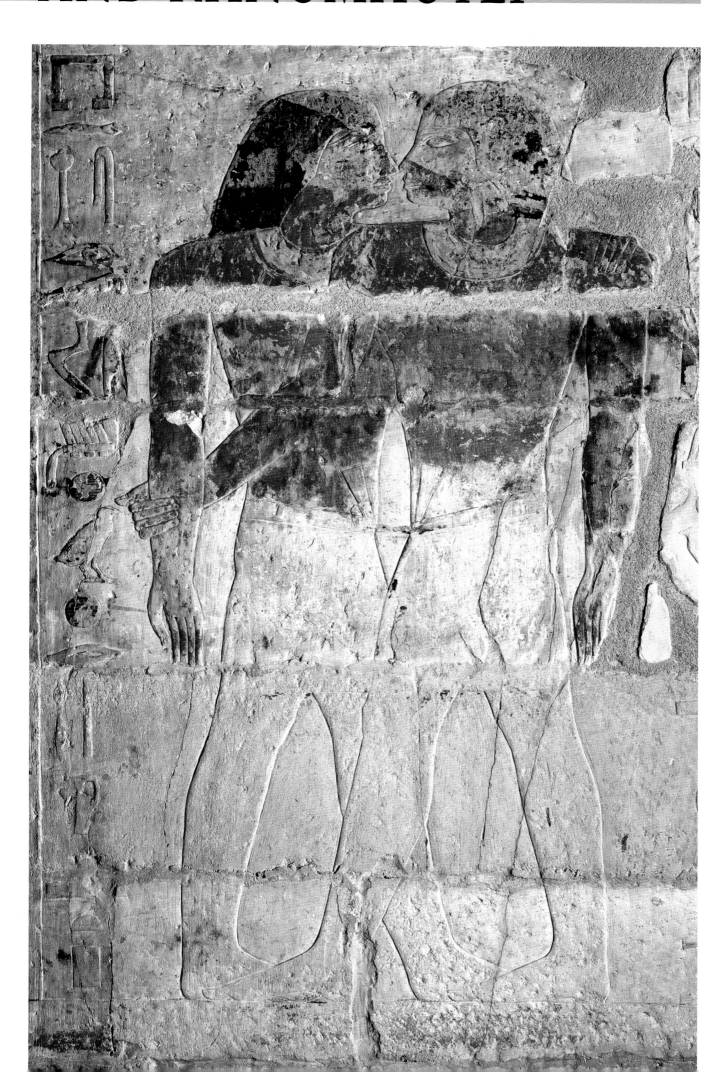

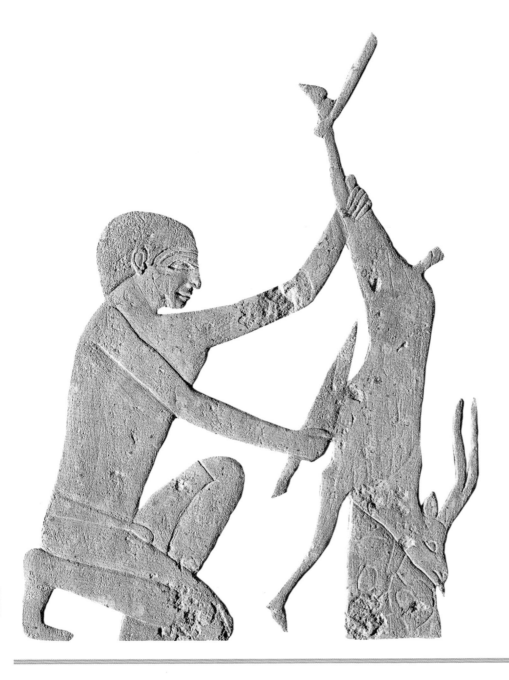

200

200-201 ONE PART OF THE
'MASTABA OF THE TWO
BROTHERS,' BUILT FOR
NIANKHKHNUM AND

KHNUMHOTEP IN THE FIFTH
DYNASTY, WAS DUG OUT OF THE
ROCK AND THE OTHER PART BUILT.
THE WALLS ARE COVERED WITH

VERY DETAILED SCENES OF A MAN
CUTTING OPEN AN ANIMAL HE HAS
JUST KILLED AND OF A FIGHT
TAKING PLACE ON BOATS.

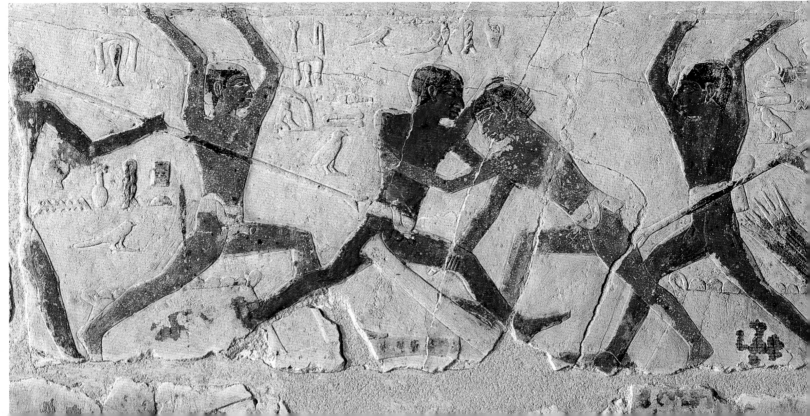

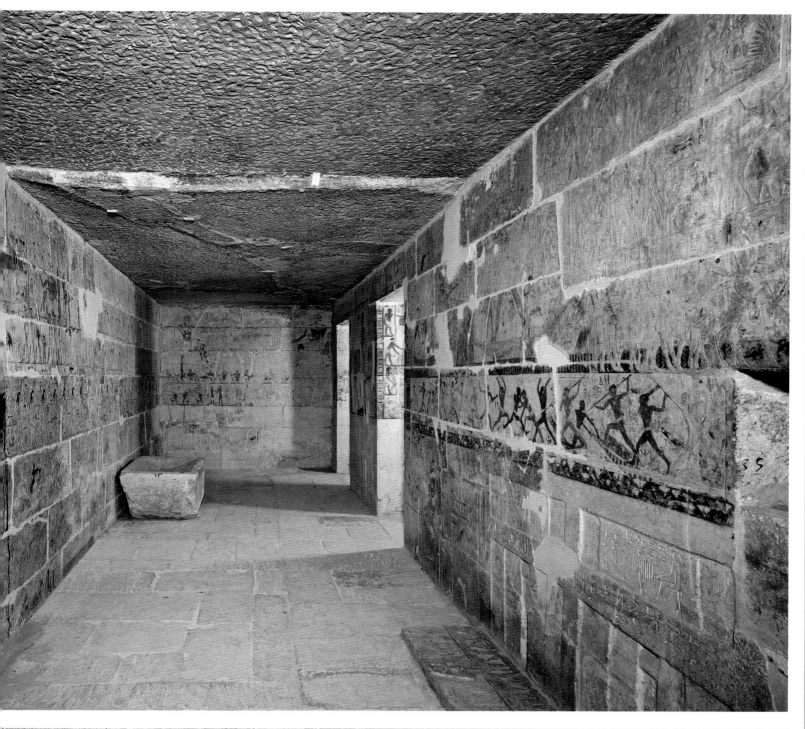

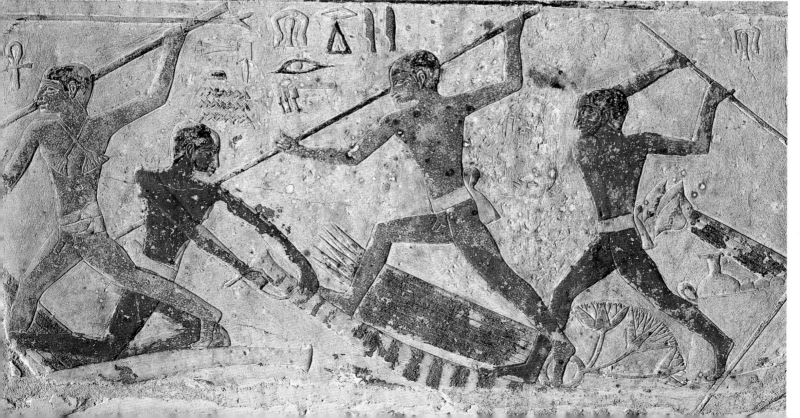

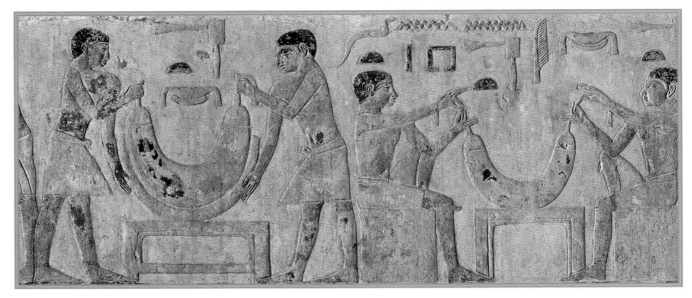

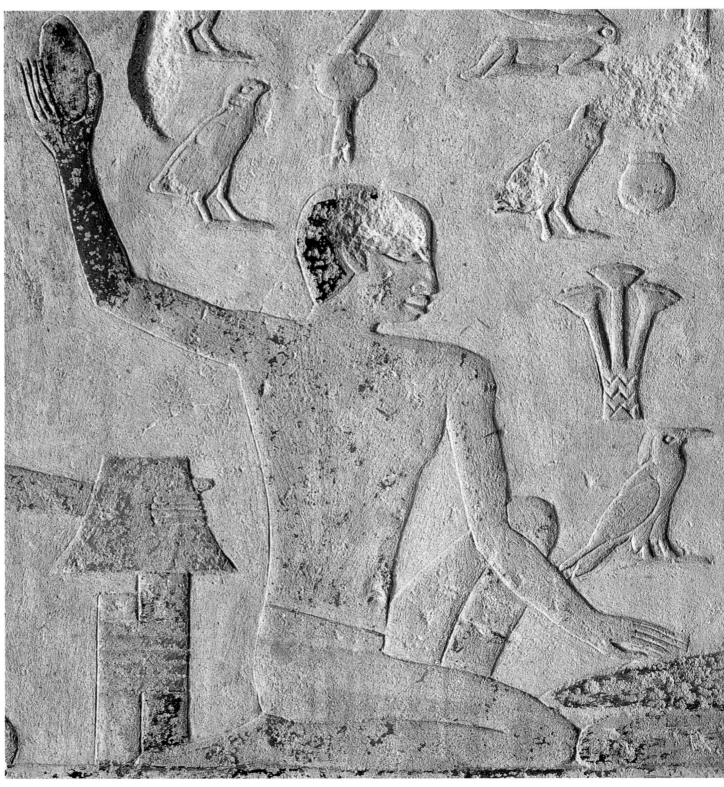

202-203 *THE SCENES DEPICTED
ON THE WALLS OF NIANKHKHNUM
AND KHNUMHOTEP'S MASTABA
SHOW VARIOUS EVERYDAY
ACTIVITIES PERFORMED BY THE*

*SKILLED CRAFTSMEN OF THE OLD
KINGDOM. HERE WE SEE MEN
PREPARING OBJECTS TO BE USED
AS THE GRAVE GOODS FOR THE
DECEASED PAIR, IN PARTICULAR*

*THE MANUFACTURE OF JEWELED
COLLARS (TOP LEFT AND BOTTOM
RIGHT). AT BOTTOM LEFT NOTE
TWO CROUCHING SERVANTS
WORKING TOGETHER.*

THE TOMB OF NIANKHKHUM AND KHNUMHOTEP

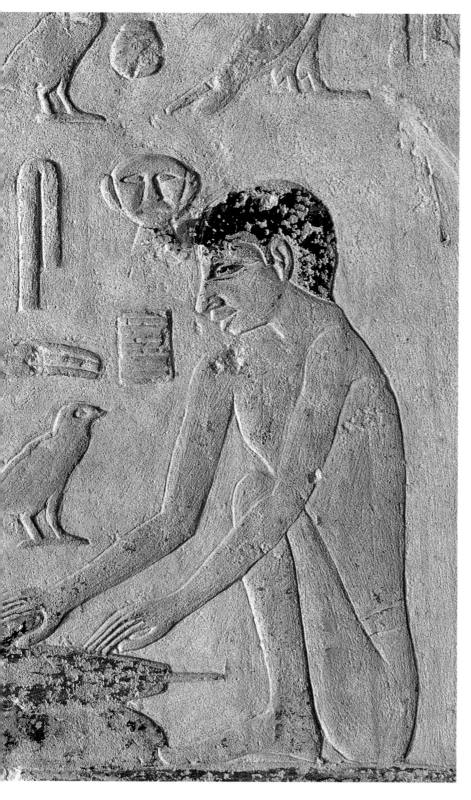

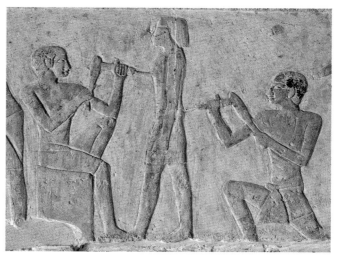

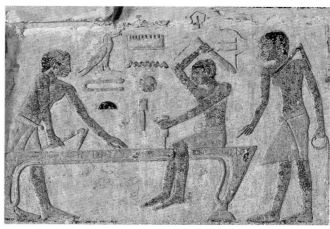

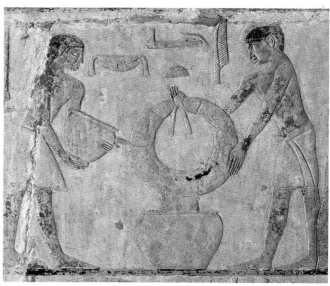

THE TOMB OF MEHU

204 TOP THE SUPERSTRUCTURE OF THE TOMB OF MEHU HAS A COURT, A CORRIDOR, AND TWO COVERED ROOMS. UNDERGROUND THE SMALL BURIAL CHAMBER IS REACHED DOWN A NARROW SLOPING CORRIDOR.

204 BOTTOM AND 205 VIVID COLORS SHOW UP THE FIGURES AND HIEROGLYPHS PAINTED ON THE WALLS AND FALSE DOORS OF MEHU'S MASTABA. MEHU WAS THE VIZIER AND MINISTER OF JUSTICE DURING TETI'S REIGN.

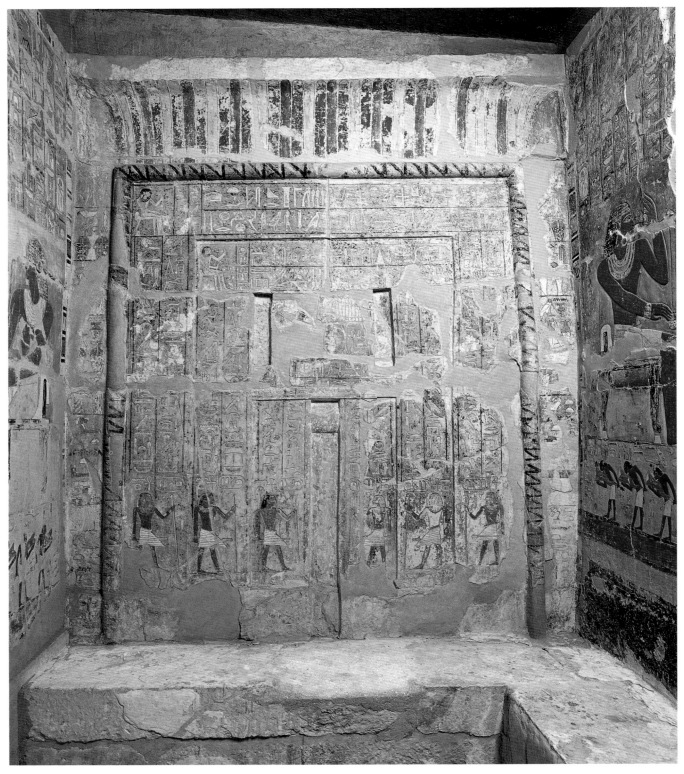

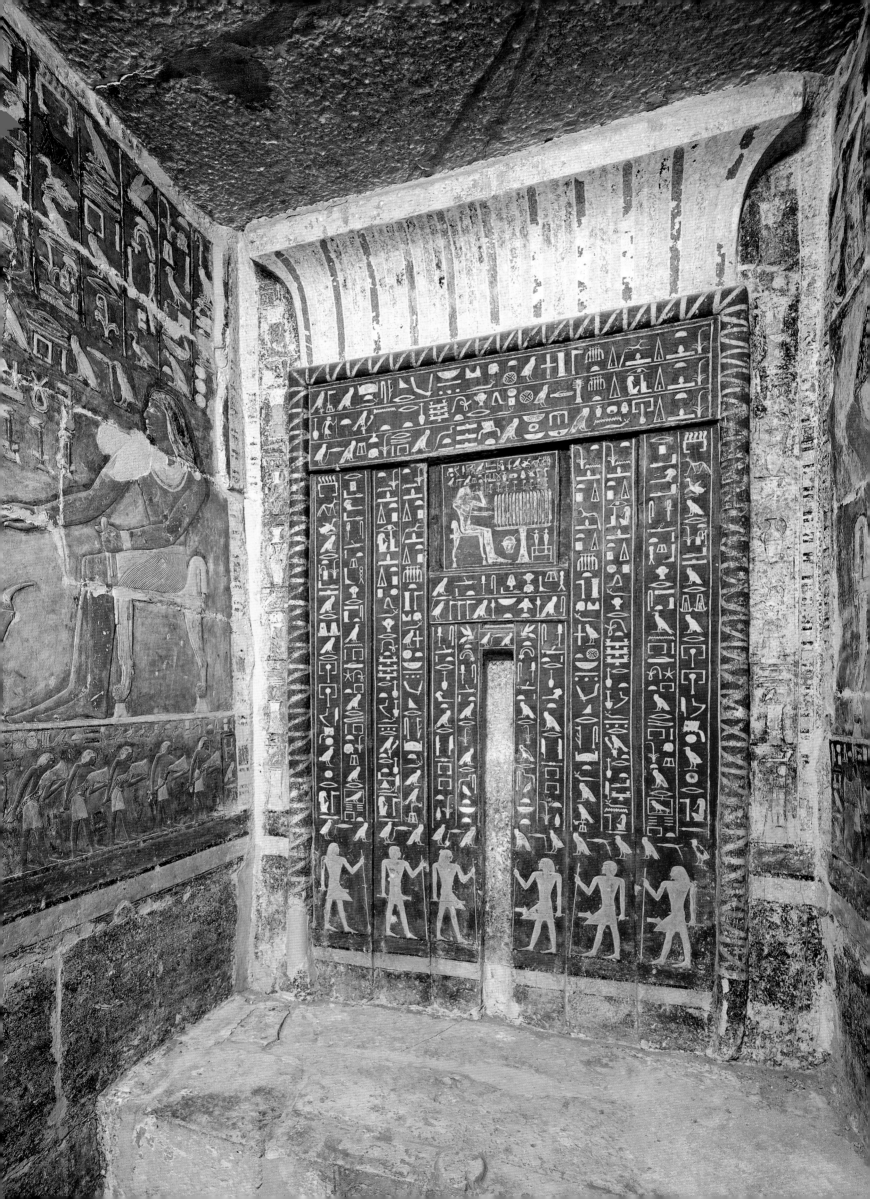

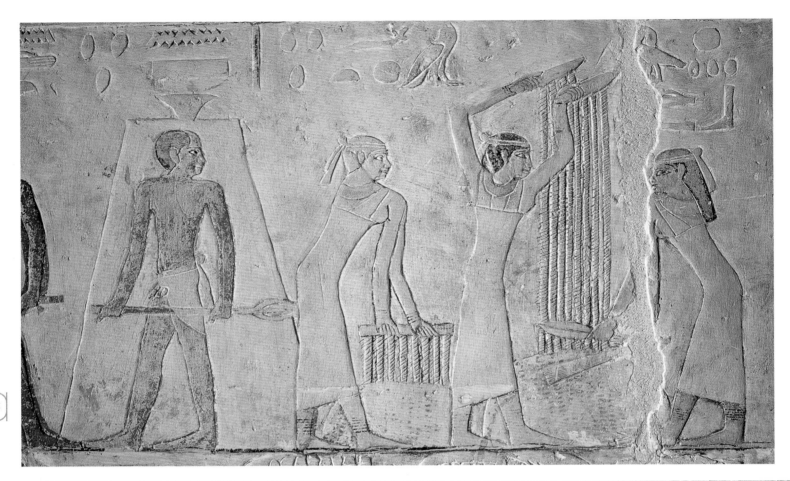

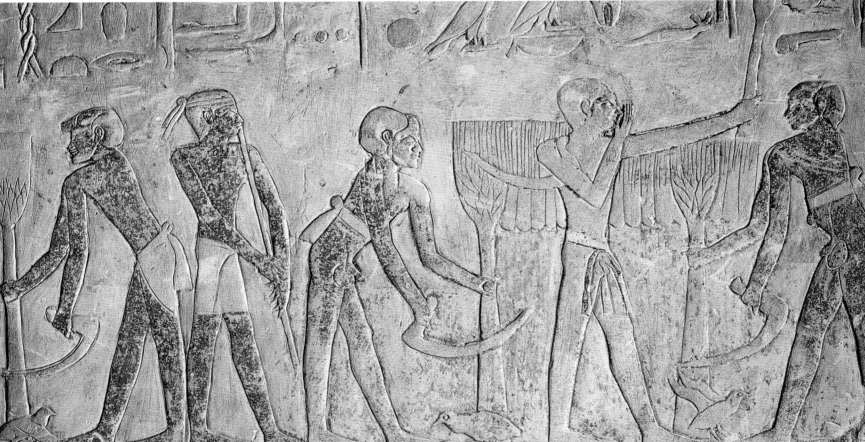

206 TOP AND 206-207 SERVANTS
BRING FOOD, LOOK AFTER THE
ANIMALS AND CARRY OUT
DOMESTIC AND AGRICULTURAL
DUTIES ON THE WALLS OF
MEHU'S TOMB.

207 TOP MEHU'S MASTABA HAS
A REPRESENTATION OF AN
IMPRESSIVE SAILING BOAT. IN
THIS RELIEF ONE CAN ADMIRE
THE CREW WHILE WORKING AT
THE BIG SQUARE SAIL.

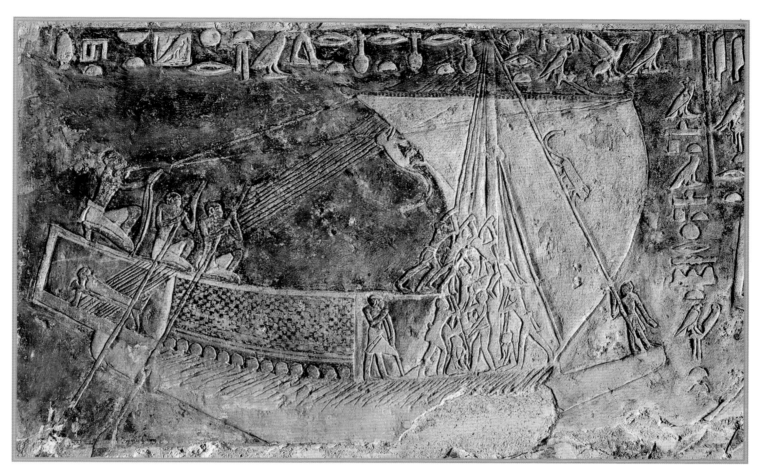

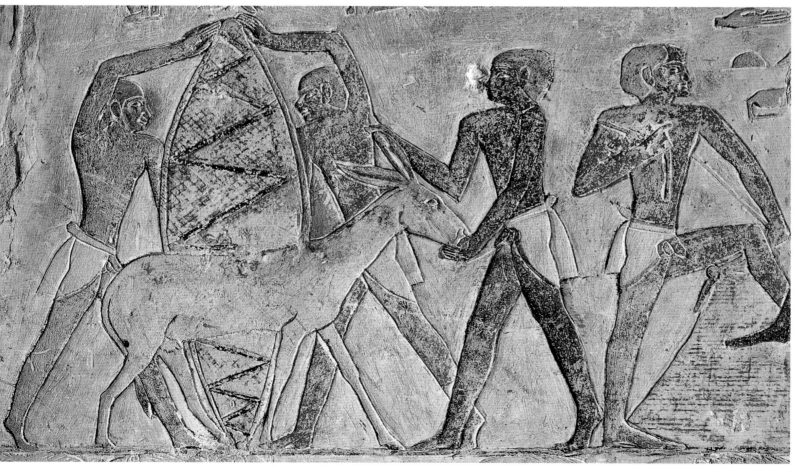

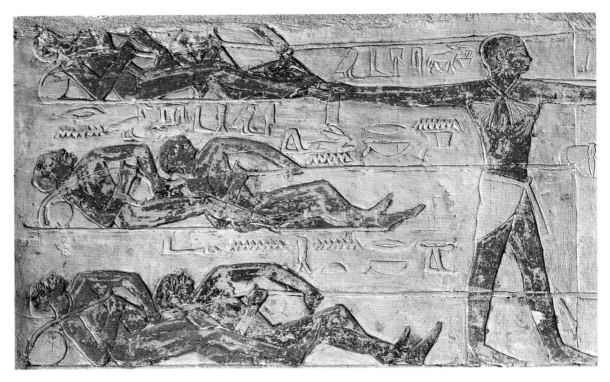

208 TOP ONE OF THE SCENES
REFERRING TO THE POSSESSIONS
OF THE DECEASED IS OF MEN
TRAPPING BIRDS. ONE MAN
STANDING DIRECTS OTHERS WHO
ARE SEATED OR LYING DOWN AND
GATHERING UP THE NETS IN
WHICH THE BIRDS ARE CAUGHT.

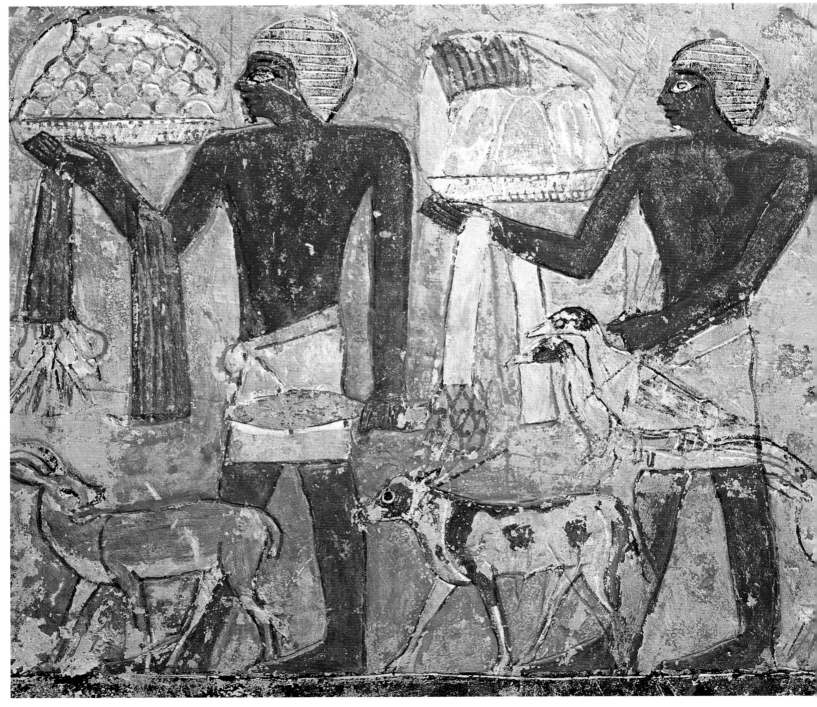

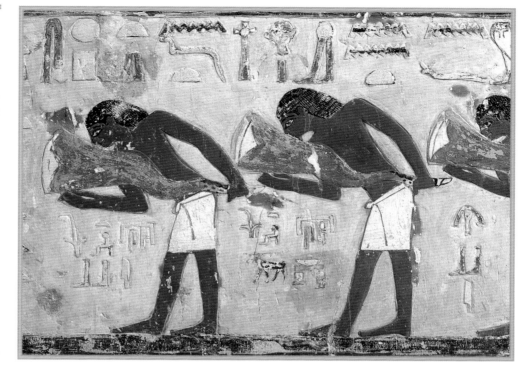

208-209, 209 TOP, AND 210-211 HIGHLY COLORED ROWS OF BEARERS WEIGHED DOWN WITH FOOD, DOMESTIC ANIMALS, WILD ANIMALS, BIRDS OF VARIOUS TYPES, OBJECTS, AND CONTAINERS OF ALL SIZES ARE ILLUSTRATED ON THE REGISTERS ON THE WALLS OF MEHU'S TOMB.

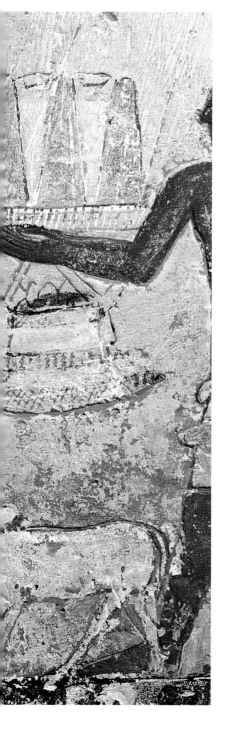

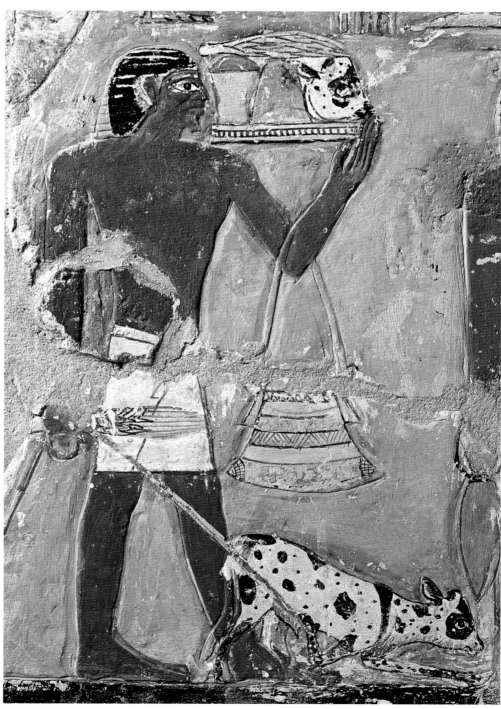

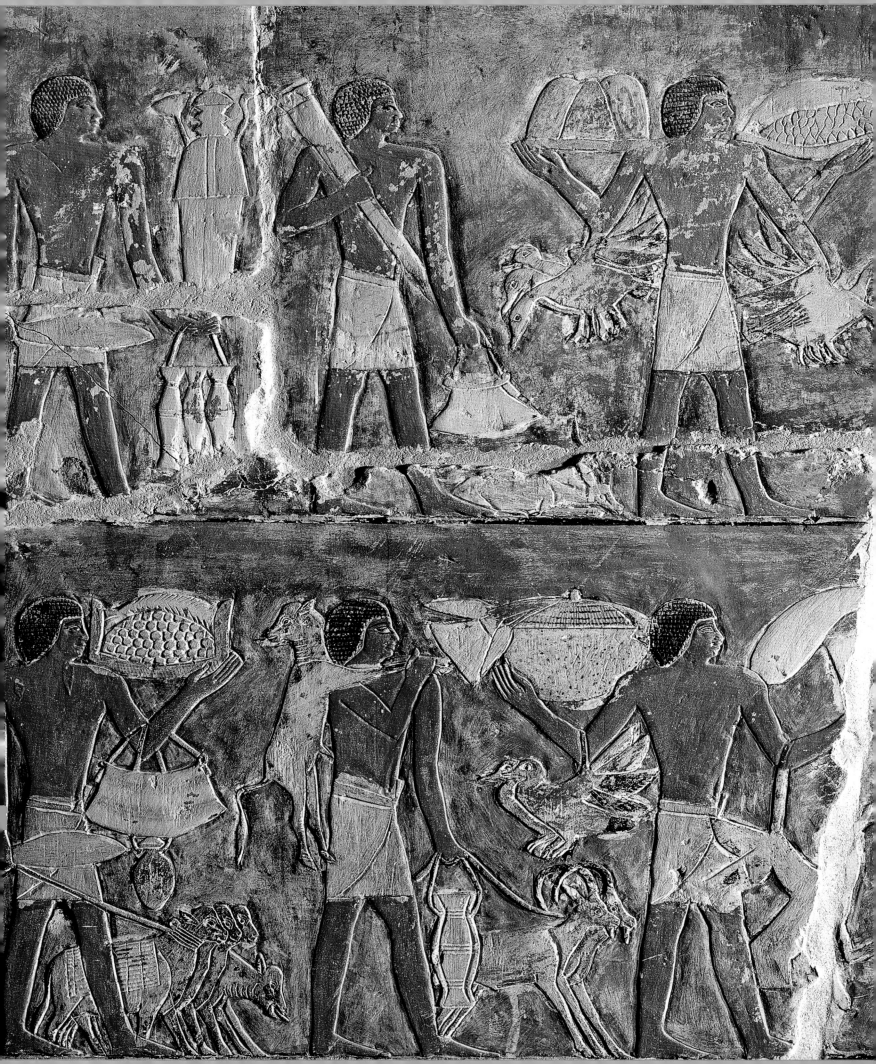

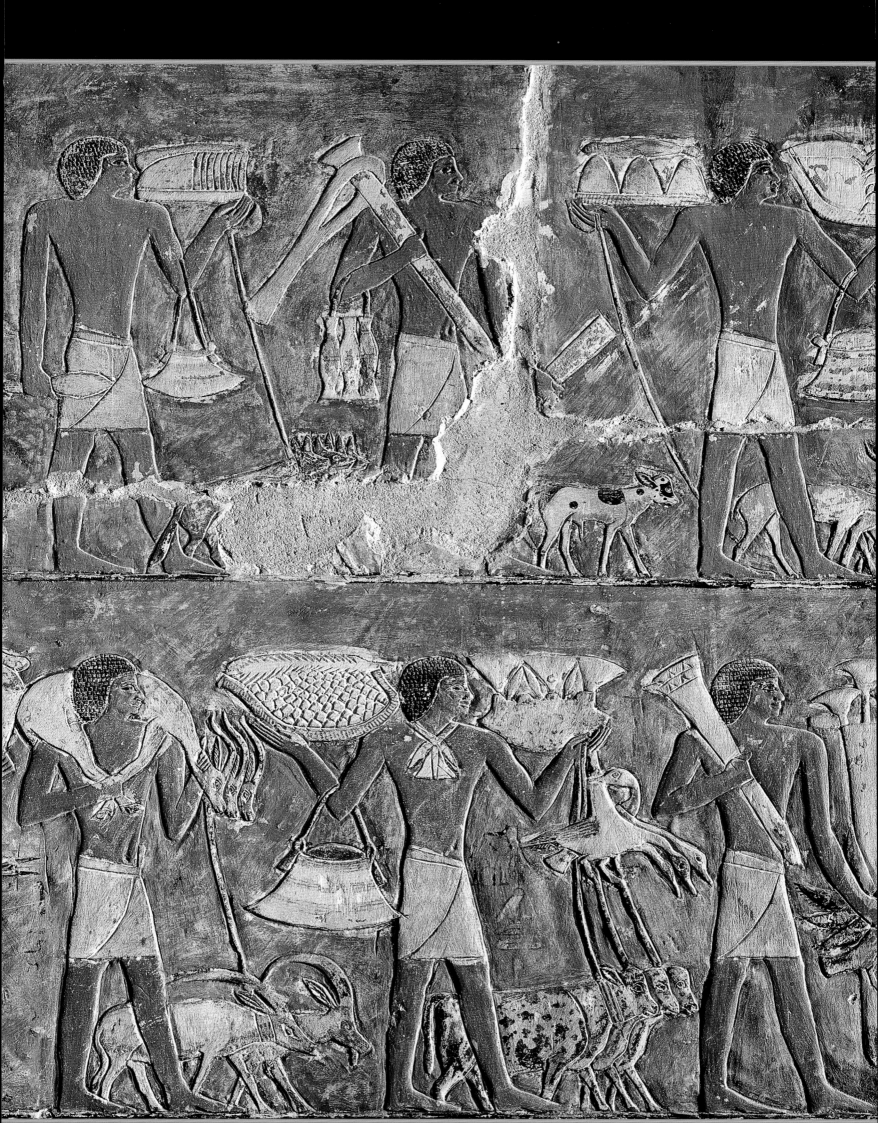

THE TOMB OF IRUKAPTAH

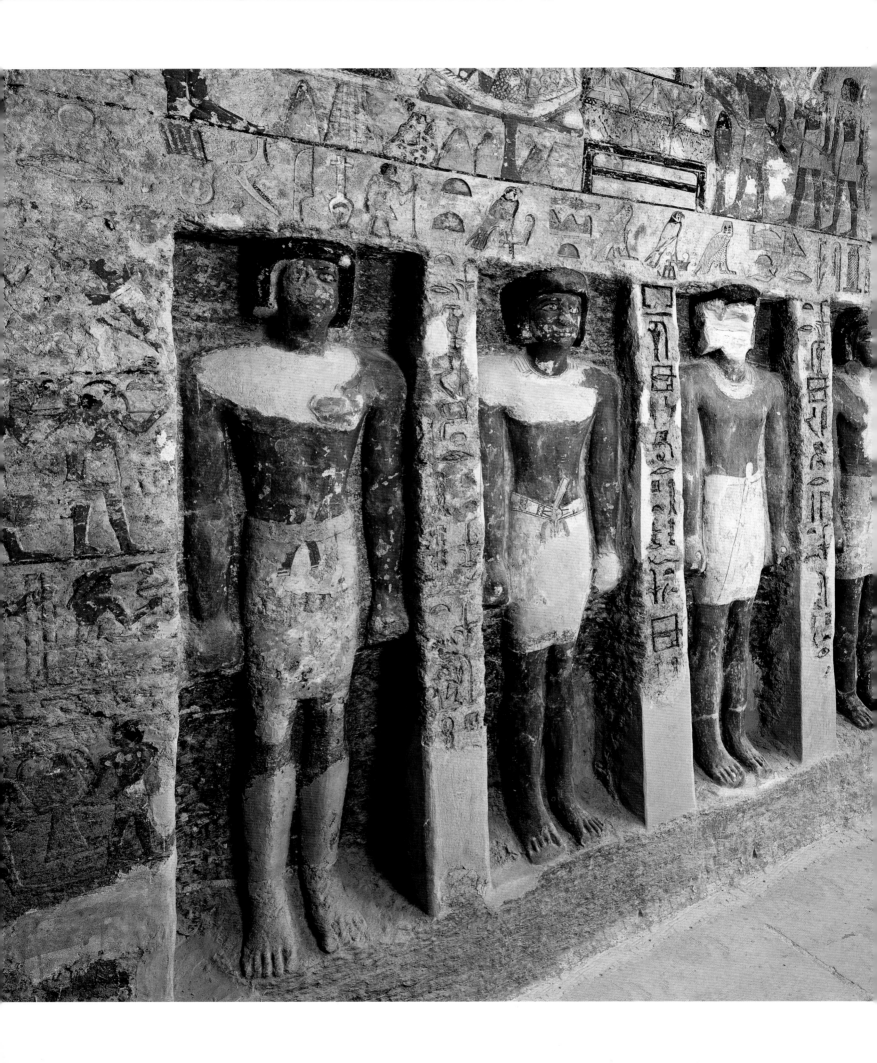

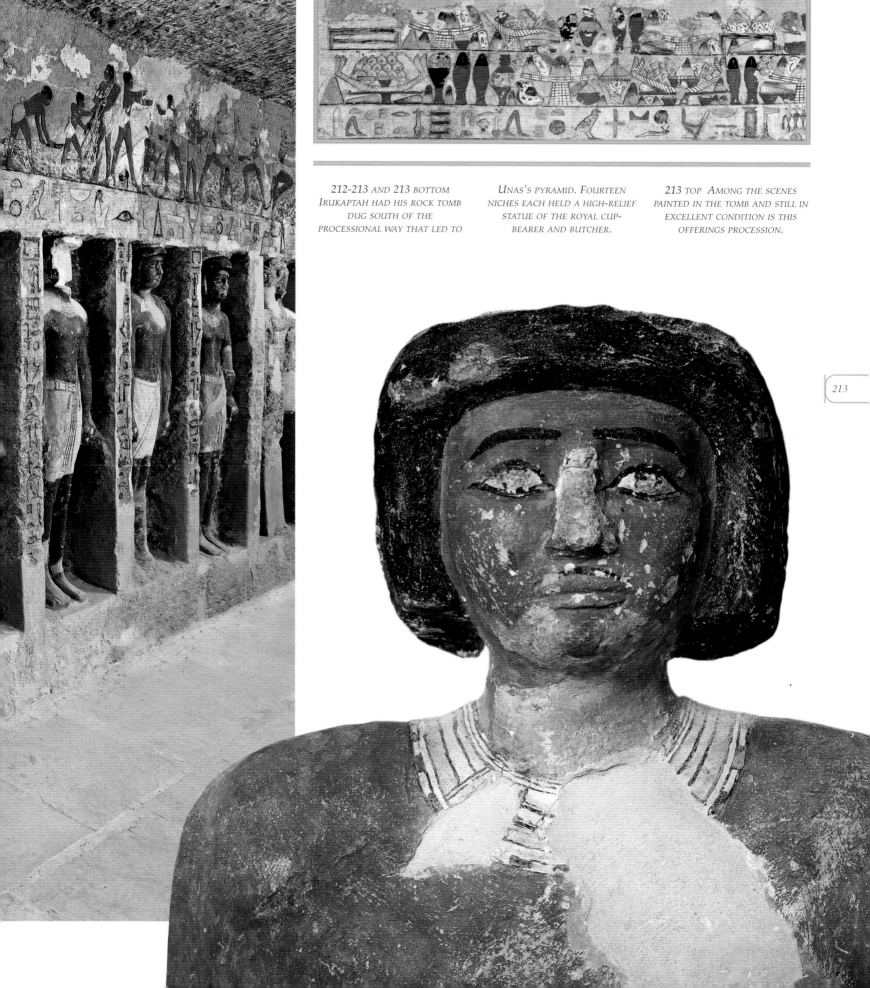

212-213 AND 213 BOTTOM
IRUKAPTAH HAD HIS ROCK TOMB
DUG SOUTH OF THE
PROCESSIONAL WAY THAT LED TO

*U*NAS'S PYRAMID. FOURTEEN
NICHES EACH HELD A HIGH-RELIEF
STATUE OF THE ROYAL CUP-
BEARER AND BUTCHER.

213 TOP AMONG THE SCENES
PAINTED IN THE TOMB AND STILL IN
EXCELLENT CONDITION IS THIS
OFFERINGS PROCESSION.

213

THE TOMB OF
IRUKAPTAH

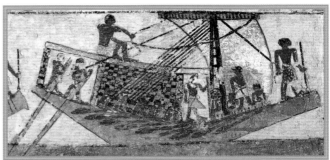

*214 LEFT AND 215 IN ADDITION
TO STATUES AND PAINTED RELIEFS
(RIGHT), IRUKAPTAH'S TOMB
CONTAINS A FALSE DOOR (LEFT)
ON WHICH THE DECEASED IS
SHOWN SEATED IN FRONT OF
AN OFFERINGS TABLE.*

*214 TOP RIGHT ANOTHER OF
THE SCENES ON THE WALLS IN
IRUKAPTAH'S TOMB IS THIS
PAINTING OF A SAILING BOAT
WITH A LARGE COVERED CABIN
AND A LARGE TEAM OF
OARSMEN.*

*214 CENTER AND BOTTOM RIGHT
STATUES, RELIEFS, AND
HIEROGLYPHS CARVED ON
THE WALLS OF IRUKAPTAH'S*

*TOMB STILL HAVE THEIR
ANCIENT DAZZLING COLORS
AND FINELY ILLUSTRATED
DETAILS.*

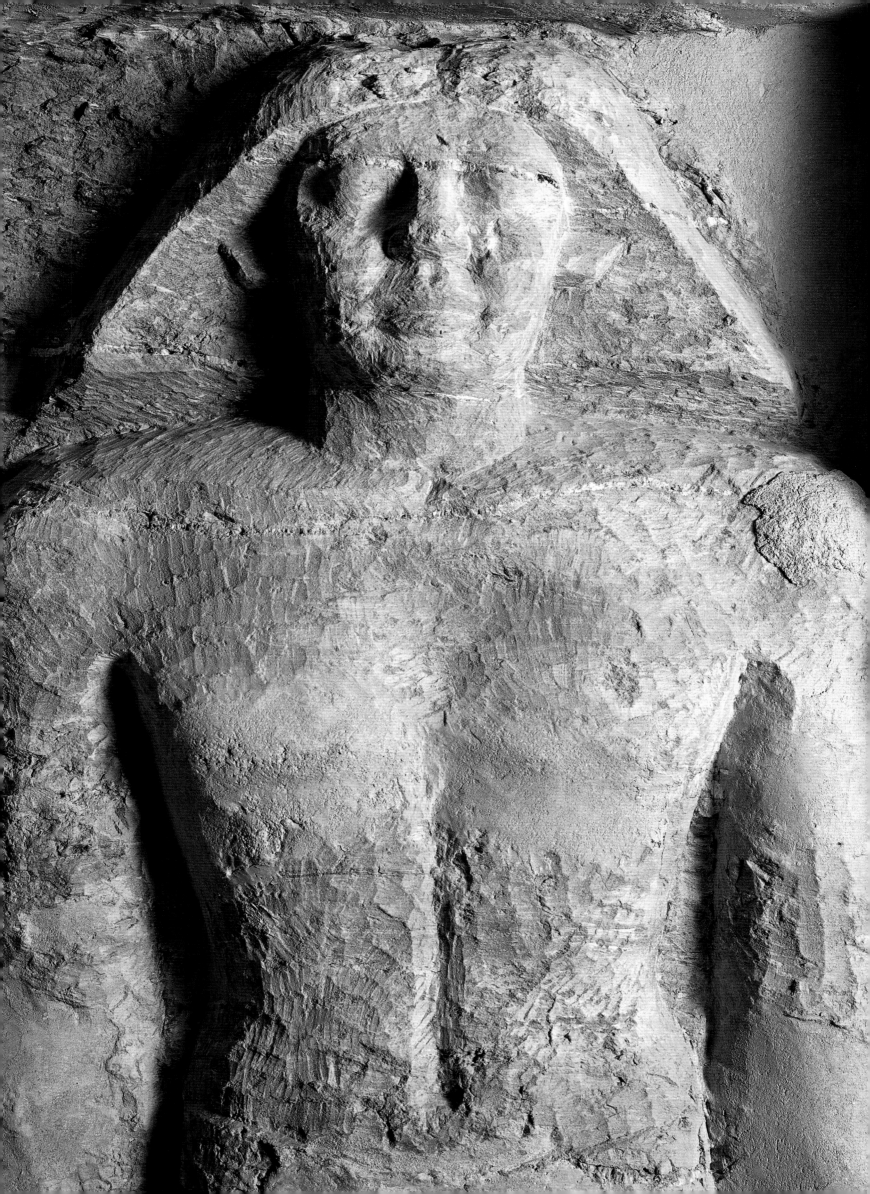

216 TOP *THE TOMB OF NEFERHERENPTAH, HAIRDRESSER OF THE GREAT HOUSE, HAS FAIRLY DELICATE AND REFINED RELIEF DECORATIONS. THE PICTURE SHOWS A SCENE OF WORK IN THE FIELDS.*

216 CENTER AND BOTTOM *ONE OF THE LOVELIEST SCENES IN NEFERHERENPTAH'S TOMB IS OF A GROUP OF MEN CUTTING DOWN LARGE BUNCHES OF GRAPES FROM A PERGOLA. THE GRAPES ARE PLACED IN LARGE BASKETS AND CARRIED AWAY TO BE PRESSED.*

216-217 *IN NEFERHERENPTAH'S TOMB TO THE SOUTH OF THE PROCESSIONAL WAY OF UNAS'S PYRAMID, ONE OF THE SCENES OF AGRICULTURAL LABOR REFERS TO THE HARVESTING OF SYCAMORE FIGS.*

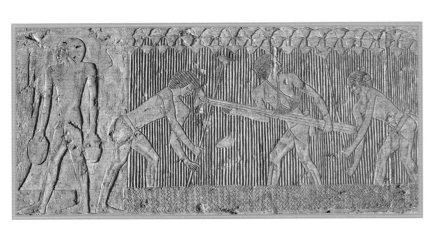

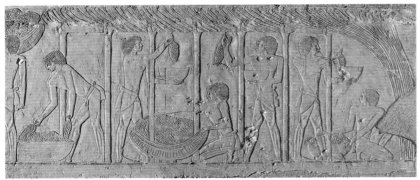

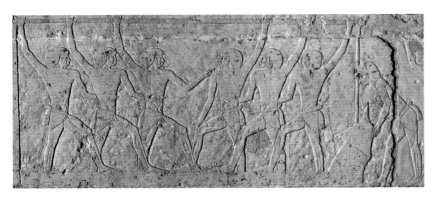

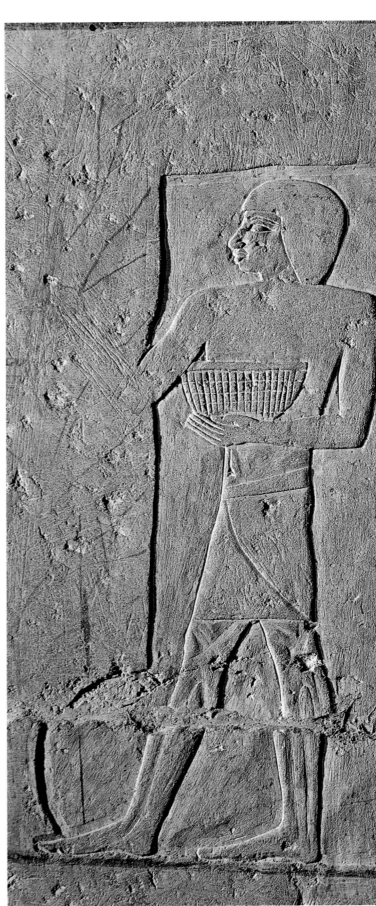

NEFERHENPTAH

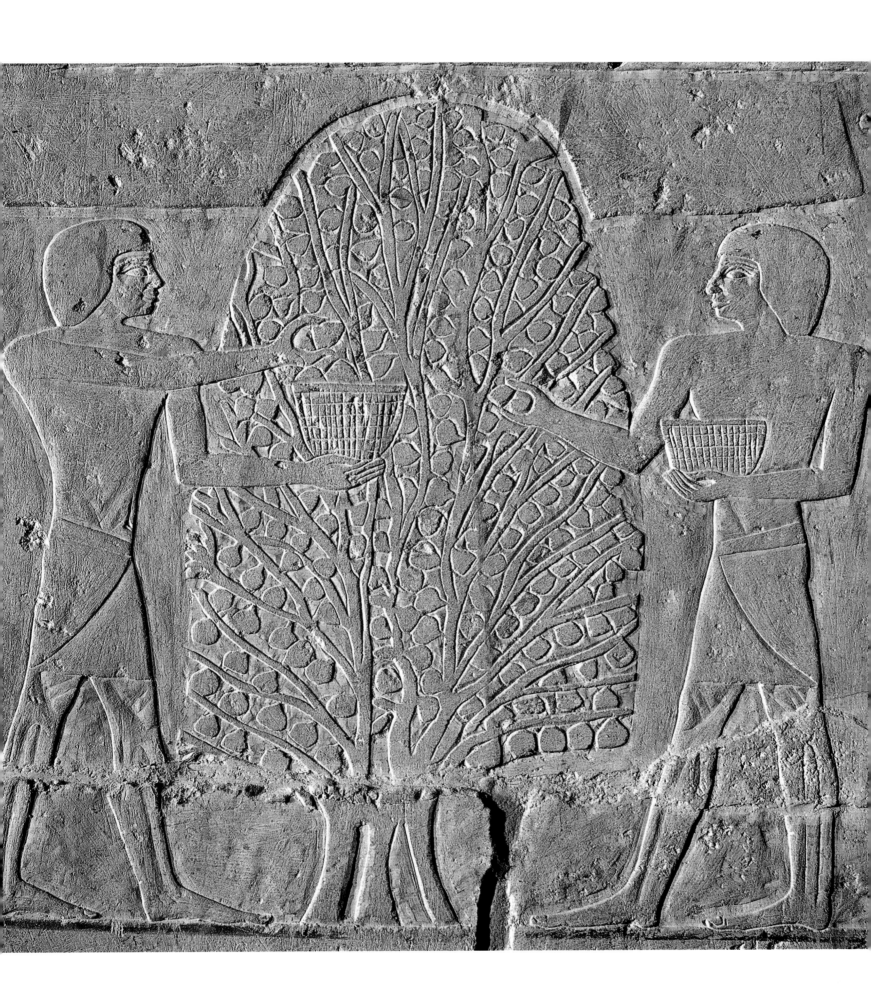

THE TOMB OF NEFERHENPTAH

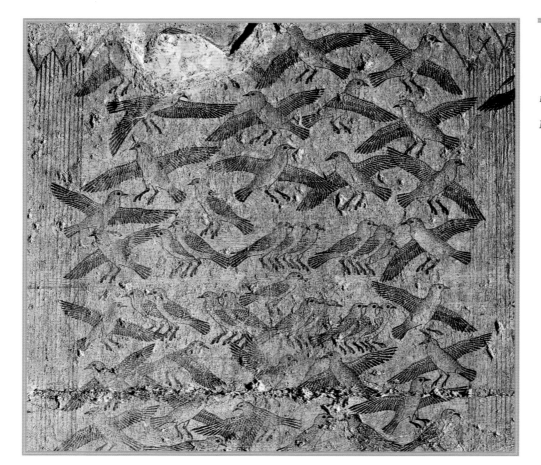

218 AND 219 THE ABUNDANCE OF BIRDS AND THE VARIETY OF ANIMALS THAT LIVED ALONG THE BANKS OF THE NILE AND IN THE FIELDS INSPIRED MANY SCENES ON THE WALLS OF EGYPTIAN TOMBS. NEFERHERENPTAH'S TOMB IS ALSO KNOWN AS THE "TOMB OF THE BIRDS" AS IT CONTAINS MANY SCENES OF BIRD-TRAPPING.

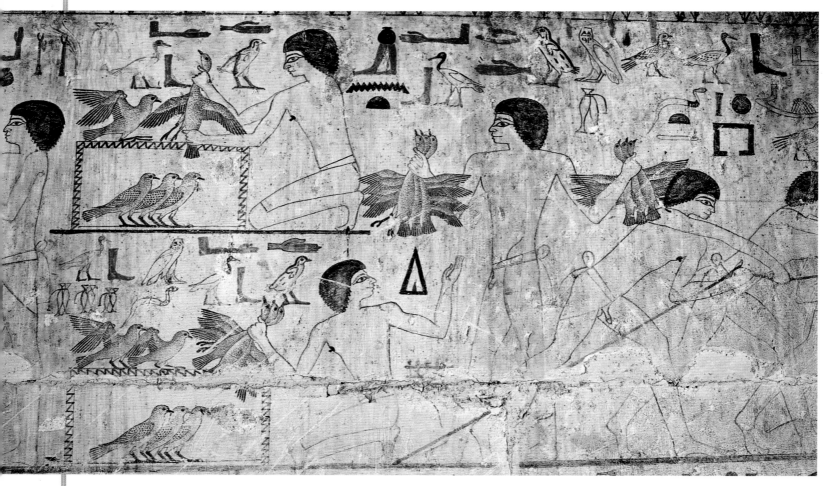

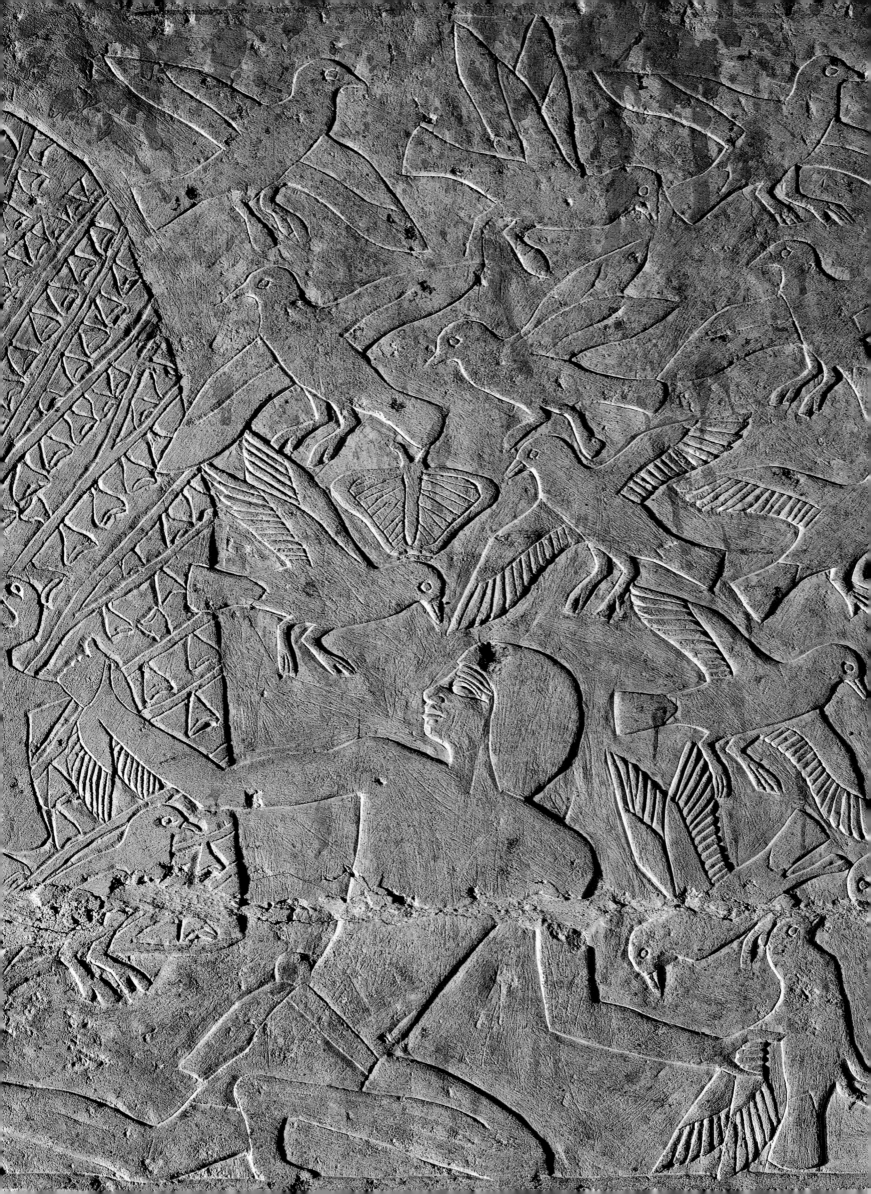

THE TOMB

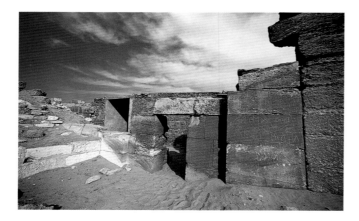

220 *Neferseshemra lived in the Sixth Dynasty and had a large mastaba built at Saqqara that even had a ladder to reach the roof.*

221 *The false door carved on a wall stands in a molding that includes an imbedded statue on either side and the half-length portrait of a figure surrounded by inscriptions.*

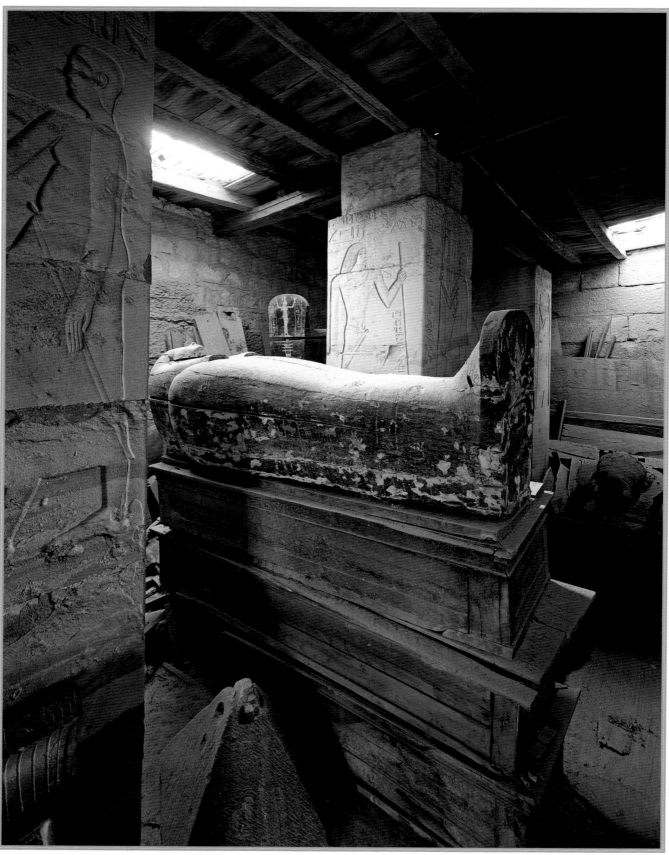

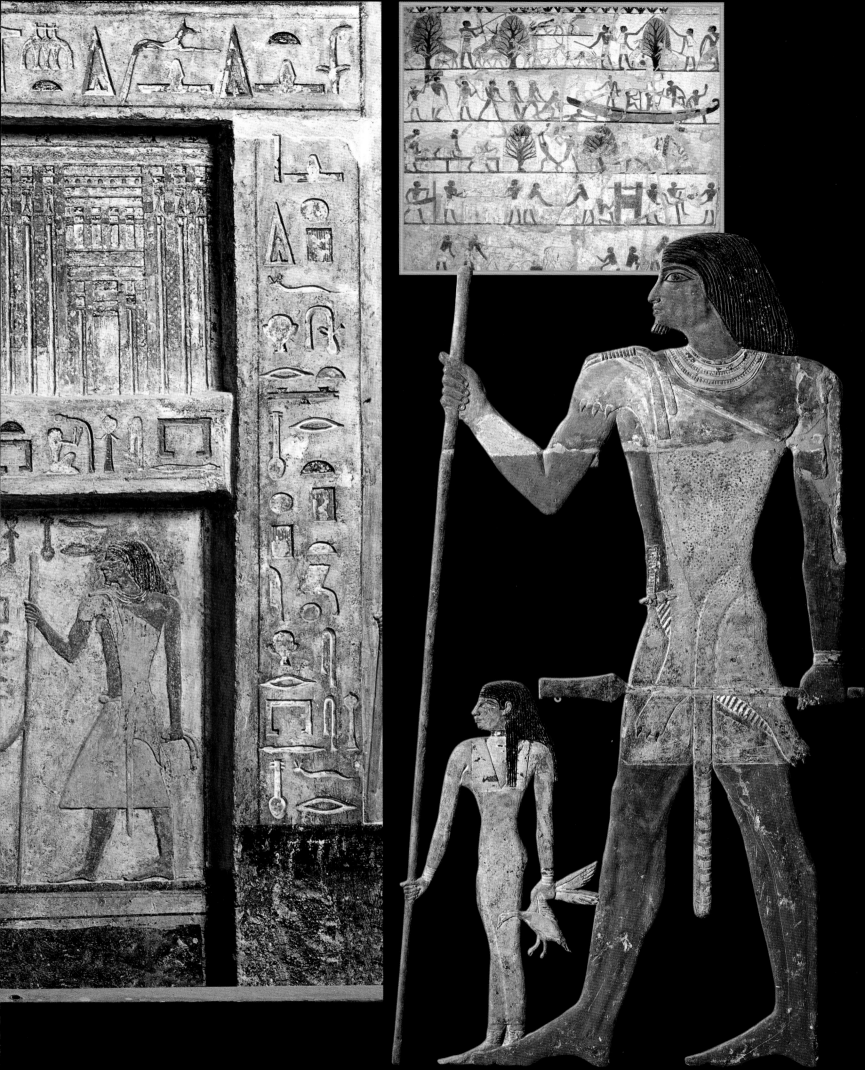

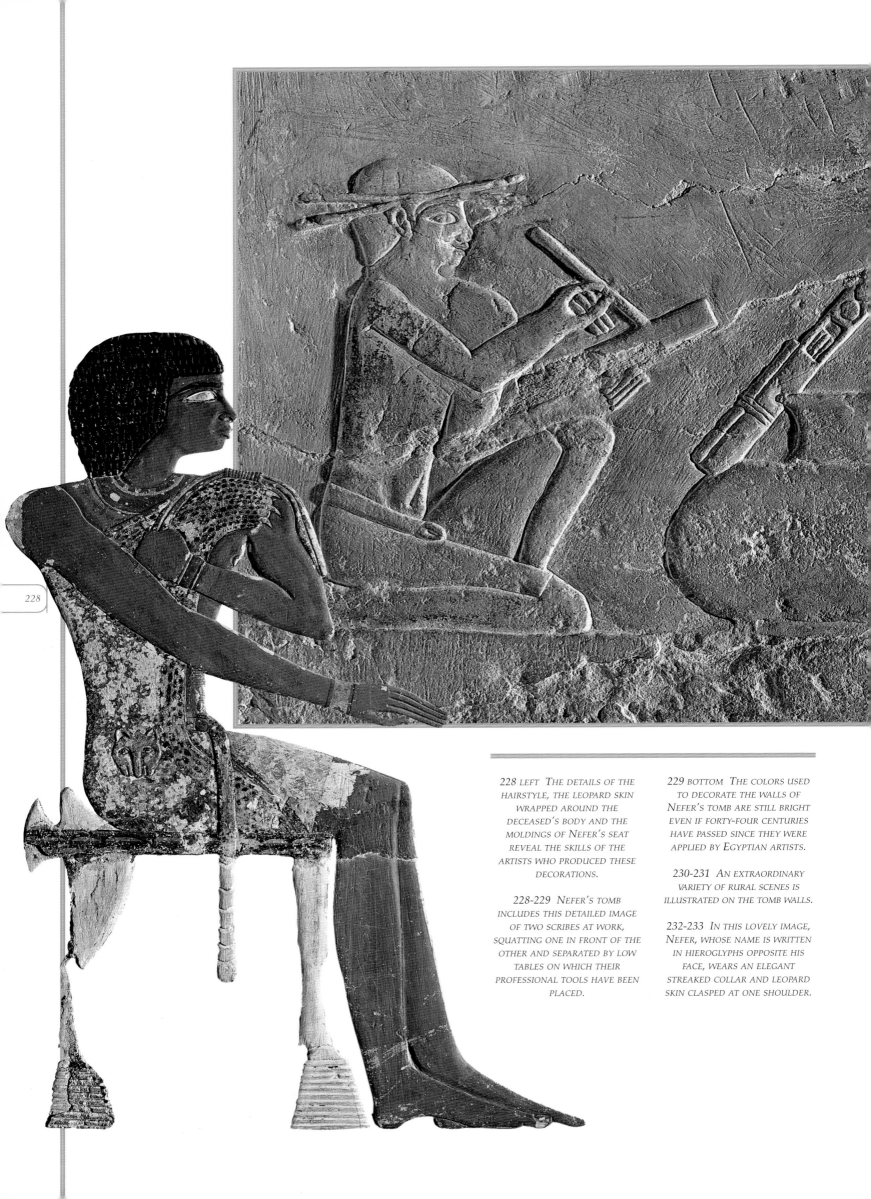

228

228 LEFT THE DETAILS OF THE
HAIRSTYLE, THE LEOPARD SKIN
WRAPPED AROUND THE
DECEASED'S BODY AND THE
MOLDINGS OF NEFER'S SEAT
REVEAL THE SKILLS OF THE
ARTISTS WHO PRODUCED THESE
DECORATIONS.

228-229 NEFER'S TOMB
INCLUDES THIS DETAILED IMAGE
OF TWO SCRIBES AT WORK,
SQUATTING ONE IN FRONT OF THE
OTHER AND SEPARATED BY LOW
TABLES ON WHICH THEIR
PROFESSIONAL TOOLS HAVE BEEN
PLACED.

229 BOTTOM THE COLORS USED
TO DECORATE THE WALLS OF
NEFER'S TOMB ARE STILL BRIGHT
EVEN IF FORTY-FOUR CENTURIES
HAVE PASSED SINCE THEY WERE
APPLIED BY EGYPTIAN ARTISTS.

230-231 AN EXTRAORDINARY
VARIETY OF RURAL SCENES IS
ILLUSTRATED ON THE TOMB WALLS.

232-233 IN THIS LOVELY IMAGE,
NEFER, WHOSE NAME IS WRITTEN
IN HIEROGLYPHS OPPOSITE HIS
FACE, WEARS AN ELEGANT
STREAKED COLLAR AND LEOPARD
SKIN CLASPED AT ONE SHOULDER.

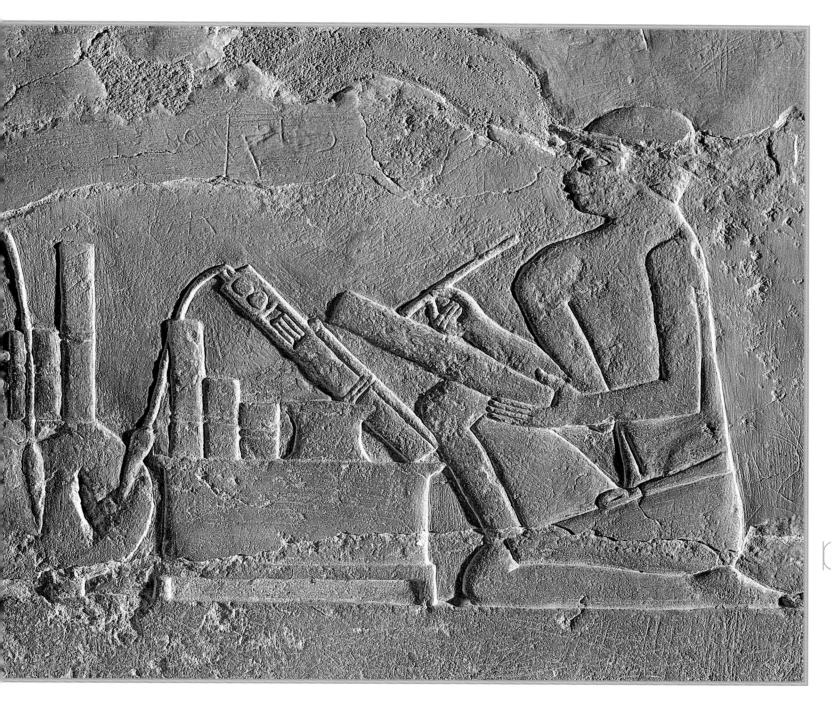

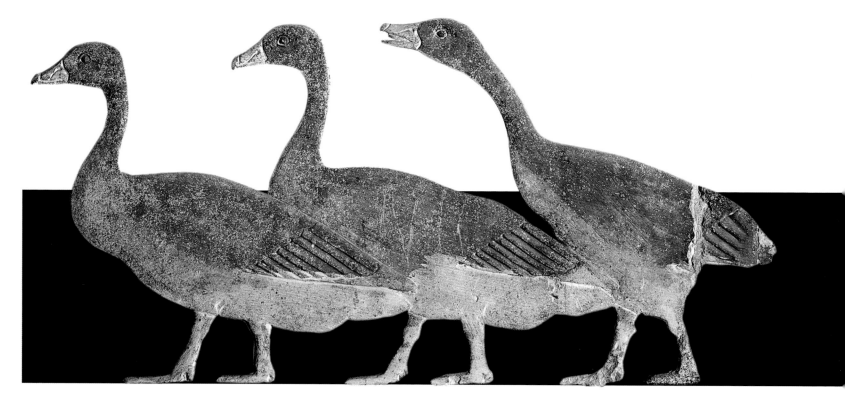

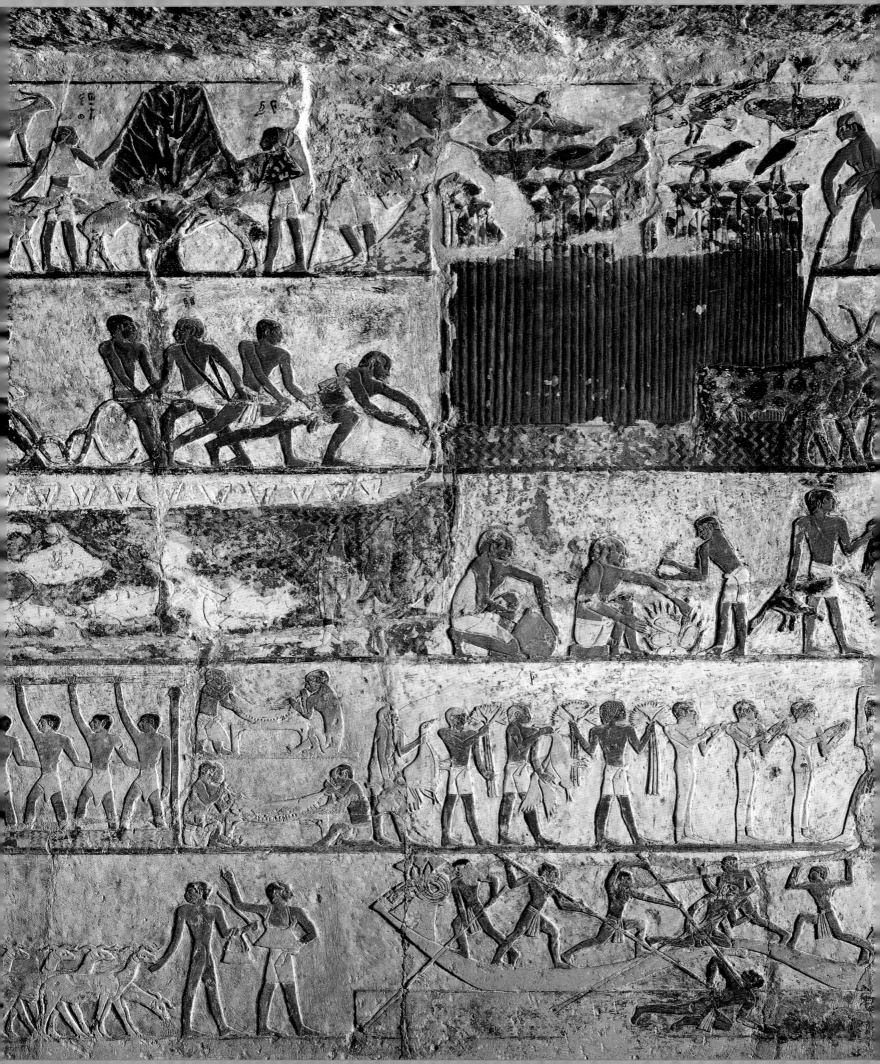

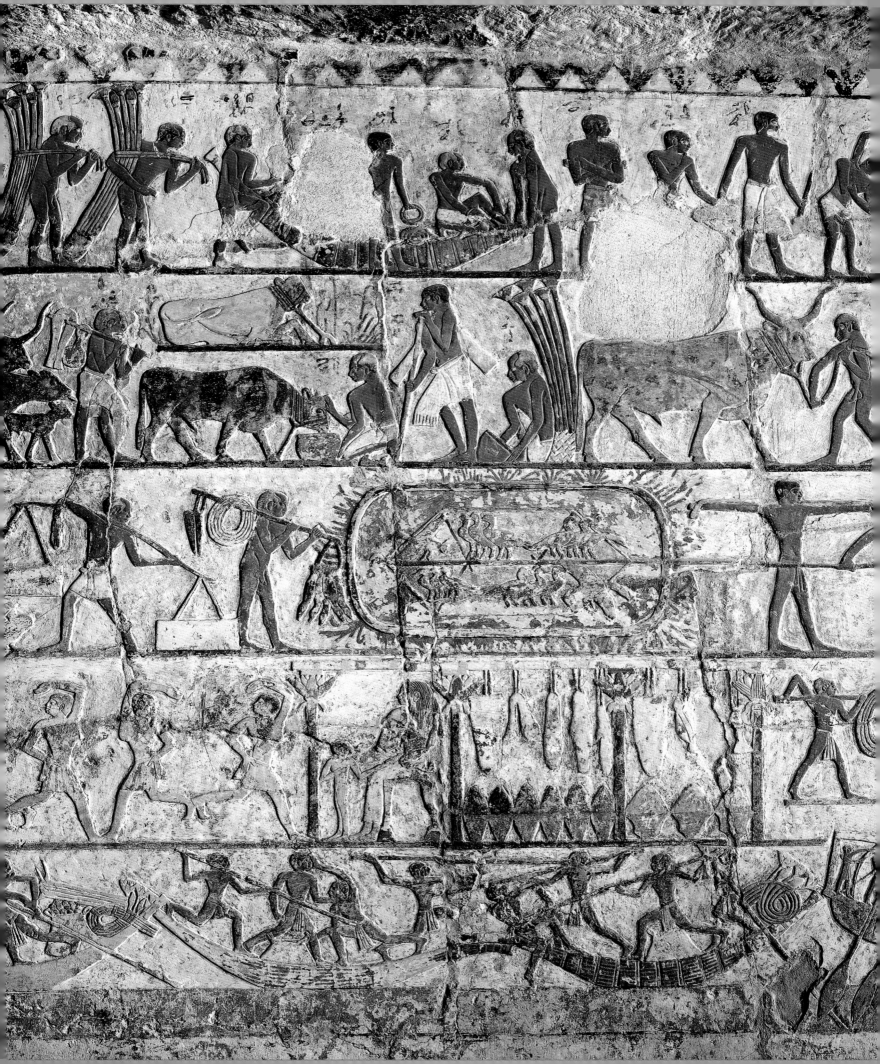

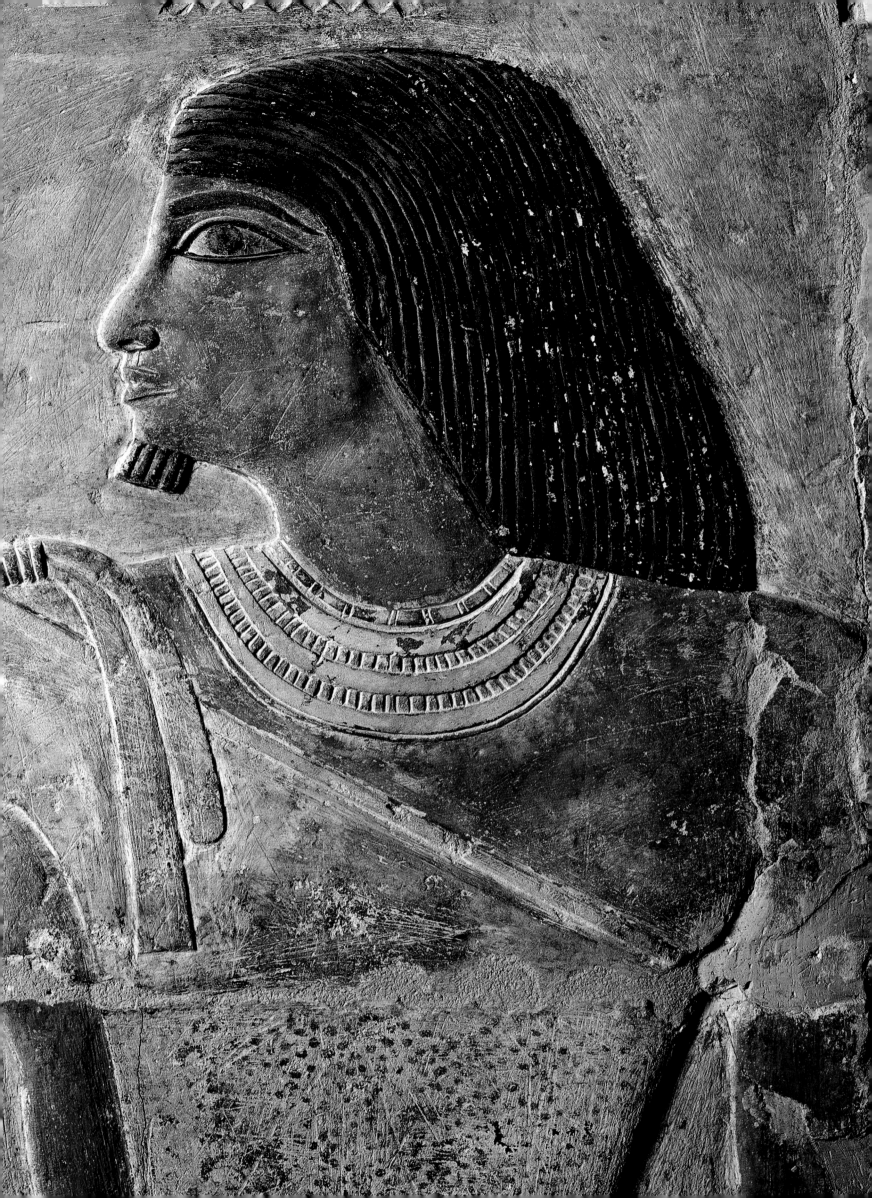

THE PYRAMID OF PEPI II

234 *TOP IN PEPI II'S FUNERARY COMPLEX NUMEROUS STONE BLOCKS HAVE BEEN FOUND COVERED WITH FINELY CHISELED INSCRIPTIONS.*

234 *BOTTOM THIS FRAGMENT OF STONE FOUND NEAR PEPI II'S FUNERARY COMPLEX SHOWS THE PHARAOH EMBRACED BY THE FALCON-HEADED GOD HORUS.*

T he last king of the Sixth Dynasty was Pepi II, who came to the throne as a child and reigned for ninety-four years. His death brought to an end not just the Sixth Dynasty but also the period of stability represented by centralized power that had characterized the first part of the Old Kingdom: in the one hundred years that followed, no pharaoh was able to rule the entire country. The confusion and political uncertainty of the period remained impressed in the historic memory of the ancient Egyptians to the extent that, 1600 years later, the priest Manetho wrote that the Seventh Dynasty had seen seventy pharaohs succeed one another in seventy days. Of the kings in successive dynasties, which contested power during what is conventionally referred to as the First Intermediate Period, only a very few attempted to build a pyramid. It was necessary to wait for the reunification of Egypt under the powerful Twelfth Dynasty for a royal pyramid to be constructed once more.

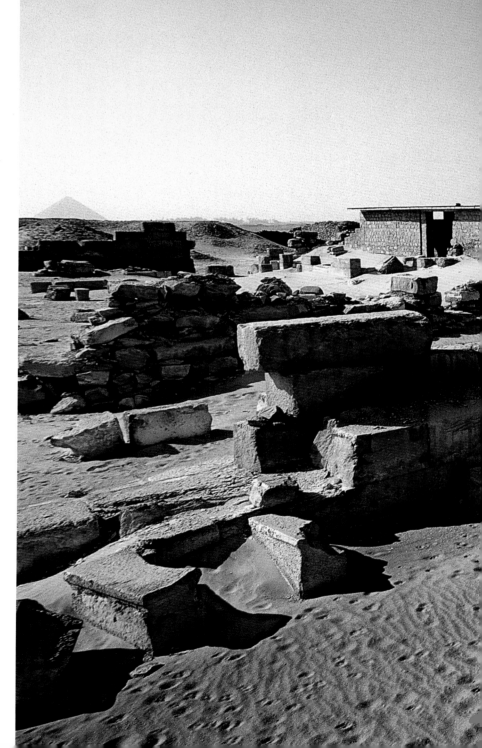

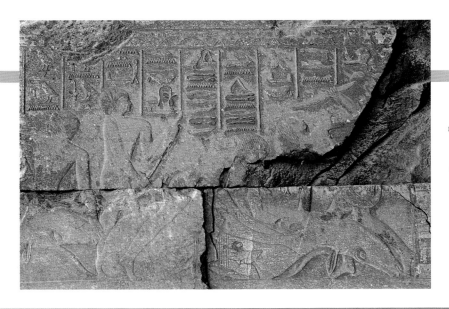

234-235 AND 236-237 PEPI II'S
COMPLEX AT SAQQARA CONSISTED
OF THE LARGEST PYRAMID FOR
THE PHARAOH, A SATELLITE
PYRAMID, AND THREE MORE
SMALL ONES FOR HIS THREE
QUEENS, EACH OF WHICH WAS
ACCOMPANIED BY A MINIATURE
SATELLITE PYRAMID OF ITS OWN.

235 TOP THERE ARE MANY
FRAGMENTS FROM THE MAIN
BUILDING IN PEPI II'S COMPLEX
THAT HAVE NOT YET FOUND THEIR
RIGHTFUL LOCATION OR WHICH
ARE STILL UNDER STUDY.

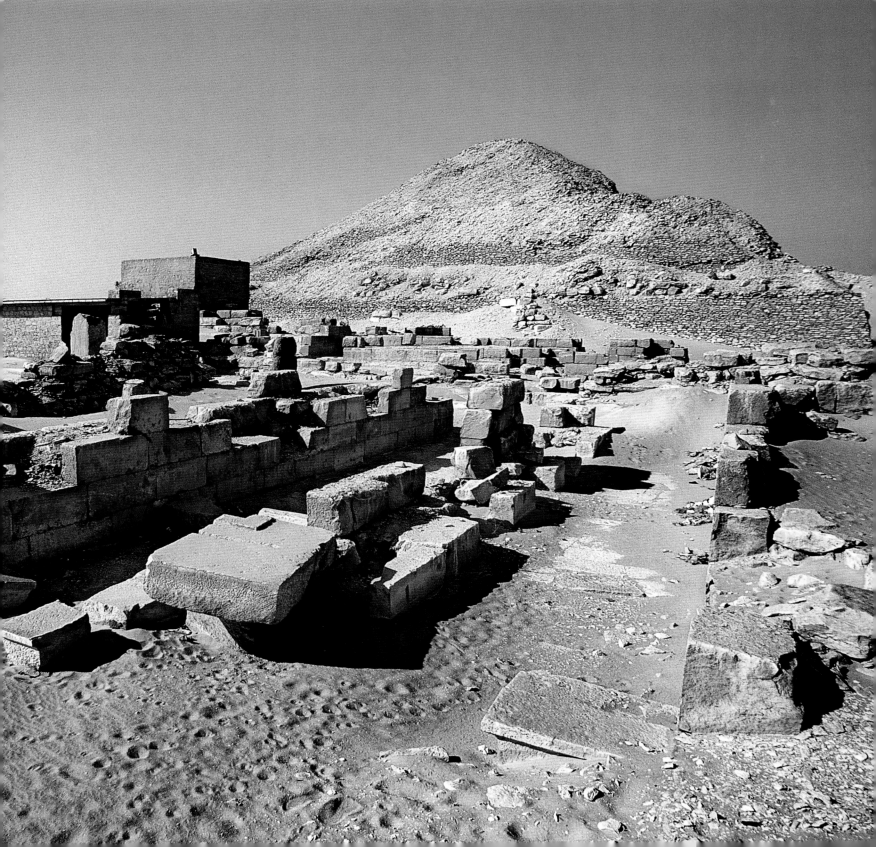

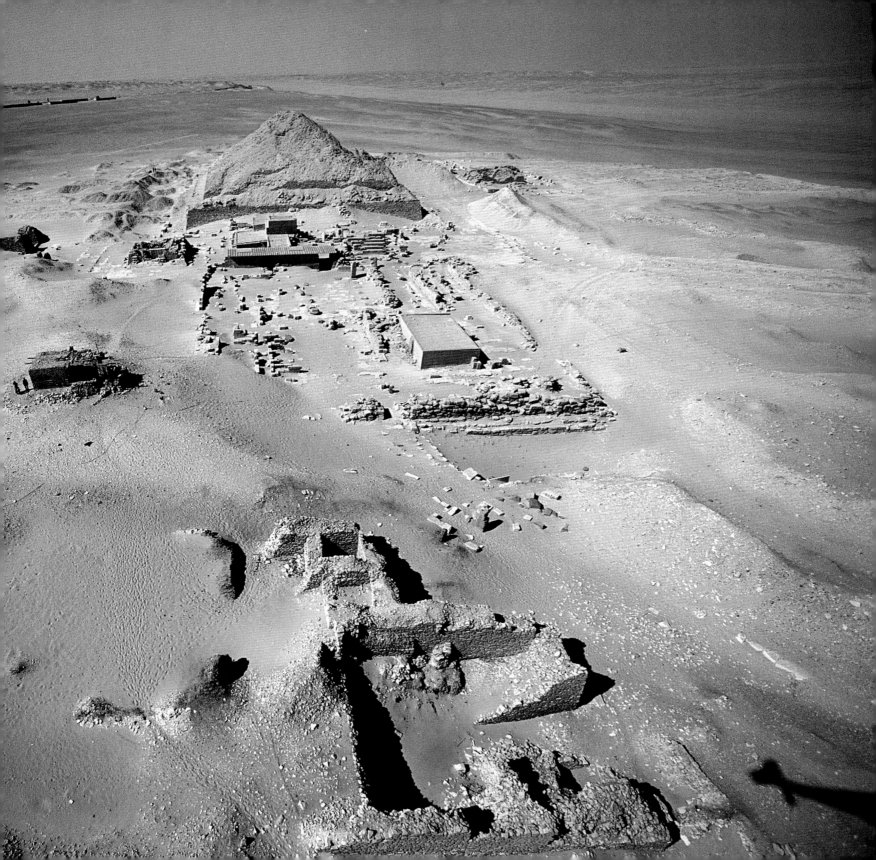

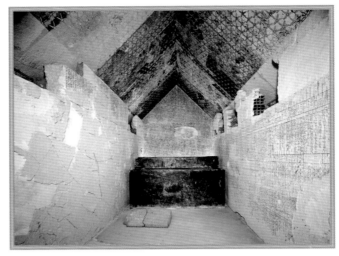

238 AND 239 *PASSAGES FROM THE PYRAMID TEXTS COVER THE WALLS OF PEPI II'S FUNERARY APARTMENT, THE CEILING OF WHICH IS DECORATED LIKE A STAR MOTIF. THE HIEROGLYPHS USED IN THE TEXTS ARE PAINTED GREEN FOR THE COLOR'S ASSOCIATION WITH LIFE AND REGENERATION, AND THE TWO NAMES OF THE PHARAOH – PEPI AND NEFERKARA – APPEAR CONTINUOUSLY IN CONSECUTIVE PAIRS OF CARTOUCHES.*

THE PYRAMID OF PEPI II

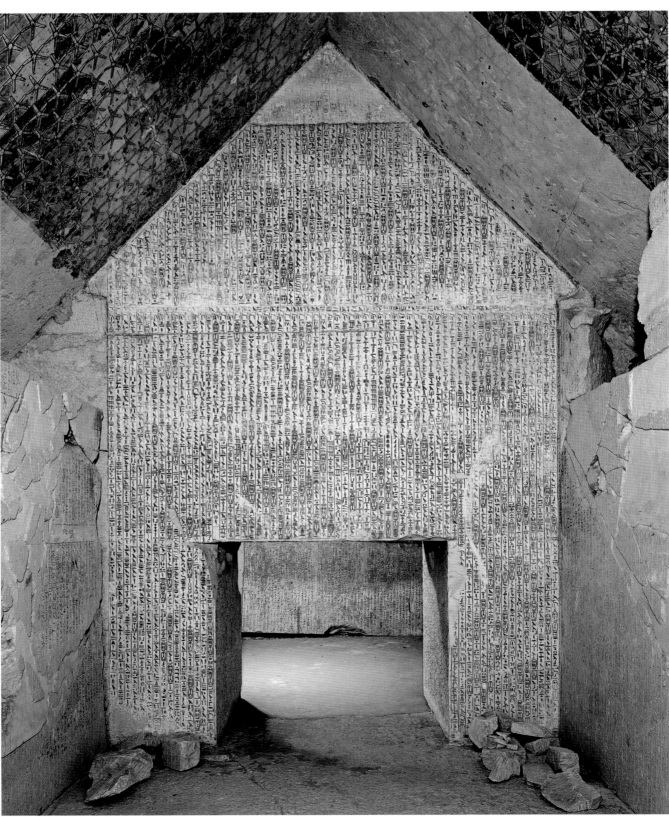

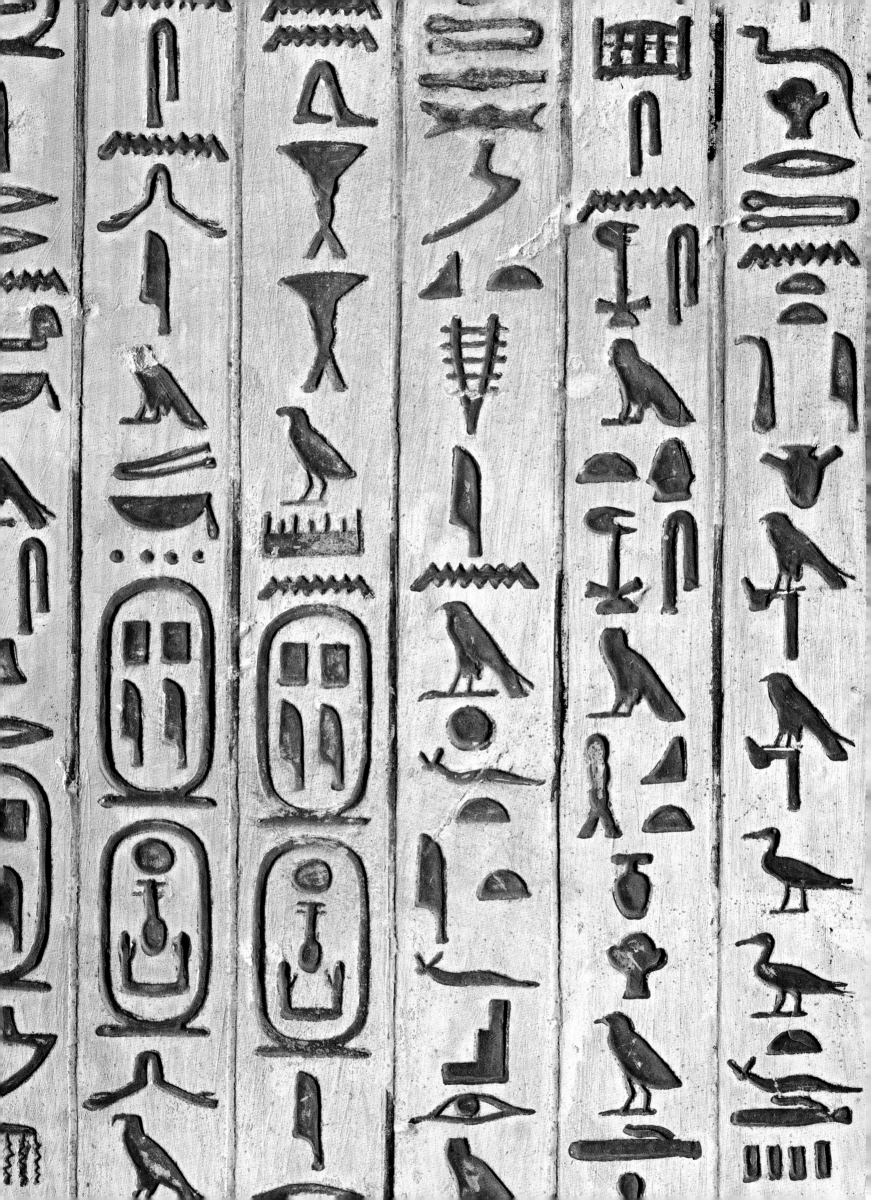

THE PYRAMIDS OF

240 TOP A FRAGMENT OF AN ARCHITRAVE FROM AMENEMHET I'S FUNERARY COMPLEX AT AL-LISHT SHOWS THE PHARAOH SEATED ON A THRONE AS HE RECEIVES THE SYMBOL OF THE INFINITE YEARS OF HIS REIGN TO MARK HIS JUBILEE.

Centralized power returned to the ancient splendors around 1990 BC with the start of the powerful Twelfth Dynasty, when both the center of power and the royal necropolis were moved north once again. Pharaoh Amenemhet I founded a new capital with the significant name of *Amenemhat-itj-tawy* ("Amenemhet the Conqueror of the Two Lands"). It has not yet been located but must have lain in the area between the oasis of Fayum and the Nile Valley. This pharaoh turned back to the tradition of the Old Kingdom and built a medium-sized pyramid for himself at Lisht, inside which, with little scruple, he incorporated decorated blocks taken from funerary complexes from the previous period. Little remains of the other elements of his funerary complex but it seems that the pyramid was surrounded by *mastabas* and shafts dug to hold the remains of various members of the royal family.

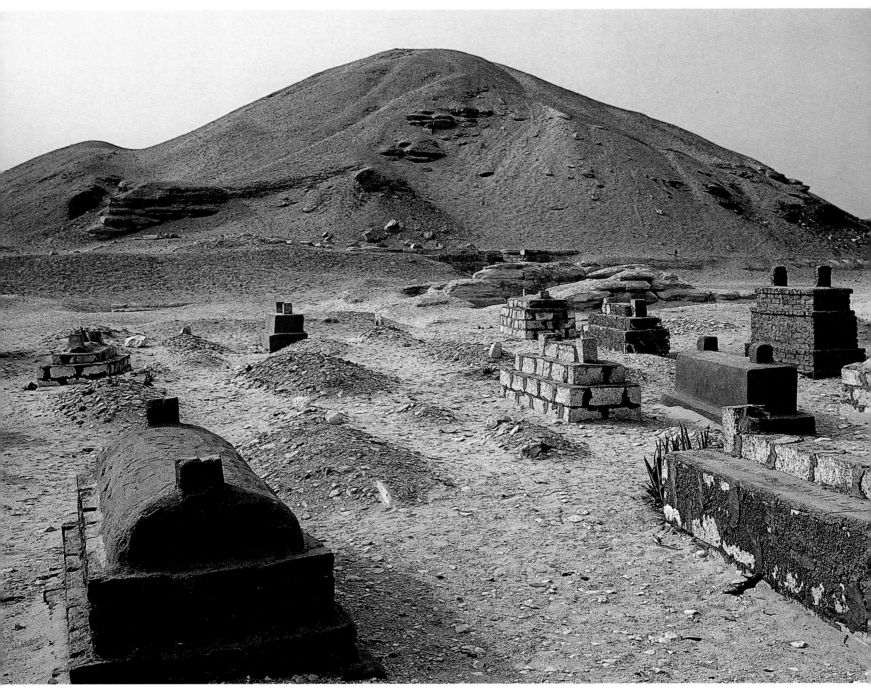

THE MIDDLE KINGDOM

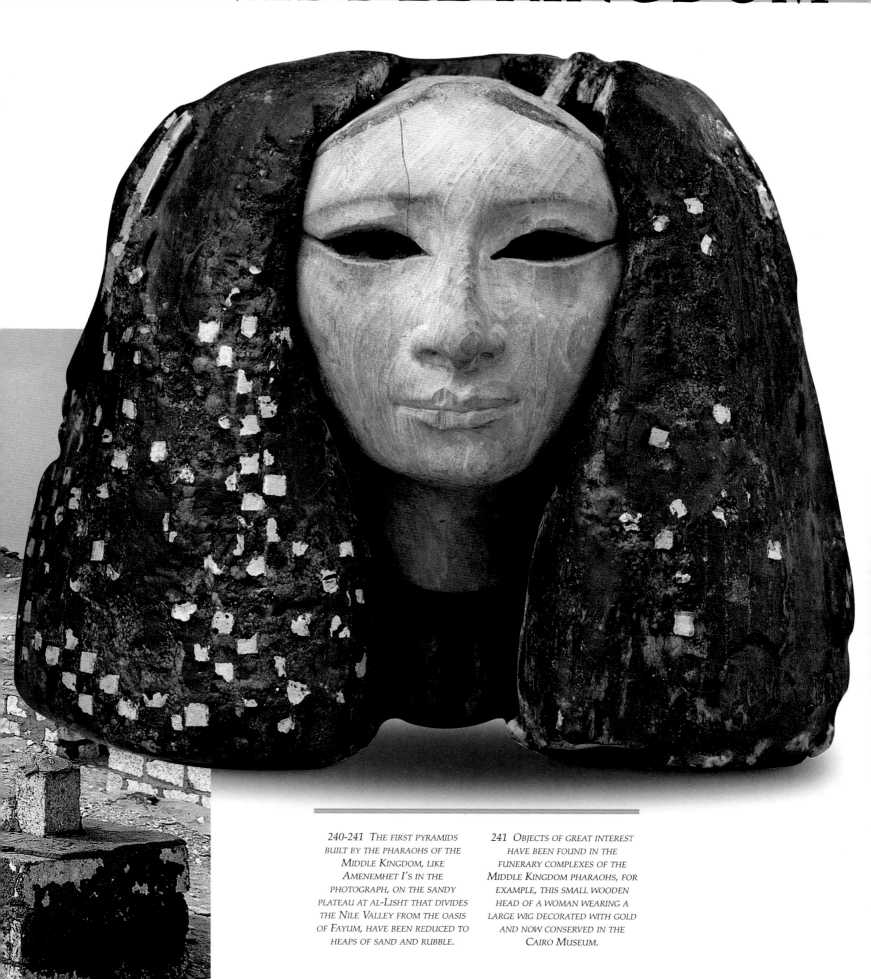

240-241 THE FIRST PYRAMIDS
BUILT BY THE PHARAOHS OF THE
MIDDLE KINGDOM, LIKE
AMENEMHET I'S IN THE
PHOTOGRAPH, ON THE SANDY
PLATEAU AT AL-LISHT THAT DIVIDES
THE NILE VALLEY FROM THE OASIS
OF FAYUM, HAVE BEEN REDUCED TO
HEAPS OF SAND AND RUBBLE.

241 OBJECTS OF GREAT INTEREST
HAVE BEEN FOUND IN THE
FUNERARY COMPLEXES OF THE
MIDDLE KINGDOM PHARAOHS, FOR
EXAMPLE, THIS SMALL WOODEN
HEAD OF A WOMAN WEARING A
LARGE WIG DECORATED WITH GOLD
AND NOW CONSERVED IN THE
CAIRO MUSEUM.

THE PYRAMID OF

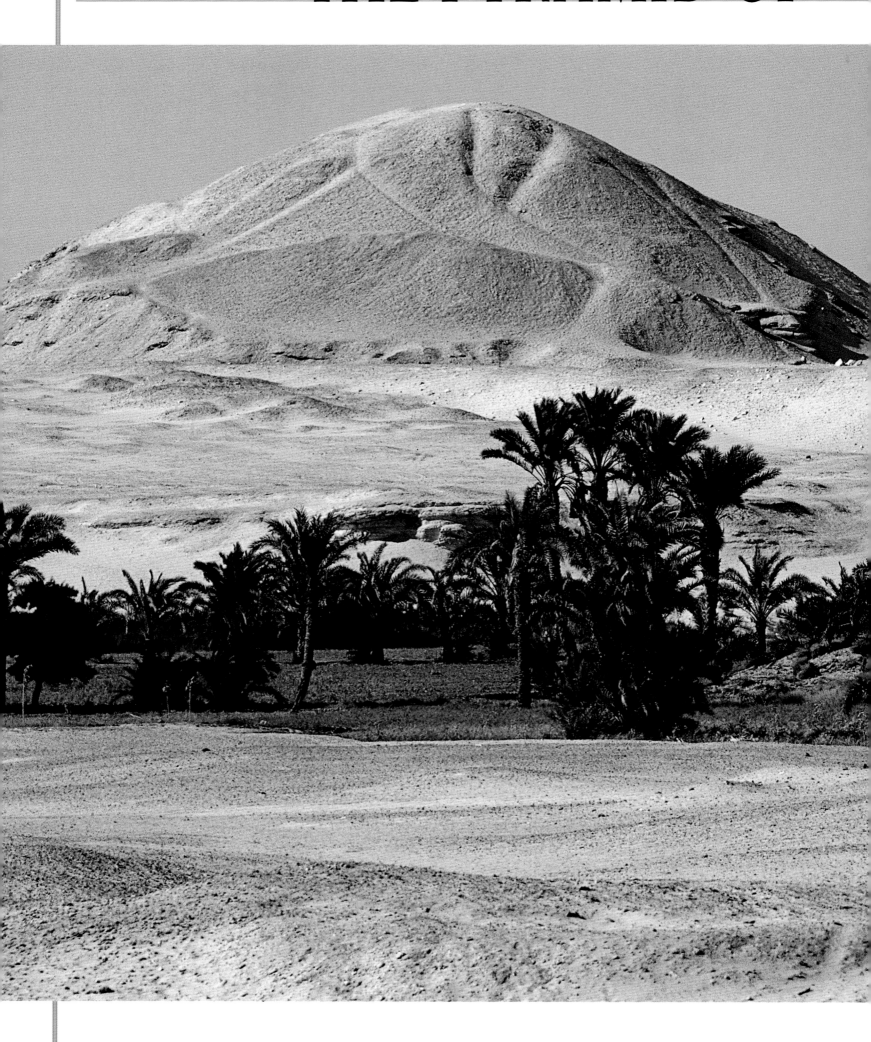

AMENEMHET I

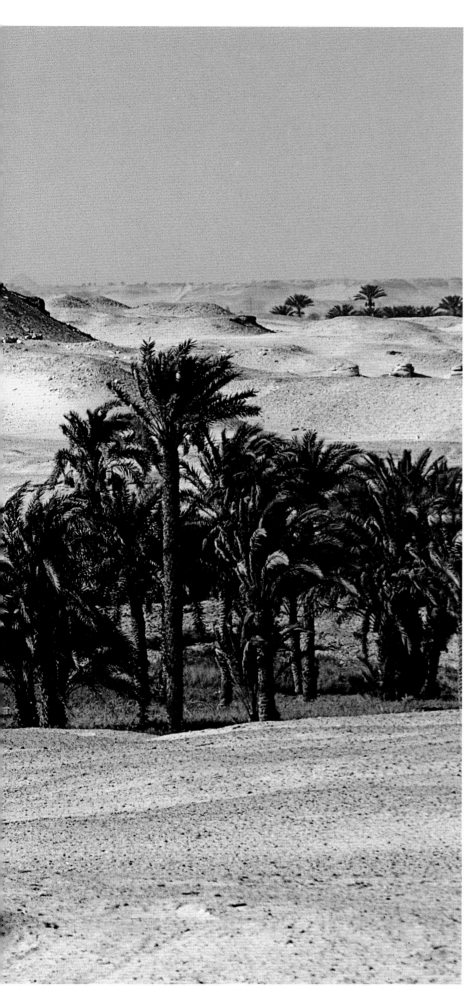

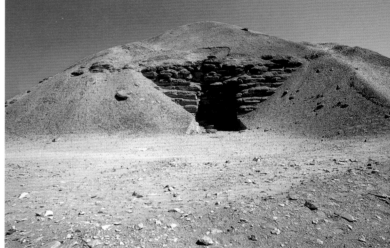

242-243 *The reason that the Middle Kingdom pyramids – like Amenemhet I's – are now just piles of rubble is that the removal of their stone lining* *exposed their internal structure and, being made of mud brick and loose stones, they were eroded by the elements.*

THE PYRAMID OF

Senruset I, the son of Amenemhet I, experimented with a construction technique that was later adopted by his successors: instead of building the pyramid like a more or less solid stone block, the monument of Senruset was constructed on the base of a skeleton of walls made from orthogonal stone blocks. The spaces between the blocks were filled with stone slabs arranged in a step fashion and the whole thing was lined with good quality stone. A small chapel on the north side provided the entrance to a sloping corridor that descended underground to reach the burial chamber. The complex was completed by a temple, a satellite pyramid, and nine pyramids for the pharaoh's various queens.

SENRUSET I

244 LEFT IN THE CAIRO MUSEUM YOU CAN ADMIRE THIS PAINTED WOODEN STATUE THAT MAY REPRESENT THE PHARAOH SENRUSET I. HE WEARS THE WHITE CROWN OF UPPER EGYPT AND STRIDES FORWARD HOLDING A STAFF.

244-245 THE PYRAMID OF SENRUSET I AT AL-LISHT IS SURROUNDED BY A SATELLITE PYRAMID AND NINE QUEENS' PYRAMIDS, ALL WITHIN A LARGE RECTANGULAR ENCLOSURE.

245 TOP THE PYRAMID OF SENRUSET I WAS BUILT WITH A VERY SIMPLE FUNERARY APARTMENT THAT CONSISTS OF A SLOPING CORRIDOR THAT ENTERS THE BURIAL CHAMBER (TODAY THIS IS NOT ACCESSIBLE).

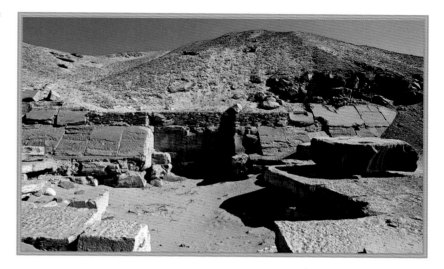

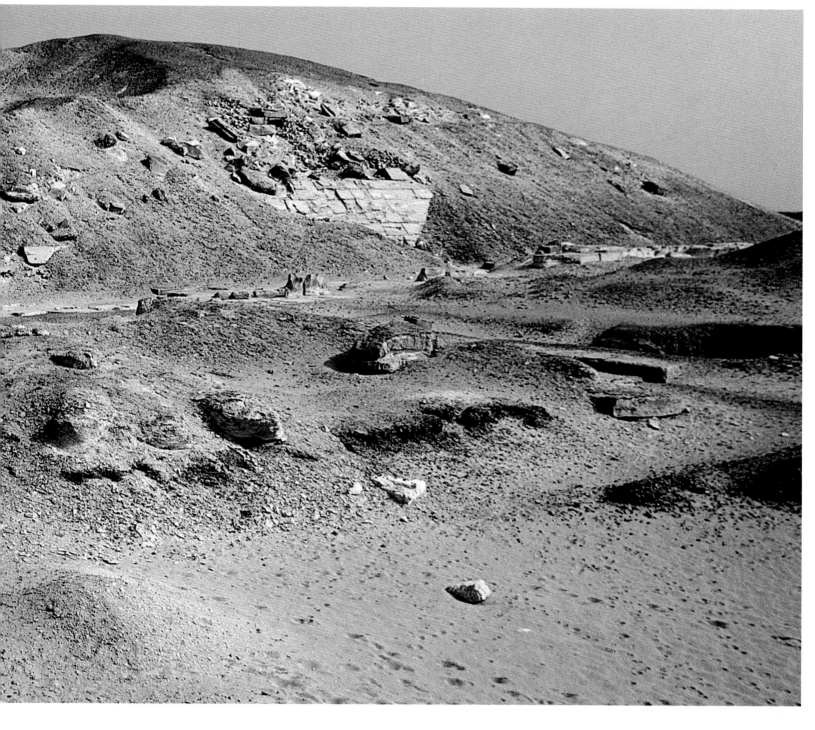

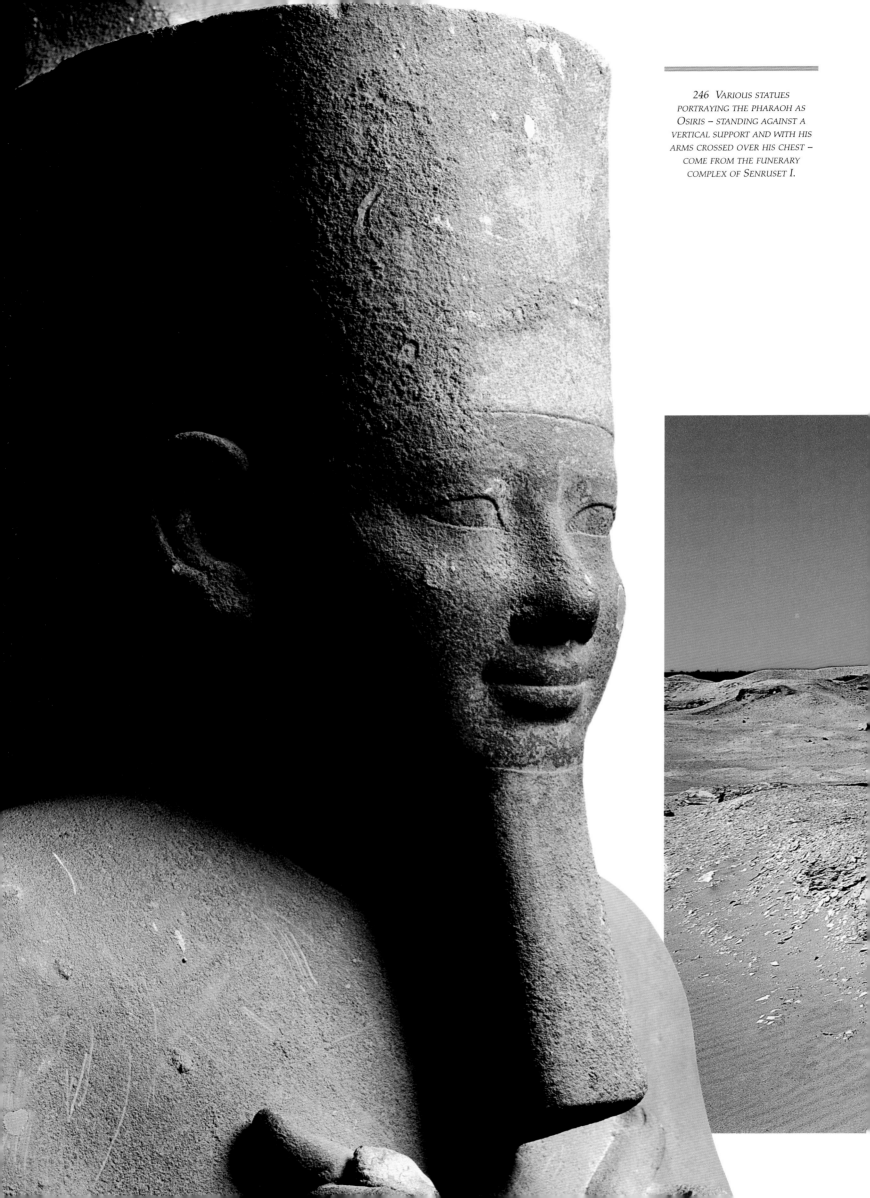

246-247 *The photograph shows part of the surviving brick structure of Senruset I's pyramid.*

247 top *There are only a few structures remaining in pyramid 5 to the northwest of Senruset I's pyramid.*

However, at a later period, the level of the water-table later rose; it swallowed up not just the burial chamber but some of the corridor too.

Removal of the limestone facing stones from all those Middle Kingdom pyramids built using the skeleton technique with spaces filled with loose material led to the ruination of the monuments. Amenemhet II filled the spaces of his monument with sand, but when the outer layer was removed the structure practically disintegrated; in fact, it has never been possible even to measure the base or the pyramid's inclination.

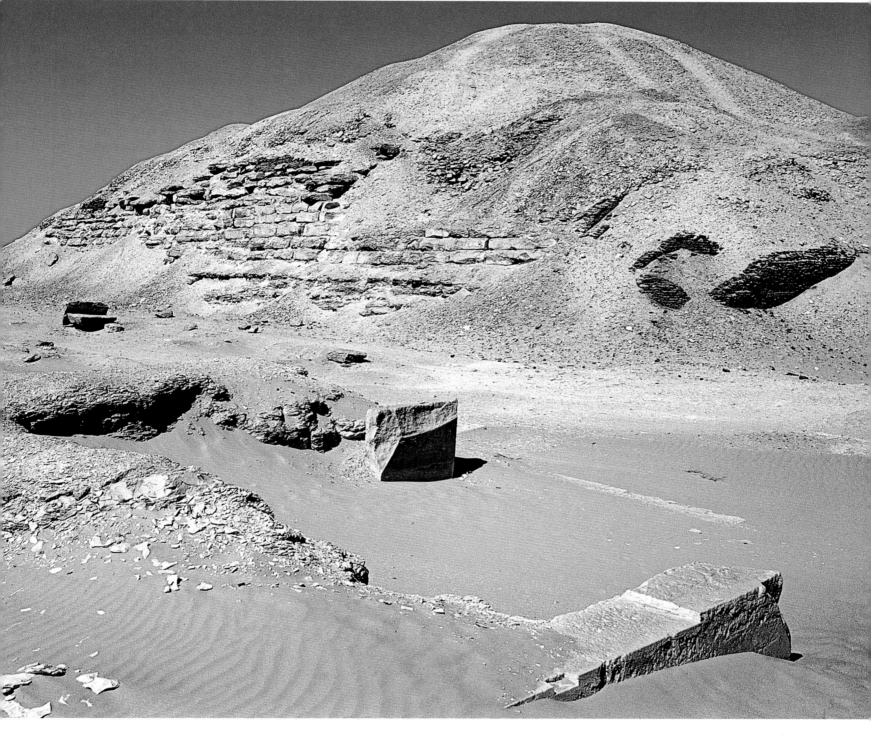

248 TOP NOTE PART OF THE
THRONE OF A STATUE OF SENRUSET
I IN THIS DETAIL.

248-249 THE PYRAMID OF
SENRUSET I AT AL-LISHT SEEMS
VERY DAMAGED.

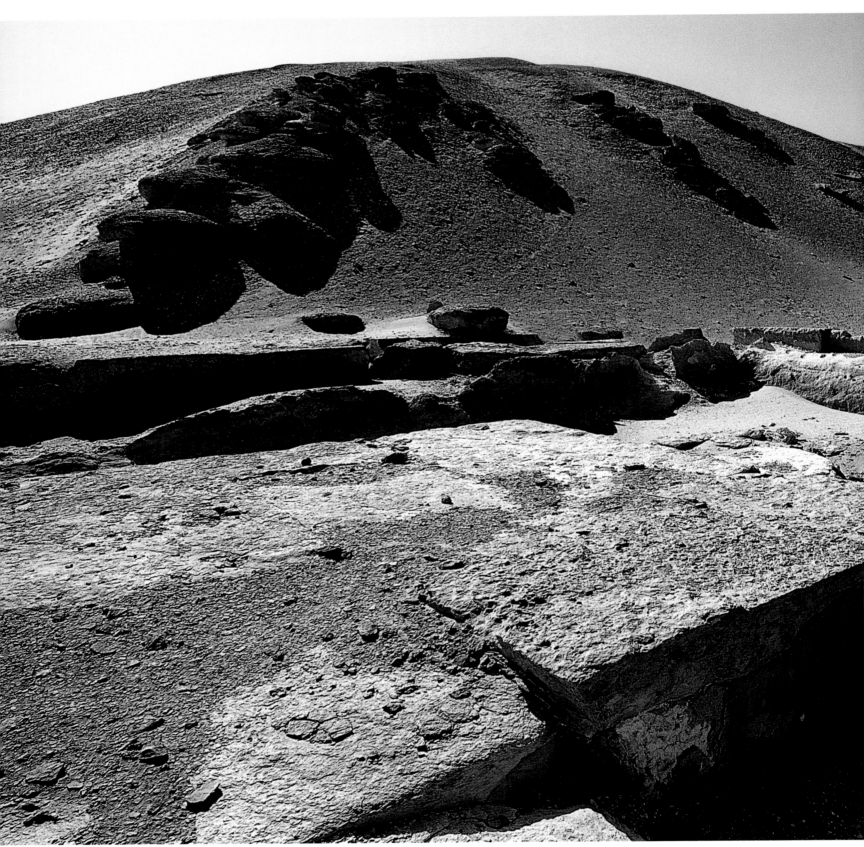

249 THIS LIMESTONE STATUE OF SENRUSET I STANDS OVER SIX FEET HIGH. IT WAS FOUND NEAR THE PHARAOH'S PYRAMID AT AL-LISHT AT THE END OF THE NINETEENTH CENTURY. TODAY IT IS DISPLAYED IN THE CAIRO MUSEUM.

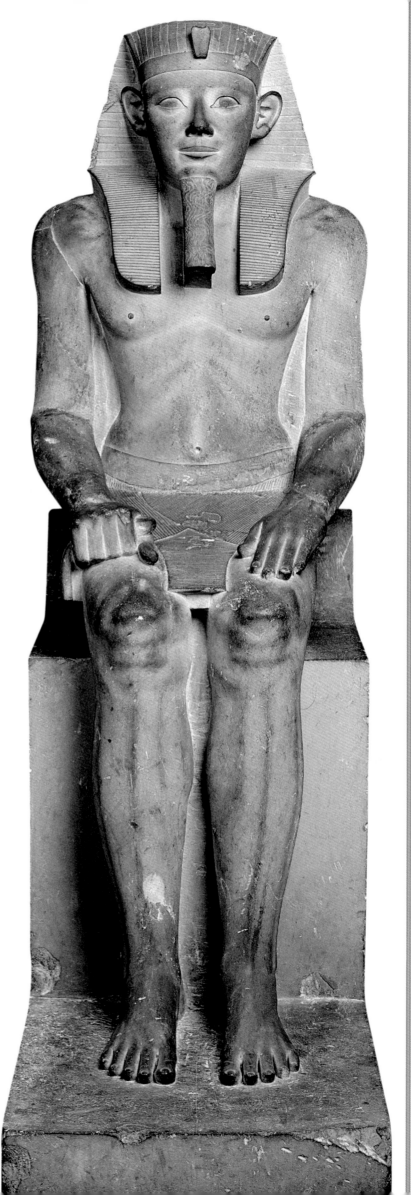

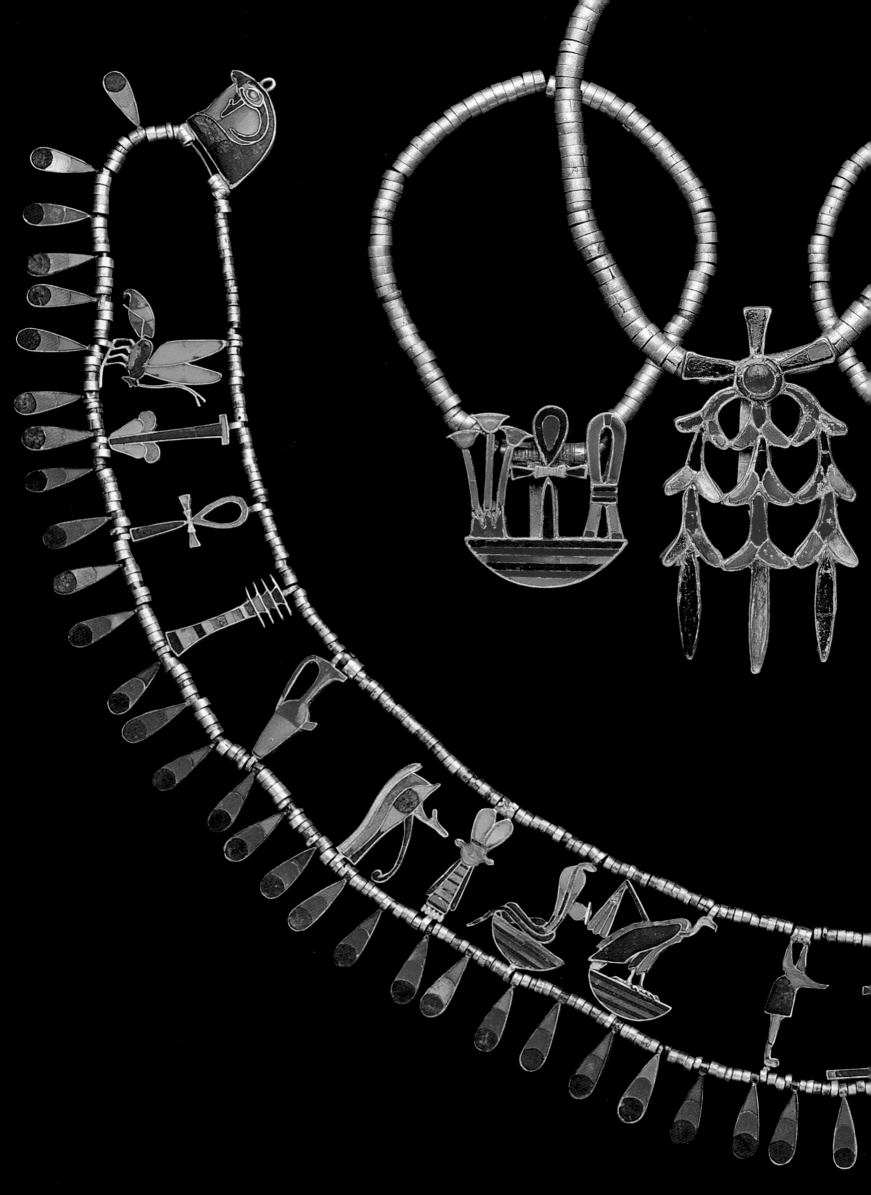

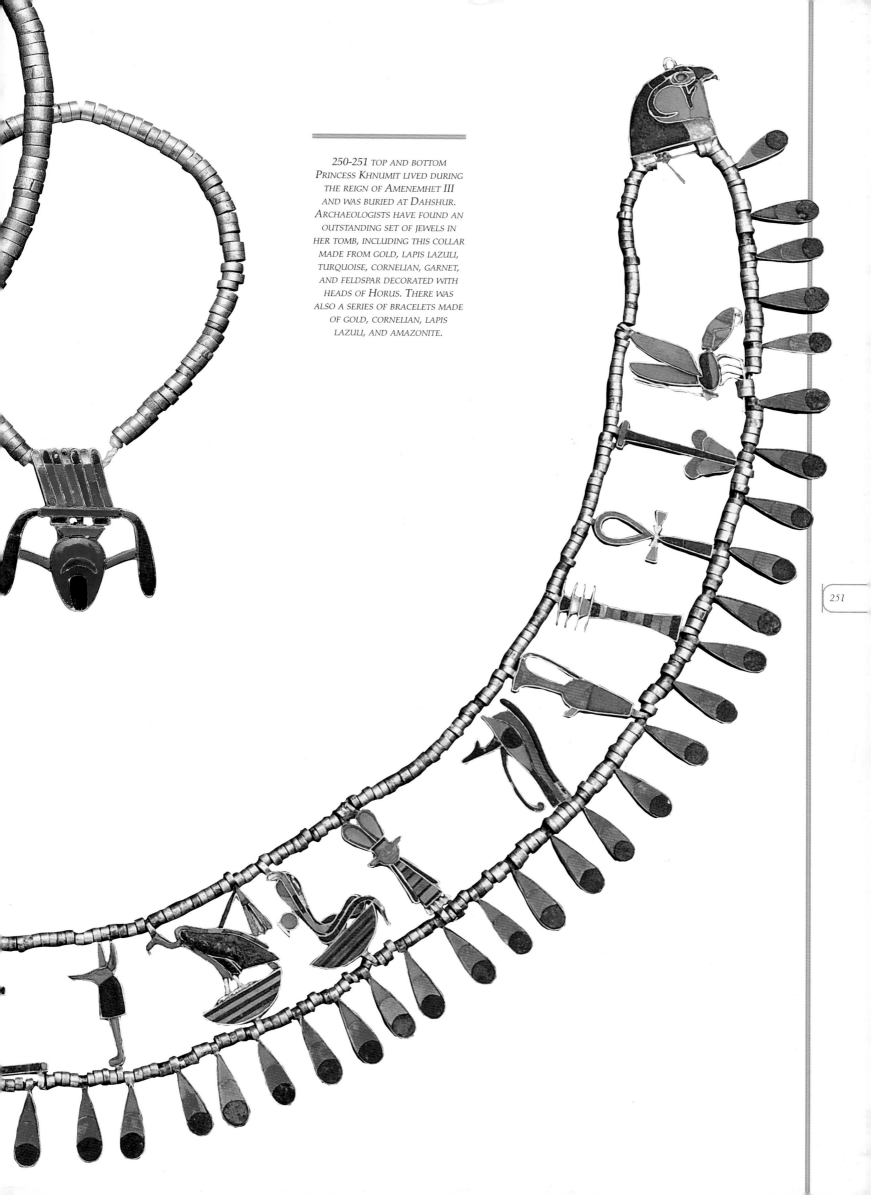

250-251 *top and bottom*
Princess Khnumit lived during
the reign of Amenemhet III
and was buried at Dahshur.
Archaeologists have found an
outstanding set of jewels in
her tomb, including this collar
made from gold, lapis lazuli,
turquoise, cornelian, garnet,
and feldspar decorated with
heads of Horus. There was
also a series of bracelets made
of gold, cornelian, lapis
lazuli, and amazonite.

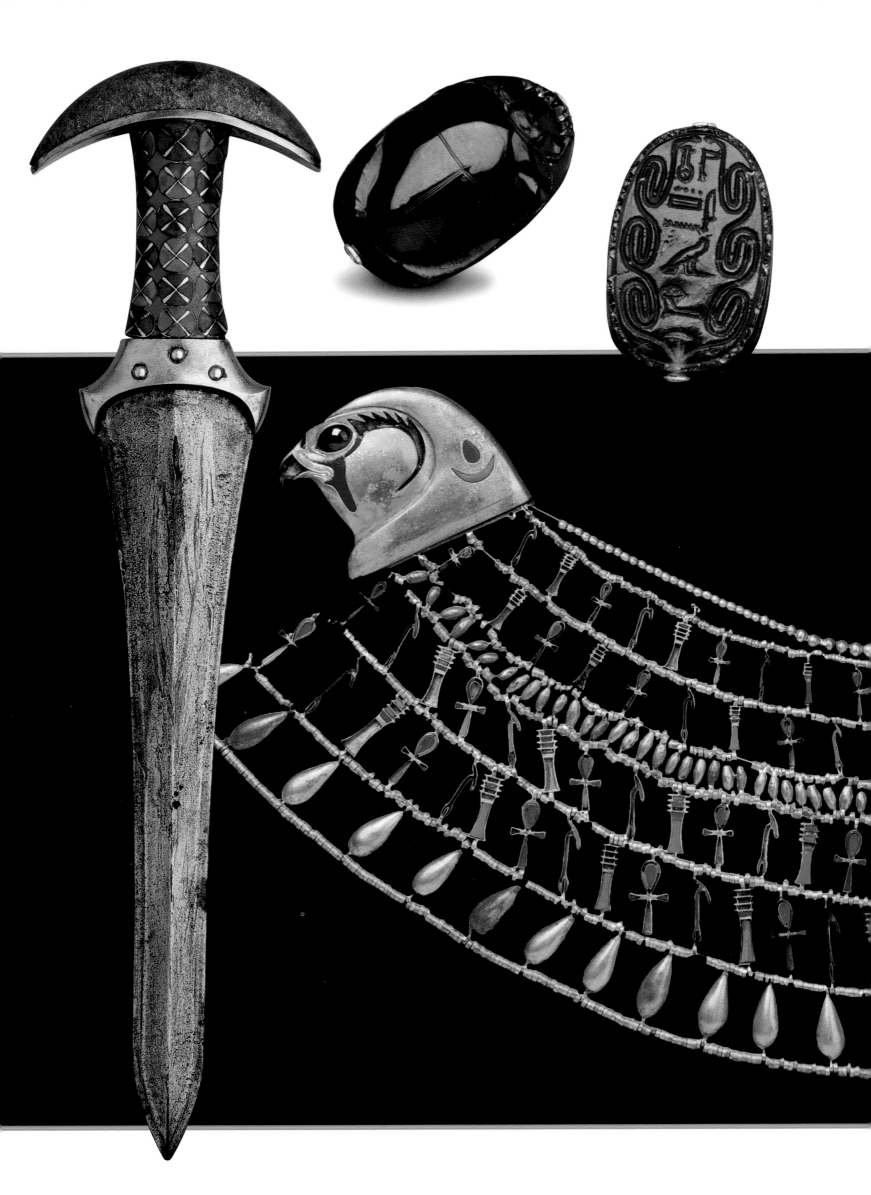

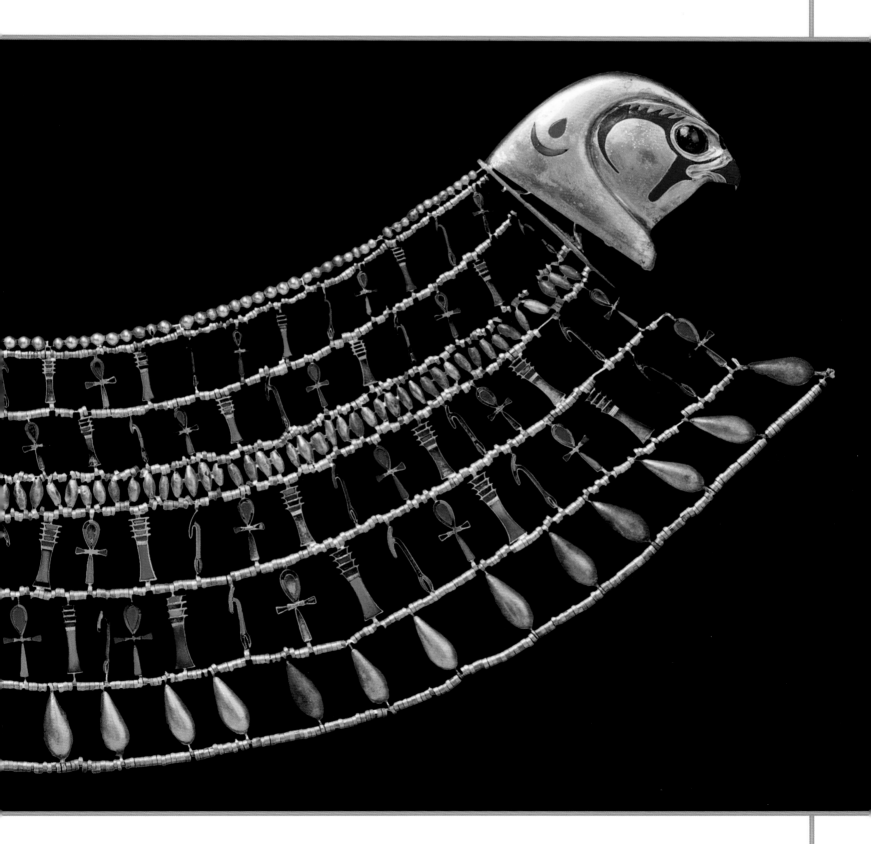

THE PYRAMID OF SENRUSET II

Senruset II preferred mud bricks to fill his pyramid, a solution that was also adopted by Senruset III and Amenemhet III. Their funerary monuments still stand majestically on the edge of Dahshur plateau even if their strange and irregular forms do not immediately suggest they were pyramids.

The pharaohs of the Middle Kingdom must have known that in antiquity robbers attacked tombs of their Old Kingdom predecessors because they dreamed up various means to defend their own pyramids' funerary apartments. For example, Senruset II broke the tradition that placed the entrance to the underground section of the pyramid on the north side of the monument and implemented the innovative idea of a vertical shaft dug a certain distance south of the monument. This notion deceived the British archaeologist Sir Flinders Petrie who for months searched for the entrance on the other side, but even when it was finally possible to enter the funerary apartment, archaeologists found the tomb robbers had got there first.

254 TOP THE REMOVAL OF THE LINING THAT ONCE COVERED SENRUSET II'S PYRAMID HAS EXPOSED THE CORE OF THE STRUCTURE AND CAUSED DETERIORATION BUT THE MASSIVE BULK OF THE MONUMENT STILL TOWERS OVER THE SURROUNDING DESERT.

254 CENTER AND 255 THE PYRAMID OF SENRUSET II AT AL-LAHUN WAS FORMED BY A SKELETON OF RADIAL WALLS MADE FROM SQUARE BLOCKS OF LIMESTONE AND A LARGE MASS OF MUD BRICKS THAT FILLED THE SPACES BETWEEN.

254 BOTTOM LEFT THIS SERPENT MADE FROM GOLD, LAPIS LAZULI, CORNELIAN, AND FELDSPAR ORIGINALLY ADORNED THE HEADDRESS OF PHARAOH SENRUSET II. IT IS NOW DISPLAYED IN THE CAIRO MUSEUM WITH MANY OTHER ITEMS OF JEWELRY FROM THE SAME PERIOD.

254 BOTTOM RIGHT THE PYRAMID OF SENRUSET II AT AL-LAHUN WAS FLANKED BY A SINGLE PYRAMID BUILT FOR ONE QUEEN AND BY EIGHT MASTABAS FOR OTHER MEMBERS OF THE ROYAL FAMILY. THE MASTABAS STOOD IN A LINE ON THE NORTH SIDE OF THE PYRAMID.

256-257 THE PYRAMID OF SENRUSET II DOMINATES THE GREEN OASIS ON THE EDGE OF DAHSHUR PLATEAU.

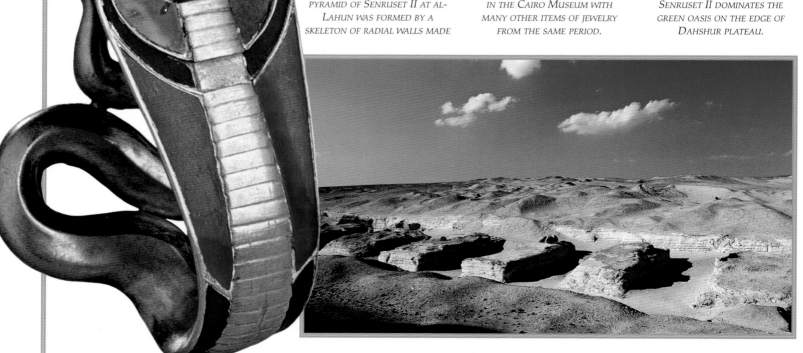

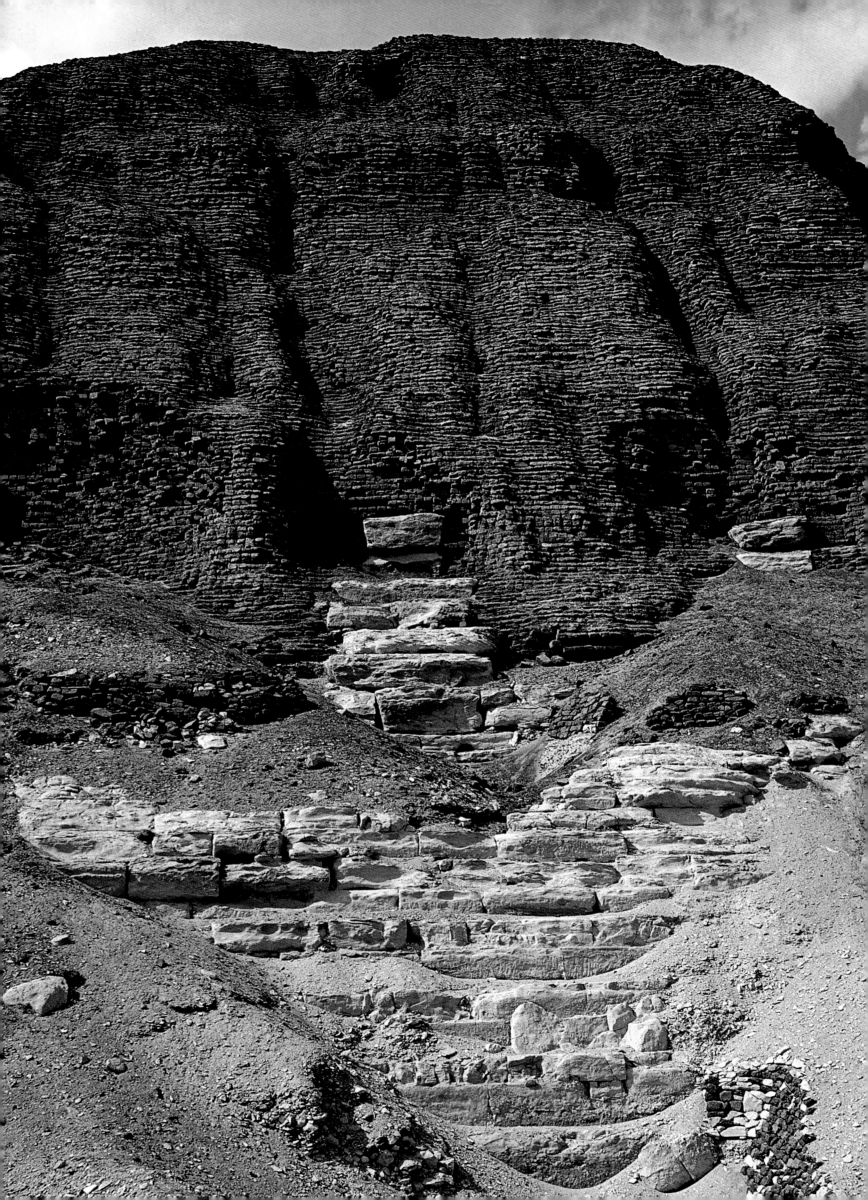

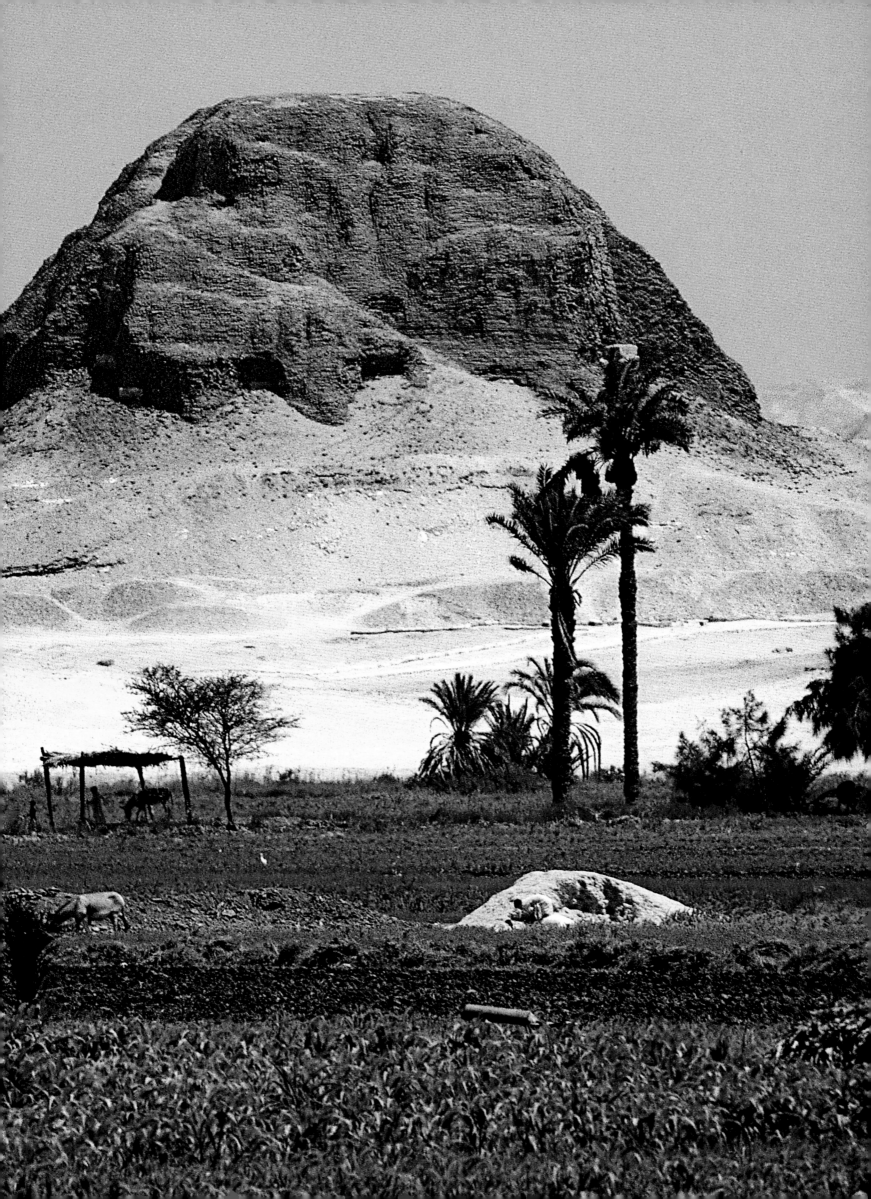

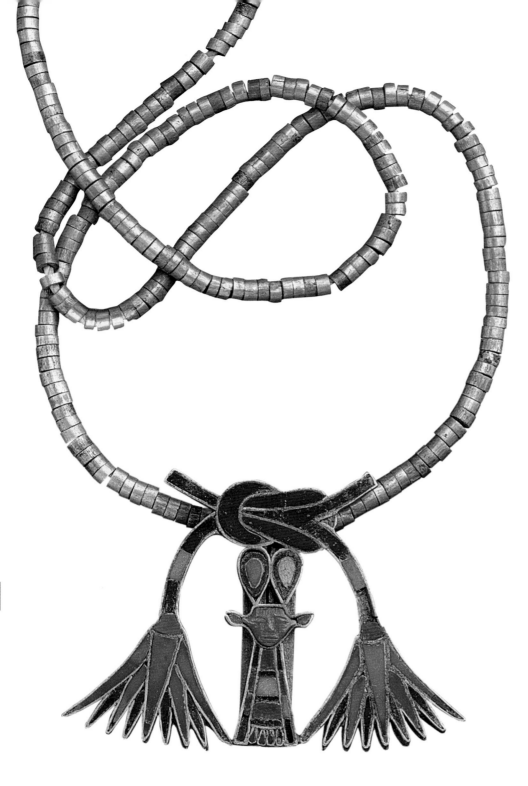

258 TOP *THIS LOVELY NECKLACE MADE FROM GOLD, LAPIS LAZULI, TURQUOISE, AND CORNELIAN WAS FOUND IN THE TOMB OF PRINCESS SATHATHOR IN THE FUNERARY COMPLEX OF SENRUSET III AT DAHSHUR. THE PRINCESS WAS ONE OF THE PHARAOH'S DAUGHTERS.*

258 BOTTOM AND 259 BOTTOM *THESE BRACELETS ARE CLOSED BY A DJED PILLAR AND COME FROM THE TOMB OF QUEEN URET, THE MOTHER OF SENRUSET III, IN THE PHARAOH'S PYRAMIDAL COMPLEX AT DAHSHUR.*

258-259 *THE ELABORATE BREASTPLATE MADE FROM GOLD, LAPIS LAZULI, CORNELIAN, TURQUOISE, AND AMETHYST COMES FROM THE TOMB OF PRINCESS MERERET AT DAHSHUR. SHE LIVED DURING THE REIGNS OF PHARAOHS SENRUSET III AND AMENEMHET III.*

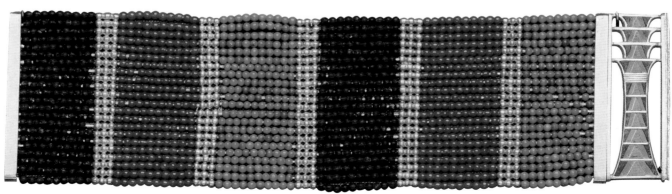

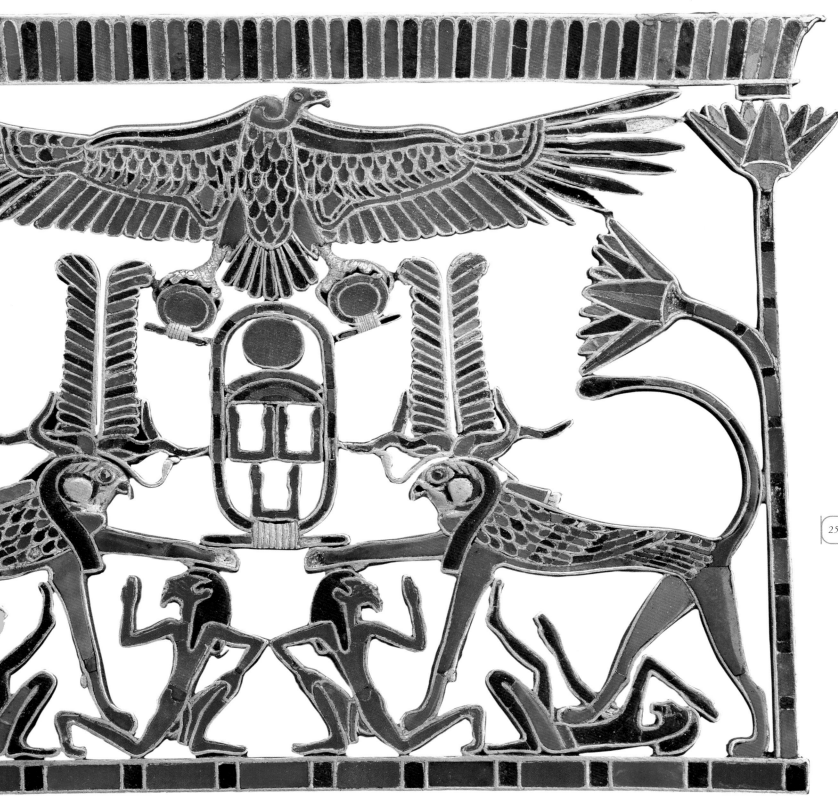

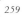

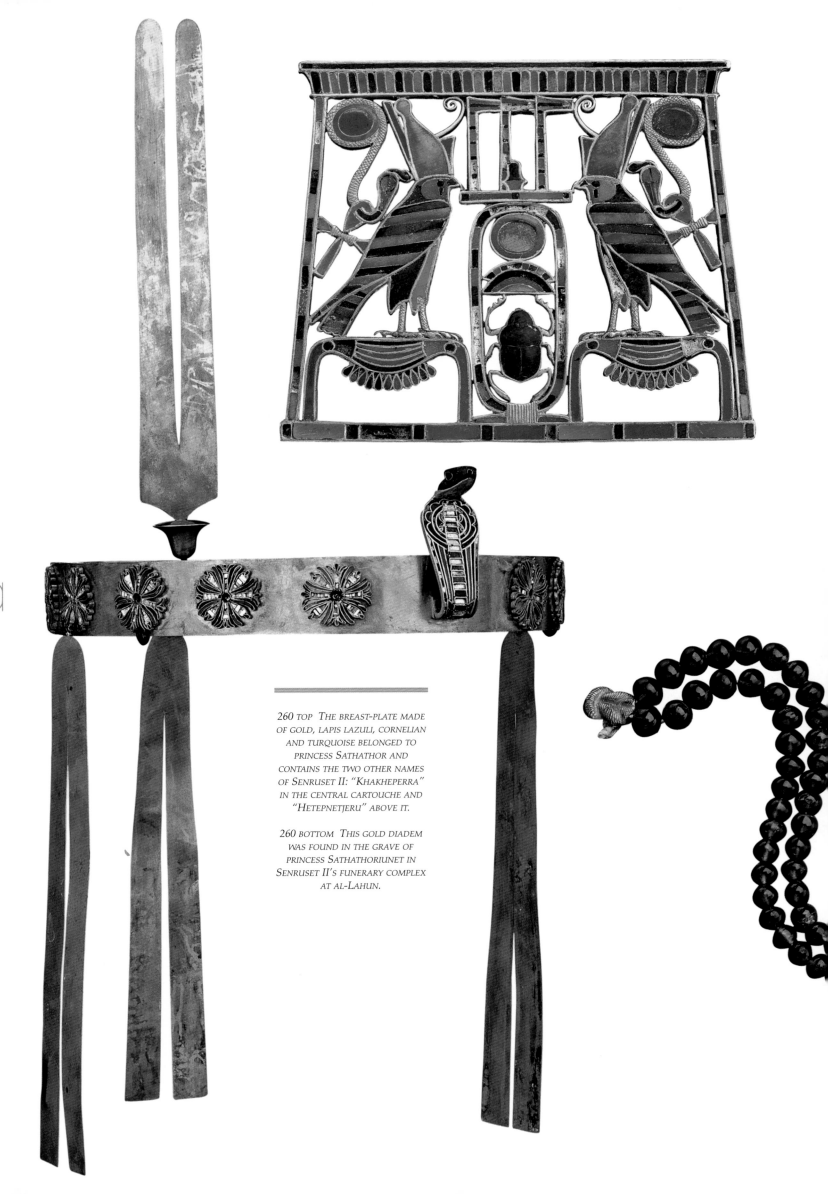

260 TOP THE BREAST-PLATE MADE
OF GOLD, LAPIS LAZULI, CORNELIAN
AND TURQUOISE BELONGED TO
PRINCESS SATHATHOR AND
CONTAINS THE TWO OTHER NAMES
OF SENRUSET II: "KHAKHEPERRA"
IN THE CENTRAL CARTOUCHE AND
"HETEPNETJERU" ABOVE IT.

260 BOTTOM THIS GOLD DIADEM
WAS FOUND IN THE GRAVE OF
PRINCESS SATHATHORIUNET IN
SENRUSET II'S FUNERARY COMPLEX
AT AL-LAHUN.

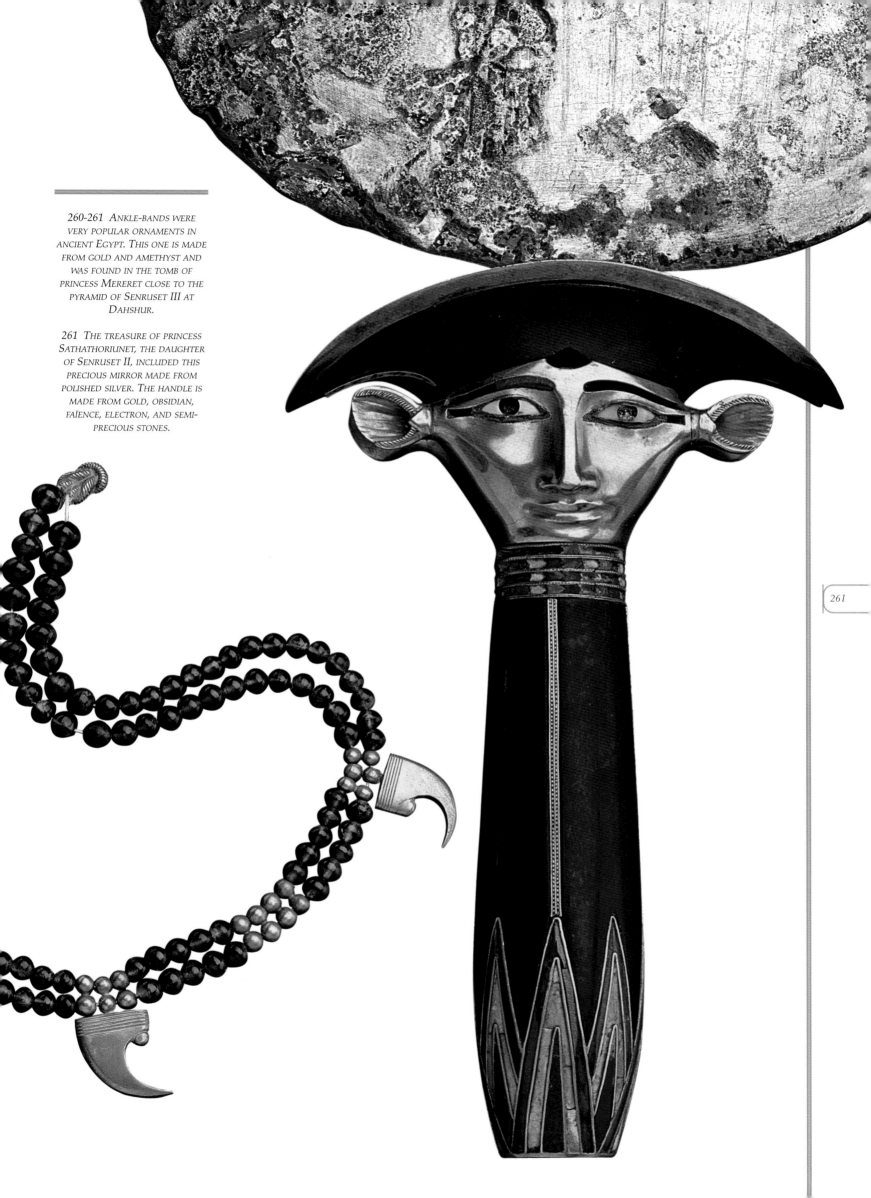

260-261 *Ankle-bands were very popular ornaments in ancient Egypt. This one is made from gold and amethyst and was found in the tomb of Princess Mereret close to the pyramid of Senruset III at Dahshur.*

261 *The treasure of princess Sathathoriunet, the daughter of Senruset II, included this precious mirror made from polished silver. The handle is made from gold, obsidian, faïence, electron, and semi-precious stones.*

THE PYRAMID

262 SENRUSET III, PHARAOH OF THE
TWELFTH DYNASTY, IS PORTRAYED IN
THIS GRANITE STATUE MORE THAN
TEN FEET TALL. IT WAS FOUND AT
KARNAK AND TRANSFERRED TO
THE CAIRO MUSEUM.

262-263 SENRUSET III CHOSE
DAHSHUR TO BUILD A PYRAMID
WITH SEVEN SMALL PYRAMIDS FOR
HIS QUEENS, ALL OF WHICH
WERE ENCLOSED IN A LARGE
PANELED WALL.

OF SENRUSET III

I n his pyramid at Dahshur, Senruset III tried another variation on the new notion of a hidden entrance, this time digging a sloping corridor on the west side of the monument. The thieves solved the problem by digging their own tunnel into the body of the pyramid as far as the burial chamber.

The archaeologist who first studied this pyramid, Jacques de Morgan, used the same unceremonious method in 1895: by excavating beneath and inside the pyramid, he came across the thieves' ancient tunnel which allowed him to reach the burial chamber without having to do the hard work.

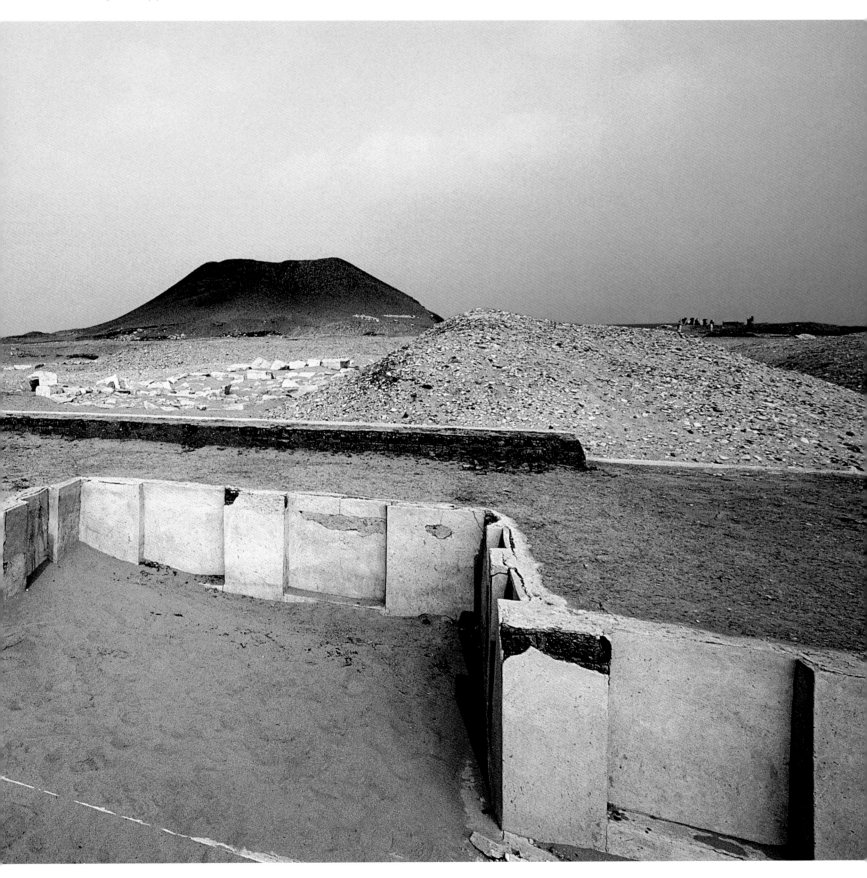

THE PYRAMIDS

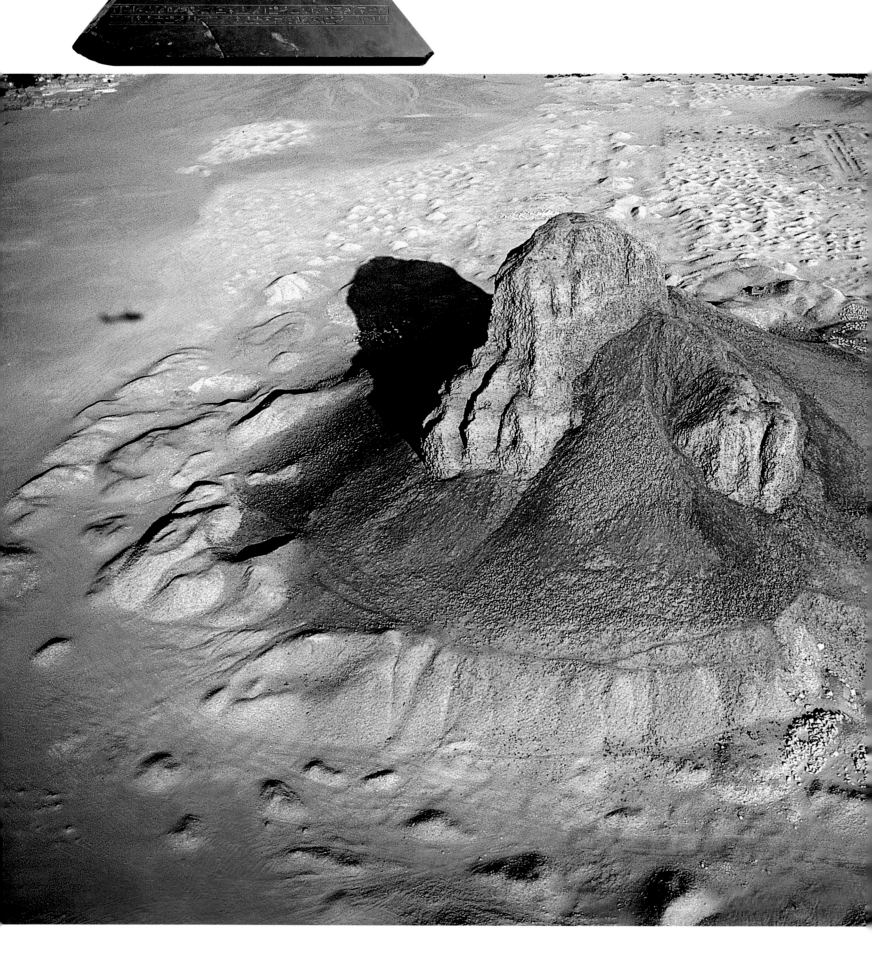

OF AMENEMHET III

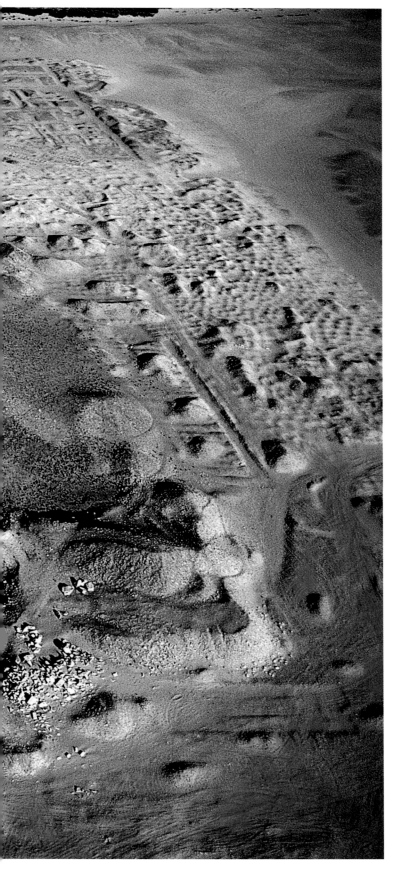

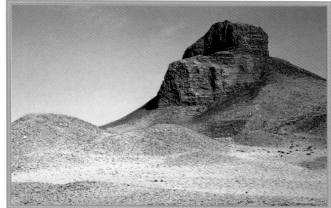

The growing uncertainty over the fate of royal tombs is made clear by the design adopted by Amenemhet III. Under his pyramid at Dahshur he had an intricate system of corridors that led into a large number of rooms of different dimensions used to hold the remains not just of the pharaoh, but also various members of his family. However, the construction was not adequately stable, probably due to the decision to build the monument close to the muddiest terrain in the valley and the fact that the construction contained so many empty spaces. For this reason Amenemhet III decided to build a second pyramid at Hawara on the edge of the oasis of Fayum. This pyramid was completed by a temple that later became legendary with the name of 'the Labyrinth.' According to the Greek historian Herodotus, the building contained three thousand rooms, but it was used to supply building materials from the Roman age onward. Today almost nothing remains of it.

After Amenemhet III the Middle Kingdom entered a phase in which centralized power declined. Few of the Thirtieth Dynasty pharaohs began construction of pyramids and only a small proportion of those begun were completed. However, the era of large royal pyramids finished with the end of the Middle Kingdom around 1650 BC. From the New Kingdom on, pyramids retained their function as a funerary symbol but ceased to be the prerogative of the pharaoh and his queens, and were used by commoners to complete their own tombs. A hundred or so years after the last great royal pyramids, the pharaohs of the New Kingdom decided on a new design for their monumental tombs, even though it too drew on ancient symbolism. For their necropolises they chose the famous Valley of the Kings and Valley of the Queens, which stretched to the foot of an enormous mountain shaped like a pyramid. The mountain was called *Meret-seger*, which means "She who loves Silence." In the bowels of the mountain, the pharaohs dug their funerary apartments, decorated them with brilliantly colored scenes and filled them with offerings and treasures that were supposed to accompany them in their eternal sleep.

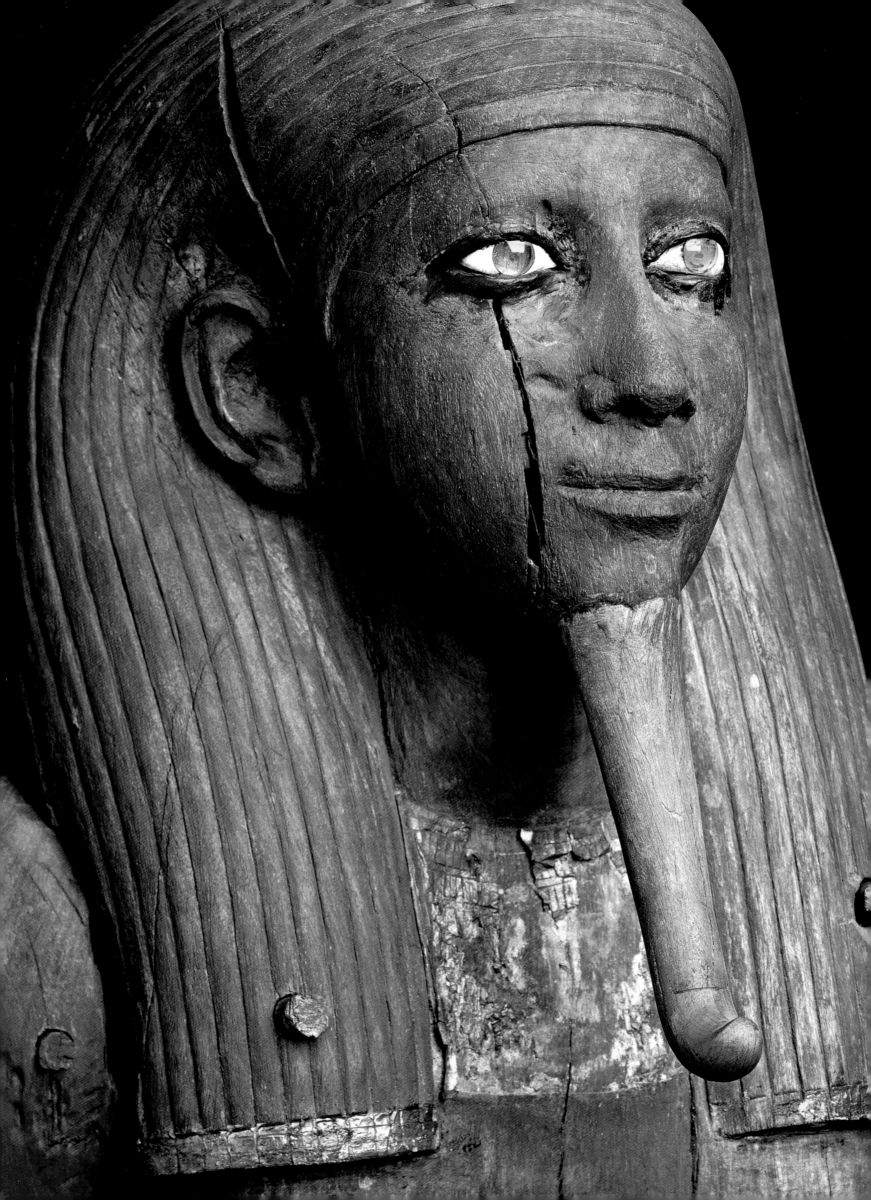

THE PYRAMIDS OF AMENEMHET III

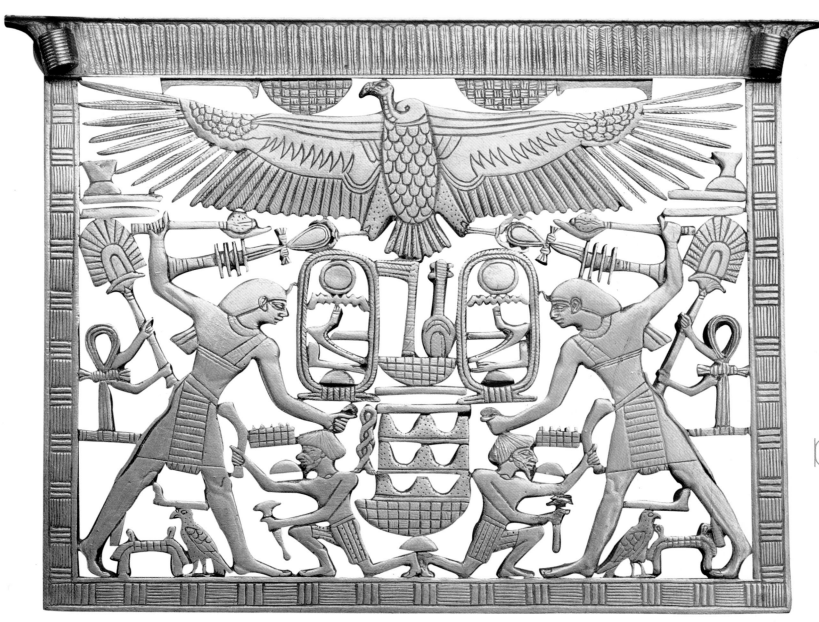

266 FEW FUNERARY MONUMENTS HAVE REMAINED OF THE PHARAOHS OF THE THIRTEENTH DYNASTY, BUT THIS WOODEN STATUE OF AWIBRA HOR, FOUND CLOSE TO THE PYRAMID OF AMENEMHET III AT DAHSHUR, REVEALS THE ABILITY OF THE ARTISTS OF THE PERIOD.

267 THE ELABORATE BREAST-PLATE FOUND IN THE TOMB OF PRINCESS MERERET, A DAUGHTER OF SENRUSET III, CONTAINS TWO SYMMETRICAL IMAGES OF THE PHARAOH AMENEMHET III KILLING AN ENEMY HE HOLDS BY THE HAIR.

268-269 THE AERIAL VIEW OF THE SITE OF DAHSHUR SHOWS THE REMAINS OF AMENEMHET III'S PYRAMID IN THE FOREGROUND AND, BEHIND ON THE LEFT, SNEFRU'S BENT PYRAMID AND, ON THE RIGHT, HIS RED PYRAMID.

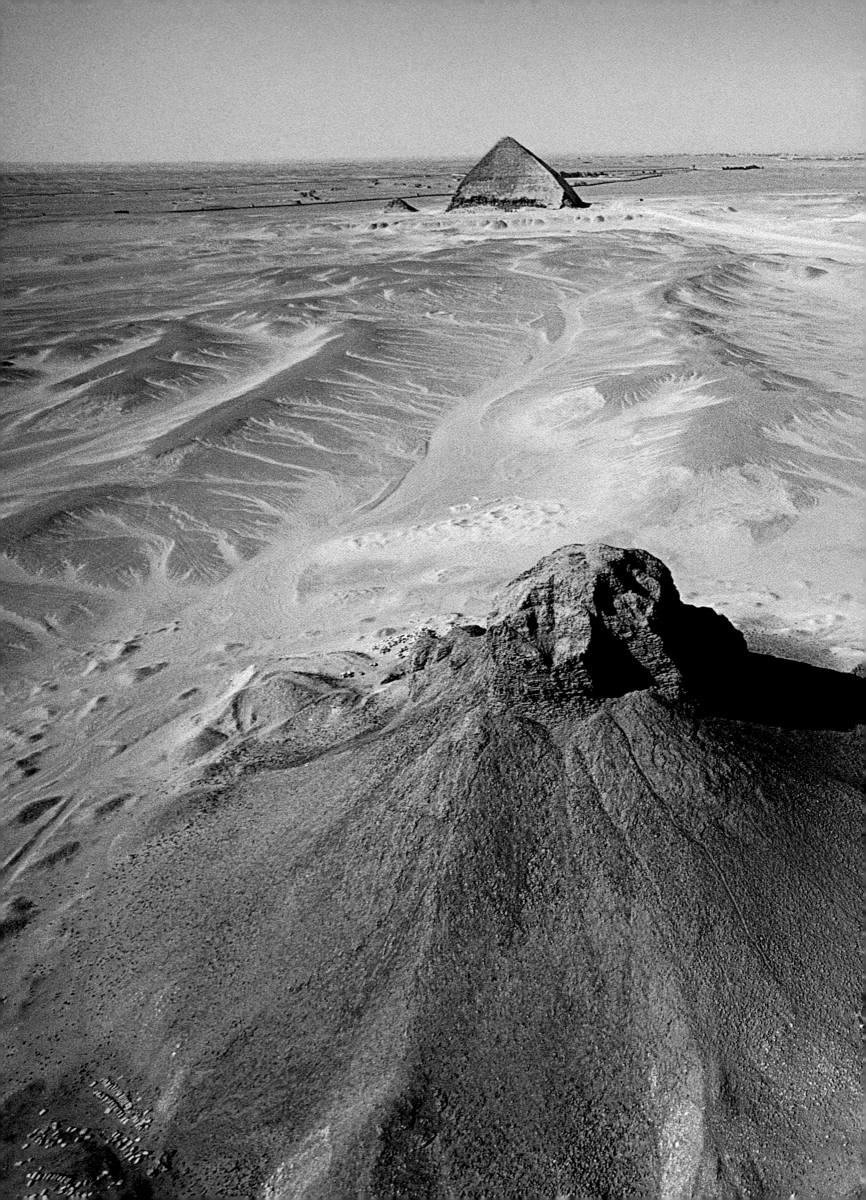

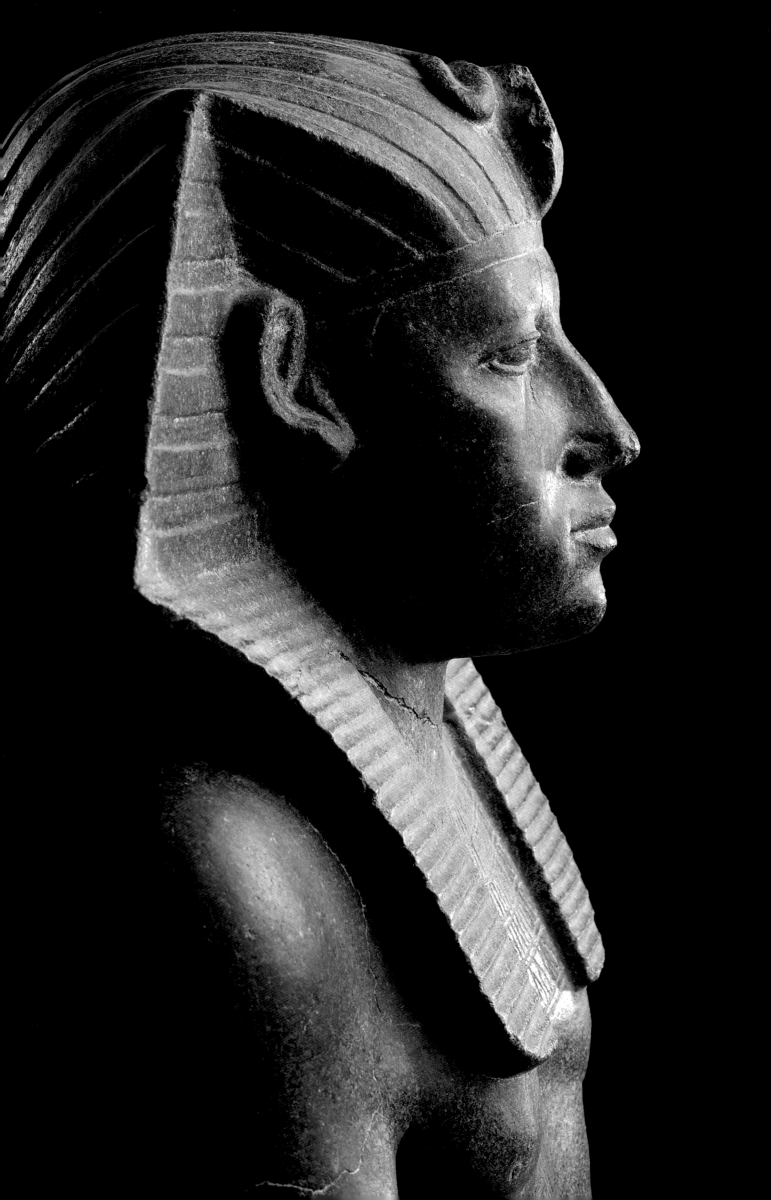

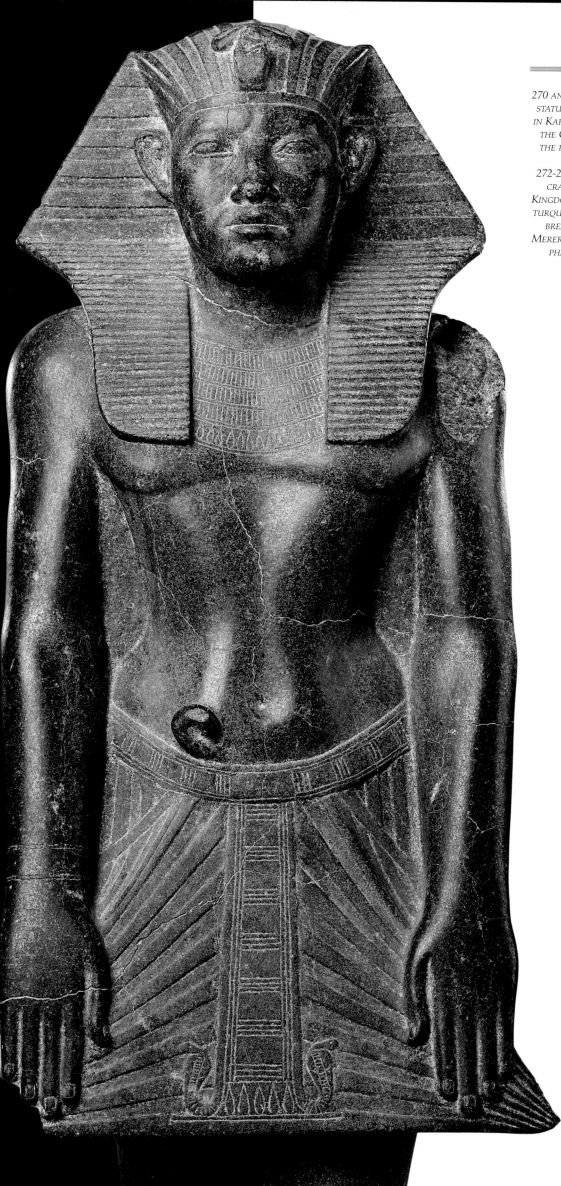

270 AND 271 THIS BLACK GRANITE
STATUE FOUND IN THE CACHETTE
IN KARNAK TEMPLE AND TODAY IN
THE CAIRO MUSEUM PORTRAYS
THE PHARAOH AMENEMHET III.

272-273 MADE BY THE SKILLFUL
CRAFTSMEN OF THE MIDDLE
KINGDOM FROM GOLD, CORNELIAN,
TURQUOISE AND LAPIS LAZULI, THE
BREAST-PLATE BELONGING TO
MERERET BEARS THE TITLES OF THE
PHARAOH AMENEMHET III.

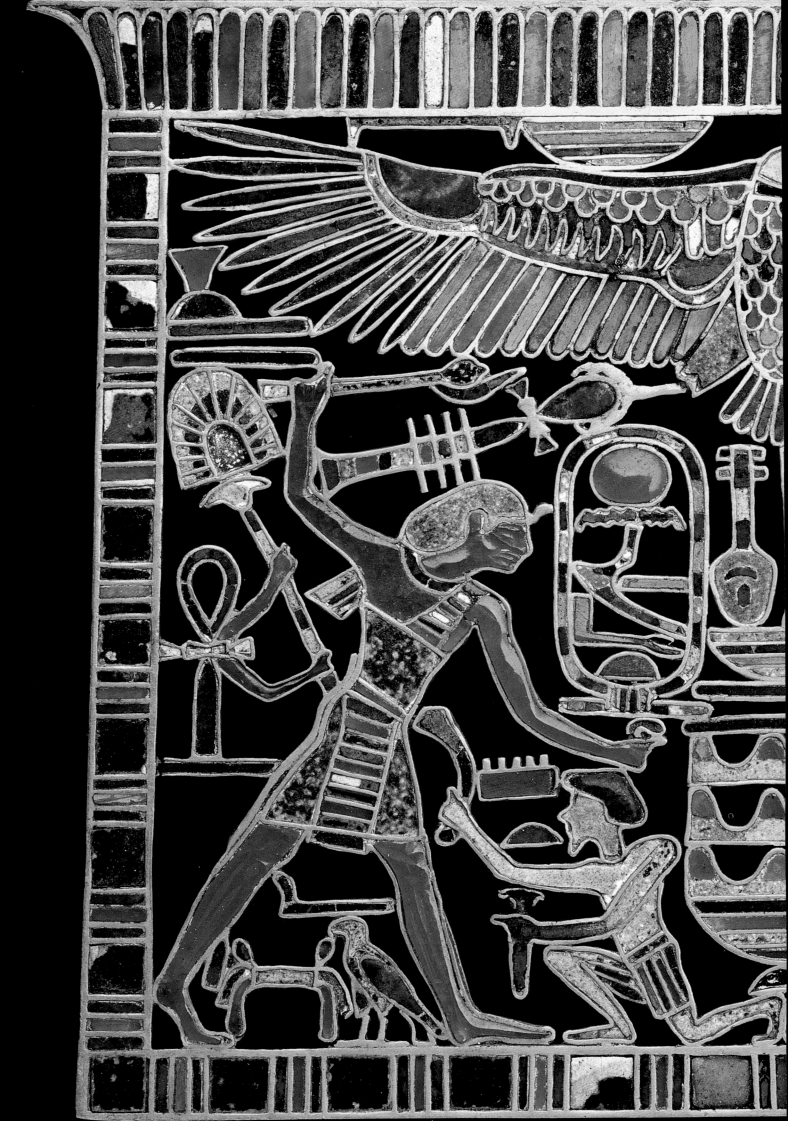

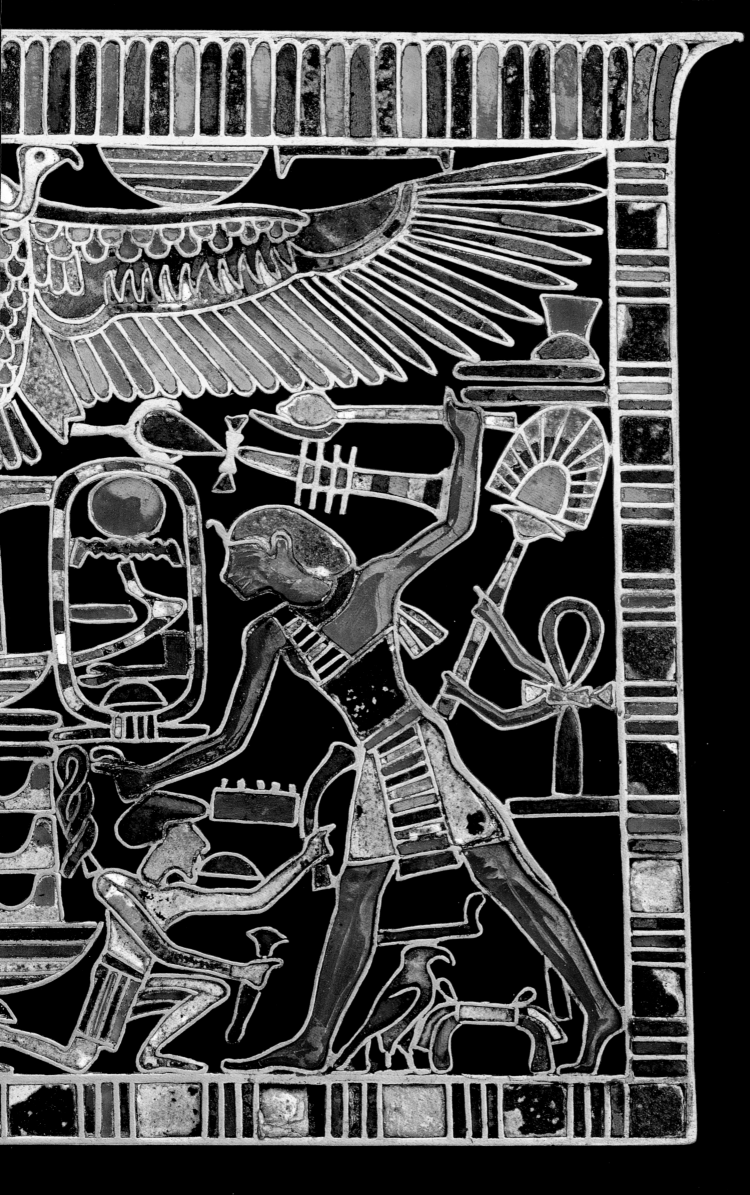

274-275 A NUMBER OF SERIOUSLY
DAMAGED STRUCTURES RING THE
PYRAMIDAL COMPLEX OF
AMENEMHET III AT HAWARA.

274 BOTTOM THIS FINE COLLAR
MADE FROM GOLD, CORNELIAN,
FELDSPAR AND GLASS PASTE
BELONGED TO PRINCESS
NEFEUPTAH, A DAUGHTER OF
AMENEMHET III. IT WAS FOUND IN
THE FUNERARY COMPLEX OF
HAWARA.

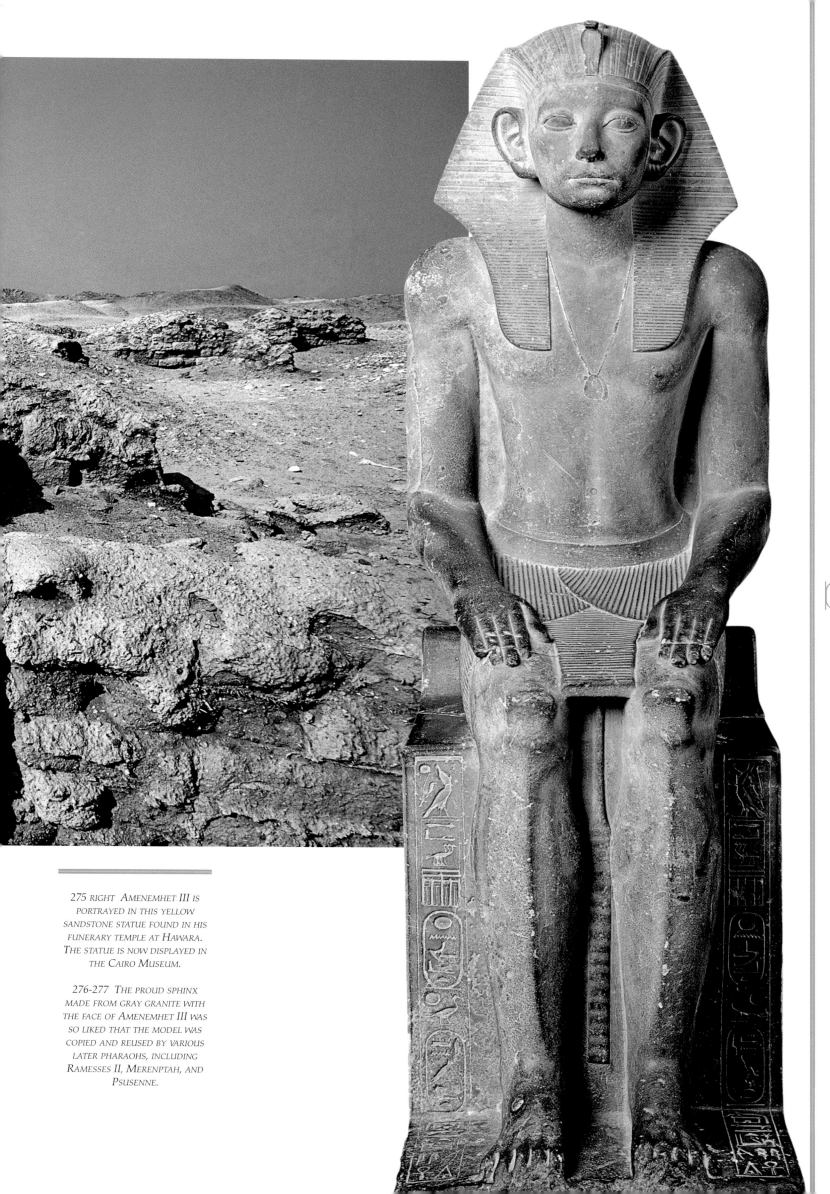

275

275 RIGHT AMENEMHET III IS
PORTRAYED IN THIS YELLOW
SANDSTONE STATUE FOUND IN HIS
FUNERARY TEMPLE AT HAWARA.
THE STATUE IS NOW DISPLAYED IN
THE CAIRO MUSEUM.

276-277 THE PROUD SPHINX
MADE FROM GRAY GRANITE WITH
THE FACE OF AMENEMHET III WAS
SO LIKED THAT THE MODEL WAS
COPIED AND REUSED BY VARIOUS
LATER PHARAOHS, INCLUDING
RAMESSES II, MERENPTAH, AND
PSUSENNE.

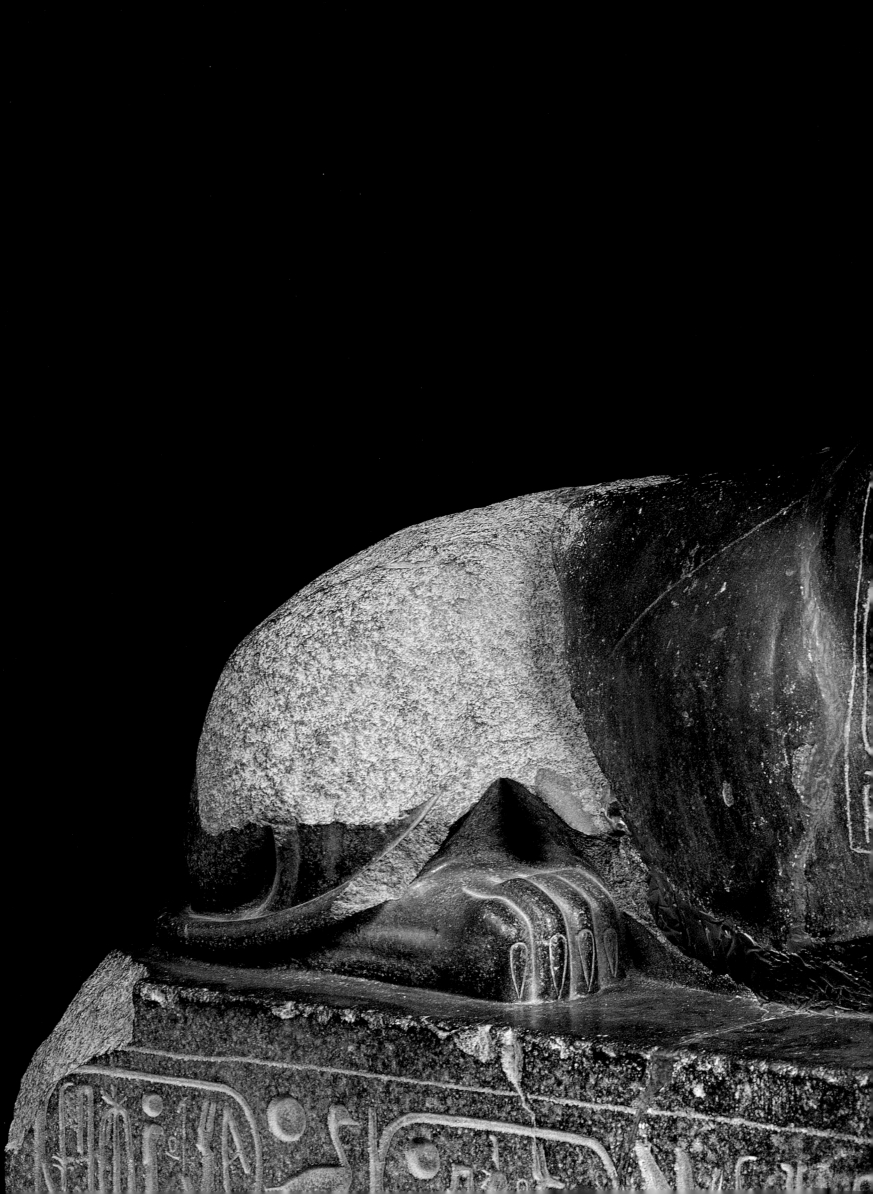

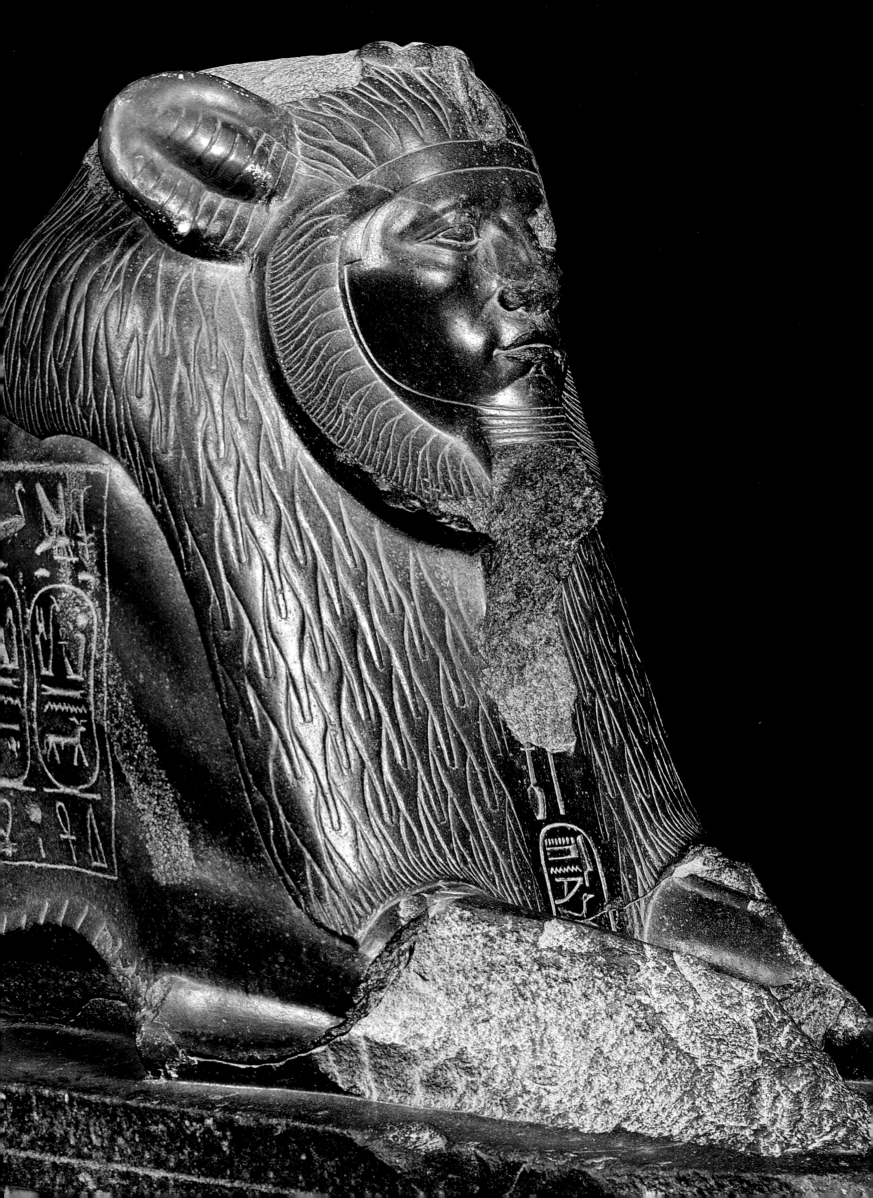

INDEX

PHOTOGRAPHIC CREDITS

Archivio White Star: pages 16 and 17, 18 and 19, 20 and 21, 22 and 23, 24 and 25, 26 and 27, 28 and 29, 30-31, 32-33, 34-35.

Antonio Attini/Archivio White Star: pages 73, 99 bottom.

Marcello Bertinetti/ Archivio White Star: pages 4-5, 6, 12-13, 14-15, 36-37, 39 top, 40-41, 42-43, 44 top, 44-45, 46-47, 48-49, 50 bottom, 55, 57, 63, 66-67, 68-69, 70-71, 72, 72-73, 76-77 top, 79, 80-81, 82-83, 84 bottom, 86-87, 88, 91, 92-93, 94, 98-99, 130-131, 132-133, 134-135, 136-137, 138-139, 140 top, 141, 145, 236 e 237, 254 top, 264-265, 268-269.

Angelo Colombo/Archivio White Star: page 8.

Araldo De Luca/Archivio White Star: pages 7, 10-11, 36, 44 bottom, 49 bottom, 52, 53 bottom, 54, 58-59, 59, 60-61, 71, 74, 75, 76-77 bottom, 78, 83, 84 top, 85, 100 and 101, 102 and 103, 104 and 105, 106 and 107, 108 and 109, 110 and 111, 112 center and bottom, 113, 114, 115 bottom, 117 bottom, 118 and 119, 120 and 121, 122 and 123, 124 and 125, 126 and 127, 128-129,130, 132, 133, 135, 139, 140 bottom, 143, 146 and 147, 148 and 149, 150, 151 left, 152 bottom, 154-155, 156, 157 right, 158-159, 160 and 161, 162 and 163, 164 and 165, 166 and 167, 168, 168-169, 170 and 171, 172 and 173, 174 and 175, 176-177, 178, 179 top right, 179 bottom left, 180-181, 182-183, 184 and 185, 186 and 187, 188 bottom, 188-189, 189 bottom, 190 and 191, 192 and 193, 194-195, 198 and 199, 200 and 201, 202 and 203, 204 bottom, 205, 206 and 207, 208 and 209, 210-211, 212 and 213, 214 and 215, 216 and 217, 218 and 219, 220 bottom, 221, 222-223, 223, 224 and 225, 226 and 227, 228 and 229, 230-231, 232-233, 238 and 239, 240, 241 top, 244, 246, 248, 249, 250 and 251, 252 and 253, 254 bottom left, 258 and 259, 260 and 261, 262, 264, 266 and 267, 270 and 271, 272-273, 274, 275, 276-277, 280.

Alfio Garozzo/Archivio White Star: pages 39 bottom, 49 top, 50 top, 50-51, 53 top, 58, 62 top, 64 right, 144 bottom, 179 top left, 179 bottom right, 188 top, 189 top, 243, 242-243, 245, 246-247, 248-249, 254 center, 256-257.

Karol Myslievic: pages 196-197, 197.

Giulio Veggi/Archivio White Star: pages 1, 2-3, 38-39, 56 left and right, 62 bottom, 64 left, 65, 74-75, 80, 81, 82, 89, 90, 94-95, 95, 96-97, 99 top left and right, 99 center, 112 top, 115 top, 116-117, 117 top, 134, 137, 138, 142-143, 144 top and center, 150-151, 151 right, 152 top, 153, 157 left, 169, 204 top, 220 top, 222 top, 222 bottom, 234 and 235, 240-241, 244-245, 247, 254 bottom right, 255, 262-263, 265, 274-275.

The publishers would like to thank:
His Excellency Farouk Hosny - Egyptian Minister of Culture;
Zahi Hawass - Secretary General of the Supreme Council of Antiquities and
Director of the Giza Pyramids Excavations;
Taha Abd Elaleem - President of the Egyptian Information Center;
Attiya Shakran - General Director of the Cairo Press Center;
Gamal Shafik of the Cairo Press Center;
Guido Paradisi and Fabio Calamante - Araldo De Luca's assistants.

280 THIS PENDANT MADE FROM
GOLD, TURQUOISE, LAPIS LAZULI,
AND CORNELIAN BELONGED TO
PRINCESS MERERET, A DAUGHTER
OF THE TWELFTH DYNASTY
PHARAOH SENRUSET III.